English & Irish Delftware 1570–1840

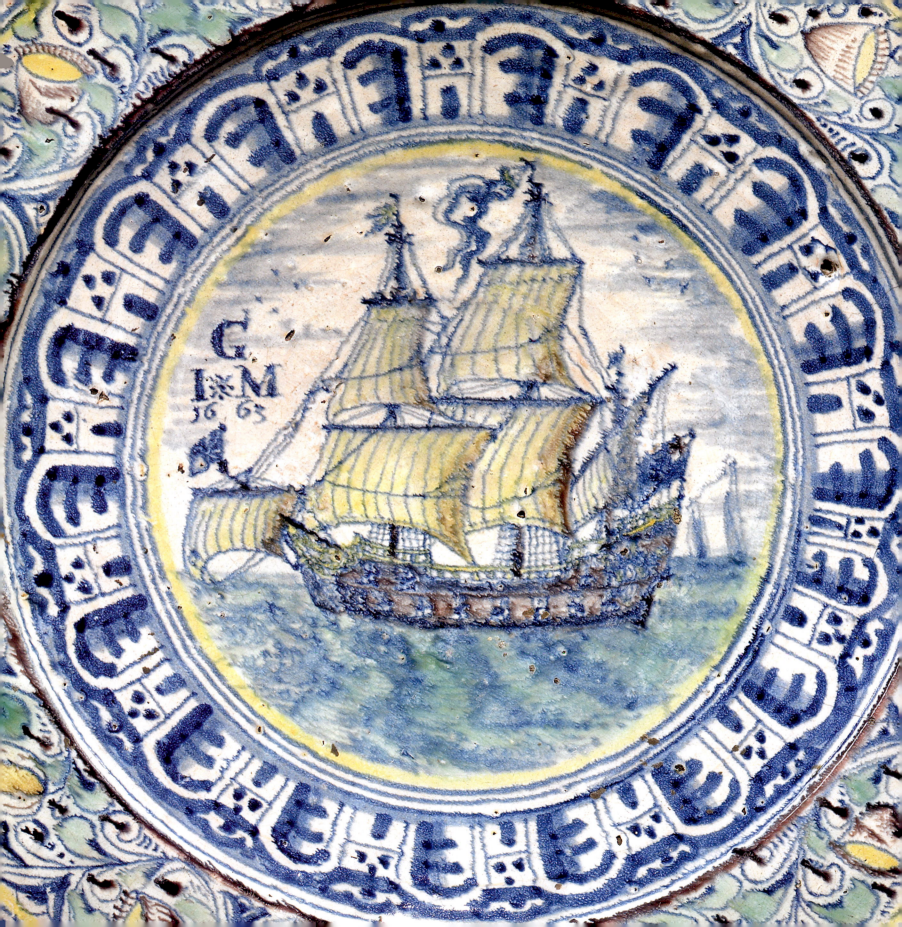

English & Irish Delftware
1570–1840

Aileen Dawson

THE BRITISH MUSEUM PRESS

Dedicated to the memory of my late parents,
Ben and Muriel Dawson, and to Jonathan Horne

© 2010 The Trustees of the British Museum

Published in 2010 by The British Museum Press
A division of The British Museum Company Ltd
38 Russell Square
London WC1B 3QQ

www.britishmuseum.org

Aileen Dawson has asserted the right to be identified as the author of this work

A catalogue record for this book is available from the British Library

ISBN 978-0-7141-2810-8

Designed and typeset in FFScala by Tim Harvey

Printed in China

Photographs by Saul Peckham © The Trustees of the British Museum,
courtesy of the Department of Photography and Imaging,
except for the following:
© The British Library Board: figs 1, 2
© The British Museum: figs 8, 12, 14, 15, 16
© The Metropolitan Museum of Art, New York: fig. 13
© Society of Antiquaries of London: fig. 10
Maps and line drawings by Stephen Crummy, British Museum: figs 2, 3 and p. 300

Frontispiece
Detail from a charger, 1663 (no. 5)

Contents

Preface and acknowledgements

The British Museum Press and the author are grateful to the following for their generous support for this book:

CERAMICA-STIFTUNG BASEL

Sir Harry and Lady Djanogly

The British Museum collection of English delftware, although not the largest, is one of the most interesting. It has been the writer's intention to make it better known and to show how it can be used to illuminate the political, social and technological history of the nation. In this endeavour I have been greatly assisted from the outset by Stephen McManus, a collector and volunteer who has been an invaluable support in my research, and who has also compiled the index. Jonathan Horne provided immense encouragement and shared his deep knowledge of delftware with me all through the project. Margaret Macfarlane and Michael Archer have also generously given their time to discuss many of the problem pieces in the collection.

The Ceramica-Stiftung in Basel have given a substantial grant towards the production costs of this book, for which I am immensely grateful.

I should like to thank Sir Harry Djanogly for his hospitality, encouragement and generosity in supporting the project.

My colleagues both at home and abroad have been immensely supportive and I should like to thank Jessie McNab, formerly of the Metropolitan Museum, New York, Jan Daniël van Dam of the Rijksmuseum, Amsterdam, Pat Halfpenny and Lesley Grigsby, Winterthur Museum, Delaware, Stella Beddoe, Brighton Museum and Art Gallery, Julia Poole, Fitzwilliam Museum, Cambridge, Neil Hyman, Hampshire Museums Service, Robin Emmerson, National Museums Liverpool, Hazel Forsyth, Museum of

London, Alison Copeland, Manchester Art Gallery, Timothy Wilson and Dinah Reynolds, Ashmolean Museum, Oxford and Miranda Goodby, Potteries Museum, Stoke-on-Trent, for allowing access to their collections, and spending long hours in conversation with me about delftware.

In the British Museum I owe a debt of gratitude to Jessica Harrison-Hall, Department of Asia, Barrie Cook and Philip Attwood, Coins and Medals, Jonathan Williams, Jill Cook, Beverley Nenk and Dora Thornton, James Peters and his team, Prehistory and Europe, Joanna Bowring, Head of Public Libraries, Antony Griffiths, Martin Royalton-Kisch and Sheila O'Connell, Prints and Drawings and to Ivor Kerslake and John Williams, Photography and Imaging.

Much information has been discovered about a whole range of pieces and I wish to acknowledge help from all those who have been kind enough to respond to my enquiries and give me the benefit of their expertise, including Garry Atkins, Jane Baxter, Jane Bradley, Local Studies Librarian, Bristol Reference Library, Anthony du Boulay, Maisie Brown, Marjorie Caygill, Clive Cheesman, Mark Dennis, archivist, Freemason's Hall, Penny Fussell, archivist, the Worshipful Company of Drapers, John Graves, National Maritime Museum, Antoinette Hallé, Musée National de Céramique, Sèvres, Trevor Hines, Clerk, the Worshipful Company of Gardeners, Bob Houghton, Adrian James, Librarian, Society of Antiquaries of London, Suzanne Lambooy, Aronson Antiquairs, Camille Leprince, Jennifer Marin, Jewish Museum, London, Eve McClure, Norfolk Heritage Centre, John Mallet, Margaret McGregor, Bristol Record Office, Susan North, Victoria and Albert Museum, Jean Rosen, Sheila Vainker, Ashmolean Museum and Francesca Vanke, Norwich Castle Museum and Art Gallery. Special thanks are due also to Louise Phelps and Rodney Woolley, Christie's.

Julia Barton, Conservation and Scientific Research, has performed miracles in restoring and cleaning a large number of pots, Maickel van Bellegem has cleaned metal mounts and assisted in their study, Caroline Cartwright has examined with me the plate with Masonic arms and Janet Ambers X-rayed the bust of Charles I. Photographs for the book have been taken by Saul Peckham of the British Museum Department of Photography and Imaging, whose skill and patience have been, as always, remarkable.

Without the encouragement of Teresa Francis of British Museum Press this book would not have been written, and I owe her much. Sarah Derry, my editor, to whom I am deeply grateful, has patiently guided the book to press.

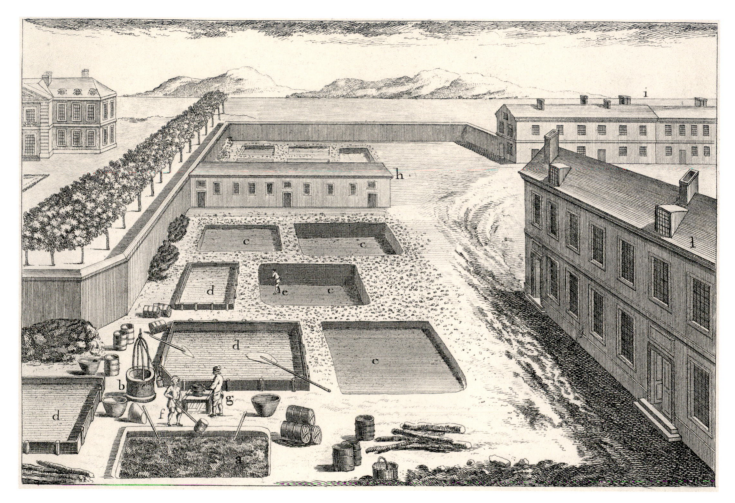

Fig. 1 A tin-glazed pottery factory, showing settling tanks for combining clay and water, and large paddles for stirring.
From Diderot's *Encyclopédie, ou Dictionnaire raisonné des sciences, des arts, et des metiers*, vol. XXI, Fayencerie, plate 1, Paris 1751. British Library

Introduction

'Delftware' is earthenware covered with a glaze containing calcined lead, to which ashes of tin have been added to produce an absorbent white surface. It has functioned as a measure of status and, more mundanely, to hold both 'wet' and dry drugs, for feasting and drinking, in kitchens, for lighting, and even to hold human waste. In the early seventeenth century this kind of pottery was known as 'galleyware'. Later in the century and up to the early eighteenth century it became known as 'white ware' and subsequently it has been called 'delf' or, most usually from the nineteenth century, 'delftware' after the Dutch city of Delft where enormous quantities of the ware have been made from about 1620.[1] Its white surface was eminently suitable for painted decoration and many pieces are embellished with lavish biblical or mythological scenes, with Chinese-inspired motifs or landscape scenes.

Tin-glazed earthenware was first made in the Middle East, gradually spreading to Europe in the early thirteenth century through Spain and Italy to France and the Low Countries (present-day Belgium and Holland). It was known in Britain in the late fifteenth to early sixteenth century by way of Mediterranean imports from Italy of maiolica, a high-status product destined for the houses and tables of royalty and the aristocracy.[2] Cipriano Picolpasso (1524–1579) of Castel Durante, in The Marches region of Italy, mentioned in his treatise *Li tre libri dell'arte dell vasaio* (*The Three Books of the Potter's Art*) that one of his fellow citizens, a certain Guido di Savino, had taken the technique to Antwerp at least as early as 1508.[3] A

number of dishes made there are in a demonstrably Italianate style.[4] In 1567 two Antwerp potters named Jasper Andries (the son of Guido di Savino) and Jacob Jansen came to Norwich, East Anglia, to escape religious persecution. Three years later they applied for a patent to make tin-glazed earthenware. The application failed, probably because a group of Lincolnshire noblemen had also applied.

There is a lack of evidence to demonstrate that delftware was ever made in Norwich. However, a tile painted with the arms of Bacon, which was ploughed up in a field beside a house belonging to Sir Nicholas Bacon (1509–1579) at Gorhambury, near St Albans, might perhaps date from this early period, if it was in fact made in England rather than in Antwerp, Flanders.[5] A quantity of biscuit fragments have been found in Norwich, and analysis has shown that some differ in composition from any others analysed from London and Antwerp sites.[6] In any case Jansen went to London, where he worked with other Flemish potters at the first tin-glaze pottery, established in 1571 on a site north of the River Thames within the former Holy Trinity Priory in Duke's Place, Aldgate. This site was outside the jurisdiction of the City of London and so free of many restrictions on its activity. A number of dishes made in London display a distinctly Italian influence (see no. 38), transmitted in a matter of two generations, or a few decades, via the Low Countries.

Once tin-glazed earthenware began to be made in London, a whole series of factories sprang up there during

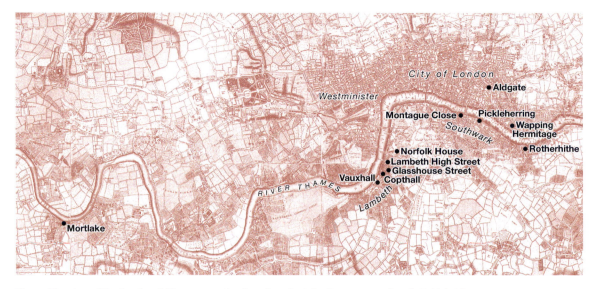

Fig. 2 The sites of the London delftware potteries, based on the John Roque map of 1746. British Library

the course of the seventeenth century, all near the River Thames. Evidence suggests that they mostly occupied earlier structures, such as manor houses (in the case of the Pickleherring pottery, Southwark) or former monastic buildings (Aldgate pottery and Montague Close pottery, Southwark), which were outside the City of London.[7] Few concerns were purpose-built, so potting practices were adapted to the available space. The earliest pottery after Aldgate, and one of the most important, was at Montague Close. It began around 1613 and continued in production for nearly 150 years until about 1755. The owners, Hugh Cressey and Edmund Bradshawe, were granted a twenty-one-year patent in 1613 to make pots, dishes and tiles 'of all fashions after such manner as used in Fiansa and other parts beyond the seas'. Although they were no doubt using the name of Faenza in Italy, a famous centre of maiolica production, to promote their own pottery, some of the early wares show a marked Italian influence (see no. 37). Christian Wilhelm (active c. 1618–30), who had come from the Rhineland Palatinate in 1604, established a delftware pottery at Pickleherring Quay in Southwark possibly as

early as 1612 and certainly by 1618. It survived until 1723.[8] In 1663 the Rotherhithe pottery moved to Still Stairs, Southwark, whilst the Hermitage pottery was established in Wapping in 1665. A pottery at Bear Garden, Southwark, was in existence before 1671. Norfolk House pottery, Lambeth, and the pottery at Putney both date from 1680, three years before the Vauxhall pottery came into existence. A pottery at Gravel Lane, Southwark, was set up in 1694, closing in around 1750. There were other delftware concerns at Vauxhall (Lambeth), Lambeth (where there were potteries on several different sites) and at other sites in Southwark.[9] The proliferation of factories in and around London (nineteen kiln sites are known)[10] makes attributions to particular potteries difficult, except in the case of some of the very earliest pieces.

From the mid-seventeenth century, delftware production began at centres outside London, emphasizing the strong demand for vessels of all kinds even in this relatively fragile material, and continued until the third quarter of the eighteenth century. By this time it had been overtaken by more durable stoneware, cream-coloured

earthenware and whiteware, or pearlware. Two potteries in the West Country date from the middle years of the seventeenth century, one at Brislington and the other in nearby Bristol in the area known as Temple Back. Like them, the pottery established at Lord Street, Liverpool, in 1710 was an offshoot of the London industry. During the course of the eighteenth century around a dozen factories were operating in Liverpool; attributions to particular concerns remain difficult. Punch bowls painted with named ships (no. 94) and cornucopia wall-pockets (no. 133) are typical of what was made there. Other concerns at Wincanton, forty miles from Bristol, in operation from ?1735–?1750, as well as in Ireland (in Belfast, Dublin and elsewhere) and in Scotland (Glasgow) from 1748 to around 1770, supplied local markets during the eighteenth century

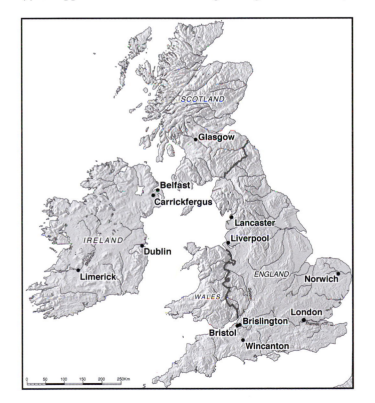

Fig. 3 Map showing delftware factory sites in the United Kingdom and Ireland.

and also exported considerable quantities to North America. Excavations in recent decades, especially in Virginia, as well as the study of household inventories and merchants' records, have revealed the considerable extent of this trade, particularly in the eighteenth century.[11] All delftware factories, except Wincanton, were situated either at a port or on a river that gave access to a port, so that raw materials could be obtained and the finished products shipped out.

The most recently excavated British delftware pottery site is located in Lancaster.[12] In operation from 1754 to at least 1781, it is evidence of the continuing demand all over Britain for tin-glazed earthenware.

Making delftware

Tin-glazed earthenware is a low-fired pottery which is relatively fragile. Most surviving pieces have damage to their rims, such as loss of glaze or chips, as they are not durable. They may also be crazed. Because they are not vitrified, like stoneware for instance, they will not withstand hot liquids, and it is for this reason that relatively few tea and coffee wares have survived, despite the great popularity in Britain of both tea and coffee by the middle of the eighteenth century.[13] In the inventory of the Pickleherring pottery, Southwark (see below) many dozens of 'Chocoletts' and 'Coffees', some painted, are listed. That delftware continued to be used for hot drinks up to the mid-eighteenth century is evident from a letter in the *Gentleman's Magazine* of April 1763, stating that 'the glazing of many kinds of pottery ... frequently cracks upon receiving hot water ... for the same cause that it making the glazing crack, makes it also scale off after it is cracked, which is universally the case with all earthenware, particularly that which is called Delft'. To avoid this, it is assumed, tin-glazed stoneware was developed in Liverpool (see no. 95), in the expectation that a higher-fired stoneware body would be more durable.

As Staffordshire, rather then Liverpool, was noted for

its stoneware, and as many of the shapes of surviving tin-glazed stonewares bear a close relationship to Staffordshire products, it has been suggested that stonewares were taken from there to Liverpool for glazing and painting.[14]

Raw materials

The potters at Aldgate, and the earliest potters in Southwark, probably used white clays, or marls, with a high level of calcium carbonate, which helped to prevent warping, shrinkage and cracking. These clays were shipped from Yarmouth to London. From around 1639 to 1725 white clays from Boyton, south-west of Aldeburgh on the Suffolk coast, were in use.[15] Another source for these essential clays was in Aylesford, Kent. During the eighteenth century clays from Carrickfergus, north of Belfast, which were matured for three years, were particularly important for the industry, which had spread to Liverpool, Bristol, Belfast, Glasgow and elsewhere. These Irish clay exports reached a peak of over 500 tons annually around 1750.[16] The calcareous clays were combined with pliable red plastic clay, which was much more commonly found, and white clay from Dorset to make a body which could be thrown and moulded.

Method of manufacture

All types of clay had to be prepared by weathering and purification. Small stones and other impurities were removed in tanks or cisterns so as to achieve as homogeneous a body as possible (see fig. 1). In general the fabric of delftware is buff-coloured, although a red body is occasionally encountered. Pieces were thrown on the wheel, or moulded, in some instances perhaps using a wooden template-type former.[17] Moulding seems to have been in use from a fairly early date to judge from the salts, nos 46 and 101, for instance. In the first firing the 'raw' pot was fired between 980 and 1,000 degrees centigrade. The unglazed (biscuit) pot, was then covered with a transparent lead glaze, to which ashes of tin were added to produce an opaque white glaze. Tin was obtained from mines in Cornwall.[18] The glaze composition also included 100 lbs fine white sand, 40 lbs soda, 30 lbs potash, some copper filings and a small amount of smalt, or cobalt.[19] Glaze materials had to be ground. Mills were not always attached to the pottery but might be operated independently.[20] Once prepared, the ingredients were mixed and fired to form a glassy mass, or frit, which was then ground and suspended in water, to which tin oxide was added. Decoration was applied using pigments composed of metal oxides, which were combined with a fluxing material to make them melt during firing. These were painted on top of the dry powdery glaze. Colours that could be fired 'in-glaze' were blue, from cobalt oxide, purple from manganese oxide, brown from iron oxide, green from copper oxide, yellow from antimony and iron-red. After decoration, the piece was fired a second time at a temperature of 980–1,000 degrees centigrade. Delftware painters could not correct their mistakes as the glaze was absorbent. Some designs may have been drawn on paper

Fig. 4 Unglazed earthenware mug, made in Southwark around 1650. Height 7.5 cm. British Museum 1907,1014.1

first but hardly any of these have survived. From the early seventeenth century many designs were strongly influenced by Chinese porcelain, or, in the case of biblical subjects, Dutch prints; or they were copied from Dutch originals, as in the case of tiles. Around the mid-eighteenth century pattern books such as *The Ladies Amusement or The Whole Art of Japanning Made Easy* (published by Robert Sayer shortly before 1762) may have been used as sources, just as at contemporary porcelain and creamware factories, and the Chinese influence continued to make itself felt. Pounce paper could be used to prick through designs in outline, which were then transferred onto the unfired glaze by means of powdered charcoal and then finished in colour. Landscape scenes and Chinese-style motifs remained popular throughout most of the eighteenth century.

Excavated 'wasters', or pieces that misfired, have shown that early dishes in Low Countries style (see no. 37) were fired upside down in the kiln, separated by three-pronged trivets that left three scars in the glaze.[21] This was probably in order to avoid damage to the decorated surface from falling soot or wood. Wares were protected from direct heat and falling debris by saggars, or fireclay containers, which also made it easier to stack them in the kiln. Towards the end of the seventeenth century the evidence from excavations suggests that pins placed in holes in the side of the saggar supported delftware plates during the second firing, leaving scars on the underside of the rim. Some kilns have been excavated and appear to have been modelled on Continental updraught examples.[22] They had a chamber to hold the pots, a firebox, stokehole and flue, or chimney, and were usually rectangular or square in shape. Kilns, which were fired with wood, needed frequent repair because of the high temperatures reached and could be re-built several times. Stacking the kilns was a highly skilled task, and both biscuit and glazed pieces seem, on occasions at least, to have been fired at the same time.[23] Firing cycles lasted

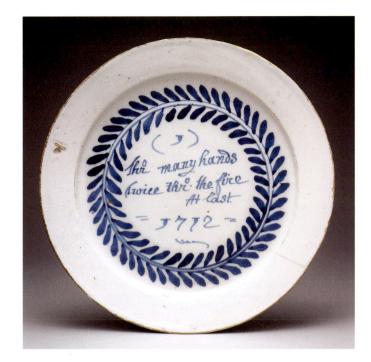

Fig. 5 Plate, inscribed 'Thro many hands twice thro the fire at last 1712'. Diameter 22 cm. Private collection

around four days, and it took up to two days for the kiln to reach the firing temperature. As there was no means of measuring heat, the skill of the fireman in calculating this by eye through a spyhole was crucial. Kilns were in general wood-fired, using oak for the early stages of firing and ash for the later phase, although exceptionally coal was used, as in Dublin (see no. 91). On average kilns were fired when full, once a week at the most, and perhaps more usually once a fortnight or every three weeks.[24]

Sources of information about the scores of English delftware potteries are mainly confined to inventories, in general made after the death of an owner, or sale of a factory. When John Robins, manager of the Pickleherring pottery, Southwark, died in 1699 an inventory was taken by four assessors, two of whom were well-known potters.[25] A vast array of products is listed including 'Garden potts' and 'butter stall Jarrs' as well as the more usual chamber

Fig. 6 Earthenware kiln-support, perhaps seventeenth century. Length 10.8 cm. British Museum 1856,0701.370

pots. The inventory describes over 150 dozen of these all told under the heading 'White and Painted Perfect Ware', obviously of different sizes. Posset pots, porringers, barbers' basins, salts and many other forms were also made at two pothouses in Vine-yard [?] and Stoney Lane, Southwark. The inventory presents a detailed picture of the enterprise, including all its raw materials and tools. The list of household goods reveals what a prosperous potter's family owned: even some silver as well as a looking glass and a clock and case. The entire contents of

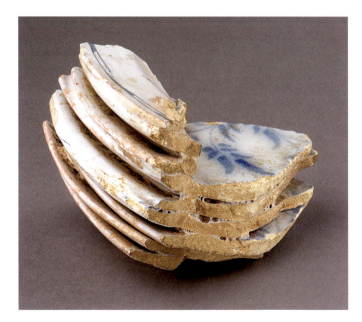

Fig. 7 Fragment of nine delftware plates fused during firing, 1730–40. Length 11.5 cm. British Museum 1920,1026.14

garrets, chambers, another room, kitchen, washhouse, buttery, parlour and a further room, together with all the linen, amounted to £28 0s 6d, whilst the pottery contents were valued at £1,217 3s 5d.

The workforce

It is possible to discover much about the factories and their workforces from early insurance policies, such as those issued by the Hand-in-Hand company from 1702 and Sun Assurance from 1711, and their renewals, taxation records, parish rating assessments and proceedings in Chancery (lawsuits).[26] Factories employed variable numbers of workers according to demand. In the 1620s there were ten potters' names in the registers for St Saviour's parish, Southwark. This number increased in the following decade and from 1640 to 1680 there were forty-three.[27] The average workforce at a factory throughout the period of delftware manufacture was around twenty to thirty men.[28] The structure of the workforce has been determined: the owner or part-owner was generally a master potter with technical knowledge, who could manage the factory on a day-to-day basis; a clerk, who was also qualified and could deputize for the master and was in charge of the finances, paying the workers and in charge of sales; pot painters; 'turners', who made the pieces, using simple vertical lathes to smooth and trim pieces in the final stages of their fashioning; a clay manager, who mixed the clays and ensured that supplies were available; kiln men, who packed and unpacked the kiln and fired it, and labourers and apprentices who prepared the glaze and colours and did other manual work.[29] At the Pickleherring pottery, and no doubt elsewhere, additional men were required to use and care for three horses, harnesses and cart furniture.[30] Apprentices had to work for several years for low wages until the final phase of their five- or seven-year term, thus providing cheap labour. Names of apprentices and of their masters are known and recent analysis has emphasized the many links between the

pothouses as a consequence of the movement of labour and kinship.[31]

By at least the middle of the eighteenth century, if not considerably earlier, the danger of using lead in the glaze was recognized. Potters' health was affected by dust produced in the grinding of the raw glaze materials, and by contact with the liquid glaze into which once-fired pieces were dipped by the potters before being painted.

Markets

Between 1600 and 1800 there was a rapid change in standards of living, as much greater comfort became possible and levels of luxury extended downwards into society. Delftware manufacture can be seen as a mirror of the tastes and habits of those who were well off but not necessarily of royal or aristocratic rank. These included the growing numbers of merchants, professionals (such as lawyers) and businessmen, as well as the landed gentry and those who were entitled to bear arms. Painted pieces, particularly large chargers and even tulip plates (see no. 106), were items of prestige and were intended for show unlike undecorated delftware, such as candlesticks, chamber pots, ointment pots and wine bottles that were intended for everyday use.[32] Some items, including punch bowls, posset pots and wine bottles, into which wine was decanted for serving at table, were kept for ceremonial occasions. Delftware was probably bought principally by those living in towns, although even farmers owned quite impressive pieces (see no. 92). Many wealthy citizens owned houses in the country and here, too, delftware was in use, both domestically and for ornamental purposes. Apothecaries ordered large numbers of drug jars to furnish and decorate their premises. Many of these jars survive together with numerous sherds from sites that have been excavated, especially in London. Other tradespeople, such as barbers, also used delftware (see no. 62).

Many potteries had their own warehouses where the products could be shown and purchased by merchants or individual customers. Some shops or warehouses sold delft, along with tea, coffee and chocolate and glass wares. The trade in London was controlled by the Glass Sellers' Company, but the pothouses in Southwark and Lambeth were not subject to economic regulation by the City of London.[33] Marketing tools included advertisements. Grantham's 'Earthen-Warehouse, at the Spread-eagle in the Upper Market, Norwich' announced in the *Norwich Mercury* for 9 December 1758 that there was to be a sale of pieces, 'Much cheaper than Common, under Prime Cost', which included 'A very large Variety of Superfine Liverpool Delft'.[34] Another Norwich china dealer was Ralph Lewis, who was established by 1771 and advertised in the *Mercury* on 2 July 1774: 'CHINA, DELF and EARTHENWARE, NOW on SALE, under Prime Cost, at RALPH LEWIS'S shop adjoining to Pudding-Lane in the Market-Place, and at his Warehouse near the Green Man, Conisford Street, Norwich'.[35] There were travelling salesmen who might take orders (see no. 92) and hawkers or peddlers, often women, who carried large baskets of wares, which they might sell to individual customers.[36] Trade cards survive of some of the shops, the majority of which were in London (fig. 8). Regional markets and fairs were also important outlets (see fig. 12). Exports were a significant part of the delftware trade from at least the third quarter of the seventeenth century, and were made and despatched from potteries in Scotland and Ireland as well as from London, Liverpool and Bristol. Pottery was destined for the West Indies and North America as well as continental Europe, including Germany and Spain.[37] Excavations in Virginia reveal that delftwares of the highest as well as of the most ordinary quality were imported from England in the middle of the seventeenth century. Here, and in other areas such as Connecticut, they were in use alongside foreign pottery, stoneware, pewter and wood, according to household circumstances.[38] Probate inventories for the Connecticut Valley dating from 1750 to 1775 show that

plates and punch bowls were the most popular delftwares there, but plates, dishes and platters were all in use, and were even owned by a blacksmith, a farmer and a cabinetmaker.[39]

Little evidence has been discovered for the prices of delftware, but it was certainly far less expensive than English porcelain, which in any case was not made until around 1745. One surviving document dated 4 April 1696 is connected with the Excise Act of that year.[40] It lists five different kinds of pottery, giving prices. Besides tiles and 'Fulham Ware' (stoneware), there was 'Fine Painted Ware', which included mustard pots, basins, mugs, porringers, dishes and punch bowls. These cost from four shillings to three shillings per dozen. 'White Ware' included chamber pots, which cost eight shillings for the large size and three shillings and sixpence for the small size, per dozen. Syllabub pots and caudle pots for milky drinks were valued from two shillings to four pence a piece. In the section on 'Purple & Blew Ware', the first glazed with manganese, the second also known as 'bleu Persan', or Persian blue, as the decoration originally came from the Middle East by way of Europe, 'Large Fine Garden-Pots' were four pounds for a pair. Surprisingly expensive were 'Wine Cups and Blood porringers' (or bleeding bowls) at sixteen shillings and sixpence the dozen. The list shows that a considerable range of pieces were in production, examples of which do not seem to have come down to us: it would now be difficult to identify 'Venison Potts' and 'Pigeon-Potts' in the 'Purple & Blew Ware' list. The volume of delftware made and sold in the eighteenth century was extremely large. Frank Britton has estimated that millions of items were made per ton of clay. Replacement of broken pieces of this relatively fragile material and the furnishing of tea gardens such as that at Vauxhall which served large numbers several times a day, would have required considerable stock.[41]

In Ireland, pottery from the World's End pottery in Dublin, owned by John Crisp from before May 1747 until

early 1749, was advertised on 4 June 1748 in the *Dublin Courant*: 'At the Irish Delft Warehouse on the North Strand, near the ship building, Dublin, are made and sold by the retail and wholesale a variety of blue and white delft-ware', but no prices were given.[42] The first mention of sales by Henry Delamain (1713–1757) (see no. 91), who occupied the same site, occurs in an announcement in the *Dublin Journal* of 10 June 1755, where he writes: 'The ware will be sold at the India warehouse in Abbey Street, where all orders will be received and executed with expedition. The ware will be sold wholesale at the factory only.'[43] This

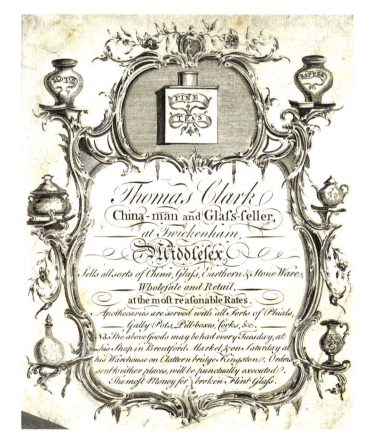

Fig. 8 Draft of a trade card for Thomas Clark, china and glass seller at Twickenham, 1750–1800. Engraving, 17.3 × 13.7 cm. British Museum Heal, 37.15

was, in part at least, a response to the sale by 'some of the clerks' of 'some faulty ware that was ordered to be broken'. The India warehouse was a good choice, since it had been occupied by Catherine Davey who sold a 'great variety of China toys & ornamented China' there from 1743'.[44] Delamain died in January 1757. His consort owned the pottery briefly before she died, after which ownership passed to Henry's brother William, who took charge of the pottery with Samuel Wilkinson, almost immediately announcing in the press that he was reducing prices by ten per cent. In August 1761 Henry's executors also advertised reductions to the price of earthenware in the *Dublin Journal*. Plates were reduced from 'nine shillings a dozen to seven shillings English, the second sort from six shillings to four shillings and six pence'.[45] Further information about prices is given in *Falkner's Dublin Journal* on 6–12 August 1766, when it was announced that prices were being lowered by fifteen per cent: 'The fine painted Landscape plates from 9s per dozen to 7s English, the second sort from 6s to 4s 6d; Dishes, Tureens, Epergnes, Boats, Bowls, Fruit and Salad Dishes and all other articles lowered 15 per cent ... All commands to be directed to Mrs. Ann Day, at the ware-house in Abbey Street'.[46] Such reductions signalled the decline of the business, which changed hands in 1768.

In England at least, sales were often made on credit and payment could be slow in coming. In many cases delays of over a year were not uncommon. Inventories made after death, such as that of John Robins (who ran the Pickleherring pottery from around 1684) taken in 1699,[47] often include long lists of debtors. Names in the inventory of the glass manufacturer Francis Gerrard taken in 1683, for instance, encompass members of the nobility as well as small shopkeepers and grocers from as far afield as Ireland, Wales, Devon and Yorkshire.[48] Reliance on credit sales could easily lead to bankruptcy.

Concerning trade in North America, there is evidence that from the 1750s delft was supplied to the Connecticut Valley by local merchants who purchased consignments from large concerns in New York City or Boston.[49] Merchants, including William Ellery of Hartford, advertised in the *Connecticut Courant*. Plates and punch bowls were especially popular. Fisher Gay bought delftware from Frederick Rhinelander in New York, paying five shillings a dozen in 1771 for '2 Doz Delph Plates', which cost him seven shillings in the following year, although these were described as 'fine', so may have been better quality. The client would, of course, have paid a higher retail price. By the last decade of the century delftwares had been replaced by the more durable Staffordshire creamwares, so advertisements for delft declined, as did purchases noted in the merchants' account books.

Collecting delftware

The wealthy and eccentric politician and author Horace Walpole (1717–1797), son of Sir Robert Walpole (1676–1745), was in all likelihood the first recorded collector of British delftware. In his gothic house at Strawberry Hill, Twickenham, Middlesex, he had a China Room in which he displayed all sorts of ceramics.[1] These he published in *A Description of the Villa of Horace Walpole*, under the imprint of the Strawberry Hill Press in 1774, and again in 1784 in his *A Description of the Villa of Mr Horace Walpole*. By 1774 he owned 'An earthen-ware dish, with the heads of Charles 2d. and queen Catherine in blue and white; a present from Mr. Ibbot.'[2] Also in the China Room was 'An earthen bottle; painted on it *Sack 1647*; it was thus sold by apothecaries. From the collection of Mrs. Kennon, the vitruosa midwife'.[3] The contents of the house were sold on 25 April 1842 and twenty-three following days. The twelfth day's sale on 7 May, 'The rare contents of the China Room including beautiful Porcelain of every country and time, and rare Venetian Glass', included lot 33, 'A very curious old English dish with portraits of King Charles II and his Queen, and a ditto with shipping and motto God Preserve the Fishery'. Although it is not stated, these items must be delftware. The lot fetched two pounds two shillings and was sold to Smith. Lot 132, which sold for two pounds five shillings to Foster, was 'A curious old German blue and white jug, a smaller ditto, and 2 old English bottles, one lettered Sack the other Claret, dated 1646'.[4] This, surely, was the beginning of the mania for seventeenth-century delftware wine bottles, which marked

collecting from the middle of the nineteenth century and resulted in the considerable group of such pieces assembled by Sir Augustus Wollaston Franks and others. A list of these wine bottles was compiled and published by Professor A.H. Church in 1884.[5] Although the wine bottles were only around one hundred years old when they belonged to Walpole, they evidently appealed to his love of old things.

In 1850 Joseph Marryat, brother of Captain Marryat, author of sea-faring tales such as *Mr Midshipman Easy* as well as the more famous *Children of the New Forest*, published his *A History of Pottery and Porcelain*.[6] In this first edition there was no mention of delftware, but by the second edition of 1857 the author had gathered a considerable amount of information on 'Enamelled Pottery'. His own extensive collection was sold in 1867 and included just one piece of delft, 'A blue and white vase, of English delft'.[7] The rapid disappearance of knowledge of relatively recent productions is always surprising. Marryat writes: 'The manufacture in England of that soft enamelled pottery which is commonly called Delft has been hitherto doubted' – presumably excusing himself for its omission in the first edition of his book.[8] We can glean from his account the names of collectors such as Franks, who owned a puzzle goblet with pierced border bearing the arms of the Drapers' Company and the date 1674 (no. 49),[9] Octavius Morgan and even the Revd T. Staniforth, of Storrs, Windermere, whose name is usually associated with Continental porcelain.[10] Of the owners whose names

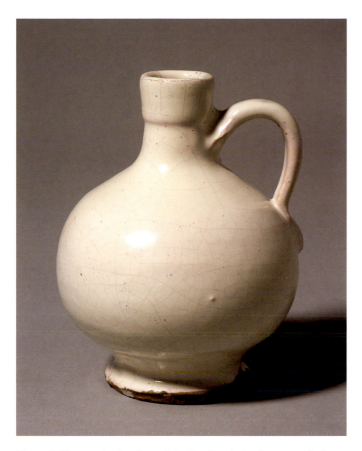

Fig. 9 Delftware wine bottle made in Southwark, London, around 1650. Height 12.7 cm. British Museum 1887,0210.115

are less familiar to us, Mr Clements of Shrewsbury owned a 'wine pot' inscribed 'Sack' and dated 1651 and another inscribed 'Claret' dated 1650; Mr John Bruce, FSA, had one inscribed 'Sack' dated 1651; and Mr H. Belward Ray owned a 'Fecundity' dish (see no. 44). Several museums are mentioned including Norwich Museum, which owned wine bottles, the Museum of Practical Geology and the South Kensington Museum (later the Victoria and Albert Museum). Also mentioned is the British Museum, where there was already a dish painted with the scene of Jacob's Dream (no. 38) dated 1660, as well as a dish with the portrait of King Charles II, dated 1668 (no. 7).[11] Although

purchases in 1855 by the British Museum of Italian Renaissance maiolica from the Bernal Collection by far outnumbered those of English delft, it is notable that Bernal, an informed and discriminating collector, did not disdain the material about which, apparently, very little was known, although it had been in continuous production in Britain for almost 300 years and was still in fact being made, although in small quantity.

By contrast, there is almost no mention of English delftware in the *Catalogue of the Art Treasures of the United Kingdom collected at Manchester in 1857*. The section on 'Ornamental Art' included a quantity of Italian Renaissance maiolica, as well as some German stoneware, Dutch delft, Wedgwood and even a few, presumably Kentish (Wrotham), tygs (mugs with up to four handles) of lead-glazed earthenware, one dated 1612. Right at the end of the description of the contents of Case E on the south side of the exhibition (p. 147) is one sentence, which may indicate that a few pieces of English delft were shown: 'Amongst the curious pieces of English pottery of the 16th century and later, contributed by J. Mills, Esq., C. Bradbury, and others, may be seen some rough and amusing imitations of the Majolica ware.'

Joseph Mayer of Liverpool (1803–1886) was an omnivorous collector whose acquisitions of delftware have been overshadowed by those of ancient and British antiquities, Western manuscripts, Late Antique and medieval ivories and Wedgwood.[12] He was a friend of Franks and, as a native of north Staffordshire, was involved with the Potteries, not least through his brother Thomas, who took over the Dale Pottery, Longport. Amongst the tin-glazed earthenware in the collections of National Museums Liverpool are several significant pieces such as a plate with a portrait, inscribed 'GR' for King George I,[13] another inscribed 'God Save/King George/ 1716'[14] and an exceptionally large manganese-ground dish made for the election of Nicolson Calvert and John Martin as members of parliament for Tewkesbury in 1754 (see

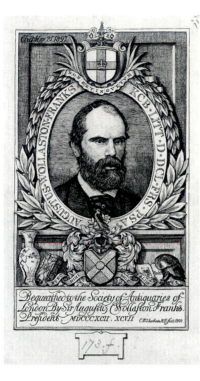

Fig. 10 Bookplate with a portrait of Augustus Wollaston Franks, designed by C.W. Sherborn in 1898. Society of Antiquaries of London

no. 24).[15] Another exceptional large jug is painted with a portrait of William Pitt.[16] It is not known exactly when Mayer was collecting delftwares, although a date in the 1860s and 1870s is likely, but it seems quite possible that his approach was influenced by that of Franks, who was committed to the acquisition of pieces of historical interest, which still predominate in the British Museum delftware collection to this day.

Llewellynn Jewitt, FSA (1815–1886), a noted illustrator and engraver who contributed to the *Illustrated London News* and *Punch*, was head librarian of Plymouth Public Library from 1849 to 1853.[17] He then returned to his native Derbyshire to edit the *Derby Telegraph* and was the next to write a survey of British ceramics, publishing a work that still holds great interest, *The Ceramic Art of Great Britain*, in 1878.[18] This not only includes information about the production of delftware in the nineteenth century – at Mortlake, Surrey, for instance[19] – but also details of the

various delftware factories of the earlier period: Aldgate, Lambeth and, most fully, Bristol. This last section contains the only illustrations in the book of delft pieces and some of their inscriptions.[20] All were in private collections such as those of William Edkins, Hugh Owen,[21] Henry Willett and a descendant of the Bristol potter Joseph Flower (active 1736–d. 1785). Election plates with landscape or chinoiserie scenes or flowers shown in line drawings, and two plates with 'The taking of Chagre in the West Indies by Admiral Vernon' are mentioned. William Edkins's 'Celebrated Collection of English Porcelain and Pottery', sold by Sotheby, Wilkinson & Hodge on 21–3 April 1874, included fourteen lots of 'Bristol delft and earthenware' according to the sale catalogue, one of which was a rare election plate inscribed 'Nugent Only 1754' and another a plaque painted with a view of Bristol Cathedral (no. 136). Edkins was in some sense a special case as his grandfather Michael Edkins (c. 1733–1811) had worked as an enameller in Bristol. By the 1870s collecting delftware that reflected historical events was already an established practice, Henry Willett (1823–1905) of Brighton being the most active in this field.[22]

One of the greatest collectors of ceramics was Lady Charlotte Schreiber (1812–1895).[23] Although her name is not generally associated with English delft, her *Journals* reveal that on 7 May 1876, while visiting Bruges, a Monsignor de Bethune presented her with by a wine bottle inscribed 'Whit-Wine 1641', which she had admired and which had been found 'under water, in one of the canals, or on the beach'.[24] In June 1876 she paid three shillings and four pence to a Monsignor Emmering of Alkmaar for 'a little plate with a ship upon it, dated 1745, which might be Bristol ware'.[25] When in Bruges once more in May 1878 she presented some pieces of Samian ware to the Monsignor in recognition of his earlier gift of the dated wine bottle, remarking that it had been exhibited at the Archaeological Museum (in fact, the Royal Archaeological Institute), the previous day and been the subject of a

lecture by R.H. Soden Smith.[26] On 23 September 1884 she went shopping in London with her son, and at the dealer Aked's 'had the great good fortune to find one of the Lambeth Wine bottles (mentioned by Horace Walpole) marked "Claret". I already possessed the "Whit Wine" and "Sack" – so this makes my set complete.' Lady Charlotte's contact with the British Museum and her friendship with Franks are well known. In her *Journal* entry for 17 November 1884 she describes a visit to 'Mr Read', assistant to Franks, to show him 'a cat I had picked up lately at Buttons which he pronounced to be Lambeth (dated 1676) and which, hideous as it is, I suppose I shall have to buy for "the collection".'[27] Lady Charlotte's *Journal* entry for 19 November reads: 'My cat belonged, as I suspected, to Mr. Willett – I can only suppose he parts with it because he has two older and better specimens – viz., 1672 and 1674 – but I think it a desirable addition to my collection.' It cost three pounds, the same as the 'Claret' wine bottle.

In 1911 the collection of Sir John Evans KCB, FRS (1823–1908), erstwhile Trustee of the British Museum, numismatist, amateur geologist and ring collector, was sold at Christie's.[28] It is interesting to see from the sale catalogue how the pattern of Evans's collecting mirrored that of his near-contemporary, Lady Charlotte Schreiber. The first twenty-one lots are wine bottles. Lot 20, an example dated 1660, fetched the high sum of 31 guineas. He appears to have valued documentary pieces and amongst the fifty-five or so items is a 'Fecundity' dish dated 1661, which sold for 65 guineas,[29] and a mottled blue-and-brown jug, its silver mount engraved with an inscription commemorating a former owner who died in 1658, which fetched 165 guineas.[30]

John Eliot Hodgkin, FSA (1829–1912), and his daughter Edith (1856–1938), were not only collectors, but also brought together a whole series of dated and inscribed examples of pottery in 1891, which they published in a subscription volume.[31] The names of the subscribers are presumably those of the collectors whose pieces are listed, and included sixteen museums. The section on delft comprised examples attributed to Lambeth, Bristol, Liverpool and Staffordshire (we now know that tin-glazed earthenware was not made in the region) and others described as 'uncertain', as well as 'Dutch delft connected with England'.[32] The book is a good guide to the sort of pieces that were collected at the end of the nineteenth century. Some were exhibited in London under the aegis of the Burlington Fine Arts Club in 1913.[33] Edinburgh, Sheffield, Liverpool, Brighton and Taunton museums were included amongst the lenders, as well as the Yorkshire Philosophical Society, the Merchant Taylors' School, Crosby and the National Art-Collections Fund.

The collector Thomas Tylston Greg (1858–1920), a cotton spinner of Quarry Bank Mills, Styal, Cheshire, began collecting about 1880 and assembled a remarkable group of delftware, which was presented to Manchester City Art Gallery by Greg and his wife, together with other generous gifts.[34] He published his own *A Contribution to the History of English Pottery* in 1909 and soon after his death a summary entitled *Catalogue of the Greg Collection of English Pottery* was compiled by fellow-collector Dr E.J. Sidebotham, issued in 1924. This collection also included pieces of historical interest and, although not large in scale, was intended to be representative of delftware production.

During the twentieth century much was discovered about the history of English delftware, which had been little studied since it was first collected. In 1919 the Revd Edward Downman issued his *Blue Dash Chargers and other early English tin enamel circular dishes*.[35] The first general book about delftware as a whole was published in 1928 by Major R.G. Mundy.[36] Profusely illustrated, it preceded the more rigorous approach adopted in the following decade in articles by authors such as Professor F.H. Garner (see below). By this time interest had already begun in 'archaeological' finds, not excavated according to modern

methods, but often indicative of production places. Fragments from London had entered the Museum collection from Charles Roach Smith (1807–1890) as early as 1856,[37] and from 1913 William Pountney (1849–1925) was presenting fragments to the Bristol Museum.[38]

Delftware collecting in Britain in the twentieth century was dominated by a few great collectors, including the mathematician Dr J.W.L. Glaisher (1848–1928), who had begun to collect delftware in the 1890s and bequeathed his collection to the Fitzwilliam Museum, Cambridge;[39] the eminent chemical engineer Professor F.H. Garner (1893–1965);[40] Louis Lipski (1914–1979) and Robert Hall Warren (1870–1941), whose collection is now at the Ashmolean Museum, Oxford and has been well published.[41] All built up large and representative groups of delftware, which included pieces related to those in the British Museum painted with biblical scenes, political subjects, battles and armorials, and with inscriptions of various sorts.

Interest in objects for everyday use also increased as knowledge of the many aspects of delftware production grew. Delftware tiles also became collectable in the later years of the nineteenth century. The research of Garner and Lipski was particularly important in building up a picture of delftware production, and Garner's *English Delftware*, first issued in 1948, has remained a standard work for many decades. The most recent publication by Michael Archer on the Victoria and Albert Museum delftware collection – the most extensive public collection in Britain – has not only added much to our knowledge but has also placed the subject in the context of contemporary life.[42]

The collection of fragments from the major London factories and the publication of various sites in the area became a major preoccupation of the Museum of London and its archaeological service (MOLAS) from the 1960s. A steady stream of academic papers has shed much light on how and where delft was made, and tons of fragments now stored at Mortimer Wheeler House in East London are a freely available resource for researchers.

Delftware collecting in the United States was certainly well established from at least as early as the 1930s, when some fine pieces were acquired by the Metropolitan Museum of Art, New York (see fig. 8). From the 1950s the Museum at Colonial Williamsburg, Virginia, was building a collection that is now probably the largest in North America.[43] This group of pieces has particularly strong links with the local archaeology and includes an exceptional number of rare and interesting items, demonstrating the huge range of delftware production in the British Isles. The emergence onto the market of ever rarer pieces was perhaps encouraged by private collectors such as Frank and Harriet Burnap, whose collection was assembled from the early 1920s and was given to the William Rockhill Nelson Gallery, Kansas City, in 1941;[44] Stanley and Polly Mariner Stone, who collected delftware from 1946, establishing the Chipstone Foundation, Milwaukee in 1965; Philip Kassebaum, who began collecting at the end of the 1950s,[45] and the Longridge Collection, established in the late 1970s. The market continues to be based in London. At the outset delftware collecting was the preserve of the wealthy, and in general it has remained so, although some of the commoner items can still be acquired at reasonable cost, despite the sharp rise in prices paid for the most outstanding and unusual pieces during the last twenty to thirty years, as American collectors came to dominate the market. The peculiarly British charm of delft ensures that it will always remain popular with the public at large, as it tells us much about how our forebears lived.

Collecting delftware at the British Museum

The English and Irish delftware collection at the British Museum has a special character. Although not fully representative of the entire range of tin-glazed earthenware made in the British Isles from the first half of the seventeenth century to the first half of the nineteenth century, as there are no pieces made in Scotland, for instance, it is especially rich in rare and dated specimens. This is because it reflects the outlook of the man who built up the collection from the 1850s, Sir Augustus Wollaston Franks (1826–1897), who joined the Museum staff in 1851 and retired in 1896.[1] Franks firmly believed that the Museum's collections should reflect historical events and that dated pieces were essential for reference purposes. Even today, over one hundred years after his death, the delftware collection is a particularly telling illustration of his collecting framework.

In the early years of the nineteenth century, not long after delftware began to be seen as historically interesting and around the time it stopped being made in the British Isles, the Museum owned only four tin-glazed earthenware floor tiles (no. 142), painted with a chequer pattern, a lion running, a ram walking and a standing dog. These were purchased by the Museum in 1839 as part of the collection of the geologist and palaeontologist Dr Gideon Algernon Mantell, MD, FRS (1790–1852). The tiles date from the late sixteenth to the early seventeenth century; one (not included in this book as the surface is worn) was probably made at the factory of Jacob Jansen and Jasper Andries in Aldgate, London, and the other three at the Pickleherring

pottery, Southwark, although their place of manufacture has not been established without doubt. Further acquisitions were not made until 1854, when a drug pot[2] and an unglazed candlestick, found in the City of London and made at one of the delftware potteries in Southwark, were bought from Henry J. Ingall.[3] In 1856 two biscuit *albarelli* (drug jars) and a fragmentary vessel were purchased from Charles Roach Smith.[4] These were described in the manuscript catalogue of this collection as, 'found on the site of a potter's kiln, during excavations for Mr Humphrey's warehouse, near St Saviour's Church, Southwark. Larger quantities of fragments of similar pots were dug up at the same time.'[5] These acquisitions, made early in the career of Franks, who had joined the Museum in 1851, prefigure the role of archaeology in the study of delftware production, which has been of prime importance in the twentieth century.

The sale in 1885 of the outstanding collection of works of art and ceramics belonging to Ralph Bernal, MP (1784–1854) enabled the Museum to make its first two significant purchases of dated chargers: a 'Fecundity' dish dated 1659 (no. 44) and a dish painted with a portrait of King Charles II standing on a chequered floor and the date 1668 (no. 7). The year 1855, which also saw the purchase of the dish dated 1660 and painted with 'Jacob's Dream' (no.38), marks the beginning of the development of the particular character of the British Museum collection of English delftware. From this time dated and signed examples, often with a historical association, were to be

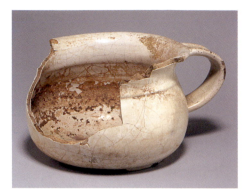

Fig. 11
Unglazed
earthenware
chamber pot,
made around
1650–1700.
Height 12.2 cm.
British Museum
1961,1102.157

acquired at an increasing pace. Franks, an insatiable collector, probably made his first acquisition of delft in 1875, later given to the Museum. This was a wine bin label inscribed 'SACK' (no. 97), which bears an inscribed label, apparently indicating that it once belonged to the collector Horace Walpole (1717–1797). In fact it refers to a wine bottle with the same inscription, which was in Walpole's collection and so was intended to explain or amplify the importance of this relatively humble object.

The largest and most significant gift to the Museum of English delftware was made by Franks in 1887. Of a total of 187 items of English pottery, which he presented in March that year, fifty-nine pieces were delftware. Many were rare, such as the posset pot and cover painted with a Chinese-inspired 'bird-on-a-rock' motif and dated 1632 (no. 68), the large ship charger dated 1663 (no. 5), the tray painted with a figure representing Summer and dated 1729 (no. 89), and a bowl inscribed 'William Goodenough Gardener at Barns in Surry' (no. 55). Amongst the pieces reflecting British history in his gift were several plates with the initials 'GR' for King George I (p. 301, nos 6, 7), a plate inscribed 'Duke William for Ever' (p. 301, no. 4) and an election plate inscribed 'Calvert and Martin For Ever 1754 Sold by Webb' (p. 303, no. 20). Unfortunately, this last group was destroyed by enemy action in May 1941.

Franks, who had been appointed Keeper of the Department of British and Medieval Antiquities in 1866,

was instrumental in ensuring that the Museum purchased thirty-five exceptional pieces of English delft from the renowned Brighton collector Henry Willett (1823–1905) in the same year as his own gift.[6] The continued expansion of the collection at this time included Willett's cistern dated 1641 (no. 72), his book-shaped hand-warmer dated 1658 (no. 134), his charming jug modelled as a cat and dated 1674 (no. 135), a plate commemorating the Duke of Cumberland's victory over the Jacobite forces under Bonnie Prince Charlie at Culloden (no. 21), and an unusual Pope Joan gaming dish (no. 125). These are only a few of the outstanding acquisitions from the Willett Collection.

Franks's generosity, in this as in so many other areas of Museum collecting, continued, and the collection kept growing in the ten years before his retirement. In 1888 he presented the highly attractive charger painted with scenes from the parable of the Prodigal Son dated 1659 (no. 37). In 1890 he donated another election plate for Calvert and Martin, who fought an election at Tewkesbury, Gloucestershire in 1754 (no. 24). In 1896 he gave a punch bowl painted inside with a bust crowned with laurels and the inscription, 'Confusion to the Pretender 1746' (no. 20) and in 1897, the year of his retirement, a large blue-ground charger bearing the arms of King Charles II, painted in white (no. 10). His bequest included a number of other significant pieces. His legacy in this single field of ceramic collecting (he contributed greatly to many other areas) was of immeasurable importance.

Several other well-known nineteenth-century collectors helped to extend the Museum's delftware collection. Alexander Christy (died 1894), brother of the industrialist, ethnographer and archaeologist Henry Christy (1810–1865), presented the bowl painted with Bonnie Prince Charlie in Highland dress (no. 23) in 1890.[7] The omnivorous china collector Lady Charlotte Schreiber (1812–1895) gave a posset pot, inscribed 'AY/1677' (no. 81), in 1891. Sir J.C. Robinson, who played a key role in the

formation of the sculpture collection at the Victoria and Albert Museum, presented a highly important moulded salt in 1899 (no. 101).[8]

In the twentieth century English delftware continued to enter the Museum collection in the form of gifts and bequests. Undecorated delftware is seldom seen in Museum collections, and indeed rarely survives, making the unglazed salt given by Sir Charles Hercules Read in 1903 something of a rarity.[9] Fragments of bleeding bowls, an unglazed mug and some kiln furniture, all recovered from Tooley Street, Southwark, London, close to the sites of several seventeenth-century delftware factories, record early interest in the archaeology of delft. These items were given in 1905 and 1907 by Geoffrey Flavian Lawrence. Further gifts in this category were made in 1914, 1920 and 1922 by W.J. Pountney. The first comprised over 250 fragments found on the site of the seventeenth-century delftware factory at Brislington, near Bristol; the second fragments of fused plates from Wincanton, Somerset (fig. 7); and finally fragments from Wincanton and the site of the Temple Back factory in Bristol. The fragments do not have the status of those held by the Museum of London, for instance, as their precise findspot was not recorded, nor was any analysis of the site made. Archaeology was in its infancy at this stage and work on post-medieval sites had barely begun.

Well-known collectors such as Max Rosenheim made generous and important gifts of delft in 1906 (no. 115) and 1911 (no. 85), latterly through the National Art-Collections Fund. There is a further piece in the Museum from the collection of Sir Maurice and Max Rosenheim.[10] This is a moulded cornucopia vase, purchased in 1923 (no. 133). Alfred Aaron de Pass made a gift of a posset pot dated 1696 (no. 84) in 1904; in 1909 another dated 1668 (no. 79) was donated by him through the National Art-Collections Fund.

The political theme running through the Museum collection can be seen in two important purchases made in 1910: a bowl, painted inside with a portrait of John Wilkes, MP, and inscribed 'Wilkes and Liberty No Bu**/45 (no. 27), and a plate, inscribed 'TC LIBERTAS POPULI', (no. 19). Both record important moments in the development of the British political scene.

Dame Joan Evans, FSA (1893–1977), was the daughter of the famous archaeologist and numismatist, pre-historian and collector Sir John Evans (1823–1908) and Lady Maria Evans, his third wife. One of two gifts of delftware in 1921 from Dame Joan and Lady Maria was a drug jar (no. 50), painted in colours with the arms of the Worshipful Company of Apothecaries. Mrs M. Greg, the wife of the well-known collector Thomas Greg, a great benefactor of the Manchester Art Gallery, gave two plates with unusual grounds (see no. 112) in 1921 in memory of her husband.

In the years immediately after the First World War acquisitions were perhaps less spectacular than in the following decade. They included, however, the cup (see no. 86) donated by the curator and ceramic authority R.L. Hobson in 1924, the plate (no. 17) commemorating the Act of Union between Scotland and England in 1707, the gift of Miss M. Lewis in the same year, and the fragment of a pomegranate charger inscribed 'IEN 1647' (no. 140), presented by J.E. Pritchard, FSA, in 1926.

One of the Museum's most important purchases of English delft was made in 1931, when the jug painted with the biblical story of Samson and the Lion, bearing two sets of initials (no. 33), was bought from Miss L.M. Campkin. Its earlier history remains unknown. Another purchase at this time was a bowl painted with a ship and inscribed 'Success to the Expedition Capt Nicholass Walter' (no. 94). This, like a rare flower brick or inkwell purchased at the same time (no. 130), came from the collection of R.G. Mundy, the first to publish a book on the subject of English delftware.[11] An important gift made by Sir Bernard Eckstein, Bt, was the press-moulded bust of King Charles I (no. 8), of which only one other example

survives. From another well-known collector, Wallace Elliot, came a gift in 1935 through the English Ceramic Circle of a money box (no. 126), another rare survivor. Elliot's bequest of 1938 included three pieces that can be counted amongst the most important in the collection. These are the charger painted with Adam and Eve in the Garden of Eden inscribed 'ADAM: ADAM:WHARE:ART: THOU' (no. 34), a mug with a portrait of King Charles II inscribed 'CR' and dated 1662 (no. 3), and a plate dated 1748 with the initials 'IEC' (no. 110). A second bequest in that year came from Rennie Manderson through Mrs Gertrude Manderson, adding to the collection a second moulded 'Fecundity' dish (no. 45). The unusual plaque painted in blue with Bristol Cathedral (no. 136) was the gift of Wilfrid Fry in the same year.

The generosity of the National Art-Collections Fund has already been recorded. Further gifts were made through the Fund in 1942 (nos. 57, 123) and 1943. It was at this time that the Irish plate inscribed 'John Stritch Limerick 1761' (no. 57), the jar dated 1700 (no. 107) and the two pieces associated with James Tidmarsh (nos 123–4) entered the collection.

The 1950s and 1960s saw renewed efforts to expand the collection. A.D. Passmore donated fourteen pieces of English delftware in 1957, two of them dated. Some of the most outstanding pieces in the collection were acquired by purchase during the 1950s and 1960s. A bird representing 'The Pelican in her Piety' dated 1651 and bearing initials (no. 36), bought in 1959, although incomplete, is one of the rarest of all delftware productions. The large punch bowl inscribed on the base 'Clay got over the Primate's Coals/Dublin 1753' (no. 91), which is of the highest importance for the history of Irish delftware, was purchased in 1960. In 1964 a mug painted with a medallion portrait of the Duke of Cumberland and inscribed 'William Duke of Cumberland 1748' and 'Samuell and Mary Plege 1748' (no. 22) was purchased as a unique and a fascinating example of anti-Jacobite

propaganda in pottery. The gift of A.C. McDonald in 1965 of a large dish painted with 'The Woman Taken in Adultery' and dated 1698 (no. 39) makes the British Museum collection one of the richest in pieces painted with biblical scenes. Frank and Kathleen Tilley, dealers who had supplied nos 1, 36, 73 and 91, presented a bowl inscribed 'Crosby and Oliver' (no. 30) in 1969 and the bequest of Miss Constance Woodward in 1981 included a rare tin-glazed stoneware teapot (no. 95).

The collection has continued to grow, but more slowly in view of the steep rise in market values of English and Irish delftware and the relative lack of outstanding pieces now available, as compared to one hundred or even fifty years ago. A tile from the series associated with the so-called ' Popish Plot' of 1678 (no. 9) was purchased in 1987 and in 1991, through the generosity of the American Friends of the British Museum in 1991, a punch bowl was acquired which is inscribed 'Success to Trade No Stamps' (no. 29). It records the passing of the Stamp Act of 1765, which was to precipitate the American War of Independence. A series of 'Popish Plot' tiles were generously bequeathed to the Museum by Dr William Lindsay Gordon in 2009, and several others from his estate were purchased on the market (see no. 9).

This account highlights just some of the best-known and most important pieces of English and Irish delftware amongst the 470 or so in the British Museum collection. The constant expansion of the collection owes an incalculable debt to private benefactors, as well as to The Art Fund (formerly the National Art-Collections Fund), and to the discrimination of my predecessors.

Fig. 12 William Hogarth, *Southwark Fair* (detail), 1734, showing pottery for sale. Etching and engraving, 36.3 × 47 cm. British Museum 1868,0822.1515

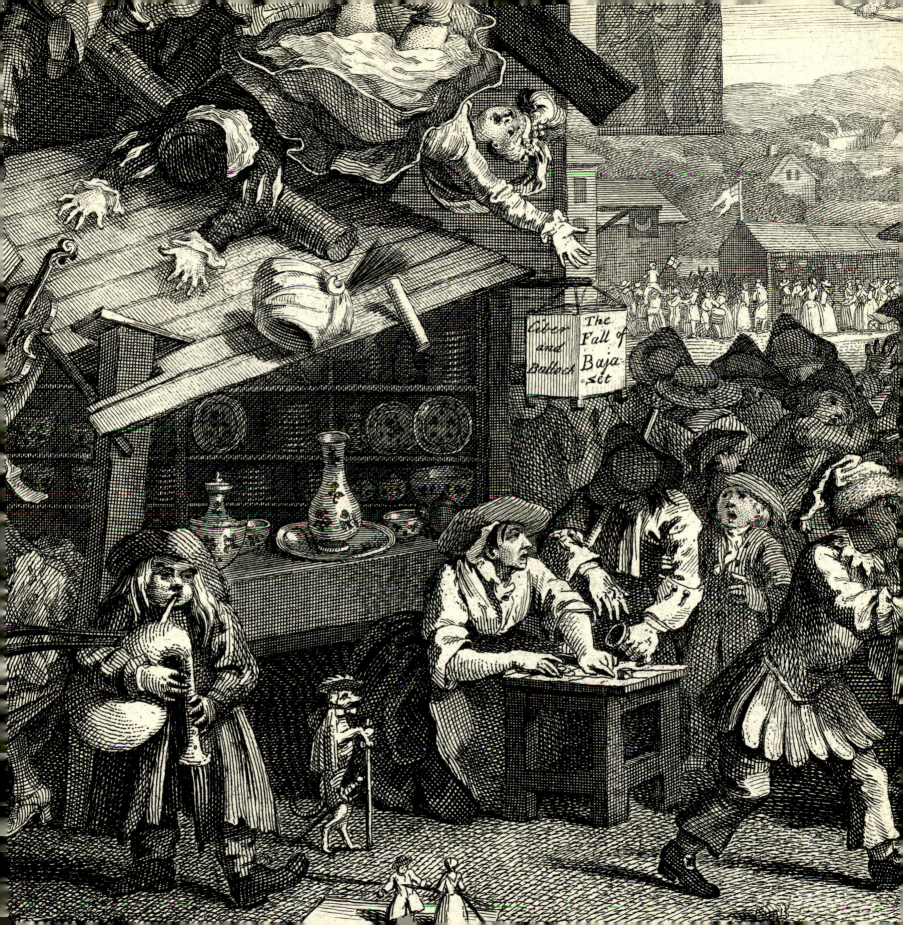

English & Irish Delftware

The book is divided into nine sections, as described below.

Political and historical delftware
Delftware was popular and widely available from the mid-seventeenth century. It was the first ceramic material used for propaganda and commemorative purposes with images documenting both public opinions and private loyalties. Portraits of the monarch on dishes and plates, as well as cyphers and royal arms on mugs, flasks and wine bottles, reinforced the position of the Crown in the decades following the Restoration, and declared their owner's loyalty. Some pieces celebrated the Act of Union in 1707 (no. 17). During the eighteenth century, plates and punchbowls proclaim support for politicians, such as Wilkes (no. 27), or for elections where drink was often offered to induce the electorate to vote. Portraits of Bonnie Prince Charlie and the Duke of Cumberland (nos 22–3) reveal the public impact of the Second Jacobite Rising in 1745. The wares also record the extension of the British empire and trade as well as the loss of the American colonies (no. 29). It is likely that the manufacturers judged the market for their products, but some pieces at least, such as those made for elections, were probably made to commission.

Religious subjects
The seventeenth century in Britain was a religious age. Delftwares made around 1630–60 in the earliest phase of production were often decorated with well-known subjects from the Bible. The story of Adam and Eve was especially popular (nos 34–5). Delft painters worked from engravings and many versions of the Creation story decorate delft dishes. The scene on the large dish no. 39, identified as 'The Woman Taken in Adultery', is exceptional, as is the figure of a bird and her three chicks, which once pecked at her breast (no. 36), although the subject, 'The Pelican in her Piety' was a common one in many media.

Armorial decoration
Delftware dishes made in the seventeenth century are often painted with the arms of the City of London or one of its Livery Companies, which still effectively controlled many trades. These arms are frequently accompanied by a triangular arrangement of three initials for a husband and wife. Pieces decorated in this way may have been commissioned by well-to-do London merchants for a wedding or in commemoration of a marriage, perhaps on an anniversary, or been offered as presents. Sometimes the arms appear with a landscape or maritime scene (no. 47), or with religious or allegorical subjects (no. 44). Towards the end of the seventeenth century and in the eighteenth century bogus coats-of-arms were sometimes used (no. 54), presumably by those who were successful, but not entitled to bear arms.

Delftware for the pharmacy
From the early seventeenth century when delftware was first made in England, containers for dry drugs, ointments

or even cosmetics were a staple of production, to judge from the many that survive. Initially most were simply decorated (no. 59), although examples painted with a Chinese-inspired pattern called the 'bird-on-the-rock' are known (no. 60). By the middle of the century jars were often painted with Latin names of drugs, sometimes accompanied by the initials of the pharmacy owner who had ordered the jar and a date (no. 61). Bowls used by barber-surgeons, indented for the customer's neck, were decorated with shaving implements and a punning inscription (no. 62). Even as late as the first half of the nineteenth century, when the industry barely survived, delftware ointment pots (no. 63) and honey jars (no. 64) continued to find a market.

Drinking

Mugs and tankards for beer, caudle cups, posset pots and punchbowls were all made in quantity in delftware during the seventeenth century to replace metal or even wood or horn vessels. Posset, a mildly alcoholic drink made with spices, was often drunk communally from finely decorated spouted vessels. Two-handled cups for caudle, another milky drink with spices, were used by invalids. Punch became extremely popular in the eighteenth century as sugar from the West Indies became freely available. It was drunk, usually by men, in clubs and at other gatherings, which were often disorderly, or on board ship (no. 94). Inscriptions inside punchbowls urged good cheer and counselled moderation (no. 88), or even sometimes excess, in alcoholic intake. Delftware could not withstand boiling water needed to make tea and coffee, so very few cups and teapots were made (nos 86 and 95).

Delftware for the table

Many large delftware dishes painted with landscapes or figure scenes were probably intended for display rather than for use at table, but the number of surviving plates indicates that they found a home in a domestic setting,
perhaps on festive occasions, and most likely in sets which may or may not have matched up. Some sets have inscriptions on the front or back of the plates, usually with the name of their owner and a date (nos 117–18).

Delftware for leisure

The popularity of public and private musical entertainments in the eighteenth century is occasionally reflected in ceramics, as on a delftware dish painted with a song (no. 124). Card games were played at home, often at parties, sometimes using delftware containers for chips (no. 125), although few of these survive.

Flower holders

Vases were made in delftware from the middle of the seventeenth century in England, probably in imitation of Italian maiolica or Dutch delft. Rising prosperity and new standards of comfort in eighteenth-century homes encouraged the production of a large number of delftware flower holders for fresh or dried flowers or for bulbs. These containers were manufactured in many different models, most frequently in the form of a brick pierced with holes (nos 128–31).

Ornaments, water bottles, fragments and tiles

Some delftware pieces, such as the figure of a cat (no. 135), must have been ornaments and not made for use. Water bottles (nos 137–8), which usually had matching basins, many now missing, may have been used at table, but were perhaps more often mounted in furniture. Two dated fragments represent items found in excavations carried out before the advent of scientific archaeology (no. 140). Delftware tiles for floors were made in England from the beginning of the industry (nos 141–2), but from around the end of the seventeenth century painted, and later even printed, tiles (no. 143) also adorned chimney-surrounds, alcoves and dairies.

1 **Jug**, 1660

Made in Southwark, London, perhaps at the Pickleherring pottery
Inscribed: 'KING/ CHARL/ES THE/ 2/ 1660/SB'
Height: 17.5 cm; width (max. including handle): 12 cm
Reg. no. 1960,1101.1; formerly in the collection of Mrs Meraud Mason
Archer 1973, no. 29; Lipski and Archer 1984, p. 220, fig. 973

The pottery at Pickleherring Quay, Southwark, was established in about 1618 by Christian Wilhelm (active c. 1618–30), a Dutchman. Granted a patent for delftware manufacture in January 1628, which was to last fourteen years, he died shortly afterwards in 1630, when he was succeeded by his son-in-law, Thomas Townsend, until c. 1645. It was then owned by a series of potters, moving to larger premises between 1714 and 1723, when it finally closed down.

In the central oval panel is a full-face portrait painted in blue, manganese and yellow-green of King Charles II (1630–1685; reigned 1661–85) in coronation robes, holding a sceptre in his right hand and an orb in his left. At either side are seascapes painted in blue, each with a ship in full sail and a building on the shore (see nos 47 and 76 for pieces painted with similar ships and buildings). Around the foot, around the neck and near the lip is a band of ornament consisting of dots. The jug is similar in form to jugs made all over Europe of tin-glazed earthenware and the applied handle imitating twisted rope is probably based on tin-glazed pottery (faïence) from Nevers in central France. It is likely to have been used for wine.

The restoration of the monarchy in England seems to have provoked the production of a large number of commemorative pieces painted with the portrait of the King, to judge from the number of surviving mugs, jugs and plates. The image of the King with the emblems of his power is designed to emphasize his right to the throne.

The jug commemorates the Restoration of the monarchy following the execution of King Charles I (1600–1649; reigned 1625–49) in 1649 and the republican period of the Commonwealth. Its original owner, probably the 'SB' in the inscription, is likely to have used or displayed it to proclaim his loyalty to the new King.

Foot restored, handle re-stuck, rim damage and loss of glaze to foot.

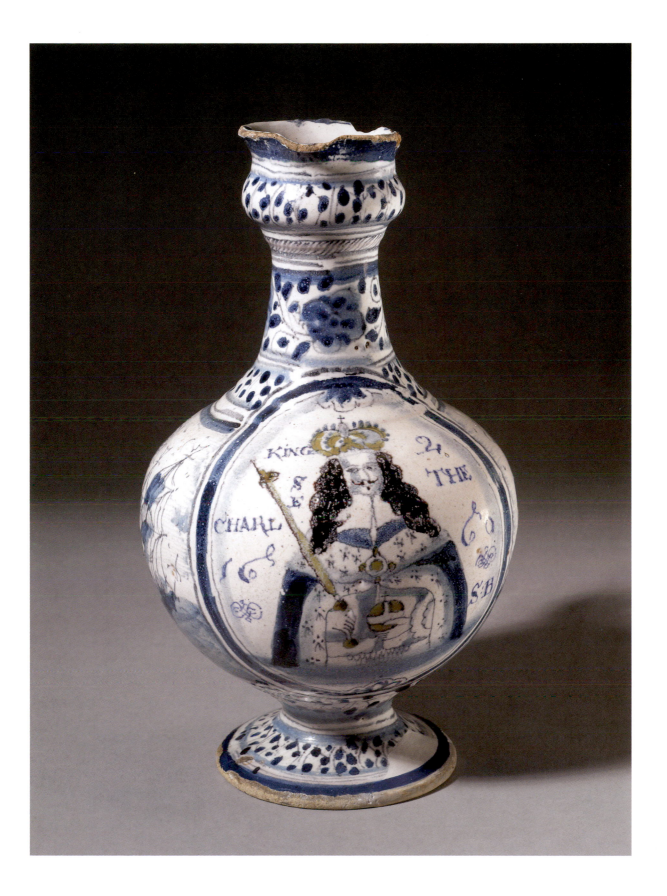

2 Mug, about 1660

Made in Southwark, London
Inscribed: 'CR:D/2'
Height: 9.2 cm; diameter: 9.8 cm
Reg. no. 1930,1024.3; bequeathed by Bryan T. Harland, 1930, collection label
Grigsby 2000, D239

The half-length portrait of King Charles II (1630–1685; reigned 1661–85) depicts the monarch wearing a crown and an order suspended from a chain over an ermine-trimmed robe. It is enclosed by a stylized laurel wreath, the ends of which are not shown. The capacity of the mug, which was probably for beer, a favourite drink in England at this time as the water was often unsafe to drink, is around a pint.

The mug is one of many objects painted with a likeness of the King, which were intended to emphasize the loyalty of the drinker to the Stuart line. As Samuel Pepys wrote in his *Diary* on 6 March 1660, 'Everybody now drink the King's health without any fear, whereas before it was very private that a man dare do it'.[1] Charles II returned to England in 1660 at the restoration of the monarchy following the death of Oliver Cromwell in 1658 and the resignation of his son Richard in 1660.

3 Mug, 1662

Made in Southwark, London
Inscribed: 'CR.2/1662'
Height: 7.5 cm
Reg. no. 1938,0314.108; bequeathed by Wallace Elliot, 1938; formerly in the Charles J. Lomax Collection (with another, see below), collection label stuck to base
Lipski and Archer 1984, no. 756; Grigsby 2000, D239

King Charles II is shown on this mug half-length in coronation dress, wearing a crown, a full wig and an ermine-trimmed robe, and holding an orb and sceptre. Charles was crowned on 23 April 1661 at Westminster Abbey. In May 1662 he married Catherine of Braganza, which may explain the date on this mug. Alternatively, the mug demonstrated support for the King at a time when he had become unpopular for the first time in his reign. The sale of Dieppe to the French (it had been captured by Cromwell), the passing of the Act of Uniformity requiring the Book of Common Prayer of 1662 to be used in church services, and the Excise Tax and Hearth Tax bills all contributed to the monarch's loss of popularity.[1]

There are several other mugs with similar decoration. Of the six recorded, four are dated 1661. One other cup dated 1662 is similar, but not identical, to the Museum example.[2] Like the Museum mug, this example was in the Lomax Collection.[3]

The portrait is a truncated version of one found on 'blue dash' portrait chargers.

All the caudle cups painted with the royal portrait depict King Charles II with the exception of one excavated at Rochester, Kent, which is painted in the same manner with a male portrait and the intials 'I' and part of a 'y' above a 'D', thought to represent the King's younger brother, James, Duke of York, and the date 1664. It was in this year that the Dutch town of New Amsterdam was renamed New York in the Duke's honour.[4]

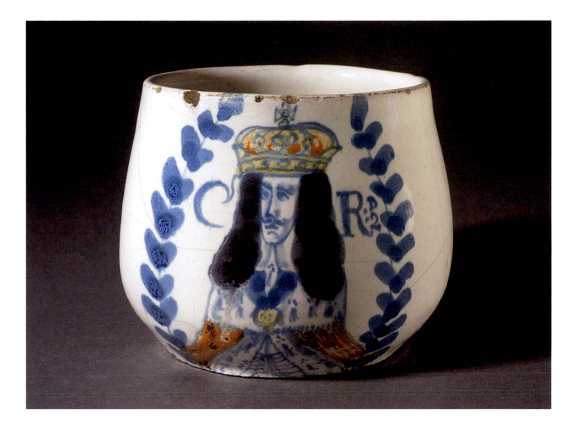

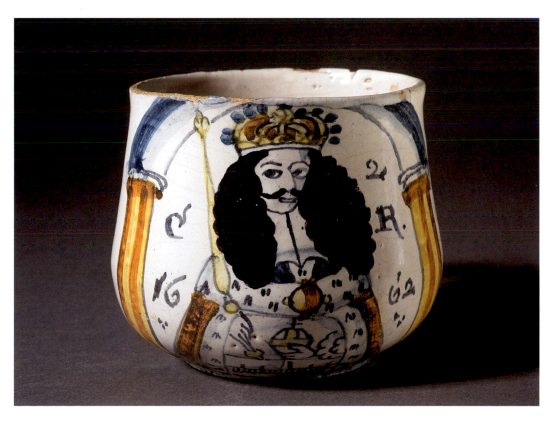

4 **Wine bottle**, about 1660

Made in Southwark, London
Inscribed: 'SACK' and 'CR2', painted in blue
Height (incl. mount): 21.1 cm
Reg. no. 1888,1110.18; presented by A.W. Franks, 1888; formerly in the Octavius Morgan collection[1]
Hodgkin and Hodgkin 1891, no. 411; Hobson 1903, E29; Grigsby 2000, D222

Sack was the term used for sweet white wines of sherry type imported from Spain and Portugal. Shakespeare associated Falstaff with sack in his *Henry IV, Part 2*; the word survives today in the name of a brand of sherry.

Wine bottles bearing the initials of King Charles II (1630–1685; reigned 1661–85) are less common than mugs with a portrait of the King, although dated examples with 'CR' for King Charles I have survived.[2] An example dated 1676 is painted with 'CR' crowned.[3] Like the mugs, winebottles with the initials of the monarch were intended to demonstrate their owner's loyalty. Some survive with coats-of-arms, such as nos 40 and 48, but in general wine bottles were inscribed only with the name of their contents and/or the initials of their owners (see no. 70). An example dated 1645 and inscribed 'SACK' between a crown surmounted by a Greek cross is in the Chipstone Collection, Milwaukee, USA.[4]

The silver mount on the neck is hallmarked for London with the gothic-style date letter 'D' for 1839–40 and the maker's mark 'IF' for John Figg, who was made free on 5 June 1833 and is last recorded in July 1848.

Wine bottles were much collected in the later part of the nineteenth century and some may even have had their (spurious) inscriptions added at this time. The fact that this example has been mounted in silver indicates how highly it was prized while the date of the mount probably indicates how early these bottles became collectable.

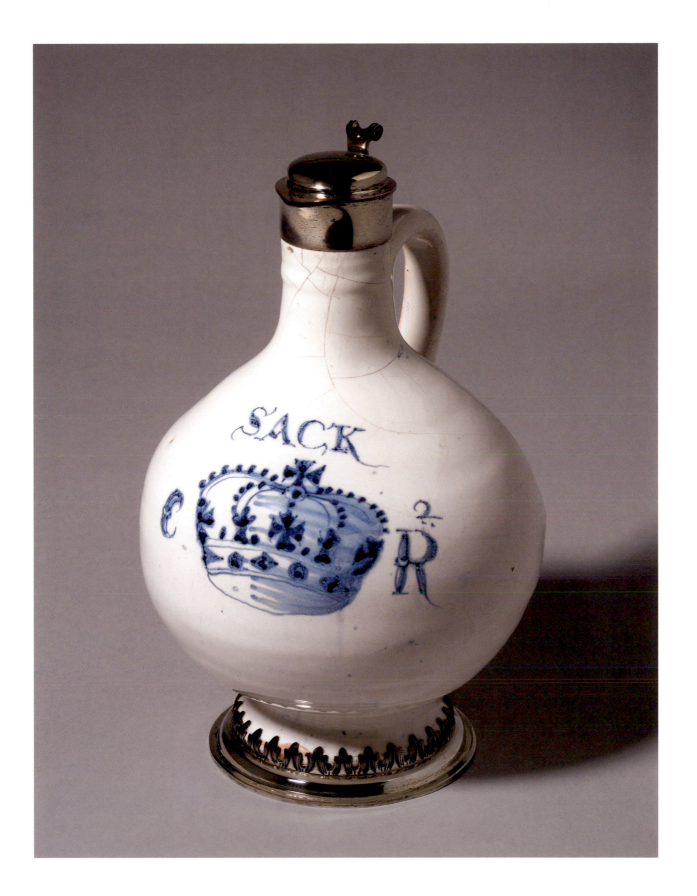

5 Charger, 1663

Made in Southwark, London, perhaps at the Pickleherring pottery
Inscribed: 'G/IM.1663' painted in blue; 'T.M.' incised on the back
Diameter: 56 cm
Reg. no. 1887,0307.E154; presented by A.W. Franks, 1887
Hodgkin and Hodgkin 1891, no. 539; Hobson 1903, E 154; Rackham 1913–14, p. 277; Rackham 1918, pl. I, opp. p. 116 and p. 122;
Warren 1939, p. 19; Lipski and Archer 1984, no. 46; Burman 1993, p. 102, fig. 2; Tait 1998, p. 12

This exceptionally large dish with a flat rim was evidently for display as it has three pierced holes for suspension in the footrim, one of which is partly blocked. It might have been shown on a buffet like silver vessels or Renaissance maiolica. Although there is a firecrack on the rim, the dish is remarkably thinly potted and has suffered little or no distortion in the kiln. The reverse is covered with a lead glaze. The decoration is carefully executed. As it is markedly different to many other dishes in size, potting and decoration, it is likely that the piece was made and decorated by highly skilled immigrant Dutch workmen.

The initials on the front may indicate that it commemorates the marriage of John Garway and his wife Mary Holgrave.[1] Garway was a Freeman of the Haberdashers' Company and a prominent wool merchant in the trade between the Low Countries (modern-day Holland, Belgium and northern France) and London. Woollen cloths and other textiles could be found at the Old Wool Quay, which was just across the River Thames from Pickleherring Quay, the site of Christian Wilhelm's pottery, established in about 1618. However, this supposition cannot be verified and as the ship has been identified as a mid-seventeenth-century warship, square-rigged with a lateen yard on the mizzen, it may not be correct.[2] In support of the identification, warships were highly important to the control of trade in the seas around England and with her colonies around the time this dish was made. The First Dutch War had ended with a victory for England in 1653. The Second Dutch War broke out in 1665, resulting in a Dutch victory and the humiliating destruction of English ships in Chatham dock and the capture of the flagship in 1667.

The blue dashes on the edge of this dish are often found on seventeenth-century delftware chargers. The border decoration is rather reminiscent of the painting on Italian maiolica, whilst the blue design of the inner border enclosing the ship recalls Chinese blue-and-white porcelains. The same border motif is found on a dish dated 1657 and painted with a portrait of King Charles I in armour at Waddesdon Manor, Buckinghamshire.[3] A rather similar border is painted in a darker blue near the rim of a charger or a 'Clapmash' dish, so-called on account of its deep shape, dated 1637 and inscribed 'John Ayers'.[4] Ships seem to appear rarely on delftware chargers, but are much more common on eighteenth-century bowls. However, a dish dated 1668 in the William Rockhill Nelson Gallery, Kansas City, is painted with the Royal Yacht carrying King Charles II.[5] The style of the decoration on this dish is unlike the British Museum example.

The Museum dish was once thought to have been made in Staffordshire.[6]

For the profile of this charger, see p. 300.

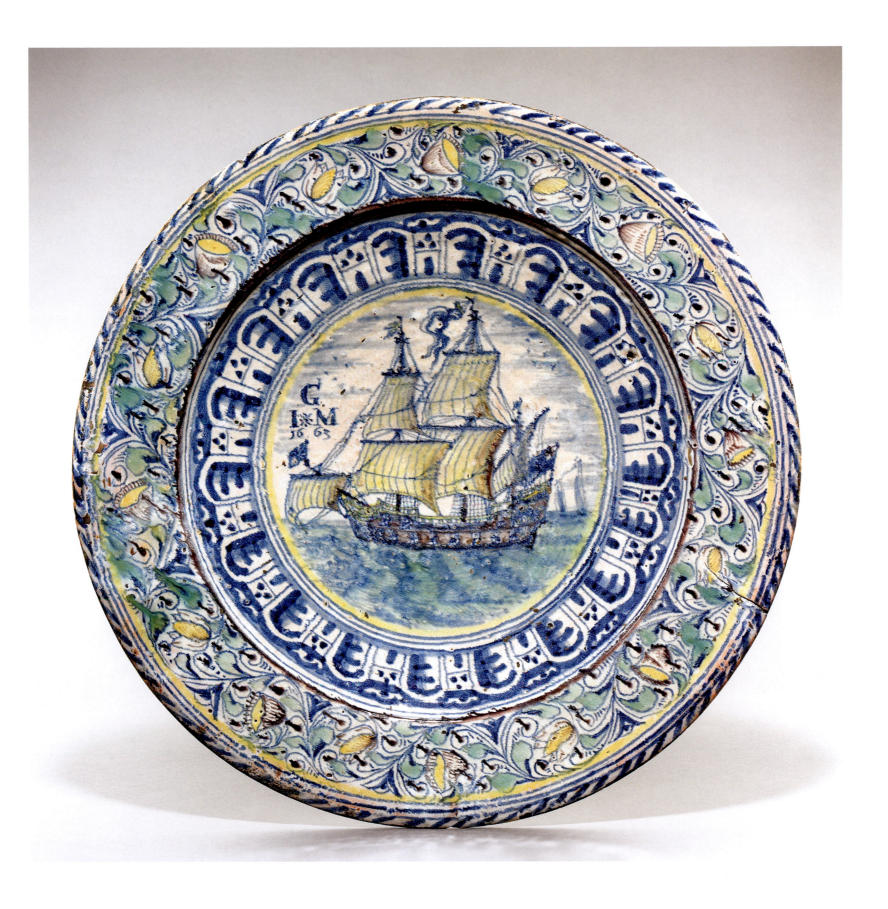

6 Flask, 1668

Made in Southwark, London, perhaps at the Pickleherring pottery
Inscribed: 'CR 'on both sides and 'IM/VIVE LE ROY/1668' on the edges
Height: 7.6 cm; width (max.): 13.7 cm
Reg. no. 1887,0307.E81; presented by A.W. Franks, 1887
Hobson 1903, E 81; Lipski and Archer 1984, p. 338, no. 1504

The flask, which imitates a pilgrim flask and would have had a stopper of some kind, was made in two parts in a mould and the scroll handles applied separately. A small 'foot', part of which is now missing, supports the flask, on one side of which is painted a half-length figure of King Charles II (1630–1685) slightly turned to the left, in an ermine-trimmed robe and crown holding a sceptre, between the initials 'CR'. The brown robe has been overfired. On the other side is a crown above the initials 'CR'.

There are a number of pieces of delftware with inscriptions relating to King Charles II (see nos 1–4), which express loyalty to the restored Stuart monarchy. The enthusiastic inscription 'Vive Le Roy' signals the re-establishment of the international status of the King, now allied with Sweden and the United Provinces in the Triple Alliance against the expansionist King Louis XIV of France. The French king had to abandon his claim to the Spanish Netherlands, signing the Treaty of Aix-la-Chapelle in 1668. The identity of 'IM' remains unknown, but was presumably the person for whom the flask was made. No other flask of this form is recorded.

The base is damaged. Its missing foot once allowed it to be displayed upright.

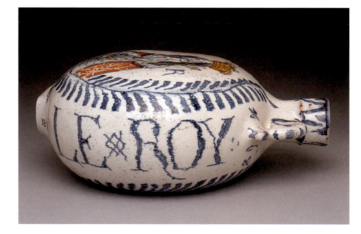

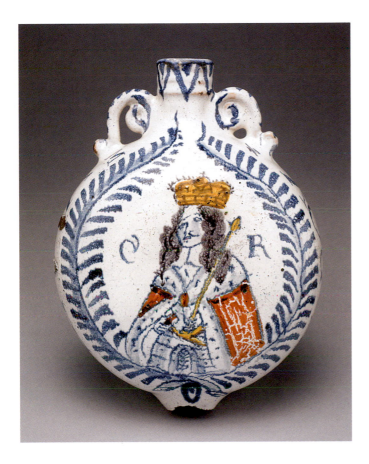 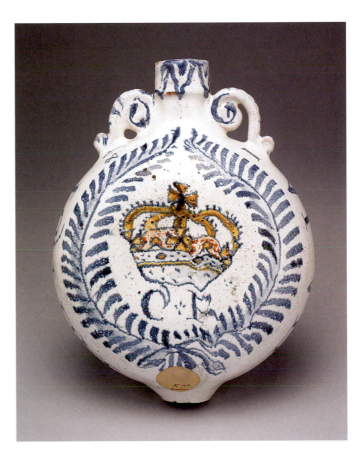

7 **Dish**, 1668

Made in Southwark, London, perhaps at the Pickleherring pottery
Inscribed: 'CR 2D/1668'
Diameter: 33.4 cm
Reg. no. 1855,1201.116 (BL 2120); formerly in the collection of Ralph Bernal, MP and purchased at his sale held by Christie's, London,
5 March 1855 and following days, 17th day, 24 March 1855, lot 2120, £3 3s
Marryat 1857, p. 144; Hobson 1903, E 149; Warren 1937, p. 20; Tait 1957, p.47; Lipski and Archer 1984, no. 52; Burman 1993, p. 101, fig. 1

The blue dashes on the edge of this dish, or charger, are characteristic of English delftware of the mid- to late-seventeenth century.

The back of the dish is lead-glazed, probably over a pale-coloured slip, and is brownish in tone. There are three stilt marks on the front of the dish from the kiln support used to prevent the dish from sticking to other glazed pots when the decoration was fired.

For the profile of this dish, see p. 300.

Dishes with a portrait of King Charles II (reigned 1660–85) surrounded by columns, arches and vaulting are known with various dates from 1661 to 1673. For the possible significance of the date 1668, see no. 6. The design, of which Austin noted ten dated examples,[1] seems to have been used for a dish depicting King Charles I. The British Museum dish is more carefully painted than many others, with a particularly fine chequered floor giving depth to the image.

The dish was sold at the Bernal sale in 1855 for three pounds and three shillings. Its earlier history has not been discovered, but by 1857 it was well known to collectors as it is mentioned in Joseph Marryat's *A History of Pottery and Porcelain, Medieval and Modern* (2nd ed.).

A portrait of King Charles II in armour by Gerrit van Honthorst on which this image may be based, wearing an ermine-trimmed cloak and holding a baton in his right hand, was sold from a private collection in 1983.[2]

For the Pickleherring pottery, see no. 1.

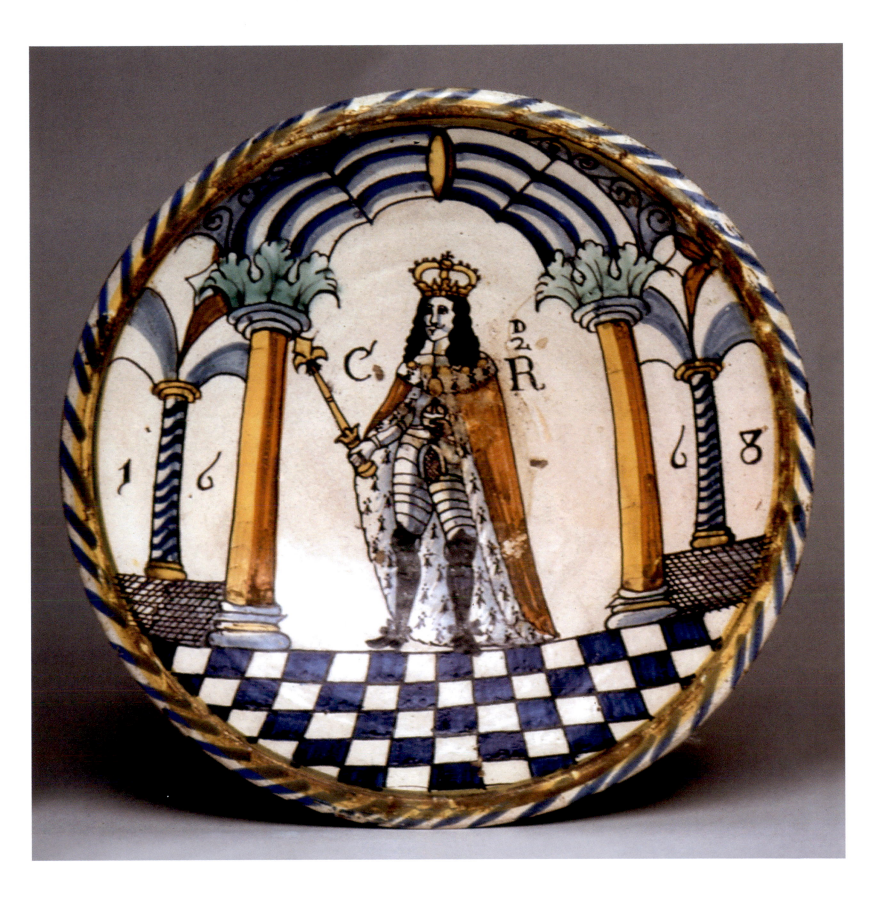

8 Bust of King Charles I, 1679

Made in London, possibly in Southwark
Inscribed: '16EC79' in blue on the plinth
Height: 18.9 cm; width of base: 8.2 cm
Reg. no. 1935,1016.1; presented by Sir Bernard Eckstein, Bt, 1935
King 1936, p. 131;[1] Falcke 1936, pp. 138–40;[2] Avery 1937, pp. 64–5;[3] Archer 1973, no. 47; Lipski and Archer 1984, no. 1744;
Macfarlane 1998, p. 261, fig. 6; p. 262, fig. 7

Although several figures and other larger busts were made, examples of which can be found in the Longridge Collection, USA,[4] busts like this of King Charles I (reigned 1625–49) are extremely rare. Only one other is known. It is in the Metropolitan Museum of Art, New York, and is inscribed '16SR79' on the front of the plinth (fig.13).[5] There are some differences in the decoration, as the robe on the New York example is painted in blue and not turquoise, but the busts are without doubt from the same mould. Both are press-moulded in two pieces, the upper part luted to the pedestal with liquid clay before firing and the reverse tin-glazed but left undecorated. The base of the British Museum example is stepped and is unglazed underneath, and differs from the New York bust which has a hollow depression inside the foot.[6]

On the British Museum example both the hair and the lace collar have been carefully rendered in dark blue.

The function of these busts remains uncertain. They are likely to have commemorated the death of the 'Martyr King', who was executed in 1649. Since the acquisition of the British Museum bust, its ultimate source has

been thought to be the marble bust of King Charles I by the Italian Baroque sculptor Gian Lorenzo Bernini (1598–1680), now lost or destroyed.[7] Alternatively, the bust may have been based on one of the many oil portraits of the King, such as that by Anthony van Dyck, which were well-known from engravings or even from a medal, such as the silver example with a left-facing portrait of Charles I on the obverse, which was found in Nacton, Lincolnshire in September 2003. This dates from the Civil War period and

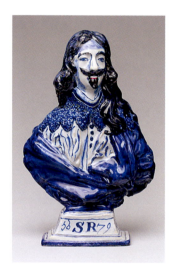

Fig. 13 Bust of Charles I, 1679.
Tin-glazed earthenware, 19.4 × 12.7 cm.
The Metropolitan Museum of Art, New York, Gift of R. Thornton Wilson, 1936 (36.159.2)

is personalized with an engraving on the reverse of a coat-of-arms and initials.[8] Michael Archer suggested in 1984 that the bust may have been made to mark the thirtieth anniversary of Charles I's execution,[9] but as Margaret Macfarlane remarks, this would not conform to seventeenth-century practice.[10] It could also be argued, however, that the execution of the monarch was a completely unprecedented event and that images of the King were in circulation at an early date. It is worth noting

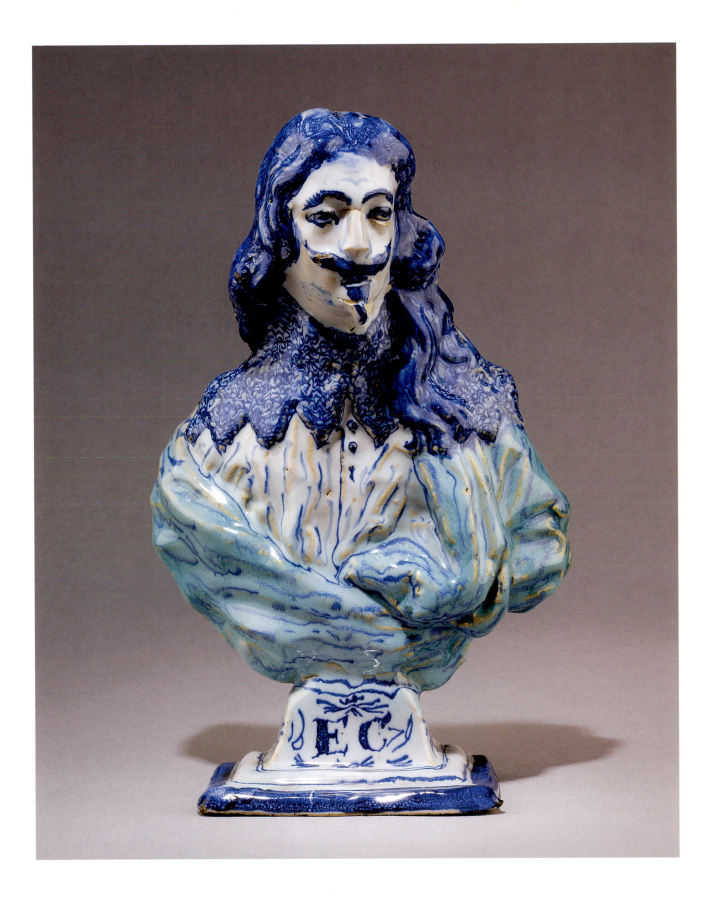

that fourteen Jesuits were hanged in June 1679 for their supposed part in the 'Popish Plot' (see no. 9), and this may have prompted a demand for images of the Protestant Martyr.[11]

Within days of his execution, Charles became the focus of a cult as the 'Royal Martyr', and reports of miracles 'wrought by his blood' began to circulate in the months following, together with relics, memorabilia and hagiographical works.[12] In June 1654 John Evelyn recorded a visit to St George's Chapel, Windsor, where the body was laid out before the altar. After the Restoration, from 1661, the date of 30 January was kept by the Church as 'a Solemn Fast and day of humiliation ... to expiate the Gilt [sic] of the Execrable Murder of the late King' and there was a special office added to the Book of Common Prayer, sanctioned by both King and Parliament. The office was only dropped in 1859.[13] In 1678, as a consequence of the growth of Cavalier Anglican sentiment, it was decided to re-inter the King's remains, buried without ceremony after his execution, and to build a monument which was to be designed by Sir Christopher Wren.[14] The plan foundered as the bill that would have raised money for the project was not passed by the House of Commons at its second reading. The small busts might have been made for one of the supporters of the mausoleum project, or at the least for one of those who venerated the 'Martyr King'.

There are tiny areas of damage on the face and loss of glaze on the chin.

A remarkable figure of Ignis, purchased by Hampshire Museums Service, bears some similarities in facture and decoration, and, more remarkably, is painted with the same initials – 'EC' – and the date 1679 on the pedestal. It seems highly likely that the two figures came from the same pottery and were made and decorated by the same craftsmen for the same buyer.[15]

A terracotta bust of King Charles I made by Louis-François Roubiliac (1702–1762) in 1759 was acquired by the Museum in 1762.[16] There are a number of other items in the collections which are associated with the King. Remarkably, the king's image was used on a large pottery plaque dating from as late as 1820, probably made in Sunderland.[17] A slightly earlier pottery plaque with the same image in relief may have commemorated the King's birth in 1600.[18]

9 **Five tiles**, about 1679–80

London, possibly made at the factory of Jan Ariens van Hamme, perhaps at Copthall or Vauxhall in Lambeth

1 Inscribed 'THE EXECUTION OF THE 5 JESUITS'
Height: 12.3 cm
Reg. no. 1987,1204.1; from the collection of Louis Lipski, sold
Sotheby, Parke Bernet & Co., 1 March 1983, lot 506;[1] formerly
probably in the collection of J. Eliot Hodgkin FSA[2]

The gruesome hanging scene records the punishment of
the alleged conspirators, five prominent members of the
Roman Catholic Jesuit Order, in the so-called 'Popish Plot'
of 1678. The hangings (in fact of fourteen Jesuits) took
place on 20th June 1679. The Revd Titus Oates, a
renegade Catholic who had lost his living on account of his
poor behaviour, swore before a magistrate of the City of
London, Sir Edmund Berry Godfrey, that he had
discovered a (fictitious) Catholic plot to kill King Charles
II, establish a Catholic ministry and to organise a massacre
of Protestants. The murder of Sir Edmund several days
afterwards was seen as a sign that Oates and his fellow
conspirators were telling the truth. Many prominent
Catholics were arrested, tried and imprisoned or even
executed. The 'plot' was used to exclude James, Duke of
York, an ardent Catholic, from the throne by the Exclusion
Bill put to Parliament in 1680, but never in fact passed
(James did succeed to the throne, although some
conditions were imposed on him), and also to prevent
Catholics from sitting in Parliament.

The stages of the Plot were depicted on a pack of fifty-
two playing cards designed by Francis Barlow
(1626–1704)[3] which proved extremely popular and were
copied on a series of tiles. Several of these tiles survive,
representing a number of different sets, including one
example painted in manganese-purple in a framed set of
twenty-one tiles.[4] This scene is shown on the five of
clubs.

This tile is a particularly rare one. It does not form part
of the set in the Victoria and Albert Museum,[5] nor is it
represented in the collection of the George R. Gardiner
Museum of Ceramic Art, Toronto, which includes three
tiles from the same set as the British Museum tile.[6] There

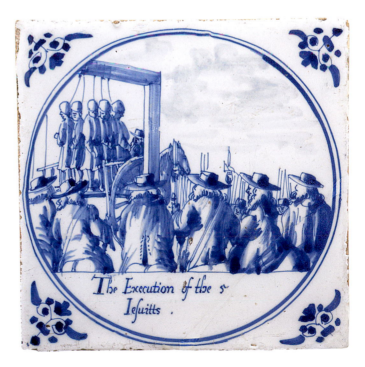

are two tiles in the Longridge Collection, USA, as well as the only plate known with a related subject,[7] but none of these shows the subject on the British Museum tile. There are several variations in the colour used for this series of tiles (see below) and design (the Longridge tiles lack inscriptions), and two different types of decoration at the corner of the tile are known: 'spider head' motifs, or, as here, 'ox head' motifs. A tile with the subject 'Pickerin Executed' in the Allen Gallery, Alton, Hampshire, has the same border motif.[8]

Jan Ariens van Hamme came from Delft, where tiles were made in quantity. He was granted a warrant in 1676 to make tiles 'after the way practised in Holland ... which hath not been practised in this our kingdome'.[9] There was apparently little or no wall tile production in London at this time. As a 'Mr John Vanham', probably Jan van Hamme, was buried at St Mary's, Lambeth, on 23 March 1680, it is likely that the tiles were made between mid-1679 and Spring 1680, since the final episode of the Popish Plot, 'The Tryall of Sr G. Wakeman and 3 Benedictine Monks', took place in July 1679. The tiles are attributed to van Hamme on the evidence of their Dutch style. This is, therefore, one of the earliest tin-glazed earthenware tiles made in Britain, apart from those floor tiles made at Aldgate and Southwark in the Continental style in the late sixteenth or early seventeenth centuries (see nos 141–2).

The tile has been restored.

2 'The Plot first hatchd at Rome by the Pope and Cardinal &ct'
Reg. no. 2009,8015.3; purchased, Christie's, South Kensington, London, 29 March 2009, lot 124; formerly in the collection of Dr W.L. Gordon
3 'The Consult at Somerset House'
Reg. no. 2009,8014.1; bequeathed by Dr W.L. Gordon, 2009;
4 'Dr Oates discovereth ye Plot to King and Counsel'
Reg. no. 2009, 8015.4; purchased, Christie's, South Kensington, London, 29 March 2009, lot 124; formerly in the collection of Dr W.L. Gordon
5 'Sir E.B. Godfree Strangled Girald going to stab him'
Reg.no. 2009,8014.3; bequeathed by Dr W.L. Gordon,2009

Height: 13 cm
Anthony W. Pullen, sold Sotheby's, 15 March 1971, lot 21

The style of the scenes on these tiles and the manganese-purple palette both suggest that they were the work of a Dutch immigrant potter. The blank area below each scene is also more typical of Dutch than English tiles, but there seems no reason why tiles illustrating an English political event should ever have been made in the Low Countries.

The scenes are based on the one of hearts (2), ace of spades (3), king of hearts (4) and nine of spades (5) in a printed pack of cards, of which there is an example in the British Museum (see note 3). A tile painted in blue showing the same subject as tile no. 4 above an inscription within a circle is in the V&A, London.[10]

Tile no. 4 has been restored.

2

3

4

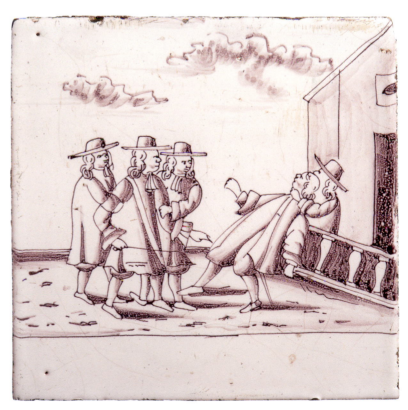

5

10 **Dish**, about 1680

Probably made in Nevers, France
Inscribed: 'CIIR', 'HONI QUI MAL Y PENSE' [*sic*], 'DIEV ET MONDROIT'
Diameter: 58.3 cm
Reg. no. 1897,0318.3; presented by Sir A.W. Franks, 1897; formerly in the possession of descendants of the potter John Dwight (d. 1703);[1]
Baylis Collection, Priors Bank, Fulham, 1862; C.W. Reynolds Collection, exhibited Special Loan Exhibition of Works of Art of the Medieval
Renaissance and more recent periods, London, 1862, no. 3, 715 and National Exhibition of Works of Art, Leeds, 1868, p. 272, Section W,
no. 2445; printed paper label 'National Exhibition of Works of Art. LEEDS, 1868. MUSEUM OF ART', 'C W Reynolds' in ink and
'PROPRIETOR' printed in black; sold Christie, Manson and Woods, London, 25 February 1874, lot 374;[2] sold Christie's, 18 December
1896, lot 270 from the collection of Captain J.H. Reynolds when purchased by Franks
[Baylis] 1862, p. 204;[3] Chaffers 1865, pp. 179–81, extract quoted by Haselgrove and Murray 1979, p. 180; Imber 1968, p. 38 and pl. 14;
Archer 1973, no. 53; Tait 1998, pp. 8–15, fig. 1

This large dish painted with the arms of King Charles II
has four small circular holes in the footrim.[4] Considered
from at least the middle of the nineteenth century as an
outstanding example of the potter's art and reputed to have
been owned by the potter John Dwight and his
descendants, the dish has continued to fascinate scholars.
Described by the anonymous writer in the *Art Journal* of
1 October 1862 as part of the collection of 'Fulham
Pottery', and said to have been part of a 'magnificent royal
dinner service', it was exhibited by the collector C.W.
Reynolds at the Leeds Exhibition with Fulham stoneware
pieces, now all in the British Museum or the V&A. The
catalogue entry reads: 'Large Fulham Ware plateau, rich
bleu de Perse ground, with white scrolls, flowers and birds;
in the centre the Royal Arms of Charles II.'

The dish was evidently considered to be French
faïence around 1900, as it was not included in R.L.
Hobson's *Catalogue of English Pottery*, published in 1903.
It has recently been firmly attributed to Nevers by two
authorities, one specializing in English delftware, the
other in the products of the French tin-glaze potteries.[5]
However, despite the close contact of King Charles II with
France, where he had spent part of his exile when
Cromwell was in power, it is doubtful that a French factory

would produce a piece
bearing the English royal
arms. The decoration is
not inconsistent with an
English origin and can be
compared with several
much smaller pieces
painted in a similar,
somewhat careless, style.
However, there are more
telling parallels attributed to Nevers, such as a large dish
painted with a vase of flowers in the centre and birds in
foliage on the broad rim in the Musée municipal de
Nevers and another similar dish in the Musée lyonnais des
arts décoratifs.[6] The unskilled painting of the lines defining
the edge of the decorated zones is particularly noticeable on
the second dish, and can be seen on the Museum example.

No other directly comparable dish is known, and no
blue-ground tin-glazed wares from either England or
France are painted with a royal coat-of-arms or have a royal
connection.

The dish has been broken and repaired with metal
rivets. Footrim damaged.

For the profile of this dish, see p. 300.

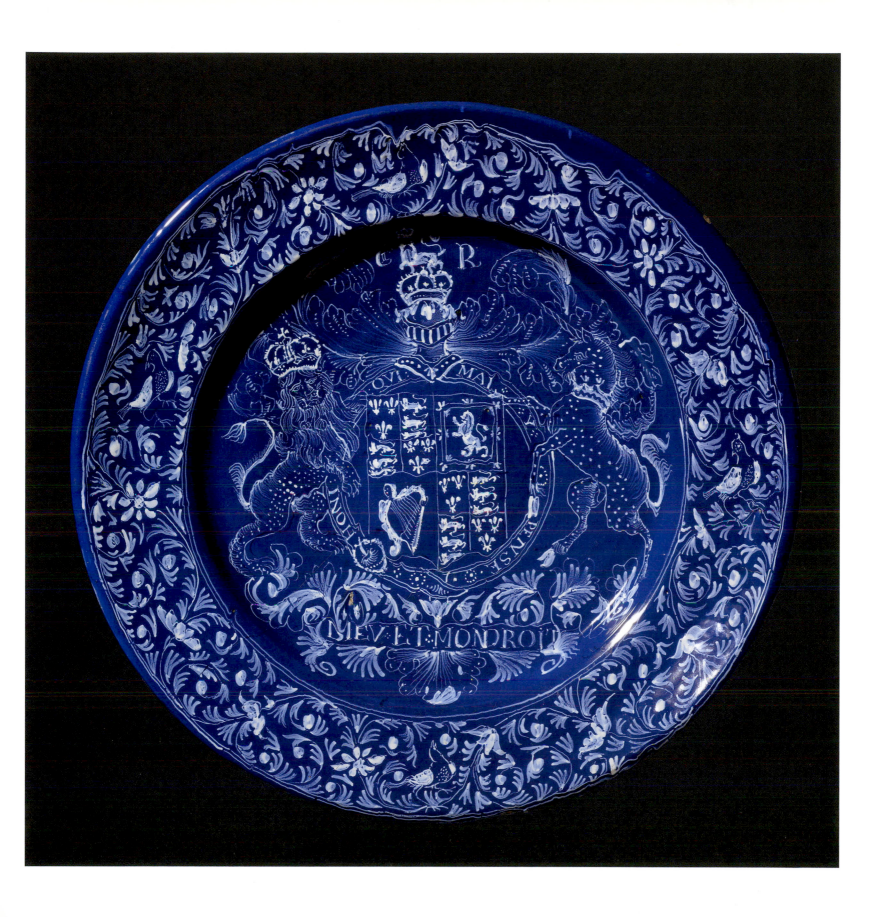

11 **Charger**, about 1680–5

Made in London, or perhaps in Brislington or Bristol
Diameter: 33.4 cm
Reg. no. 1887,0307.E152; presented by A.W. Franks, 1887
Hobson 1903, E 152

The equestrian figure on this dish, depicted in armour with a long sash and with sword and baton to indicate high military rank, is thought to represent General Monck (or Monk), first Duke of Albemarle (1608–1670). This identification was first made by Michael Archer in 1968, when the Victoria and Albert Museum acquired a dish with a horseman above whose head are the initials 'D/GM'.[1] Basing his identification on prints, one of which is reproduced here (fig. 14), he argues convincingly that this must be the General, and discusses a group of related dishes. Among these is an example in the Museum of Fine Arts, Boston, Massachusetts, which is very similar to the British Museum dish as it has the characteristic lines in the foreground and in the sky and the 'cloud-like layers of foliage' of the trees.[2] Other comparable dishes are in the Warren Collection at the Ashmolean Museum, Oxford,[3] and in the Fitzwilliam Museum, Cambridge;[4] further examples are in the Longridge Collection, USA, and on the London market in 1996.[5]

General Monck, who had served under Oliver Cromwell, played a leading role in the restoration of King Charles II in 1659–60. Ten years after his death, as Archer has pointed out, there was once more considerable public anxiety about the succession, which may have stirred memories of Monck's skilful handling of the situation after Cromwell's death. Just as the delftware potters produced numerous dishes with portraits of Charles II, so too they responded to the public desire to remember the man who had guided the King to the throne.

Part of the rim of the dish is restored. The back of the dish has a lead glaze.

Fig. 14 *George Duke of Albermarle*,
seventeenth century. Etching, 17.1 × 14.4 cm.
British Museum 1872,0713.336

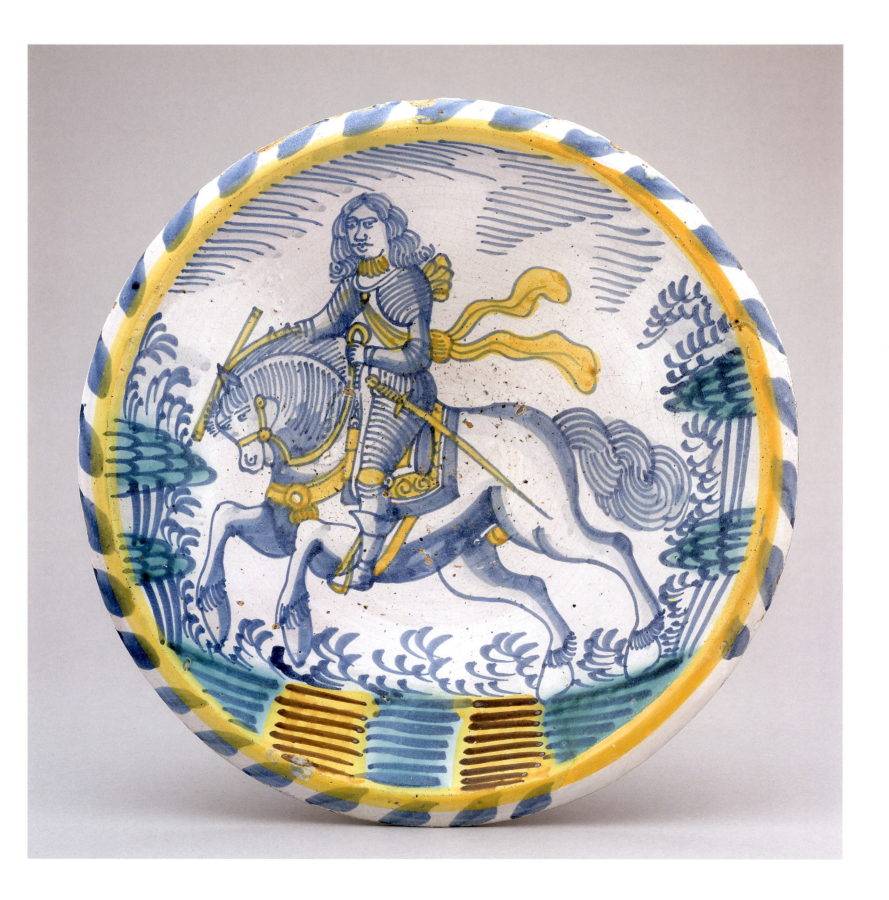

12 Plate, 1685–8

Made in Brislington, near Bristol
Inscribed: '2/JR'; mark 'G' incised through the glaze on reverse
Diameter: 20.4 cm
Reg. no. 1981,0301.1; formerly in the collection of Louis Lipski, sold Sotheby's, 10 March 1981, lot 47

King James II (1633–1701; reigned 1685–8), shown here half-length, was the second son of King Charles I and Queen Henrietta Maria. Although baptized a Protestant, he adopted the Roman Catholic faith while in exile in France after the death of his father. Following his succession to the throne of England, Ireland and Scotland he became increasingly unpopular and was overthrown in the 'Glorious Revolution' of 1688, when the Protestant William of Orange and his wife Mary, James's daughter, became king and queen.

There are few examples of plates bearing the initials of James II. A larger dish with the same initials but different decor was also in the collection of Louis Lipski[1] and another of this type was on the London market around 2000.[2] A further dish, once in the possession of Alistair Sampson, was sold from the collection of Simon Sainsbury in 2008; the catalogue description does not record whether or not it had a letter incised through the glaze on the reverse.[3] A very similar portrait with the initials 'IR' is painted on a shallow moulded dish with indented rim, also from the Lipski Collection.[4] A bleeding bowl in the Birmingham Museum and Art Gallery is, as Michael Archer points out, apparently the only piece with a portrait of James II that may not have been made at Brislington,[5] although why this factory should have a monopoly on representations of this monarch on delftware is unknown. A slightly larger dish, which is similar in many respects, including the palette, to the Museum piece, but which is inscribed 'KW' for King William, is in the Greg Collection at Manchester Art Gallery,[6] and another similarly inscribed was on the market in 2000.[7]

The unusually large letter 'G' on the reverse of the Museum dish, made by trailing a flat-ended tool through the wet glaze before firing, may be the mark of the potter or painter. No other plate marked like this is recorded.
Restored.

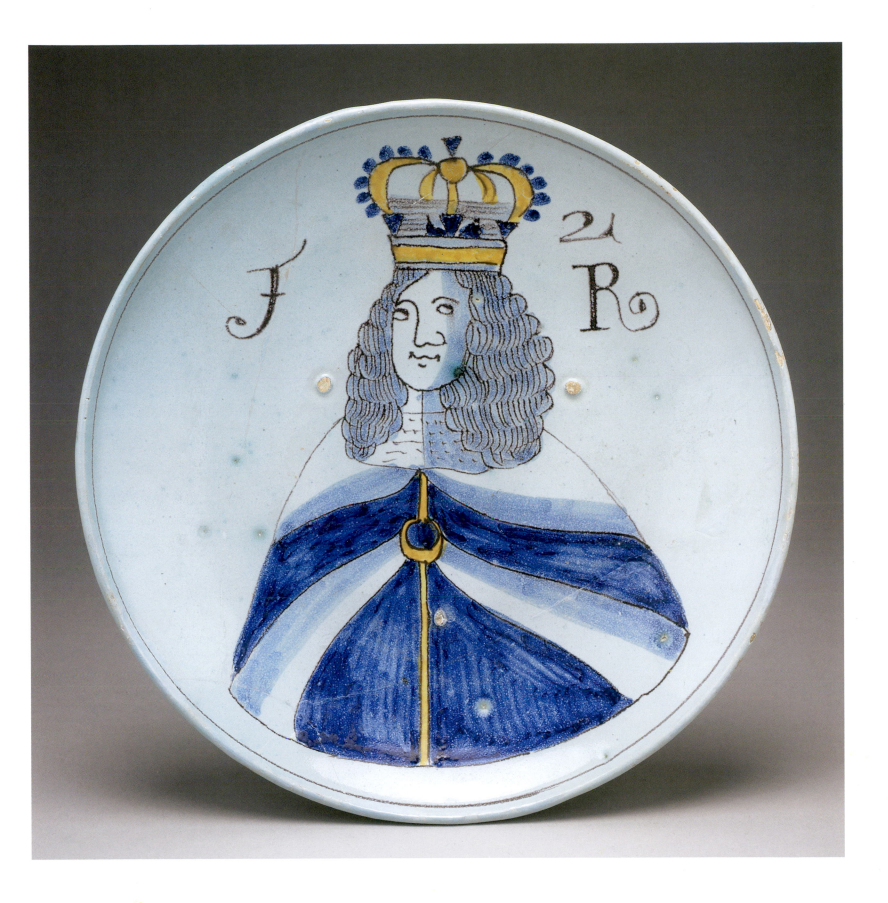

13 **Plate**, about 1690–4

Made in England, probably Lambeth, London
Inscribed: 'W/M/R'
Width: 20.5 cm
Reg. no. 1887,0307.E64; presented by A.W. Franks, 1887
Hobson 1903, E 64

Octagonal dishes like these were made in moulds. The initials stand for William Rex and Mary Regina, i.e. King William III (1650–1702; reigned 1688–1702) and Queen Mary II (1662–1694). William of Orange, who was the grandson of King Charles I and was a Protestant, married Mary, daughter of King Charles II's brother, later King James II, in 1677. As a result of the Catholic King James II of England's difficulties with Parliament, William was summoned from Holland in 1688 in what became known as the 'Glorious Revolution'. William and Mary reigned together from 1689 until Mary's death in 1694, after which William reigned alone until 1702. Dated examples of dishes like these are known from 1691 and 1694.

The King and Queen seem to have been portrayed together on delftware more frequently than any other monarchs and several different versions of their naive half-length portraits are known on various sizes and shapes of dish. Some of these are painted in colours, including yellow, manganese and green. A circular plate with a similar portrait in blue, manganese and red-brown was sold from the Kassebaum Collection in 1992.[1] Here the King is depicted in an elaborate ermine-trimmed robe, perhaps recalling the one worn for his Coronation. A circular dish with a slightly cruder version of the portraits is in the Greg Collection at the Manchester Art Gallery.[2]

Rim cracked and chipped.

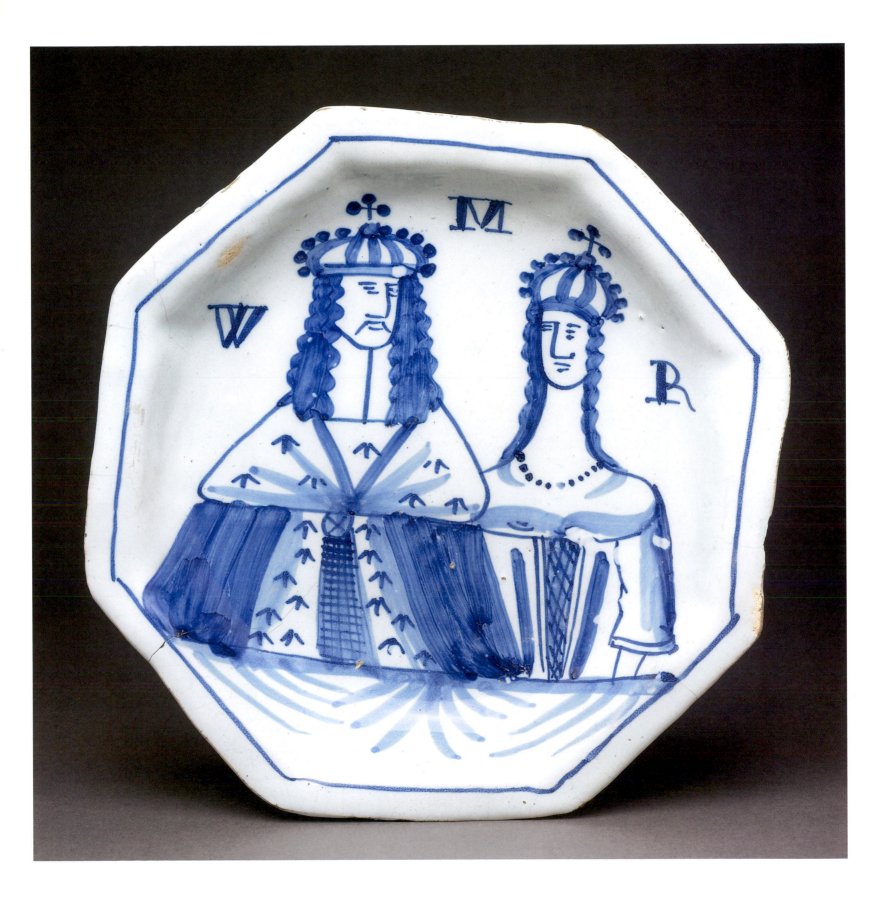

14 **Dish**, late seventeenth century

Made in Southwark, London, perhaps at the Pickleherring pottery
Inscribed: 'WR'
Diameter: 38.8 cm
Reg. no. 1887,0307.E150; presented by A.W. Franks, 1887
Hobson 1903, E 150

This dish is a particularly finely painted example, depicting
King William III (1650–1702; reigned 1688–1702) within
an arcade standing on a chequered floor. He is shown
informally without crown or Order of the Garter and sash,
in contrast to other portraits of him on delftware dishes, of
which there are a considerable number. However, the
image portrayed communicates the monarch's power
through the placing of the figure, the gesture of the
outstretched right hand holding a sceptre and the careful
and detailed rendering of the costume.

There is another similar dish in the Fitzwilliam
Museum, Cambridge.[1]

Dishes like these were not intended for use but were
for display, to proclaim the owner's loyalty to the Crown.
Comparison with no. 7 shows that the image of the
monarch under an arcade with a chequered floor persisted
for several decades.

Despite the finely executed painted scene, the glaze on
the back of the dish has 'crawled', leaving part of the
surface bare. There is also a small stone embedded in the
glaze on the back of the dish, giving further evidence of
production problems.

For a profile of this dish, see p. 300.

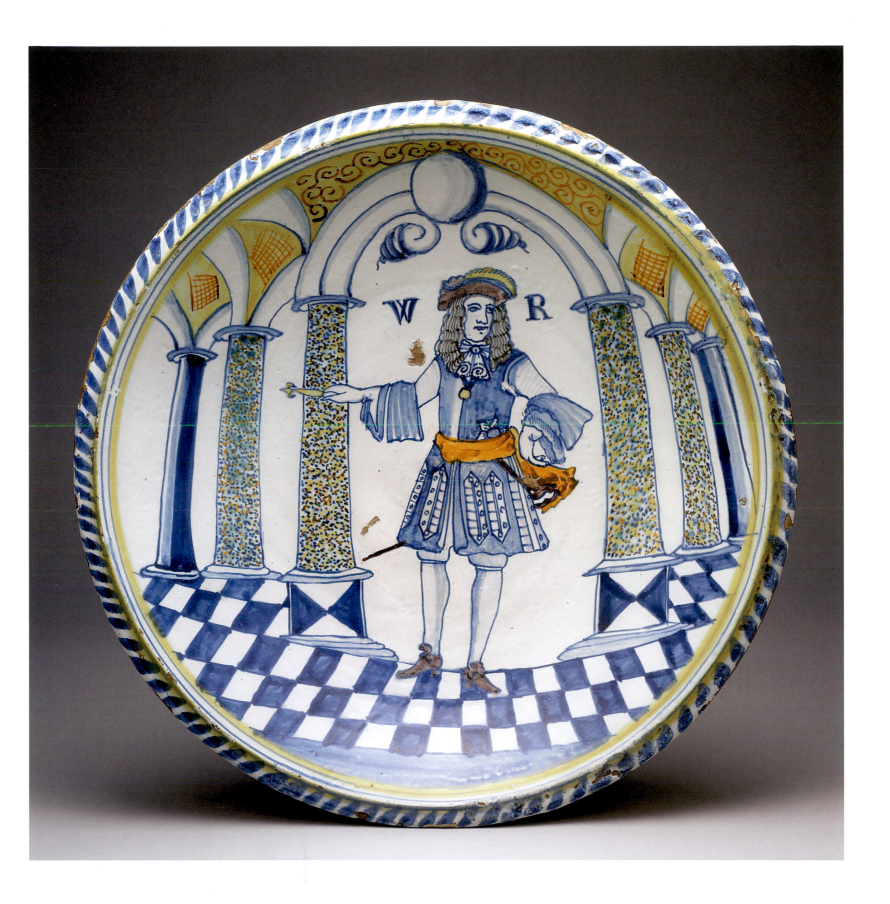

15 **Charger**, about 1700

Made in London or Bristol
Inscribed: 'KQ'
Diameter: 33.9 cm
Reg. no. 1960,0204.1; presented by Messrs Delahar, 1960
Archer and Morgan 1977, no. 29

Chargers painted with King William III (1650–1702; reigned 1688–1702) and Queen Mary II (1662–1694) together are much rarer than those with the monarchs shown separately, and most chargers are painted with blue dashes around the border rather than with two manganese bands, as here. These dishes were no doubt intended as an expression of the owner's loyalty to the Crown. The painting of the landscape and trees on this dish is less careful than is generally found on royal chargers, although the figures are comparable to those on dishes such as the one in the Longridge Collection,[1] or another in Historic Deerfield, Massachusetts.[2] Two further dishes are recorded, one in a private collection,[3] the other in the Robert Hall Warren Collection at the Ashmolean Museum, Oxford.[4] On a 'blue dash' charger in the DeWitt Wallace Decorative Arts Museum at Colonial Williamsburg, Virginia, USA, the monarchs are depicted on a chequered floor between curtains.[5] All the above dishes are inscribed 'WMR', the initials 'KQ' being rarely found.

When acquired in 1960 this dish was thought to have been made in Friesland, Holland.

Unlike many delft dishes this has a buff-coloured body covered with a white slip on the reverse that has 'crawled' at one edge. It has been repaired and the foot is damaged.

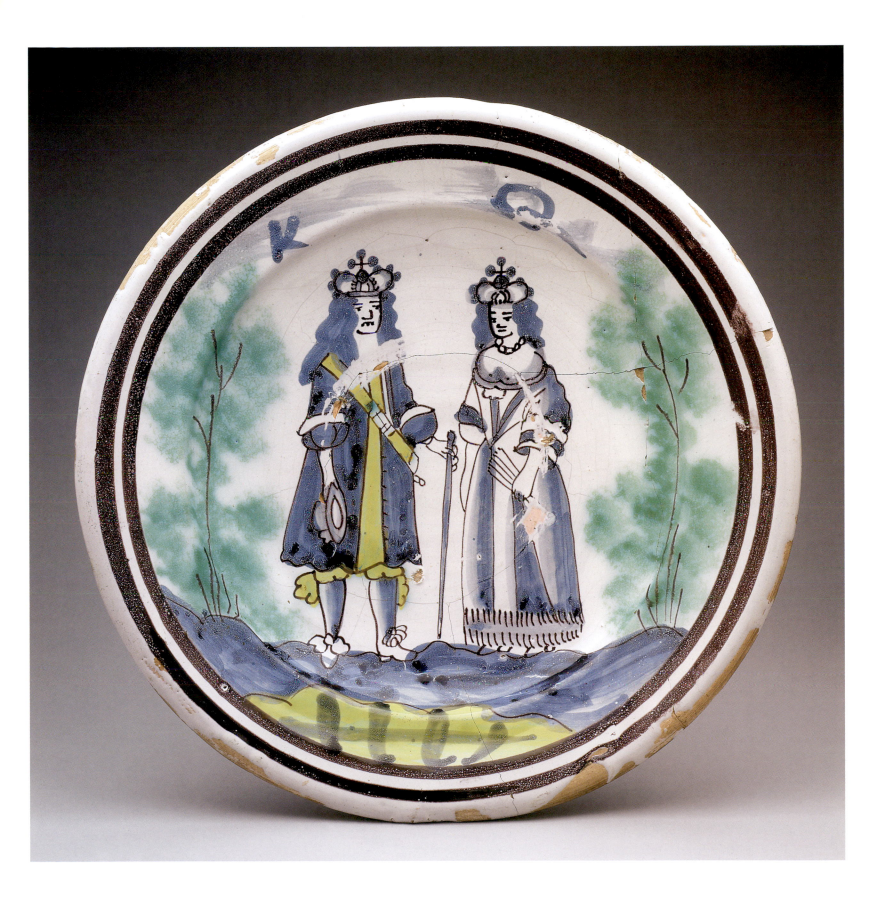

16 **Dish**, 1702–about 1715

Made in London, perhaps at the Norfolk House pottery, Lambeth
Inscribed: 'AR'
Diameter: 35 cm
Reg. no. 1887,0307.E151; presented by A.W. Franks, 1887
Hobson 1903, E 151; W. Burton, *A History and Description of English Earthenware and Stoneware*, London, 1904, fig. 20, opp. p. 70

Fragments found at the site of the Norfolk House Pottery in Church Street, Lambeth, are painted with a similar landscape to that used for other delftware dishes with royal or warrior subjects.[1] 'Blue dash' chargers like this were probably made in some quantity, to judge from the number of surviving examples. They were intended for display rather than use, and would have demonstrated their owner's loyalty to the monarch. For a much later piece of delftware with an inscription to Queen Anne and an image of her, see no. 28.

There is a similar dish in the Victoria and Albert Museum, in that collection since 1872, tentatively attributed to the pottery at Norfolk House, London by Michael Archer in 1997.[2] Another in the DeWitt Wallace Decorative Arts Museum, Colonial Williamsburg, Virginia, was attributed to Bristol in 1994.[3]

Loss of glaze on lower rim.

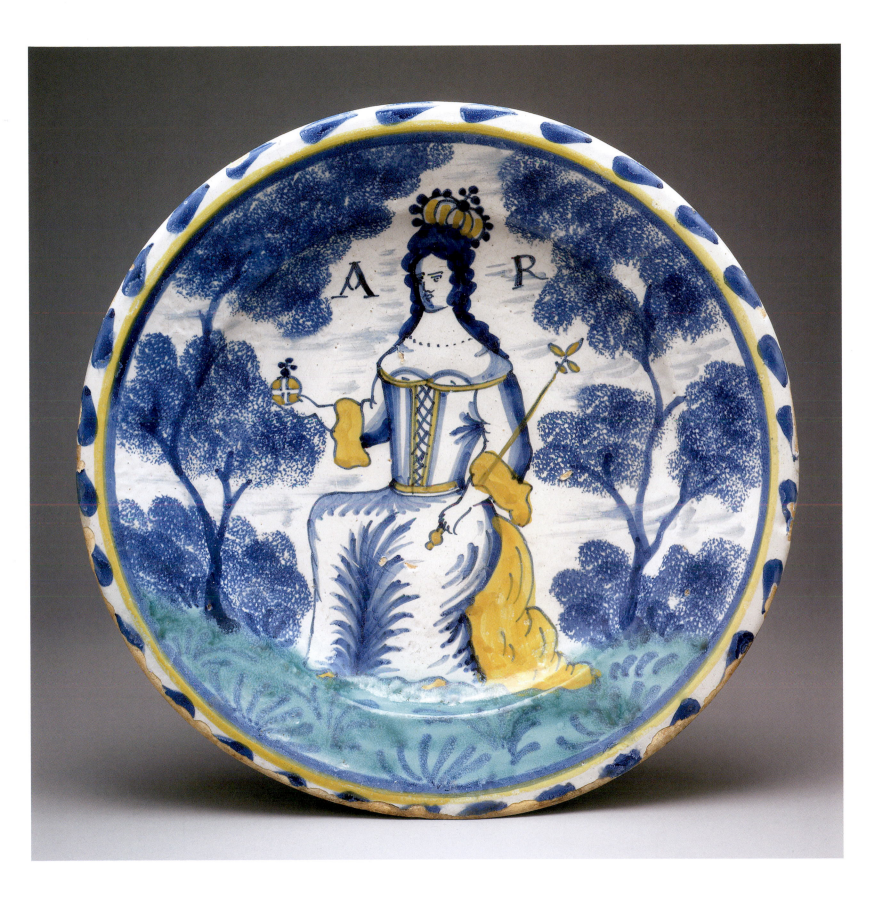

17 **Plate**, about 1707–14

Made in London
Inscribed: 'AR' with a crown
Diameter: 22.2 cm
Reg. no. 1924,1023.1; presented by Miss M. Lewis, 1924
Archer 1973, no. 81; Archer and Morgan 1977, no. 46

The stylized thistle and rose painted on this dish commemorate the Act of Union passed in 1707, which created the kingdom of Great Britain by joining the kingdoms of Scotland and England. These had shared a monarch since the Union of the Crowns in 1603, but had separate and sovereign Parliaments, which were now dissolved and reconstituted as one British Parliament with its seat at Westminster. Scotland kept its own legal system and the Presbyterian Church continued as the established Church of Scotland.

This is one of several delftware dishes with the rose and the thistle. A comparable example, on which the central decoration is framed by a series of blue lines at the edge of the well and on the rim, as on the British Museum plate, was in the Morgan Collection in 1977.[1] A plate with similar but not identical painting is in the Greg Collection at the Manchester Art Gallery.[2] Another in the Ashmolean Museum, Oxford,[3] also with serrated leaves like the Manchester example, is painted with a far more realistic thistle and has a chain motif around the border in blue. A further example is in the Glaisher Collection, Fitzwilliam Museum, Cambridge.[4] A plate painted in blue with a similar motif is in the Gardiner Museum, Toronto.[5]

The same design is found on plates with the initials 'GR' for Queen Anne's successor, King George I (1660–1727; reigned 1714–27) and examples of these have been excavated from the site of the Vauxhall pottery, London.[6] Some delftware mugs, such as one in the Longridge Collection, USA, are inscribed 'Union',[7] clearly referring to the Union of the Crowns.

Losses of glaze on the rim.

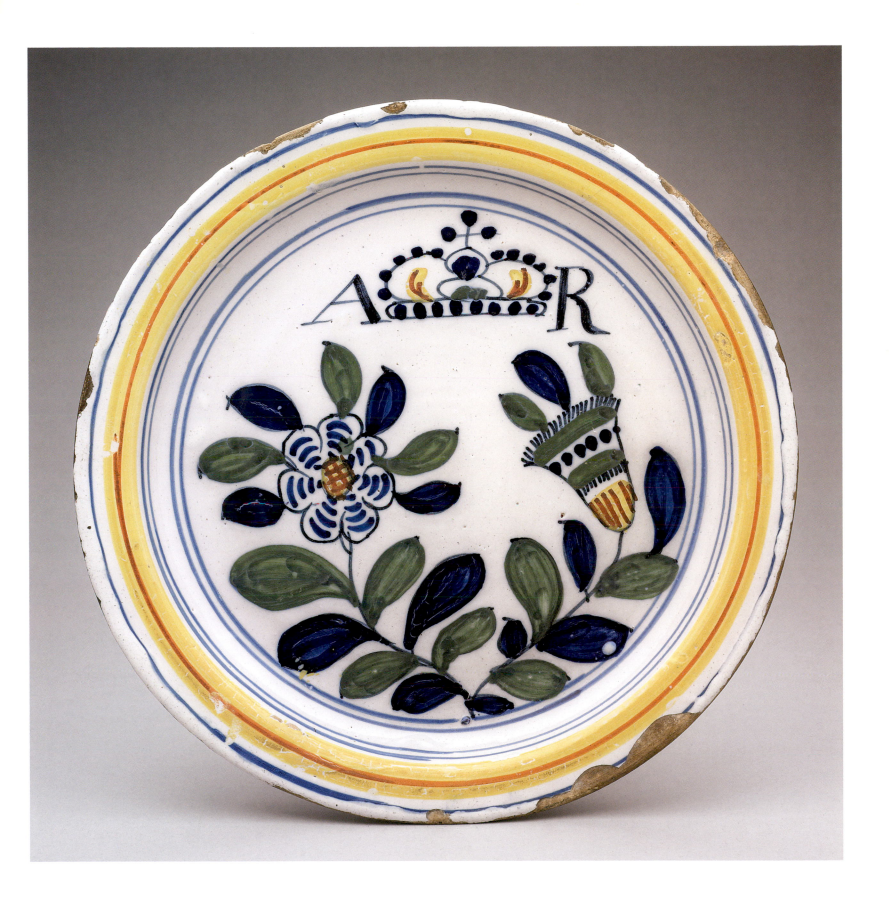

18 **Plate**, about 1720

Made in London
Inscribed: 'CR'
Diameter: 21.6 cm
Reg. no. 1939,0607.1
Archer 1973, no. 80; Grigsby 2000, p. 75

According to tradition, the future King Charles II (1630–1685; reigned 1660–85) hid in an oak tree from the forces of Oliver Cromwell after the Battle of Worcester in 1651. The oak is known as the Boscobel Oak and is close to Boscobel House, Shropshire, then owned by the Penderell family. A young tree was reputed to be growing beside the full-grown oak in which Charles hid, and this tree is said to survive. It is frequently visited and is now cared for by English Heritage. The oak is supposed to have given its name to a large number of public houses called The Royal Oak.

The Boscobel Oak assumed a symbolic significance as a Jacobite emblem for those who wished to restore the Stuart line, which ended in 1714 with the death of Queen Anne (1665–1714; reigned 1702–14), the daughter of King James II and Anne Hyde. It is likely that this dish was made in the second decade of the eighteenth century, rather than in the seventeenth century, as one of the early manifestations of Jacobite feeling. It may even commemorate the first Jacobite uprising in 1715. Another contemporary object of this kind is a drinking glass with an engraved portrait of Queen Anne, inscribed 'Memento Anna Regina' and dated 1718,[1] that is, four years after her death. The three stylized crowns, painted in red in the sponged blue foliage of the tree, are those of England, Ireland and Scotland. A pewter dish in a private collection, dated 1682 and decorated with a wrigglework scene of the 'King in the Oak' and the triple crown of England, Scotland and Ireland, indicates how long the motif remained current.[2]

There are other examples of this dish in Brighton Museum and Art Gallery,[3] the DeWitt Wallace Decorative Arts Museum, Colonial Williamsburg, Virginia,[4] the Burnap Collection, Kansas City[5] and the Longridge Collection, USA.[6] A further dish was on the London market in February 2008.[7]

The Museum plate has a small circular hole on the border, which may have been pierced later rather than when the plate was at the leather-hard stage before firing.

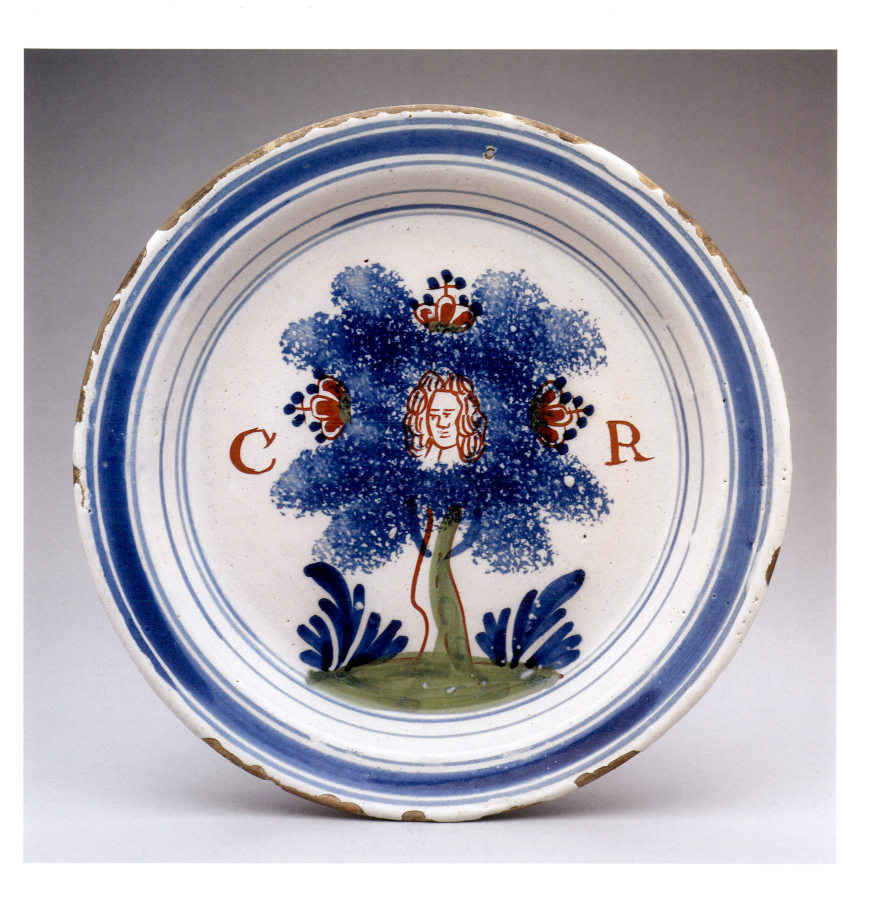

19 **Plate**, about 1734–5

Made in Bristol
Inscribed: 'T. C /LIBERTAS POPULI' and 'The Petit/ions' on the front
Mark: 'WP/4' on the back of the dish; label on the back inscribed in ink 'From Bridgwater/6141 E68a'
Diameter: 23.3 cm
Reg. no. 1910,1219.1; purchased from S.G. Fenton
Ray 1968, p. 132; Ray 2000, pp. 42–3; Grigsby 2000, pp. 90–1

The unusual painted scene of Justice, holding scales in her left hand and an upraised sword in her right, standing over a prostrate figure of a demon holding a torch and breathing fire symbolizing Evil, all below a curtained arch, supported on pillars bound with leaves, is taken from a print. The initials 'TC' stand for Thomas Coster, successful Tory candidate in the Bristol Parliamentary election of 1734. Bristol City Corporation petitioned to have the result overturned in favour of the defeated candidate, a Treasury official named Mr Scrope,[1] and here a scroll inscribed 'The Petitions' is shown on the ground under the scales of Justice. Although the franchise was still extremely restricted and British elections corrupt, towards the middle of the eighteenth century the desire for fairness was making itself felt, and Liberty was being adopted as a rallying cry, hence the inscription 'LIBERTAS POPULI' (Liberty of the People).

At least eleven other examples of these plates have been traced, some with variants in decoration and the inscription, such as two plates in the Ashmolean Museum, Oxford[2] and Bristol Museum and Art Gallery respectively.[3] These have a manganese-purple border, two angels in the arch and the demon holds a scroll inscribed 'Placemen'. 'Placemen' occupied paid posts in the government and were notoriously corrupt. Several bills against them were introduced in the 1730s and 1740s; in 1743 the Place Bill ensured the removal of at least some of them. In contrast to the rather crudely executed border in Dutch style on the British Museum dish, both the others have a running

floral design on the border. Another dish in Oxford is closer to the British Museum piece, but it is inscribed 'The Pollinn', the scene is more centrally placed and the border rather better painted.[4] The British Museum dish belongs to a group classified as Type B by Grigsby. These have the simplest decoration. The closest parallel is in the Longridge Collection, USA.[5]

Pottery provided the means to communicate propaganda, often relating to elections or satirizing unpopular political leaders, and seems to have been quite widely used for this purpose even before printing on ceramics became commonplace. The earliest ceramic documentation of any British election is a covered punch bowl painted with the arms of Liverpool and inscribed with the name of Thomas Bootle, elected Member of Parliament for Liverpool in 1724.[6]

The significance of the initials 'WP' in monogram above the number '4' on the back of the dish is not entirely certain. It may be an internal factory mark, or may possibly stand for William Pottery, who is recorded at two potteries in Limekiln Lane, Bristol.[7]

There are two chips to the rim.

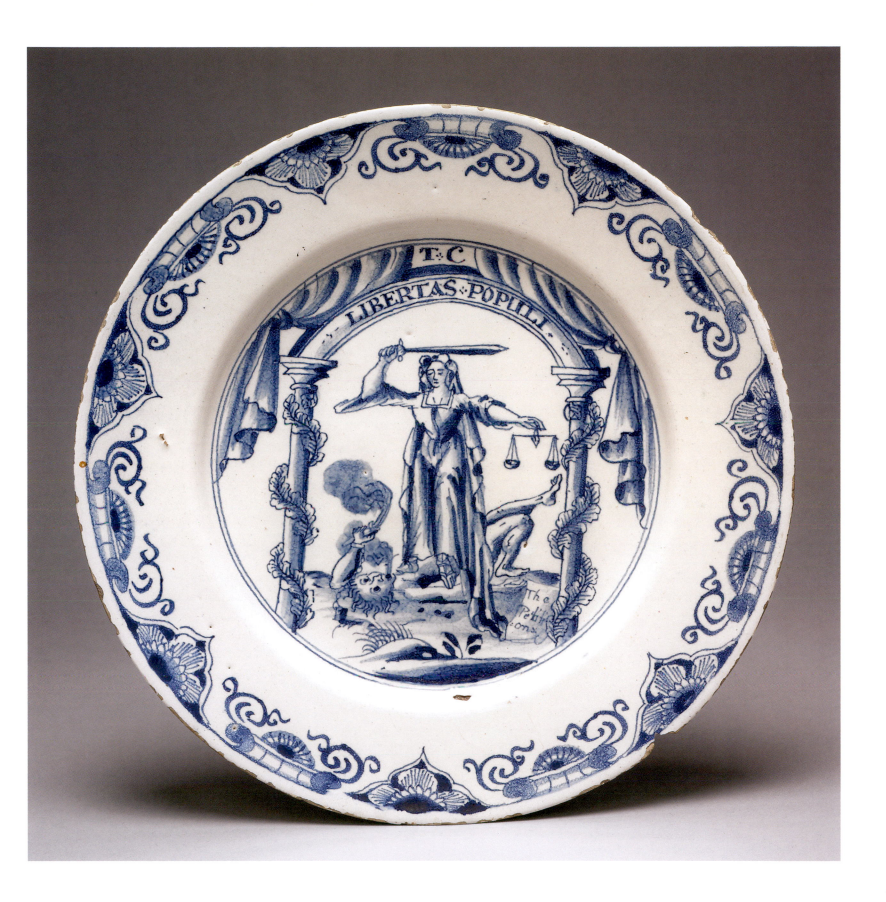

20 Punch bowl, 1746

Made in Liverpool
Inscribed: 'Confusion to the Pretender/1746', painted in blue
Diameter: 31.2 cm
Reg. no. Pottery Catalogue E159; presented by A.W. Franks, 1896
Hobson 1903, E 159; Lipski and Archer 1984, no. 1115; Grigsby 2000, D313

For over a century after the first Jacobite uprising in 1715 there was intense interest in the Stuart line and in Jacobitism, initially seen as a threat to the nation but which gradually became part of a national myth. Clubs of sympathisers with the Jacobite cause continued to exist and to hold meetings well into the nineteenth century (see no. 23). A large number of objects, including delftware as well as salt-glazed stoneware, glass, medals and prints, are known with Jacobite motifs and themes.

A similar head facing left, crowned with a laurel wreath above the inscription 'No Pretender/1746', is painted in blue on a punch bowl in the Longridge Collection, USA.[1] This bowl, too, has a brown rim, probably imitating Chinese porcelain. A punch bowl in the collection of the DeWitt Wallace Decorative Arts Museum, Colonial Williamsburg, Virginia, is painted inside the bowl with the same wreathed head and the inscription 'Long Live/The King'.[2] These heads are likely to represent King George II (1683–1760; reigned 1727–60). The bowls celebrate victory over the Young Pretender at the Battle of Culloden on 16 April 1746 (see no. 21).

The decoration on the outside of the bowl is loosely based on eighteenth-century Chinese porcelain from Jing de Zhen.

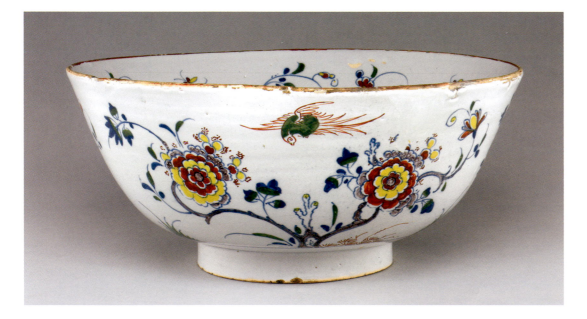

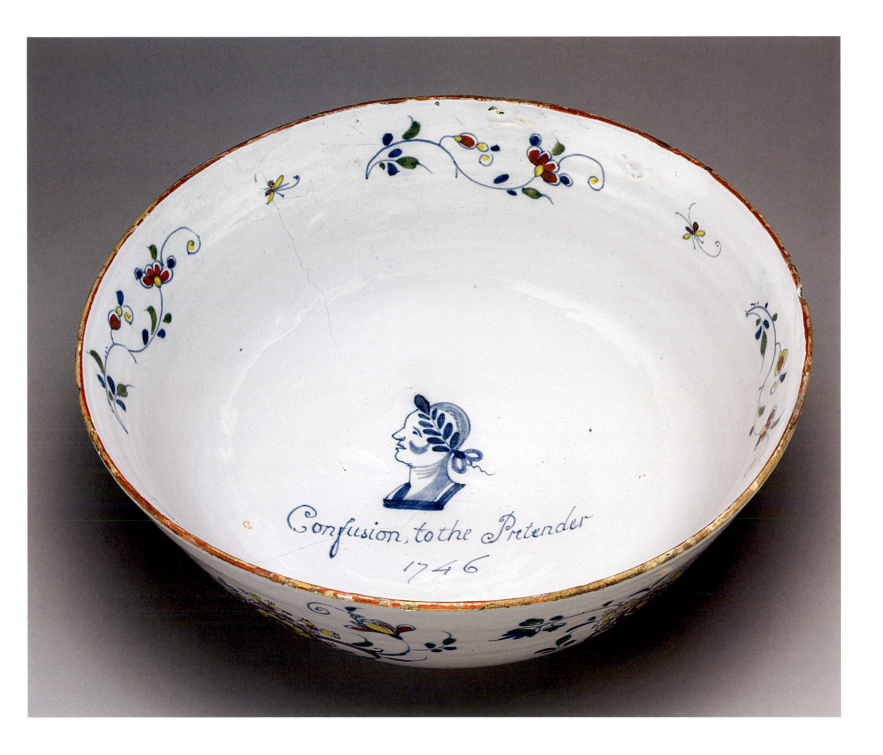

21 **Plate**, about 1746

Probably made in Bristol
Inscribed: 'God Save ye Duke of Cumberland Remember ye fight of Cullodon'
Diameter: 34 cm
Reg. no. 1887,0210.140; purchased from the collection of Henry Willett, 1887
Hodgkin and Hodgkin 1891, no. 50; Hobson 1903, E 134; Ray 1968, no. 29; Ray 2000, pp. 44–5

Prince William Augustus, Duke of Cumberland (1721–1765) was a younger son of King George II (1683–1760; reigned 1727–60) and Queen Caroline (1683–1737). After joining the Royal Navy at the age of nineteen, he transferred to the Army in 1742. In the following year, after serving in the Middle East, he was wounded at the Battle of Dettingen, south-west Germany, where he fought alongside his father. In May 1745, aged twenty-five, as Commander-in-Chief of the British, Hanoverian, Austrian and Dutch troops, he was defeated at the Battle of Fontenoy, in present-day Belgium. Late that year he was recalled to fight against Bonnie Prince Charlie (Charles Edward Stuart, the 'Young Pretender', 1720–1788), who had reached Derby with his Jacobite army. He drove back the Pretender to the Scottish border and, after a return to England to protect the south coast, again pursued him northwards in early 1746. The armies of the Jacobites and Hanoverians met at Culloden Moor, near Nairn in the Highlands of Scotland, on 15 April. After the defeat of Bonnie Prince Charlie, Cumberland earned himself the sobriquet 'Butcher Cumberland' for his active pursuit of the Prince's supporters in Scotland. He was, however, lionized in London, as well as elsewhere in Protestant England and Scotland. Handel composed 'See the conquering hero comes' in his honour. However, his later years were marked by disgrace in the Seven Years' War and failure to become Regent when his young nephew succeeded to the throne as King George III in 1761. He died four years later, at the early age of 44.

The image of the Duke on horseback, his sword raised, is probably based on a print, although no direct source has so far been discovered. A print by John Faber the Younger after John Wootton and Thomas Hudson,[1] or even a print of King George II by Simon François Ravenet after David Morier,[2] could have been adapted by the delft painter,

The inscription in the narrow band of decoration around the rim of the dish has been scratched into the blue ground with a sharp tool in a well-formed script, which is in distinct contrast to the crude lettering sometimes found on delftware dishes. This is a sophisticated production, which was no doubt intended for display as a commemorative piece, rather than for domestic use. One of these dishes was in the possession of Frank Freeth in 1910.[3] There is a similar dish in the Warren Collection at the Ashmolean Museum, Oxford.[4]

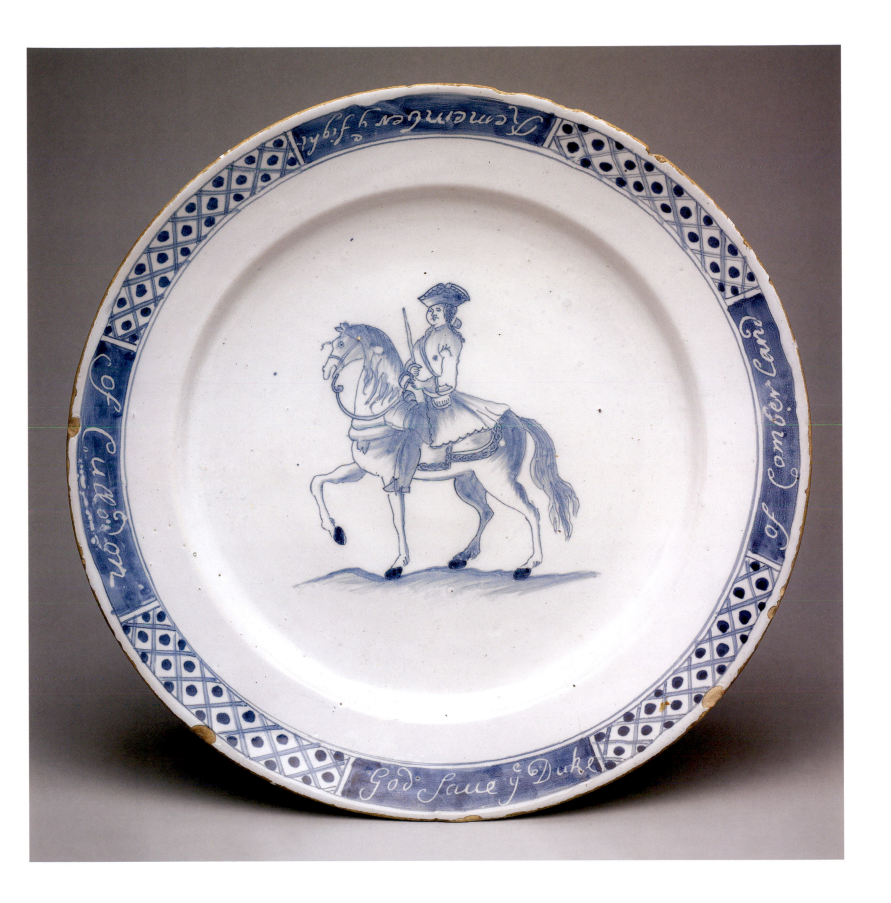

22 **Mug**, 1748

Made in London, probably at Lambeth
Inscribed: 'William Duke of Cumberland 1748' around the portrait and 'Samuell and Mary Plege 1748' around the foot
Height: 17.2 cm
Reg. no. 1964,1001.1
Lipski and Archer 1984, no. 828

This most unusual mug, which was probably intended for beer, may have been made for the marriage of Samuel and Mary Plege, although no proof that they were married in 1748 has been found and nothing is known about them. Dated so soon after the suppression of the 1745 second Jacobite uprising, ownership of the mug would have been a clear profession of loyalty to the Crown in the person of the Duke. Portraits of 'Butcher Cumberland', as he was known in the Highlands of Scotland, are much more common on punch bowls (see no. 23).

The painting, as well as the lettering, is particularly accomplished for English delftware. The Duke is shown in a lifelike pose and the details of his clothing are carefully depicted. A portrait of the Duke engraved by John Faber the Younger after Thomas Hudson may perhaps have been used as the source.[1] Equally, an illustration in the *Gentleman's Magazine*, May 1746, could have been copied by the delftware painter, particularly as it shows the Duke in a 'frame' with his name above as on the

Fig. 15 *Prince William Augustus, Duke of Cumberland*, 1740s–60s. Mezzotint by Johann Jakob Haid after Thomas Hudson, 40.1 × 26.6 cm. British Museum 1902,1011.8430

mug.[2] A trade card dated 1746 in the Department of Prints and Drawings bears the same image, together with verses celebrating the duke's crushing of the Jacobite rebellion.[3] As Louis Lipski and Michael Archer have pointed out, the decoration on the mug was carried out with both brush and quill.[4] The quill was used for the delicate scrolls and for the inscriptions. The flower spray and panel of 'cracked ice' decoration in the Chinese style near the handle may well have been painted by another hand.

The handle and part of the rim have been restored.

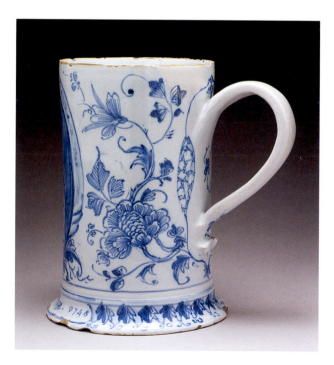

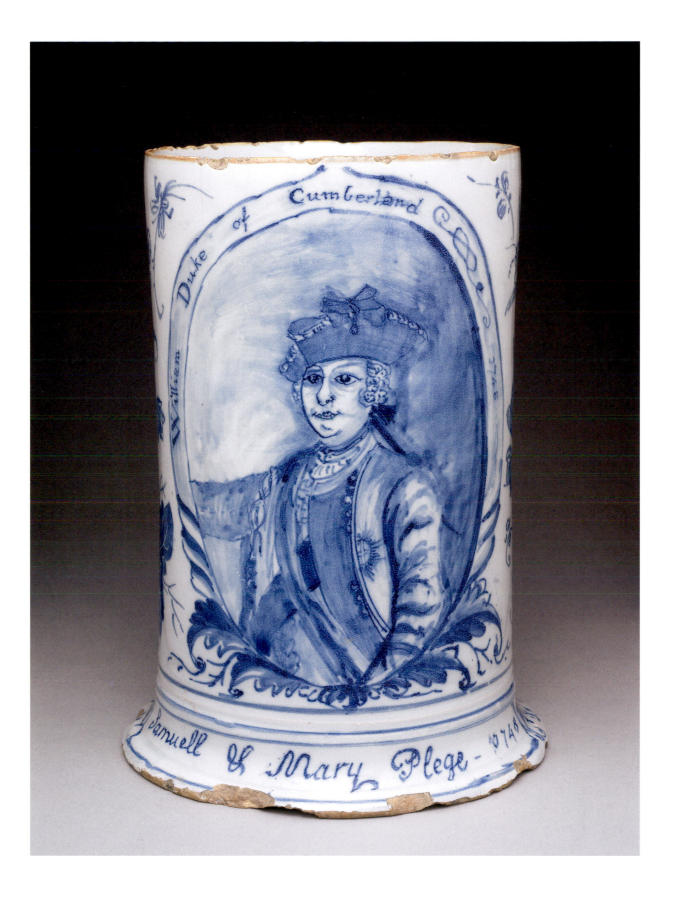

23 Punch bowl, 1749

Made in Liverpool or London
Inscribed: 'AUDENTIOR IBO ALL OR NONE' painted in blue and 'IS/1749' painted in blue on the base
Diameter: 26 cm
Reg. no. 1890,1210.1; presented by Alexander Christy, 1890
Hodgkin and Hodgkin 1891, no. 457; Hobson 1903, E 113; Archer 1973, no. 106; Lipski and Archer 1984, no. 1122; Lelievre 1986, p. 72

The rim of the bowl is painted in pale brown, presumably imitating Chinese porcelain, and the decoration, which is unique on delftware, makes it a sumptuous production. The initials on the base and its Jacobite subject suggest that it was made specially for 'IS', whose identity remains unknown.

The decoration includes not only the splendid portrait of Charles Edward Stuart, the 'Young Pretender', in bonnet, plaid and highly-coloured jacket, holding a basket sword in his right hand, but also a crown, two rifles and a targe, a type of shield covered with leather and used in the Scottish Highlands. Dated only three years after Bonnie Prince Charlie's defeat at the Battle of Culloden (see no. 21), this bowl would presumably have been used to toast the 'King over the Water'. Many Jacobite clubs were in existence before and after the 1745 uprising, although it appears, unsurprisingly, that there were most in the decade 1740–49.[1] They existed all over Britain.

The motto 'Audentior Ibo' occurs on some engraved English drinking glasses, although the authenticity of some of these glasses has been questioned.[2] The meaning of the motto was discussed in 1986 and translated as

'I shall go with greater daring', although the Loeb translation of Virgil's *Aeneid*, 9.291 reads, 'More boldly shall I meet all hazards'.[3]

The peonies and other flowers painted on the exterior of the bowl are loosely based on motifs found on Chinese porcelain.

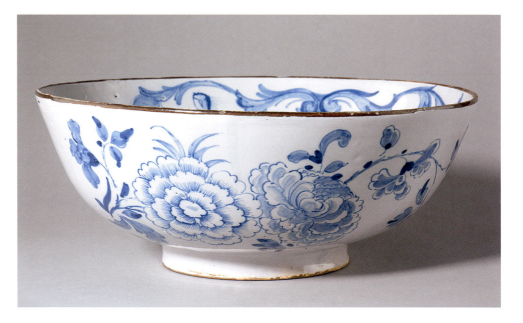

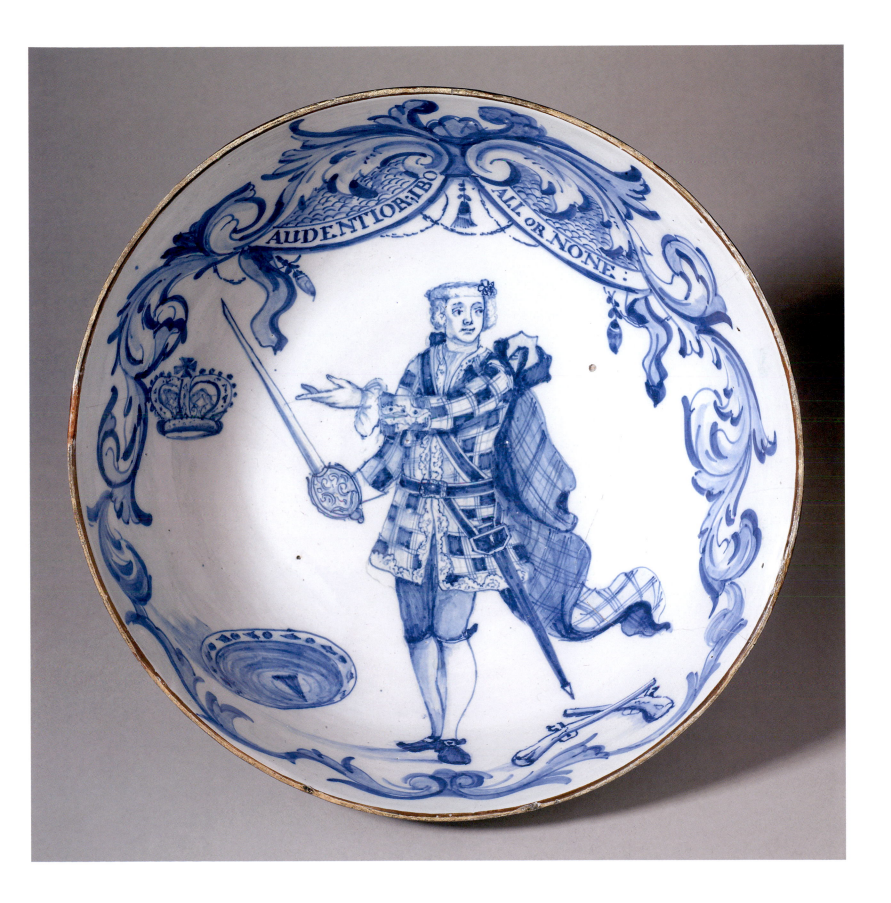

24 **Plate**, about 1754

Made in Bristol
Inscribed: 'Calvert & Martin/For Tukesbury/Sold by Webb'
Diameter: 23.1 cm
Reg. no. Pottery Catalogue E 127; presented by A.W. Franks, 1890
Hodgkin and Hodgkin 1891, no. 503; Hobson 1903, E 127; Lipski and Archer 1984, pp. 130–1

During the second half of the eighteenth century at least ten different plates were made on the occasion of Parliamentary elections, most of them held in the West Country, many during the 1750s.[1] In 1754 Nicolson Calvert and John Martin were elected as Members of Parliament for Tewkesbury, Gloucestershire. They were petitioned against in November that year. Plates like these, of which several survive, some dated 1754, were sold by Webb, who is presumed to be a local dealer. Another example is in the Willett Collection at Brighton Museum and Art Gallery.[2] An exceptionally large manganese-ground plate with the inscription 'Calvert & Martin/For Ever/1754/Sold by Webb' is in the National Museums, Liverpool.[3]

There was another election plate for Calvert and Martin in the collection, which was destroyed in the Second World War (see p. 300, no. 20).

Powdered manganese was sprinkled over the once-fired (biscuit) plate to which a resist had been applied on areas of the border and in the centre, so as to achieve the uneven purple ground. Although powdered grounds are only known in blue on Chinese porcelains dating from around 1700, the decoration in the four border panels is loosely based on Chinese plum blossom sprays.

Chip and several losses to glaze on rim.

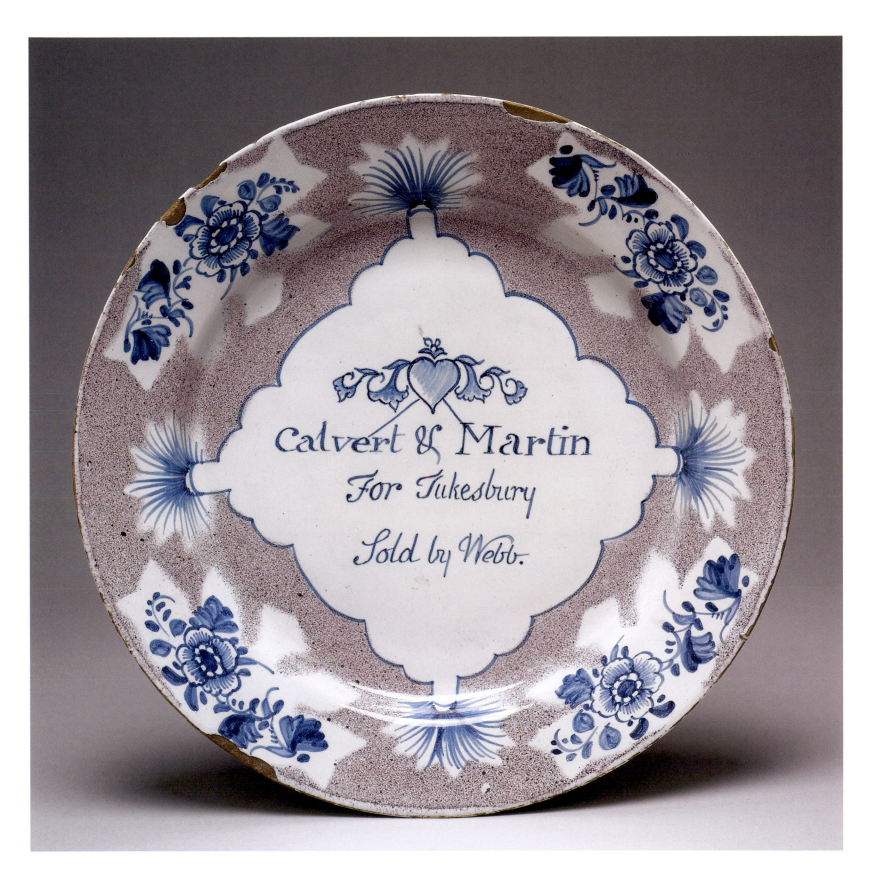

Calvert & Martin
For Tukesbury

Sold by Webb.

25 Punch bowl, about 1756–63

Probably made in London
Inscribed inside the bowl: 'Success/to the British/Arms' above a paraph
Diameter: 26.9 cm
Reg. no. 1887,0307.E115; presented by A.W. Franks, 1887
Hobson 1903, E 115

The decoration of a fence and stylized flowers, including a peony in Chinese style, is based on porcelain of the late Ming Dynasty (1368–1644). The inscription, enclosed in a carefully painted rococo frame, links the bowl with the Seven Years' War (1756–63), in which England was allied with Prussia and Hanover against France, Austria, Sweden, Saxony and Russia. Britain's aim was to destroy the commercial dominance of France, not just in Europe but also in North America, the West Indies and India. Delftware bowls with the inscription 'Success to the King of Prussia' are perhaps more common survivors commemorating the war, but bowls with the same inscription are in the Greg Collection, Manchester Art Gallery,[1] the DeWitt Wallace Decorative Arts Museum, Colonial Williamsburg, Virginia,[2] and Historic Deerfield,

Massachusetts.[3] Further inscriptions such as 'Success to the British Navy', 'Success to the British Fleet' and 'Success to British Arms in America' are known on bowls. As John Austin has noted, salt-glazed stoneware vessels were produced with Seven Years' War subjects,[4] and numerous examples of Worcester porcelain and Staffordshire lead-glazed earthenware decorated with prints of the King of Prussia show that potters found a ready market for pieces of topical interest.

Punch bowls were made in delftware in many different sizes. They were supplied to customers of merchants in the Connecticut River Valley to hold a pint, a quart or two quarts.[5] This bowl holds around three pints. It was perhaps used by one or two people rather than at larger gatherings.

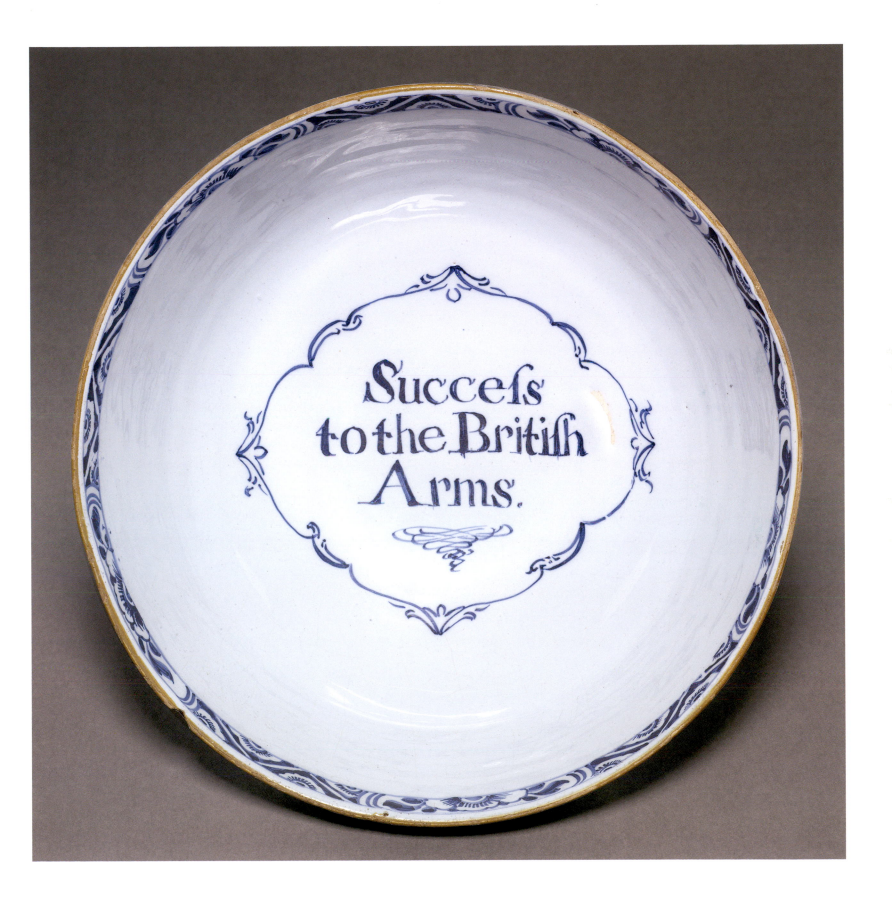

26 **Plate**, about 1761

Probably made in London
Inscribed: 'QC'
Diameter: 22.5 cm
Reg. no. 1912,1213.1; presented by Dr Edgar Willett, 1912

Half-length portraits of British monarchs are often found
on delftware plates, but less frequently left plain as here,
rather than 'framed' with blue lines and with decoration
on the border. There is a similar portrait on a plate in the
Museum of London,[1] and a portrait of King George III,
inscribed 'GR III', on a dish in the De Witt Wallace
Decorative Arts Museum, Colonial Williamsburg, Virginia,
also has a plain rim.[2] Although Queen Charlotte was not
often shown without her pearls, it seems that the
identification is probably correct.

Charlotte Sophia of Mecklenburg-Strelitz (1744–1818)
married King George III (1738–1820; reigned 1760–1811)
in 1761. Her portrait, engraved by Thomas Frye,[3] may
possibly be the source for the image on this dish. She was
also depicted on other ceramic items, including Worcester
porcelain mugs. Many portraits of the Queen appear to
have been issued at the time of her marriage and
coronation.

The rim of the plate has been restored in two places.

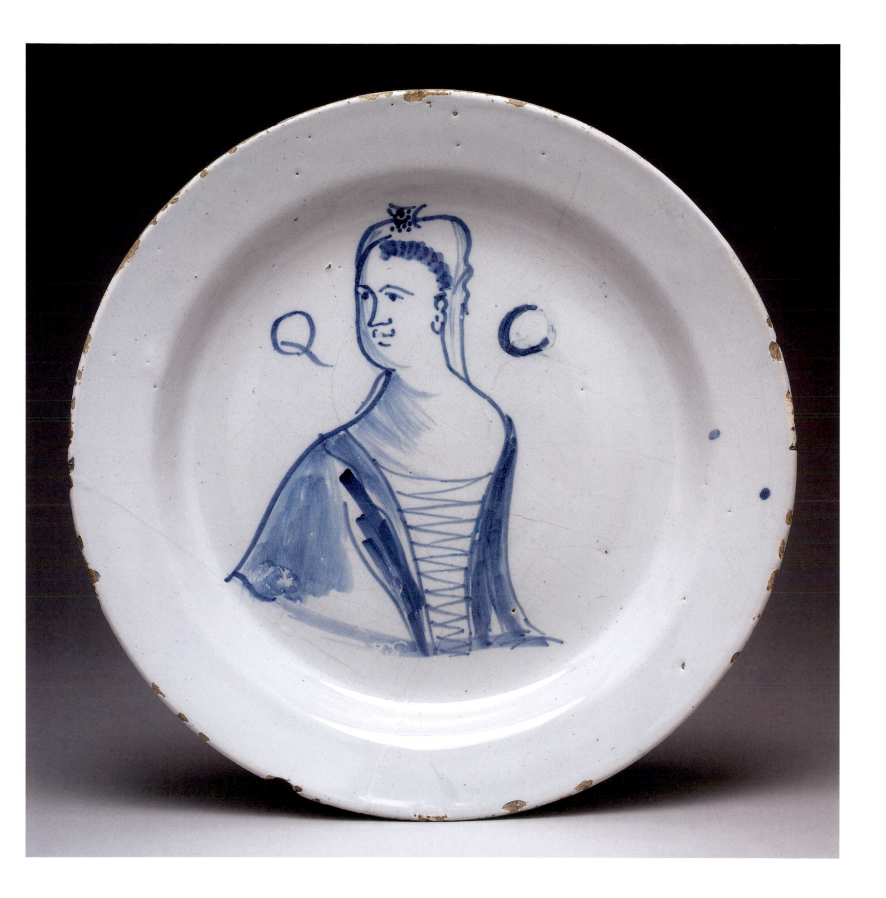

27 **Bowl**, about 1763

Made in London
Inscribed: 'Wilkes:And:Liberty:No. Bu **' and '45'
Diameter: 17.3 cm
Reg. no. 1910,1122.1

The outside of the bowl is speckled purple, a colour obtained from powdered manganese sprinkled onto the glazed surface before firing. There is a red line around the rim, presumably in imitation of Chinese porcelain.

The portrait is based on a contemporary engraving by J.S. Miller, in which John Wilkes MP is shown drawing a curtain with his right hand.[1] Another bowl, decorated inside with a powdered manganese ground and inscribed 'Wilkes:And.Honest:Iuries.No:Mad 45', is in the Glaisher Collection at the Fitzwilliam Museum, Cambridge.[2]

The '45' in the inscription refers to an issue of Wilkes's weekly newspaper the *North Briton,* published on 23 April 1763, in which he attacked the king and the prime minister, Lord Bute, whose name is probably signalled by the 'Bu' in the inscription. Bute was in office from May 1762 to April 1763. When a reprint of the newspaper was issued by Wilkes in 1763, the Public Hangman was instructed by the government to burn the proofs at Cheapside, London, but the text was seized by the assembled crowd. Wilkes was arrested for seditious libel, but the Lord Chief Justice ruled that as a Member of Parliament he was protected by privilege. He was released, but the law was soon changed and he had to flee to Paris. On his return to England in 1768 he stood as a radical candidate for Middlesex, but once elected he was sent to prison. He was found guilty of libel in June 1768, sentenced to twenty-two months' imprisonment, fined and expelled from the House of Commons. Although re-elected three times in the following year, on each occasion

Parliament overturned the election and attempts to force it to accept the will of the electors failed. Wilkes obtained release in April 1770, but was not allowed to sit in Parliament. He took part in the campaign for the freedom of the press and was eventually elected Lord Mayor of London and MP for Middlesex.

The bowl may have been used to offer punch to voters as an inducement to support Wilkes, or to express support for him. It can probably be dated to the time of the issue of the *North Briton,* when Bute was in power, even though issue 45 did not become well known until the time of Wilkes's Parliamentary campaign a few years later.

The Museum collection includes a number of items connected with Wilkes: a gold brooch in the form of the number '45' with the legend 'LIBERTY', a Worcester porcelain punch pot,[3] a Derby porcelain figure,[4] and a series of broadsides. There are three Chinese porcelain punch bowls with Wilkes subjects made for export to England in the Department of Asia, British Museum.[5]

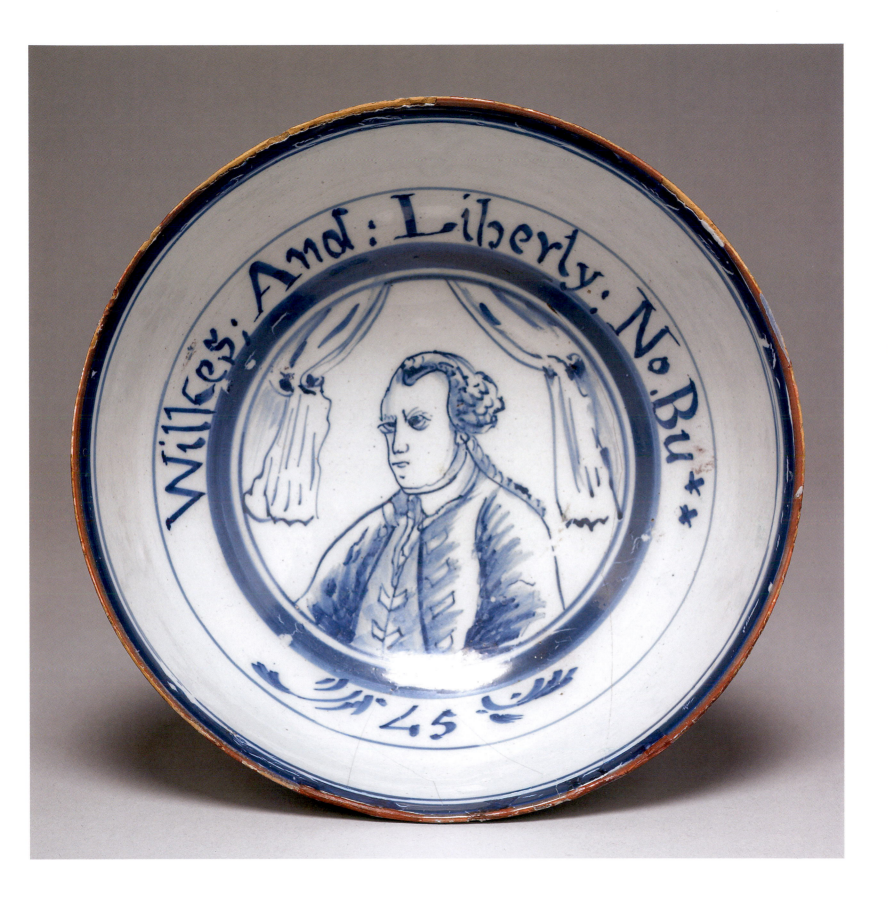

28 Tankard with lid, 1765

Made in London
Inscribed: 'ANNA. D.G. MAG.BR.ET.HIB.REGINA' and 'HONI SOIT QUI MAL [*sic*]' on the cover and '1765' on handle terminal
Height: 21.3 cm; width (max. incl. handle): 16.3 cm
Reg. no. 1887,0307.E112; presented by A.W. Franks, 1887
Church 1884, p. 71; Hodgkin and Hodgkin 1891, no. 479; Hobson 1903, E 112; Archer 1973, no. 116; Lipski and Archer 1984, no. 847; Archer 1997, p. 253

The bust portrait of Queen Anne (1665–1714; reigned 1702–14) on the lid, and the Latin inscription emphasizing her rule over Britain and Ireland (Hibernia) are taken from coinage. The two medallions around the edge of the lid contain part of the motto of the Most Noble Order of the Garter, which is in turn part of the arms of crown; within the medallion is the Star of the Order. Scotland was united with England as a single state by the Act of Union, 1707, but the first and second Jacobite uprisings of 1715 and 1745 were expressions of opposition to the succession of William and Mary, and the deposition of James II in 1688. Although the uprisings were put down, followers of Prince Charles Edward Stuart ('Bonnie Prince Charlie') remained loyal to the 'King over the Water' and opposed the Hanoverian line, which sprang from King George I. Queen Anne, the last of the Stuart monarchs, was remembered long after her death by those with Jacobite leanings.

There is a slightly larger related tankard with lid, its handle differing, in the Victoria and Albert Museum, inscribed on the underside of the lid 'L.C. Pope/1758' and dated 1758 on the handle terminal.[1] Both are likely to have been made for Jacobite sympathisers, who looked back to the last of the Stuart monarchs. They are remarkable in commemorating the Queen so long after her death.

As the lids are made from the same mould, possibly taken directly from a Continental pewter tankard set with a coin, the delft tankards are likely to have been made at the same pottery, although Michael Archer did not believe that

they were the work of the same painter.[2] Archer has compared the painting on the V&A tankard to that on the Goodenough Bowl (no. 55), but the painting on the British Museum piece is different to that on the bowl. On both tankards the original fitments attaching the lid to the tankard have been lost.

The significance of the date 1765 remains unknown. It may perhaps commemorate the fiftieth anniversary of the first Jacobite uprising. The mug was probably made for a Jacobite sympathiser, like a number of other pieces in the British Museum collection. These include a goblet diamond-engraved with a portrait of Queen Anne, signed 'Felix Foster fecit 1718',[3] and so made several years after the death of the last Stuart monarch.

Lid chipped; thumbpiece, handle attachment at upper end and part of foot restored.

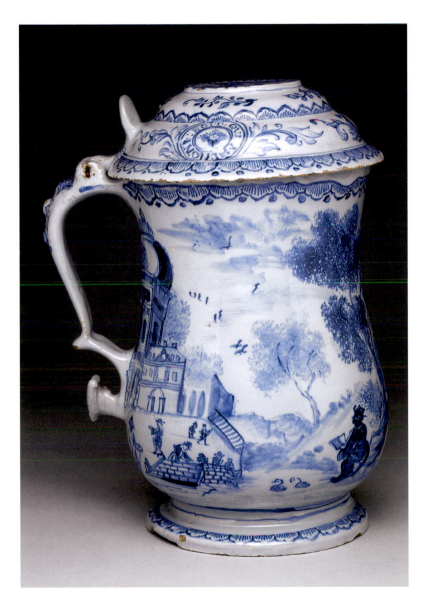 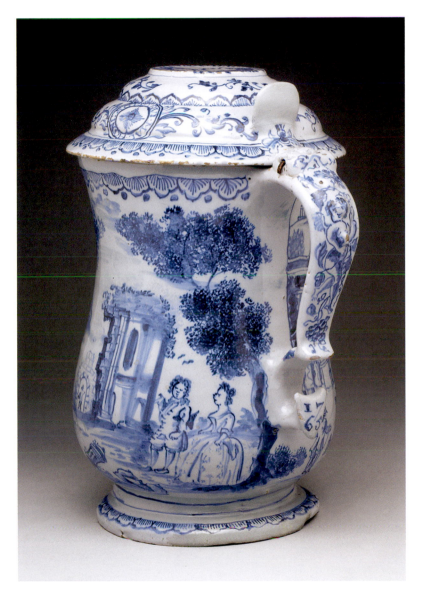

29 **Punch bowl**, about 1765

Probably made in London
Inscribed: 'Success/to Trade no/Stamps'
Diameter: 22.6 cm
Reg. no. 1991,0508,1; presented by the American Friends of the British Museum, 1991; formerly in the collection of Tom Burn at Rous Lench, Worcestershire, sold Christie's, 29–30 May 1990, lot 47

The Stamp Act was devised by George Grenville (1712–1770; Prime Minister from April 1763 to July 1765) and was designed to raise money from America for troops stationed on the frontiers of the thirteen colonies. It did so by means of revenue from stamps imposed on legal documents, including commercial contracts, newspapers, cards and dice. Passed by Parliament in 1765, it was vigorously but unexpectedly opposed, particularly in Boston, Massachusetts, and was repealed by Charles Watson-Wentworth, 2nd Marquess of Rockingham (1730–1782; Prime Minister from July 1765 to July 1766) the following year.[1] The break between Britain and its colonies was postponed for a decade, but repeal was accompanied by the Declaration Act, asserting Parliament's right to tax the colonies.

There are several medals in the British Museum collections celebrating William Pitt's role in repealing the Stamp Act, with legends such as 'No Stamps 1766', and a number of satirical prints in the Department of Prints and Drawings on the subject of the 1765 Stamp Act.

No other delftware with this inscription is known. However, there are four cream-coloured earthenware teapots in North American collections with Stamp Act inscriptions,[2] and another unusually coloured example was recently sold at auction in Derbyshire.[3]

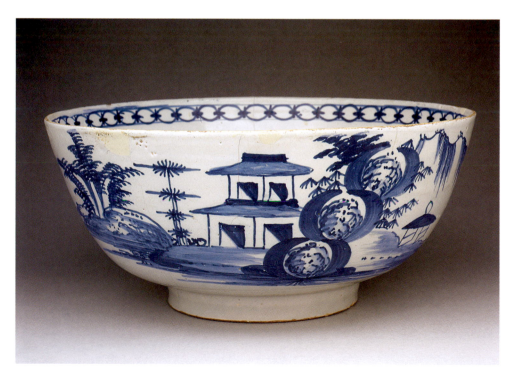

Succe**s**s
to Trade no
Stamps

30 Bowl, 1771

Probably made in Lambeth, London
Inscribed: 'Crosby/And Oliver/1771'
Diameter: 17.2 cm; height: 7.5 cm
Reg. no. 1969,0302,1; presented by Mr and Mrs Frank Tilley, 1969; formerly in the Charles A. Briggs Collection, sold Sotheby, Wilkinson & Hodge, 28 March 1917, lot 76 (with two other pieces); Mrs Radford Collection, sold Sotheby's, 3 November 1943, lot 30 (with another bowl); Professor J.H. Garner Collection, sold Sotheby's, 2 March 1965, lot 23, to Lill for £20 (with another bowl); sold Sotheby's, 18 February 1969, lot 17 to Tilley for £110 (with a Dutch delft bottle)
Anon, 'The "Crosby and Oliver 1771" punch-bowl', The *Antique Collector*, June 1969, p. 144; Lipski and Archer 1994, no. 1209

The inscription celebrates the release in May 1771 of Brass Crosby, Lord Mayor of London, and Richard Oliver, a City of London magistrate, from the Tower of London, where they had been imprisoned for supporting the publication of Parliamentary debates. Crosby and Oliver had acquitted a printer charged with the offence of printing the debates. This was deemed to breach House of Commons privilege, even though informal accounts of debates had already been published, as interest grew in the conduct of Parliament. Public protests led to the release of both men, who returned to the Mansion House in a triumphal procession. Henceforth no attempts were made to stop such reports being published. Full verbatim reporting of Parliamentary debates began in 1909, undertaken by Parliament itself. These reports are known as Hansard after Thomas Curson Hansard, who printed reports compiled by the radical, William Cobbett, in the early nineteenth century.

Brass Crosby (1725–1793) was born in Stockton-on-Tees. A lawyer, he became an alderman in the City of London in 1765 and Member of Parliament for Honiton, Devon, in 1768. He was a supporter of John Wilkes, a fellow alderman (see no. 27), and was elected Lord Mayor of London in 1770. Defeated on a radical Wilkite platform in the general election of 1774, he subsequently failed to regain his seat, although he continued to play a part in City life. An obelisk to Crosby was erected during his mayoralty in St George's Circus, Blackfriars Road, in the City of London; it was later moved to a site outside Bethlem Hospital, Lambeth, now the Imperial War Museum. His encounter with the House of Commons is the origin of the saying 'Bold as brass'.

Richard Oliver (1735–1784) was born in St John's, Antigua, West Indies, and sent to London at an early age to work for his uncle, a draper and West India merchant. He succeeded to his father's estates in Antigua in 1767. He became a Freeman of the Drapers' Company in 1770 and was elected an alderman of, and Member of Parliament for, the City of London the following year. Soon after the conclusion of the celebrated 'Printers' case', Oliver broke away from Wilkes and joined a radical faction opposed to him. He retired in 1778 and returned to Antigua to look after his estates.

A mezzotint portrait of Crosby by William Dickinson after R.E. Pine, published by Carrington Bowles in 1771, and a series of satirical prints of both Crosby and Oliver are in the Department of Prints and Drawings, British Museum.

This bowl and no. 27 illustrate the popularity of the radical cause in the mid-eighteenth century.

No other examples of this bowl are recorded, even though others must surely have been made.

The bowl is cracked.

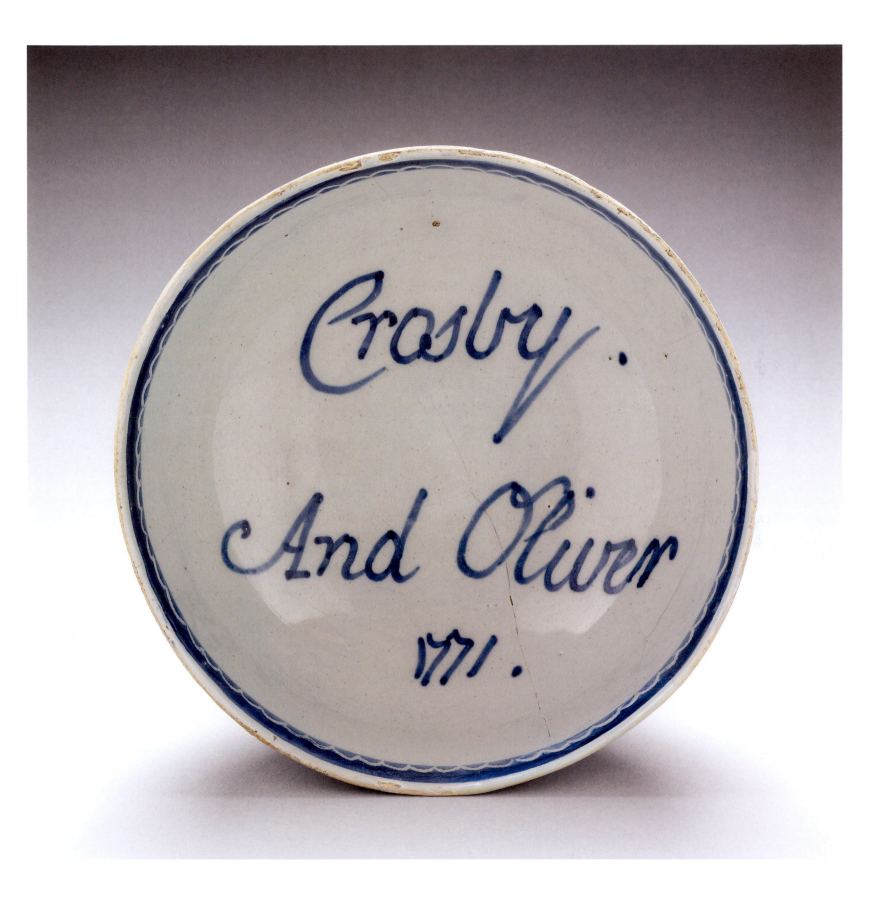

31 **Punch bowl**, about 1775–80

Made in London
Inscribed: 'Success to/Trade' above a paraph painted in blue
Diameter: 26.9 cm
Reg. no. 1887,0210.135; purchased from the collection of Henry Willett, 1887
Hodgkin and Hodgkin 1891, no. 491; Hobson 1903, E 116; Austin 1994, p. 93

No bowls painted with this inscription are dated and the painted husks in neo-classical style may suggest a date in the 1770s, or later.[1] Fragments of what seem to be four similarly inscribed bowls have been excavated in the United States: two in Virginia, one in South Carolina and another in New Hampshire.[2] The decade of the 1760s was marked by fierce competition, particularly between England and France, to secure trade in their colonies, and especially in North America.

The painted landscape and house decoration on the exterior of this punch bowl and the carefully executed border motifs inside make it one of the most luxurious of the recorded examples. Chinese influence can be seen in the unusual scene on the front of the bowl as well as in the border decoration inside the rim. The stylized leaf motif between two rather crude diaper panels on the outside is

also unusual. The lettering and its 'frame' are very similar to that on another example in the Bristol City Museum and Art Gallery, which has been attributed by Frank Britton to Liverpool and dated to about 1770.[3] Both have a bluish glaze.

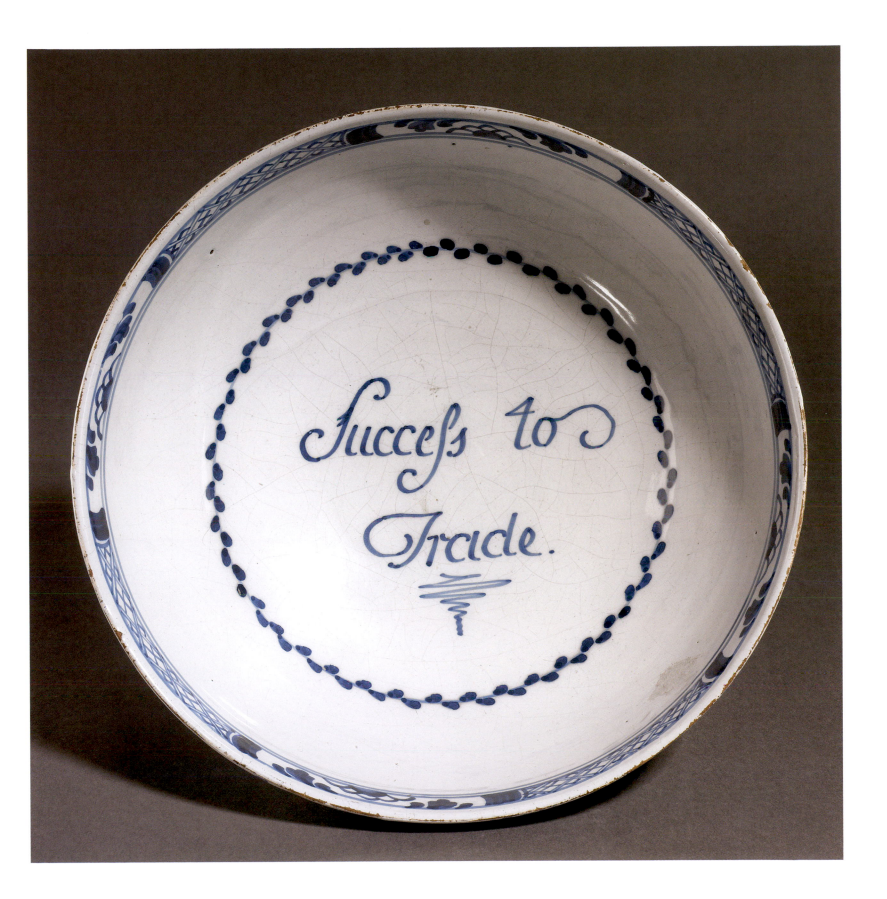

32 Dish, date uncertain, probably late nineteenth century

Place of manufacture unknown
Inscribed: 'CR', '1674/KING GOD SAVE THE' and 'RP', and 'KING/GOD SAVTH' in a 'bubble' at the base on the front
Diameter: 19.3 cm
Reg. no. 1887,0210.137; purchased from the collection of Henry Willett, 1887
Hodgkin and Hodgkin 1891, no. 338; Hobson 1903, E 155; Hannover 1925, p. 513; Jones (ed.) *Fake, the art of deception*, exh. cat.,
British Museum, London, 1990, no. 217; Tait 1998, pp. 12–13, fig. 4

The shape of this dish and its surprisingly light weight are both exceptional, and the 'sticky' painting is most unlike the painting on other examples of seventeenth-century delftware. Although thought by Hodgkin and Hodgkin in 1891 to be one of the most outstanding examples of English delft, the dish was not published by Louis Lipski and Michael Archer in 1984 as one of the dated examples and has long been thought to be a fake.

There are several decorative features, such as the bust of King Charles II in reserve at the top of the dish and the birds on either side, which may well be taken from other pieces of English delft, and it is likely that this dish was made some time in the second half of the nineteenth century with the intention of deceiving a collector.

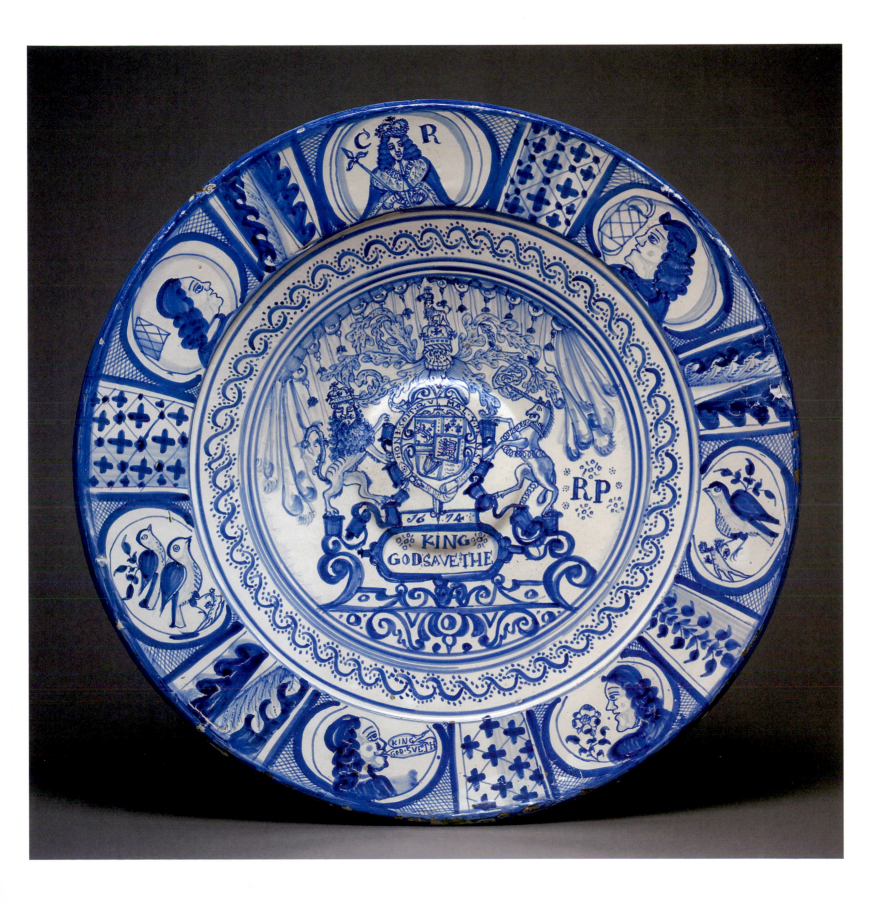

33 **Jug**, about 1620

Made in Southwark, London, possibly at the Montague Close pottery by Jacob Prynn
Inscribed: 'IP' on the neck; 'H/TD' to the left of the base of the handle
Height: 27.9 cm; width (max.): 21.8 cm
Reg. no. 1931,0317.1, purchased, 1931
Tait 1961, p. 22, figs 18a, b, 23–4, 27; Archer 1973, no. 6; Wilson 1987, no. 261; Archer 1997, p. 241

Only one other comparable jug is known.[1] Undated, it is of the same form and is painted with a figure of a young man wearing a ruff in an oval medallion, surrounded by a carefully executed inscription. The ornament on the neck and near the foot is very similar to that on the British Museum jug, even though this is painted in blue with panels of several different Chinese symbols taken from the eight Buddhist treasures, including a fan, a fly whisk, a ritual tablet, books, the eternal knot and a scroll,[2] while the body of the V&A jug is decorated all over with fruit, leaves and a bird in yellow, green and blue. This jug has been dated to around 1620 based on the style of the young man's costume.

It is likely that the young man painted on the V&A jug was based on a print, like the scene of Samson and the Lion on the British Museum jug. In the biblical story of Samson and the Lion (Judges 14)[3] Samson, whose name is a byword for strength, was attacked on the way to his wedding with a Philistine woman by a lion, which he killed with his bare hands. The subject was popular with sixteenth-century Netherlandish artists. One of the finest representations, which might possibly have been known to the painter of this jug, was made by Martin van Heemskerk (1498–1574), engraved by Philips Galle and published by Hieronymous Cock in 1560.[4]

Just as Italian influence can be seen in the fruit painted on the V&A jug, here Chinese influence dominates, although the roundel is in the style of Italian maiolica. At this early stage, delftware potters in England were still searching for a native idiom. Like a jug of early

date that is decorated with grotesques and foliage in an Italianate style and bears the initials 'D/IE' within a cartouche on the neck,[5] this jug is related to tin-glazed earthenware made in the Netherlands.

The initials IP on the neck are thought by Michael Archer to perhaps stand for the Dutch potter Jacob Prynn, who was living in Duke's Place, Aldgate, in 1617 and Montague Place in 1626. If so, it seems likely that the jug was made at the Montague Close pottery, Southwark.[6] Alternatively, as Timothy Wilson suggests, IP may be the initials of the donor.[7]

According to Frank Britton,[8] the initials near the handle may be those of Thomas Hartley, a brewer of the parish of St Olave, Southwark, who married Dorothy Staple of Orpington, Kent on 3 November 1614. It seems unlikely that the jug was made as early as their wedding year, and there is no firm evidence connecting the jug with this couple. However, the date *c.* 1630–5 proposed by Wilson in 1987 is probably rather too late.

Part of the foot has been restored, and there is some restoration to the body of the jug.

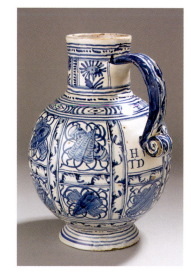

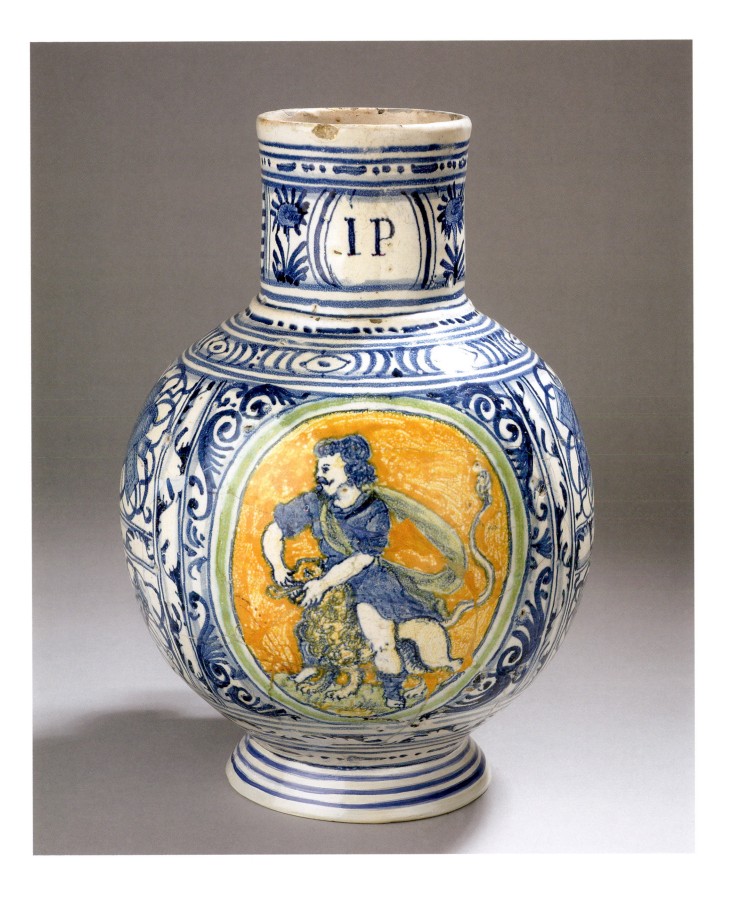

34 Dish, 1648

Made in Southwark, London
Inscribed: 'ADAM:ADAM:WHARE:ART:THO' and '1648' painted under the glaze in blue
Diameter: 36 cm
Reg. no. 1938.0314.109; bequeathed by Wallace Elliott, 1938
Mactaggart 1959, p. 63, fig. 13; Imber 1968, p. 111 and pl. 50; Archer 1973, no. 25; Lipski and Archer, 1984, no. 21

The naively painted scene on this dish shows Adam and Eve in the Garden of Eden, after eating the apple from the tree of Knowledge of Good and Evil. Up above them is the head of God in a cloud, from which issue sun rays. The scene is taken from Genesis 3: 7–9: 'And the eyes of them both were opened, and they knew that they were naked; and they sewed fig leaves together, and made themselves aprons. And they heard the voice of the Lord God, walking in the garden in the cool of the day: and Adam and his wife hid themselves from the presence of the Lord God,

amongst the trees of the garden. And the Lord God called unto Adam, and said unto him, Where art thou?'

Biblical subjects are uncommon on English delftware dishes except around the time of the Commonwealth. A notable exception is the story of Adam and Eve, which is frequently represented. Biblical scenes are found on 'blue dash' chargers, or on dishes with wide borders painted with grotesques or other ornamental motifs (see no. 35), whereas the scene on this dish extends all over the surface. However, Michael Archer[1] has traced two other dishes with the same type of painting, one depicting Susannah and the Elders, dated 1648 and bearing the initials 'EFC',[2] and the other painted with the Nativity, dated 1652 with the initials 'LBE'.[3]

The underside of the dish has a buff-coloured glaze. A large piece of stone near the footrim probably became attached to the dish during the final phase of its manufacture, and may have been part of a kiln support or debris in the kiln.

For the profile of this dish, see p. 300.

Rim partly restored, two cracks extending from the lower edge.

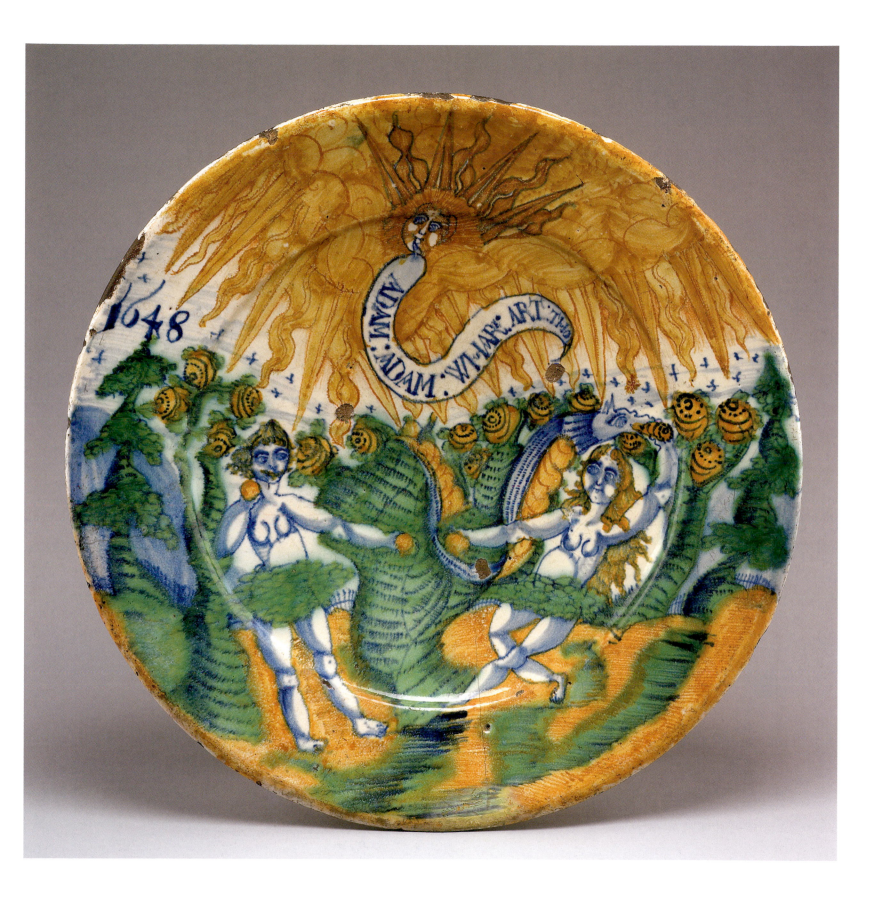

35 **Dish**, about 1630–50

Perhaps made in England or possibly Continental
Inscribed: 'ADAM EVE'
Diameter: 43.4 cm
Reg. no. 1887,0210.138; purchased from the collection of Henry Willett, 1887
Church 1884, fig. 28 and p. 39; Hodgkin and Hodgkin 1891, no. 421; Hobson 1903, E 50; Rackham 1913–14, p. 268; Rackham 1918, p. 121; Hannover 1925, p. 513 and p. 515, fig. 636; Archer 1973, no. 20

This dish, which was acquired in 1887 as English and has been published as such several times over the years, has several unusual features. The broad rim is not often found on English delftware dishes, nor is the shape of the foot typical of English manufacture. The glaze is bluish and is on both front and back of the dish, which appears much deeper than many others. The painted decoration of fruit on the rim is rather different to that found on other English pieces in the Italian style, and the figures of Adam and Eve are differently posed to those on other surviving

English Adam and Eve dishes. The couple are accompanied by pairs of animals: elephants, squirrels, deer, dogs, pigs, unicorns and a camel. The image is no doubt based on an engraving, which may have originated in Flanders in the late sixteenth century, although it could have been known in seventeenth-century England. An anonymous engraving of Adam and Eve flanking the Tree of Knowledge and accompanied by animals in pairs, including elephants, can be found in a 1611 edition of the English translation of the Bible, known as the Geneva Bible.[1]

It was suggested by Michael Archer in 1973 that the dish might be Continental in origin. When examining it in 2006, he wondered if it might be Dutch, or perhaps from Nevers, France. However, the Dutch authority Dr Jan Daniël van Dam does not agree with a Dutch attribution, nor does Madame Antoinette Hallé recognize the dish as a French production. The possibility remains that it was made in Flanders, although the inscription 'Adam Eve' is unlikely on a Low Countries dish.

For the profile of this dish, see p. 300.

The rim has been restored.

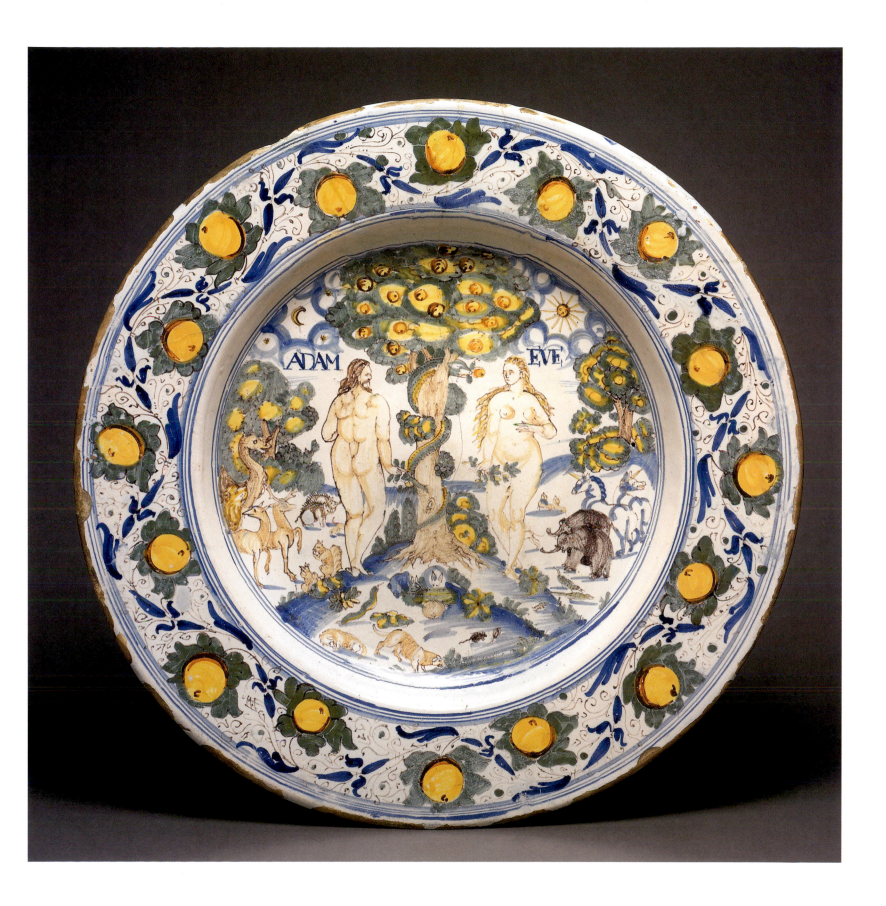

36 **Bird**, 1651

Made in Southwark, London, or possibly in Holland
Inscribed: 'EVA/1651/' painted on the base above a paraph and 'CH' below
Height: 20.6 cm; length: 25.3 cm; diameter of base (damaged): 12.8 cm
Reg. no. 1959,0204.1
'The Connoisseur's Diary', *Connoisseur*, vol. CXLIV, no. 581, November 1959, p. 194, figs left and right; Lipski and Archer 1984, no. 1739

The figure, which is hand-modelled, represents the 'Pelican in her Piety', symbolizing the sacrifice made by Christ whose blood was shed to redeem sinners. Here the three chicks (one missing) are pecking their mother's breast for nourishment. This subject was also used on seventeenth-century Staffordshire slipware dishes.

Figures in delftware were rarely made in England, to judge from surviving examples,[1] and none of those resembles this bird, the earliest dated figure in English delftware. A small delftware press-moulded parrot, which is hollow inside and is painted in blue and red-brown, belongs to the Chipstone Foundation Collection, Milwaukee, USA, and has been tentatively attributed to Liverpool. It may have been made around 1770.[2] A dog seated on a rectangular base and wearing an elaborate collar, decorated in blue, manganese and yellow, is thought to date from the last decades of the seventeenth century.[3] There remains the possibility that the British

Museum bird was made in Holland, where figure-making was far more common.

The British Museum bird is the only example recorded. Its history before it was purchased by the Museum in 1959 remains unknown. It has been suggested that it may have been made as a gift, since there are two sets of initials rather than the more usual group of three for a marriage.[4] Given its religious significance, it is possible that it might have been a devotional object, possibly even for a Catholic family,[5] perhaps kept in a hallowed place, and may have commemorated someone killed in the recent Civil War. This is perhaps more likely than the idea put forward in 1959 that 'the initials "E.V.A." may stand for a marriage of a member of the Vincent family, whose crest was a Pelican in her Piety.'[6] In addition, it was then thought that the letters 'C.H.' 'are almost certainly the initials of the potter, since they similarly appear on the large Jacob's Dream Dish, dated 1660 ... on which the same palette is used.' The present writer is more inclined to favour the theory that this was a gift and the initials represent the name of the donor (CH) and the recipient (EVA).

The head is restored, the tails broken, one of the three chicks is missing and the heads of the other two are missing. The base is incomplete.

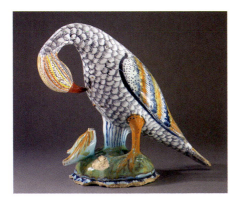

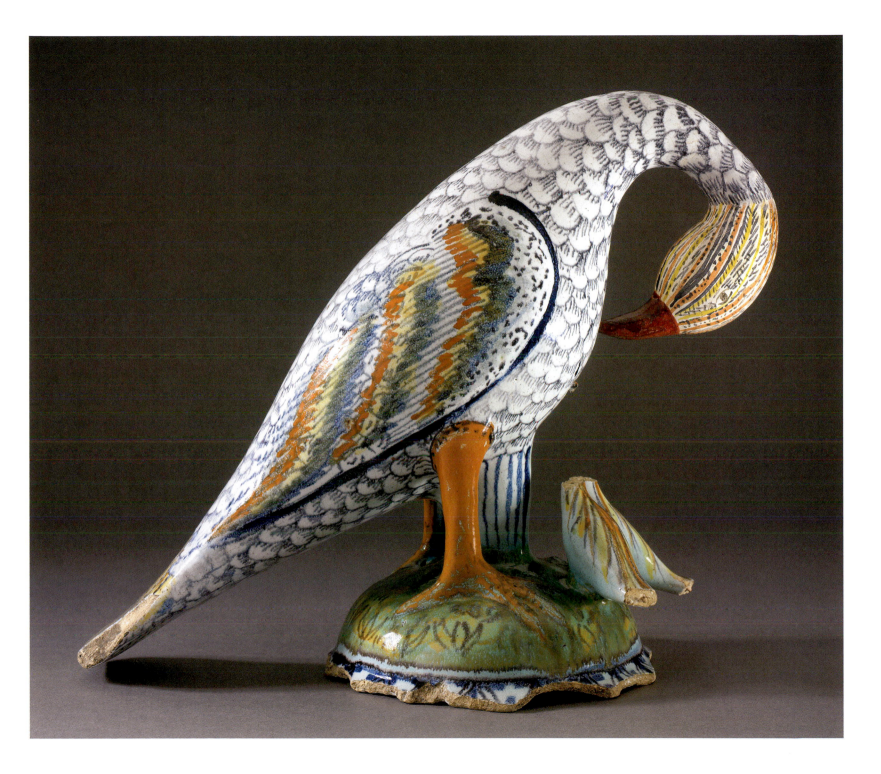

37 **Dish**, 1659

Made in Southwark, London, perhaps at the Pickleherring pottery
Inscribed: 'G/RA/1659' in blue on the front of the dish and 'W.F/1659' in blue on the base
Diameter (max.): 52.5 cm
Reg. no. 1888,1110.17; presented by A.W. Franks, 1888, formerly in the collection of Octavius Morgan[1]
Hodgkin and Hodgkin 1891, no. 304; Hobson 1903, E 153; Downman 1928, p. 221, fig. II, pp 225–6; Warren 1937, p. 17; Archer 1973, no. 24; Lipski and Archer 1984, no. 34; Burman 1993, p. 101

The biblical story of the Prodigal Son, one of the best known in the New Testament, is taken from Luke: 15 11–32. In this parable there was a man with two sons, the younger of whom demanded his inheritance even though his father was still living. He then wasted his fortune in a distant country in 'riotous living', eventually taking up employment as a swineherd. Realising the error of his ways, he decided to return home, where he was greeted with open arms by his father who killed a fatted calf to celebrate his return. To the jealous older brother, the father explained that he could only be glad that the son, who had effectively died, had come back to life. The scene shown on the right of the dish is from Luke 15:16: 'And he would fain have filled his belly with husks that swine did eat.' That on the left is from Luke 15:20: 'And he arose, and came to his father.'

The scene on the dish showing the son feeding with pigs and being greeted by his father is based on an engraving bound in a Bible of 1674, published by John Hayes.[2] It is one of three in similar style relating to the parable, one of which is signed by Claes Jansz.[oon] Visscher (1587–1652), an Amsterdam engraver, and can be attributed to this artist and dated to the first half of the seventeenth century. The style of the painting is not unlike that found on other delft dishes with biblical subjects, and may perhaps have been done by a painter originating in the Low Countries. The decoration on the border of the dish is Italianate in style, which suggests that it may have been made at the Pickleherring pottery, where the Continental influence might still have been strongly felt. It includes a woman in a Puritan-style hat, seahorses, a winged unicorn and grotesques. The blue dashes on the rim are typically English, as is the shape of the dish, which is severely warped. Dishes of this size are difficult to fire. There are three scars on the front of the dish, probably from supports used in the kiln. For the attribution, see no. 38.

The initials on the front are likely to be those of the couple for whom the dish was made, perhaps Robert Gray who married Anne Law at St Saviour's, Southwark on 23 January 1659/60.[3] The initials on the base may be those of the painter of the dish, who remains unidentified. Frank Britton suggested that they were those of William Fry, who is recorded in the Hearth Tax records of 1664 as living in the parish of St Olave, Southwark,[4] and is described as a potter in a later record of 1673,[5] but there is little reason to believe that he was a painter of pots.

There are scattered splashes of blue colour on the reverse of the dish, which has two circular holes in the footrim, perhaps for suspension.

For the profile of this dish, see p. 300.
Part of rim restored.

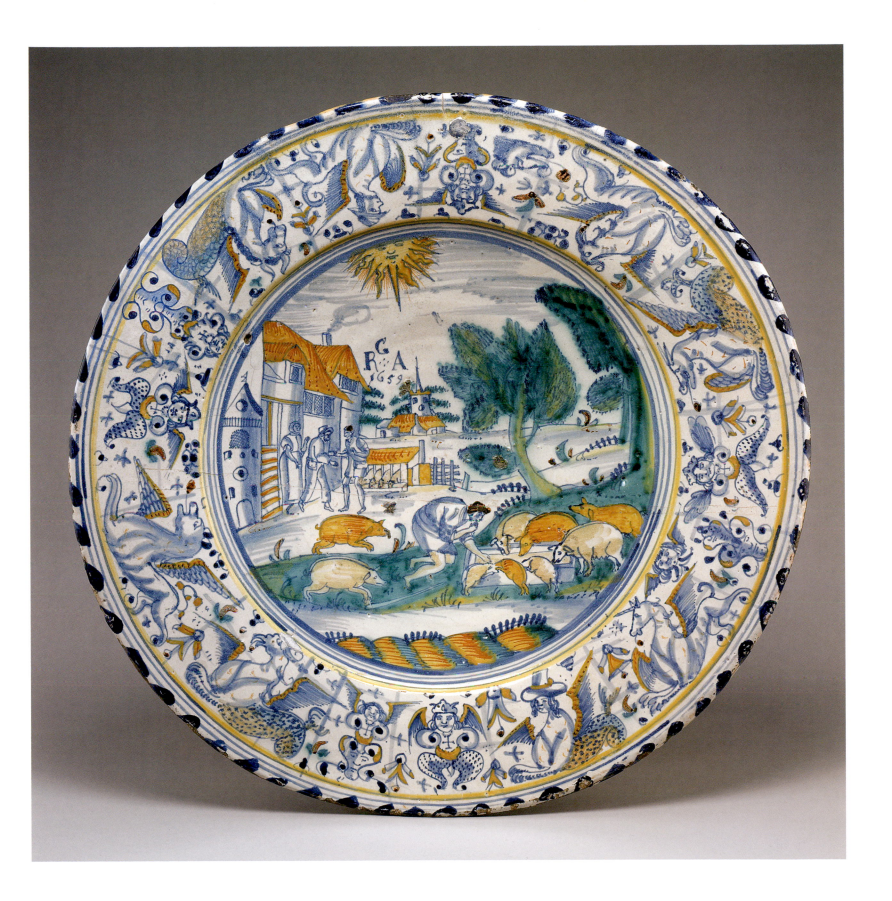

38 Dish, 1660

Made in Southwark, London, perhaps at the Pickleherring pottery
Inscribed: 'CH 1660' in an oval medallion on the rim; 'GENESIS: The:28:11' in the centre above the ladder; Hebrew inscription at the top of the ladder
Diameter: 42 cm
Reg. no. 1855,0811.2; purchased, 1855, formerly in the collection of Thomas Windus
Marryat 1857 (2nd ed.), p. 144; Marryat (3rd ed.) 1868, p. 188; Church 1884, p. 39 and fig. 29; Hodgkin and Hodgkin 1891, no. 309; Hobson 1903, E 49; Lipski and Archer 1984, p. 25, fig. 35; Wilson 1987, no. 262; Burman 1993, p. 101

The scene in the centre of this large dish with flared rim shows Jacob asleep on the ground. At his left is a ladder going up into the sky on which three angels are perched. A fourth angel stands at the foot of the ladder. In the biblical story of Jacob's Dream, Jacob fled from his brother Esau and lay on the ground to rest. In his dream he saw a ladder on which angels were ascending and descending and heard the voice of the Lord saying, 'Behold I am with you and will keep you wherever you go.' There are many interpretations of the story in both the Hebrew and Christian traditions and the subject was often treated in paintings. This naive version may be based on a printed illustration in a Bible published in 1674 by John Hayes,[1] in which the ladder faces the other way and Jacob is depicted lying against a tree.

Four medallions on the border, outlined with rope-like motifs, each contain a figure symbolic of the Seasons: from the top is a boy on a barrel holding a glass for Autumn, a female figure seated in a field holding a sickle and a sheaf of corn for Summer, a cupid flying down towards a reclining female figure in a garden for Spring and a male figure seated near a tree with bare branches for Winter. All these scenes are likely to derive from prints. The grotesque figures and terms between the medallions are loosely based on grotesques painted on the borders of Italian maiolica dishes made in Deruta.

Dishes of this size are exceptional as they were difficult to fire. The purpose of the small circular hole in the footrim is uncertain. It is suggested that the longest established concern, the Pickleherring pottery, was perhaps best placed to successfully fire and decorate pieces like this and no. 37. Another large dish, with the Adoration of the Magi shown in a domestic setting in the centre and Italianate animals and grotesque figures on the rim, dated 1638, is in the Longridge Collection, USA.[2]

The dish was already well known to ceramic collectors by 1857, the year of the second edition of Joseph Marryat's *History of Pottery and Porcelain, Medieval and Modern*, as it is mentioned there.

For the profile of this dish, see p. 300.

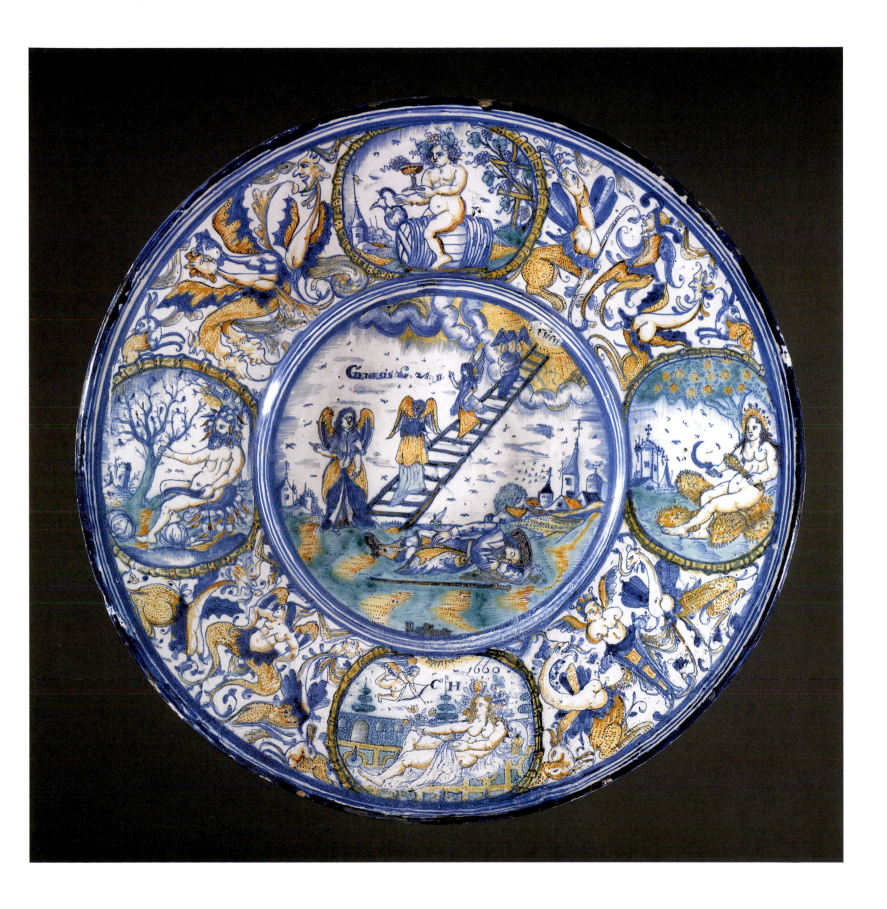

39 Dish, 1698

Made in London, or possibly in Holland[1]
Inscribed: 'P/AW 1698/octob:ye 27:' painted in blue
Diameter: 48.3 cm
Reg. no. 1965.0701.1; presented by A.C. McDonald, 1965
Lipski and Archer 1984, no.214

The scene painted in the centre within a double line has been identified as the 'Woman taken in Adultery' from the New Testament, John 8: 1–11. Christ is shown writing on the ground with his finger as the Scribes and Pharisees make their accusations of adultery. Within the well of the dish there are four groups of putti among flowers in the oriental style and various exotic birds. The border is painted with four shaped panels containing oriental flowers and birds, and a diaper pattern enclosing dots.

Like many biblical scenes painted on English delftware, this one is based on an engraving. Prints by the Flemish artist Marten de Vos (1532–1603) were used in many seventeenth-century editions of the Bible published in England, including an edition of 1674 published by John Hayes,[2] where the print is signed 'M. de Vos invent.',

'Ioan Baptista Barbe Sculp' and 'Theodor Galle excud.' De Vos, Galle and Barbe were all based in Antwerp (although de Vos spent seven years in Italy when young), so it might seem likely that the dish was painted by a Low Countries artist. A dish painted with the same subject made in Haarlem and dated 1651 was in the Dr F.H. Fentener von Vlissingen Collection until recently.[3]

The exceptional size and the unusual form of this dish, together with the painted decoration which is atypical, have also cast doubts on its English origin. Biblical scenes are more common on English delftware made several decades earlier (see nos 37–8), although the stylized flowers in the four shaped reserves on the border, which imitate those on oriental porcelains, remained popular over a long period. The form of the lettering on the reverse is perhaps somewhat unlike that on other English delftware, but the arrangement of the initials is typical for inscriptions commemorating a wedding in which the initial of the husband's surname is placed above the couple's initials. However, if this is a wedding dish, the subject seems singularly ill-chosen.

The style of the painting can be compared to that on the large punch bowl and cover dated 1697, no. 85.

As Jonathan Horne has commented, the shape of the dish is reminiscent of a metal alms dish or silver rosewater bowl, both of which have a raised boss in the centre.[4] It is therefore possible that this dish could have been used in a religious setting, despite the putti painted in the well.

For the profile of this dish, see p. 300.

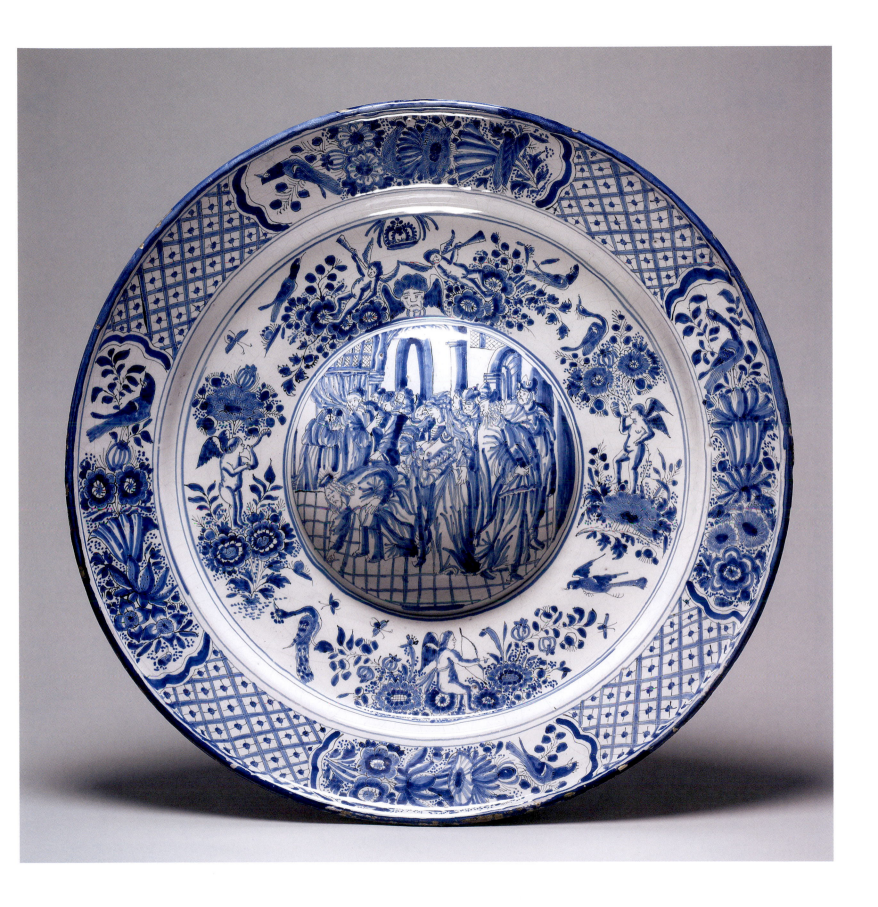

40 **Two wine bottles**, mid-seventeenth century

1 Made in Southwark, London
Inscribed: 'SACK/Wm ALLEN/1647'
Height: 15.2 cm
Reg. no.1887,0307.E20; presented by A.W. Franks, 1887,
formerly in the Williamson collection; a paper label inside the pot
is inscribed in ink, 'Mem:/I purchased this Sack Jug from a
Mr Williamson, who inherited it – it having belonged to the
uncle of his grandfather (father's father) whose name was Allen
and who was a lineal descendant of the W.M. Allen of the jug &
of Buckinghamsh …/family/Stanmore 25 June 1874 [AWF]'
Hodgkin and Hodgkin, no. 257; Hobson 1903, E 20; Burton
1904, col. pl. IV opp. p. 58; Lipski and Archer 1984, no. 1329;
Grigsby 2000, D224

This wine bottle is among the earliest of the dated wine
bottles in the Museum collection (see also no. 70) and
came into the possession of Augustus Wollaston Franks in
1874, more or less at the beginning of the vogue for
collecting wine bottles (see pp. 20–1 and no. 4). It is
painted with the arms of Allen: *ermine, on a chief 3 pierced
mullets,* surmounted by the crest of a stag's head erased
and enclosed by mantling. Personal arms are much rarer
on English delftware than the arms used by the Livery
Companies (see nos 42–4, 47, 49, 50–1, 53, 58). The
existence of another with the same arms and decoration
indicates that they were made in series.[1]

For Sack, see no. 4.
Some loss of glaze on foot and mouth.

2 Made in Southwark, London
Inscribed: '1650/JOHN:SMITH AND:MARGERI' above paraphs
Height: 18.3 cm
1891,0524.1; formerly in the collection of William Edkins Senior
Hodgkin and Hodgkin 1891, no. 271; Hobson 1903, E 23; Lipski
and Archer 1984, no. 1394; Grigsby 2000, D224

The bottle may have been a marriage gift as a John Smith,
freeman of the Worshipful Company of Pewterers,
married Margery Dunch at Newmarket All Saints in 1650.[2]
The arms on this bottle are those of the Pewterers'
Company, also found on the moulded dish dated 1655
(no. 43).

Foot chipped; loss of glaze on handle.

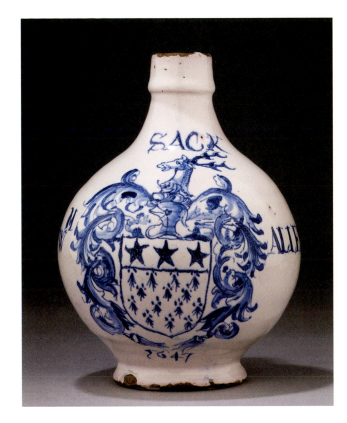

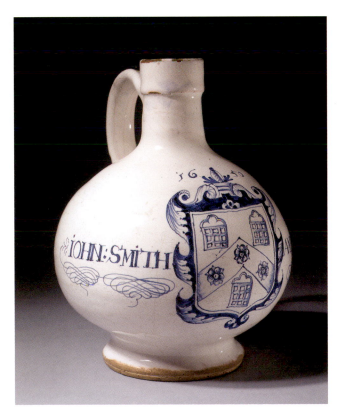

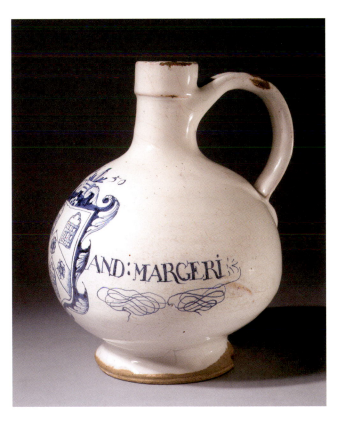

41 **Bowl**, 1653

Made in Southwark, London
Inscribed: 'P/AM/1653'
Width: 28.4 cm
Reg. no. 1891,0524.2; formerly in the collections of G.R. Harding and William Edkins Snr
Hodgkin and Hodgkin 1891, no. 283; Hobson 1903, E 44; Archer 1973, no. 33; Lipski and Archer 1984, no. 101

This is the only dated example of a moulded bowl of this shape, which is probably based on a metal original. The coat-of-arms has been identified as that of Packer, but a subsequent suggestion has been made that it is that of the Makers of Playing Cards Company or Pasteboard Makers.[1] However, more recent research reveals that the arms have been incorrectly rendered.[2] They are: *gules a cross lozengy between four roses argent*; the crest *a pelican in her piety argent*. The Packer family has been traced by Donna Smith Packer of Salt Lake City, Utah, United States,[3] whose findings are published in *On Footings from the Past: the Packers in England*, np [United States], 1988. It is possible that the bowl was made for Andrew Packer, yeoman of Minety, Wiltshire and his wife Mary Randall alias Barston of South Cerney, Gloucestershire, who were married in 1622 at South Cerney, and possibly commemorates some special event. Britton (see note 3) has found no London connections for the Packer family, except that a potter named James Barston was recorded in Southwark in 1663 and he may have been a relation of Andrew Packer's wife.

Personal arms are far rarer on English delftware than the arms of City Livery Companies (see no. 40).

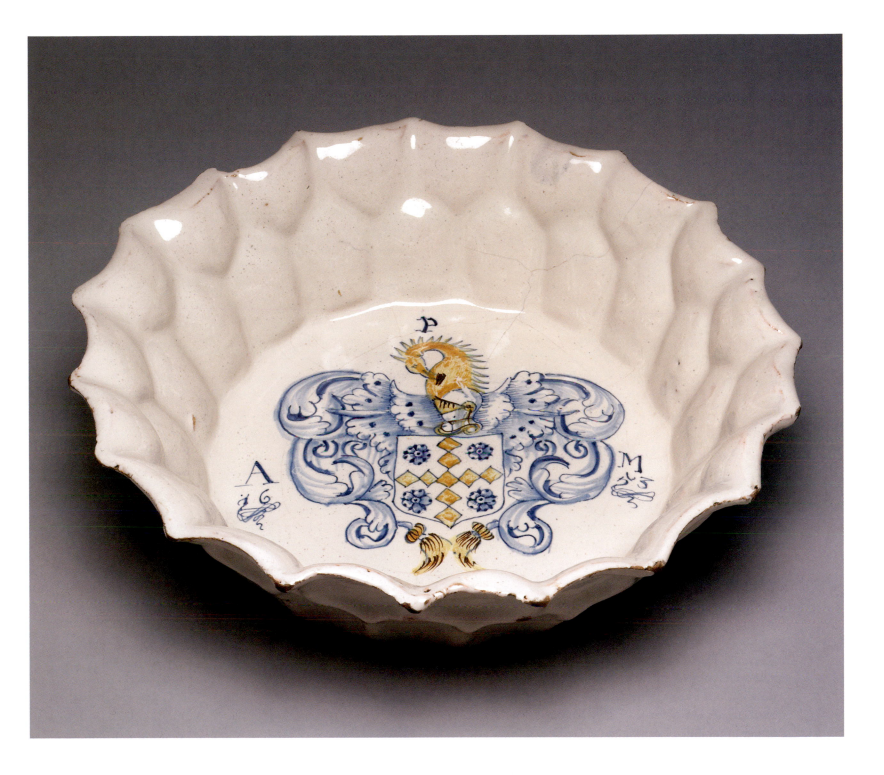

42 Mug, 1655

Made in Southwark, London
Inscribed: 'A/IM' twice and '1655'
Height: 11.1 cm
Reg. no. 1895,0720.1; presented by R.W. Raper, 1895
Hobson 1903, E 38; Tilley 1967, pp. 125–6, fig. 4; Lipski and Archer 1984, no. 732

The rim of the mug has been damaged and was replaced with a gilt iron mount (now corroded) before its acquisition by the Museum in 1895.

The arms of the Worshipful Company of Drapers are *azure, three clouds proper, radiated in base or, each surmounted with a triple crown or, caps gules,* that is, three flaming clouds crowned with three crowns of gold within a shield. The crest, which should be *on the wreath of the colours, a mount vert, thereon a ram couchant or, armed sable,* has been completely misunderstood by the painter and the supporters, instead of *two lions argent, pelletté,* are crudely painted figures of Adam and Eve, plucking fruit from the Tree of Knowledge of Good and Evil, flanking the date 1655. The initials may stand for John Alder and his wife, Mary.[1] For a puzzle goblet dated 1674, painted with the same arms, see no. 49.

Mugs of this form, perhaps used for caudle – a milky drink made with ale and spices – or for ale, survive in some number from the 1650s. Several are painted with the arms of City Livery Companies. One, decorated with the arms of the Bakers' Company and inscribed 'JOHN:LARTH:MAN:&:ROSE:1645', is in the DeWitt Wallace Decorative Arts Museum, Colonial Williamsburg, Virginia. This piece is embellished with a silver mount engraved with scrolls and the initials L/IR.[2] An unmounted mug in the Royal Museum of Scotland is painted with the arms of the Clothworkers' Company and inscribed 'RICHARD GIFFORD AND. JONE.1651',[3] and another unmounted example in the Castle Museum,

Norwich is painted with arms that may be a version of the armorial bearings of the Innholders' Company and inscribed 'R/16II53'.[4] A mug that belonged to A.W. Franks in 1885 and had passed to the collection of J.E. Hodgkin by 1891 is painted with the arms of the Bakers' Company and inscribed 'M/AR', 'M/AR 1657' and 'DRINKE: UP YOUR DRINKE/& SEE MY: CONNY',[5] a rather risqué inscription not infrequently found on seventeenth-century mugs painted inside with a rabbit. One mug still survives in the collection of the Livery for which it was originally made: it is inscribed 'EW/1660' and is painted with the arms of the Leathersellers' Company.[6]

There was evidently a vogue for these small mugs at this period and it is tempting to think that they were all commissioned from the same factory, not far from the various premises in the City of London occupied by the different Liveries.

The mug is extensively cracked; several small areas of glaze missing; touches of (later) gilding around foot.

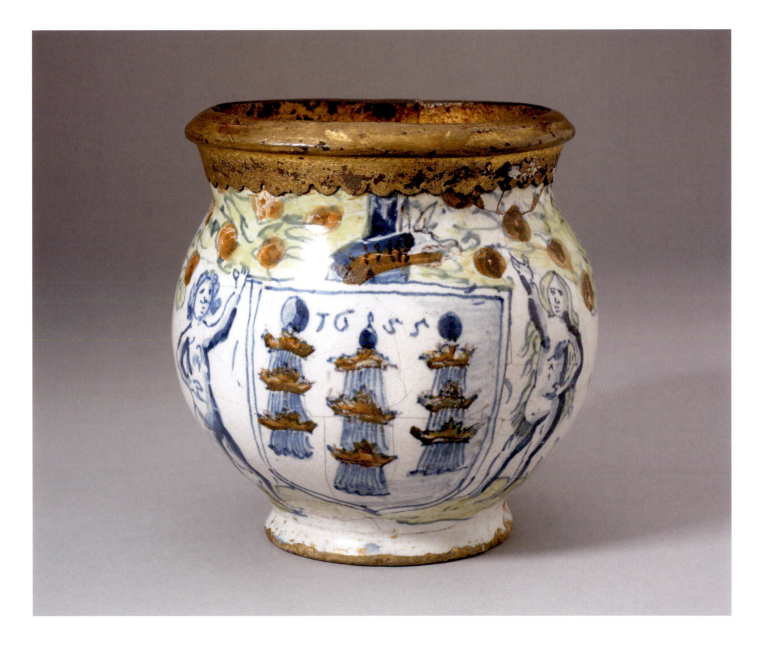

43 Dish, 1655

Made in Southwark, London

Inscribed: 'S/I.I 1655'

Diameter: 42.4 cm

Reg. no. 1888,1110.16; presented by A.W. Franks, 1888; formerly in the collection of Octavius Morgan;[1] label on back inscribed in black ink 'AF,1888:O. Morgan'

Marryat 1857 (2nd ed.), p. 144 (then in Morgan collection); Hodgkin and Hodgkin 1891, no. 287; Hobson 1903, E 51; Burton 1904, fig. 12 opp. p.54; Tilley 1967, pp. 267–8 and fig. 5; Lipski and Archer 1984, no. 103

The dish, which has numerous pinholes in the glaze, is elaborately moulded and is painted in the centre with the arms of the Worshipful Company of Pewterers: *azure on a chevron or between strikes argent as many roses gules stalked budded and leaved vert*. The Company obtained its first charter in 1473 and was granted arms in 1533. It is still actively involved with the pewter trade.

The initials (arranged with the surname at the top and 'I' standing for 'J') may refer to the marriage by Bishop of London licence of John Silk of St Mary Whitechapel and Jane Perry of St Michael Bassishaw, which took place on 15 February 1631.[2] John Silk was apprenticed in the Pewterers' Company on 11 April 1620 and became free in 1626/7, obtaining permission to open shop in 1627/8. In 1655, the date of this dish which may celebrate the event, he became Upper Warden, progressing to Master in 1658. He died in 1660. In a survey of St Paul's properties in Whitechapel made in 1649, there is reference to his residence: 'four messuages on the south side of a certain street by the name of White Chapell abutting on a messuage in occupation of John Silk towards the east'.

According to Frank Britton (see note 2), the dish could have been made for Silk by a fellow pewterer, as many potters were apprenticed in this Company because they did not have a Livery Company of their own.

A variation of the moulding on the Museum dish appears on an example once in the Moor Wood Collection, Cirencester, and now in the Gardiner Museum, Toronto, which is dated 1653 and bears the painted initials 'E/TI' in the centre.[3] Another similar dish dated 1660 with the initials 'R/NA' is at Knole, Kent.[4] These dishes are close in size. They are likely to have been moulded from a metal example, and were probably intended for decoration rather than for use.

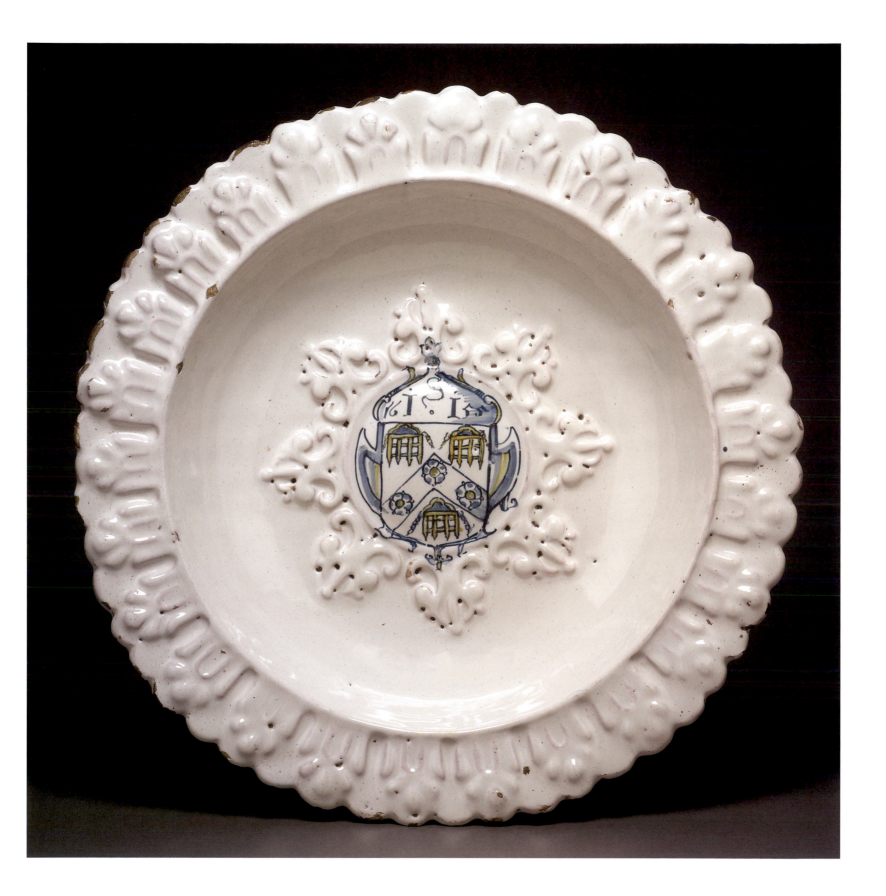

44 Dish, 1659

Made at Southwark, London, at the Montagu Close or Pickleherring pottery
Inscribed: 'C/IE' in a medallion on the border above and '1659' below
Length: 46.5 cm
Reg. no. 1855,1201.115 (BL 2119); formerly in the Ralph Bernal, MP, Collection, purchased at his sale held by Christie's, London, 5 March 1855 and following days, 17th day, 24 March 1855, lot 2119, £6
Marryat 1857 (2nd ed.), p. 143; Marryat 1868, p. 188; Church 1884, p. 39; Hodgkin and Hodgkin 1891, no. 303; Hobson 1903, E 48; Tait 1957, p. 47; Rackham 1959, p. 61; Tilley 1967, p. 267–9, fig. 6; Imber 1968, p. 116; Lipski and Archer 1984, p. 41, no. 105; Burman 1993, pp. 105–6; Slater 1999, p. 56, p. 63

This moulded dish is one of a series of eighteen dating from between 1633 and 1697,[1] which were directly moulded from similar French lead-glazed dishes with coloured glazes.[2] Once thought to have been made by Bernard Palissy (*c.* 1510–90), the renowned French potter, these are now usually attributed to Claude Barthélémy at Fontainebleau, south of Paris in the early seventeenth century.[3] Evidence for trading connections between potters succeeding Palissy and French merchants in London was first published by Rackham in 1959.[4] A potter named Claude Bauls, Baulat or Beaulat employed at

Fontainebleau around 1600 is recorded as a merchant in London in 1621 and may well have imported the French dishes. In form these dishes imitate metalware, and hark back to pewter examples such as those made by François Briot. The delftware examples, of which a total of forty-one have been noted,[5] are likely to have been cast from the Fontainebleau dishes.

The subject appears in a fresco by Rosso Fiorentino of around 1534 in the Grande Galerie at the Château de Fontainebleau, built by François Ier, as well as in a tapestry now in the Kunsthistorisches Museum, Vienna.[6]

The figure in the centre is symbolic of Fecundity, or fertility, and is accompanied by five small children. Dishes like these, usually known as 'Fecundity' dishes, have many variations in the decoration of the border and at least one is painted in blue and orange only. Some bear armorials in medallions at either side. The British Museum dish bears the arms of the City of London at the left and of the Worshipful Company of Pewterers at the right. In the other four medallions there are full-length figures of the Seasons. Around the central scene is a band of ornament in Chinese style.

It is highly likely that 'Fecundity' dishes were intended for display rather than use. The initials at the top are those of a man and wife. The original owner may have been a John Campion, who married Elizabeth Campion at the church of St Peter le Poor, Aldgate, London on 30 October

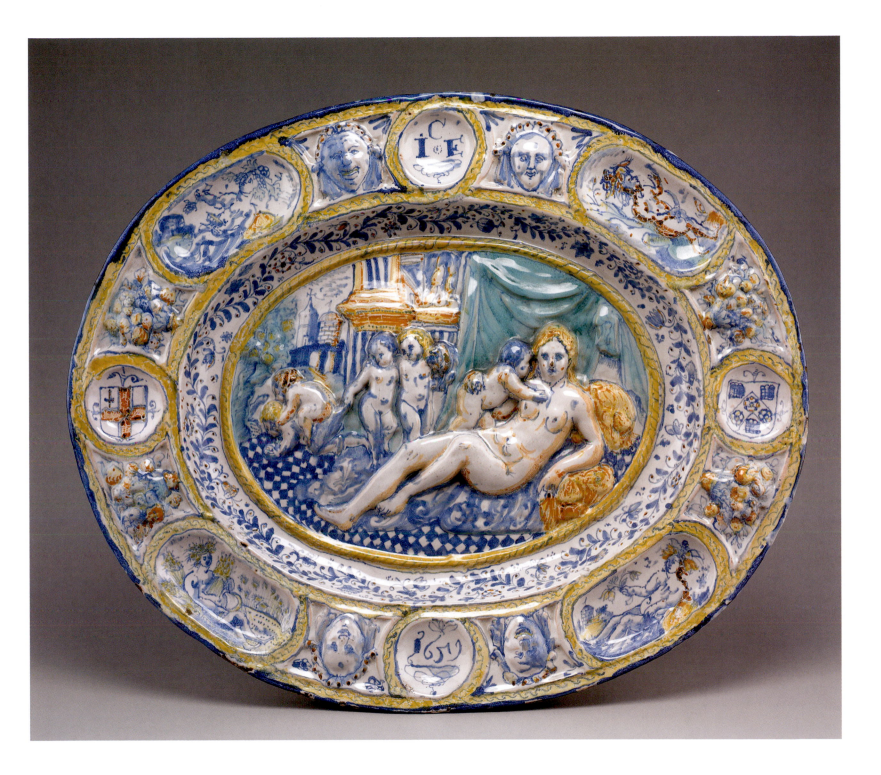

45 **Dish**, about 1640

Made in London, probably at Southwark
Length: 38.3 cm
Reg. no.1938,0519.1, bequeathed by Rennie Manderson through
Mrs Gertrude Manderson, 1938; exhibited by Rennie Manderson,
Burlington Fine Arts Club, London, 1913[1]

1659. He was apprenticed in the Pewterers' Company in 1642 and made free of his articles in 1650. Eight weeks after becoming free, he opened shop and was elected to the Livery in 1662. He managed the pottery at Hermitage Dock, Wapping, taking on his first apprentice three weeks after opening shop. He seems to have retired in 1685.[7]

By at least as early as 1857, when Joseph Marryat's *A History of Pottery and Porcelain, Medieval and Modern* had reached its second edition, this dish had become well known to the collecting fraternity.

For another 'Fecundity' dish, see no. 45; for a dish painted with the arms of the Worshipful Company of Pewterers, see no. 43; and for a salt painted with the arms of the City of London, see no. 46.

For the subject of this moulded dish, which is an allegory of Fecundity, see no. 44. The form of the dish is unusual as the border is not moulded with the usual depressions. The painted fruit, which includes pomegranates, a symbol of fecundity, is typically Italianate in style and shows a marked Netherlandish influence, but no other 'Fecundity' dish like this has been recorded. The chequered floor is found on other 'fecundity' dishes dating from the 1650s.

On both this dish and the dated example moulded with the same subject (no. 44), the painter has defined the bodies of the goddess and her attendant putti with blue lines in a manner that is reminiscent of the painting on the small bust of King Charles I (no. 8) as well as of the scene on the 'Adam, Adam' dish (no. 34). On this dish the curtain in the background and the mattress, blanket or sheet underneath the goddess are also painted with flowing blue lines.

The dish was intended for display, rather than for use.

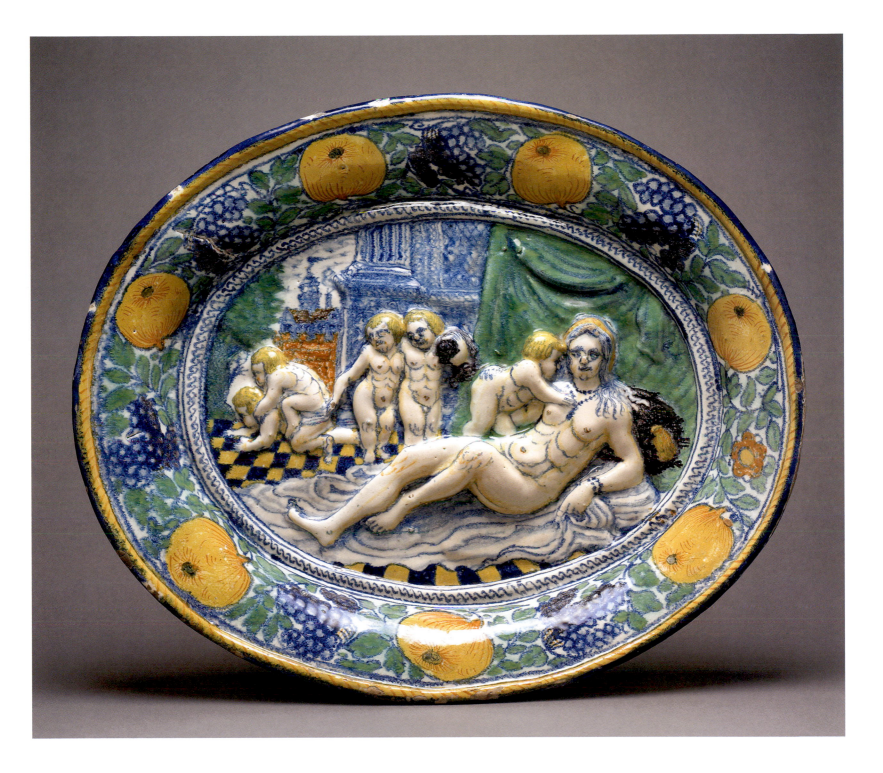

46 **Salt**, about 1650

Made in Southwark, London
Height: 9.8 cm; width: 12.7 cm; depth (max.): 9.7 cm
Reg. no. 1887,0307.E9; presented by A.W. Franks, 1887
Hobson 1903, E 9; Grigsby 2000, D207, fn 2

Salts like these, of which six are known to survive, not all of the same size, were made in moulds, no doubt in several parts which were fitted together with liquid clay when the clay was at the leather-hard stage before firing. In form and decorative style they show the influence of Italian maiolica made in the sixteenth and seventeenth centuries, although an exact prototype, which may have been in bronze, has not yet been found.

Most of the other salts are painted in colours. This salt and one in the Glaisher Collection, Fitzwilliam Museum, Cambridge,[1] are decorated in blue and yellow. Only one is painted solely in blue.[2] All bear a moulded shield, painted with the arms of the City of London at each end and a moulded angel's head on each side. Underneath are two small moulded projections. The legs are moulded as acanthus leaves. On this example the angels' wings are painted yellow and the edge is also yellow. The flower in the central well, which is similar to a flower on the blue-painted salt in the Longridge Collection, USA,[3] attributed to one of the Southwark factories, is in the style of decoration on Chinese porcelain of the late Ming period (1368–1644).

Salts of this type, perhaps based on Italian maiolica originals, possibly by way of Flanders in the late sixteenth or early seventeenth century, may have been made for merchants in the City of London.

One foot damaged.

47 Mug or caudle cup, 1660

Made in Southwark, London, perhaps at the Pickleherring pottery
Inscribed: 'BEE MERRY AND WISE 1660' and 'D/II'
Height: 10.6 cm
Reg. no. 1887,0307.E39; presented by A.W. Franks, 1887; formerly in the collection of the Revd Thomas Staniforth
Hodgkin and Hodgkin 1891, no. 306; Hobson 1903, E 39; Tilley 1968, pp. 129–30 and fig. 13; Lipski and Archer 1984, no. 743

Inscriptions around the rim of small cups like these are more common in preceding decades. The mug inscribed 'Edward Searle and Elizabeth' dated 1650 (see no. 76) is an earlier example of this kind. The 'Edward Searle' mug is also painted with sailing ships near the handle, perhaps done by the same painter (see also no. 1). He may also have painted a moulded dish with the arms of Markham impaling Faringe and ships alternating with buildings on the border, which was on the London market in December 2008.[1]

The amusing coat-of-arms outlined in yellow and manganese is that of the Worshipful Company of Leathersellers: *argent three roebucks passant regardant gules attired and unglued sable*. The Company was granted a charter in 1444 and originally controlled the sale of leather in the City of London. Another delftware mug of the same form with the same arms is inscribed 'EW/1660'.[2] This is in the possession of the Worshipful Company of Leathersellers. Both were presumably made for liverymen in the same year.

Drinking inscriptions are frequently found on these small cups. Another inscribed 'Be Mery & Wise' is also dated 1660 and is painted with a portrait of King Charles II.[3]

The unglazed base is concave and painted with blue lines.

Chip to foot, rim damaged, cracks from rim and several surface cracks, loss of glaze on handle.

48 Wine bottle, 1672

Made in Southwark, London
Inscribed: 'W/1672' above a flourish below the terminal of the handle
Height: 16.9 cm
Reg. no. 1887,0307.E28; presented by A.W. Franks, 1887
Hodgkin and Hodgkin 1891, no. 332; Hobson 1903, E 28; Lipski and Archer 1984, no. 1500

There are relatively few delftware wine bottles painted with personal arms (but see no. 40). Another with the same arms was noted by Hodgkin and Hodgkin in the collection of R.H. Soden Smith, indicating that the original owner probably had a set of wine bottles. The arms shown here – *azure, a fess between three tigers' heads erased Or* – accompanied by a helm, gryphon crest and mantling, are thought to belong to the Hunlock (or Hunloke) family of Derbyshire. The initial 'W' below the handle may stand for Wingerworth Hall, near Chesterfield, the family seat of the Hunlokes from the beginning of the seventeenth century. A larger hall, demolished in 1924, dated from the early eighteenth century. The jug may have been made for Sir Henry Hunloke (1645–1715), 2nd baronet.

The deep band of turned decoration at the rim and below the body of this wine bottle is unusual.

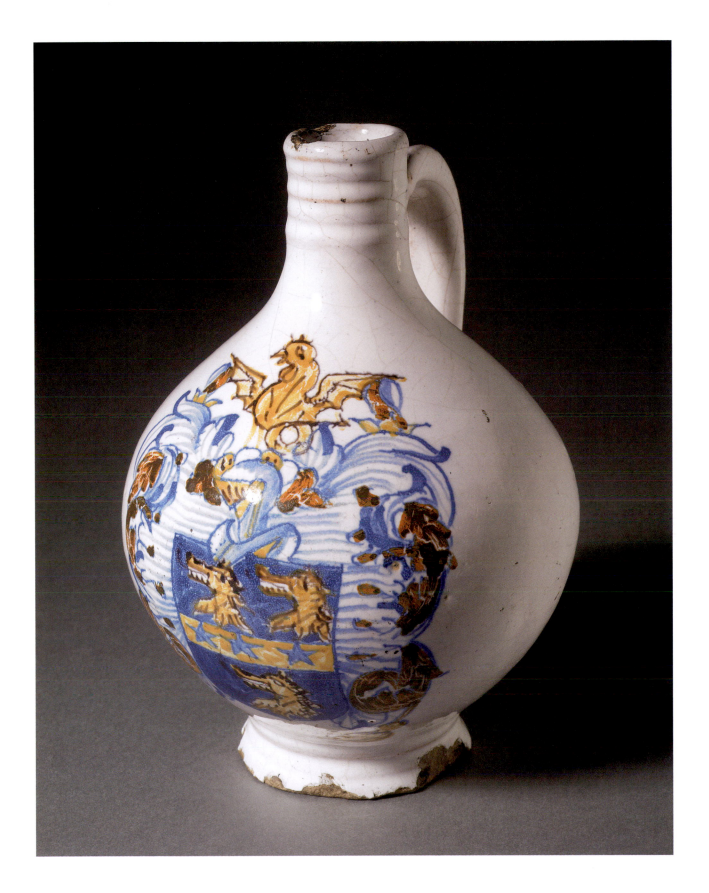

49 **Puzzle goblet**, 1674

Made in Southwark, London
Inscribed: 'IW', '1674'
Height to top of finial: 24.8 cm; width (max.): 11.6 cm
Reg. no. 1887,0307.E13; presented by A.W. Franks, 1887
Church 1884, p. 38; Hodgkin and Hodgkin 1891, no. 341; Hobson 1903, E 13; Tilley 1967, pp. 125–6 and fig. 3; Imber 1968, p. 114;
Archer 1973, no. 46; Lipski and Archer 1984, no. 875

Puzzle jugs have been made in pottery in Britain from at least the Middle Ages. They are designed so that the drinker spills the liquid unless he knows the trick, which is usually to cover a hidden hole, or holes, so that the liquid only comes out from the spout. Slipware puzzle jugs were still being made in Devon in the nineteenth century.

Examples in slipware, often with incised inscriptions, can be found in many collections.

The elaborate form of this puzzle goblet is apparently unique and miraculously it has survived more or less intact. Most puzzle jugs are similar to no. 90. In order to obtain the liquid inside, in a drinking game, the holes in the stem of this example would have been blocked while the (removable) mouthpiece was sucked to create a vacuum and empty the bowl, which has an elaborate openwork rim.

The goblet is painted with the arms of the Worshipful Company of Drapers: *three flaming clouds crowned with three crowns of gold within a shield*. The Company, originally a trade association of wool and cloth merchants, was given its charter in 1364 and was incorporated in 1438. For a mug of 1655 painted with the same arms, see no. 42. The identity of the original owner 'IW' remains unknown, but he was no doubt a Liveryman of the Drapers' Company.

Scrolls restored; damage to sucking attachment and finial, tiny chip to foot.

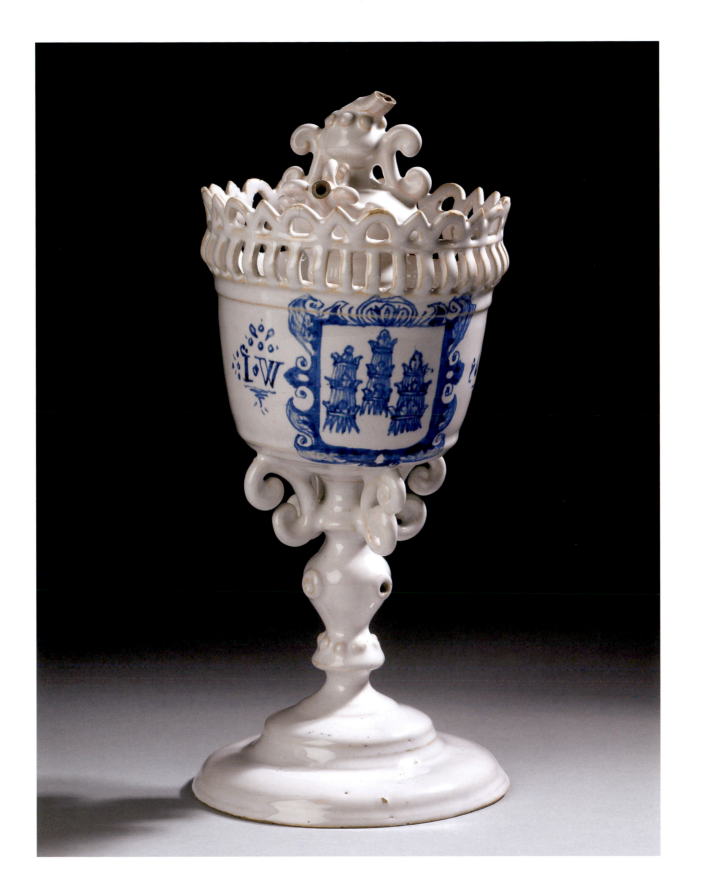

50 **Drug jar**, about 1690

Made in London
Inscribed: 'OPIFER: QUE PER ORBIM [*sic*] DICOR'
Height: 22.9 cm
Reg. no. 1921,0727.1; presented by Lady Maria Evans and Dame Joan Evans, 1921
Lothian 1951, p. 21, figs II a and b; Grigsby 2000, D394

The jar is painted with the arms of the Worshipful Company of Apothecaries of London, incorporated by royal charter in 1617. For the arms, also found on a pill slab, see no. 51. On this jar the motto is incorrectly written, and this is because the coat-of-arms has been partly restored along the lower part of the shield, near the left-hand unicorn's tail and on part of the motto. Like the pill slab, the jar may have been used as a shop sign in a shop window. It may

correspond to the 'window potts' referred to in an inventory of an apothecary's shop dated 1666.[1] Jars like this are far outnumbered by those painted with the names of various drugs, which were for storing preparations.

A larger jar in the Longridge Collection, USA,[2] painted with vines on the reverse rather than the Chinese figures in blue and manganese found on the Museum example, is dated 1656, while the collection of the Pharmaceutical Society of Great Britain includes the earliest dated jar inscribed '1647',[3] which is more elaborately painted than the British Museum jar and has Italianate floral and fruit ornament on the reverse. Another jar with the Apothecaries' arms in the same collection is decorated with a Chinese scene similar, although not identical, to that on the Museum jar but painted only in blue.[4]

Base of pot restored, and other areas of overpainting (see above), including part of the clothing of the right-hand Chinese figure on the back of the vase.

51 **Pill slab**, around 1700–30

Made in London
Height: 30.9 cm
Reg. no. 1887,0307.E70; presented by A.W. Franks, 1887
Hobson 1903, E 70; Matthews 1971, pl. 13

Pill slabs, which survive in oval, heart-shaped, octagonal and shield-shaped forms like this piece, were used by apothecaries, or druggists, for rolling pills, or as signs in the windows of their premises. The two holes at the top suggest the slabs were suspended, supporting the second theory. No surviving slabs appear worn on the surface from use.[1] Most delftware examples are painted like this one, with the arms of the Worshipful Society of Apothecaries: *azure, Apollo proper with his head radiant, holding in his left hand a bow and in his right hand an arrow, or, supplanting a serpent argent, with the crest upon a wreath of the colours a rhinoceros proper, supported by two unicorns or armed and unguled,* with the motto OPIFERQUE:PER: ORBEM:DICOR. The motto, taken from the first book of Ovid's *Metamorphoses*, can be translated as 'I am spoken of all over the world as one who brings help.' Below is an oval cartouche enclosing the arms of the City of London: *a cross, in the first quarter a sword of the second.* Pill slabs with the Apothecaries' arms date from 1670 onwards,[2] but the earliest, its date indistinct but perhaps from the 1650s, which is oblong, is painted with cartouches,[3] and a heart-shaped example of 1663 is painted with a ribbon on which is inscribed a name.[4] A shield-shaped slab belonging to the Pharmaceutical Society of Great Britain is dated 1703,[5] but the festoons on the Museum slab perhaps suggest a rather later date.[6] An almost identical pill slab is in the Glaisher Collection at the Fitzwilliam Museum, Cambridge.[7]

The apothecaries of London were incorporated in 1617 when they split from the Grocers' Company, and were given the right to 'make, mix, compound, prepare, give, apply or administer any medicines' within seven miles of the City of London. The Society applied for a grant of arms in 1620.

The presence of the badge of the City of London below the inscription suggests that the owner was a Freeman of the City of London.[8]

The upper right edge is chipped.

OPIFERQUE PER ORBEM DICOR·

52 **Punch bowl**, about 1720–40

Probably made in London
Diameter: 30.2 cm
Reg. no. 1887,0307.E158; presented by A.W. Franks, 1887
Hobson 1903, E 158

The haymaking scene on this large bowl is evocative of
English rural life in the eighteenth century. The beehive is
often found as an emblem of industry on both pottery and
enamels. The particularly dark blue is unusual for
delftware and the scene is unique.

The arms painted inside the bowl are those of the
family of Wise of Great Shelford, Cambridgeshire: *Per pale
[gules and sable] three chevronels ermine. The crest is Issuant
from a crest coronet [sable] a lion's head erased [argent] semy of
roundels [sable].*'[1]

The footrim is chipped and cracked; there are several
cracks around the rim indicating that it may have been
mounted after suffering damage. Delftware, as it is fired at
a relatively low temperature, is easily chipped and the
edges of plates and rims of bowls are rarely perfect.

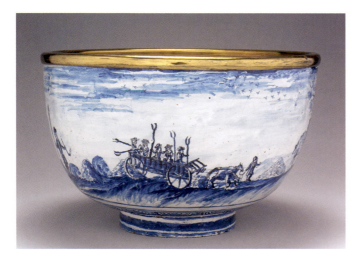

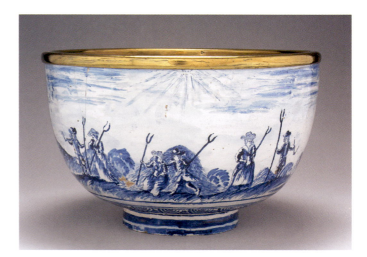

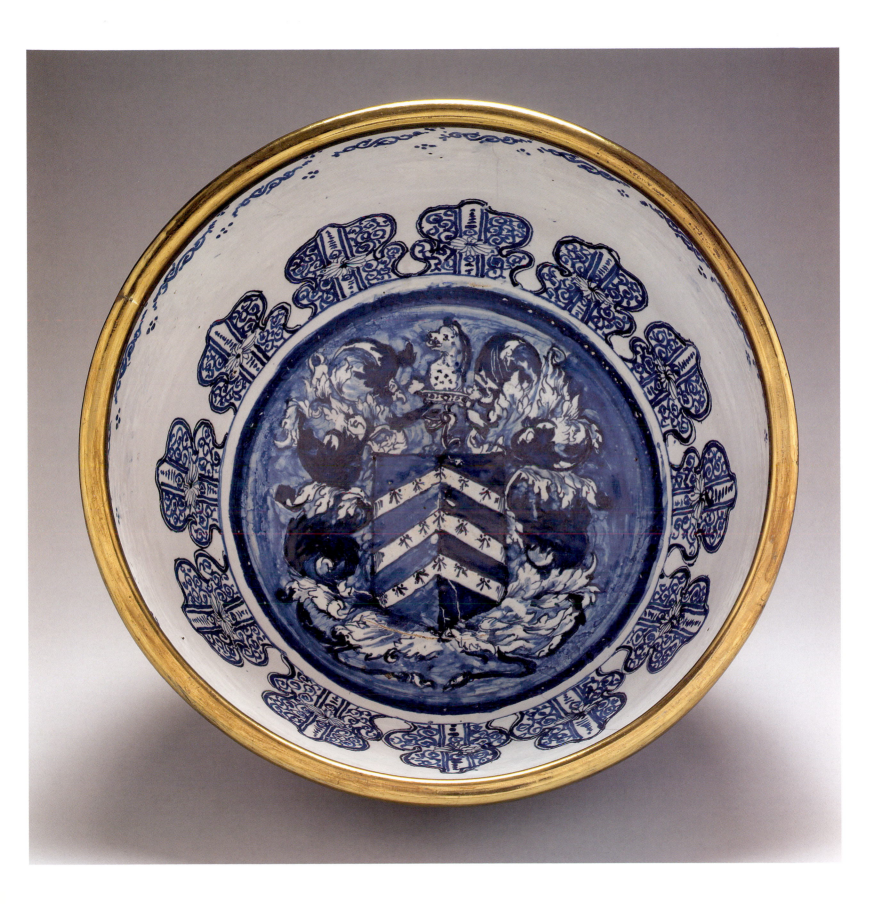

53 **Mug**, 1724

Made in England
Inscribed: 'THOMAS BILLING/1724'
Height: 16.7 cm
Reg. no. E109; presented by A.W. Franks, 1892
Hobson 1903, E 109; Tilley 1968a, pp. 126–7, fig. 3; Lipski and Archer 1984, no. 808

This mug of barrel form, which was probably intended for
beer, is painted with the arms of the Worshipful Company
of Carpenters: *a field silver, a chevron sable grailed and three
compasses of the same*, surmounted by a helmet and with
crest and mantling. The Company received its first charter
in 1477 and was granted arms in 1466.

The mug was probably made for Thomas Billing of
Weedon, Northamptonshire, a carpenter who died in
1728.[1] Although county records show that a Thomas
Billing, son of Mary of Northampton, was apprenticed in
February 1678 to Ambrose Davy, a gardener, and became a
freeman of the Borough of Northampton in June 1688, a
number of members of the Billing family, many called
Thomas, are recorded as carpenters and were free of the
Company, over several generations. It is possible that the
mug may have been made to celebrate Thomas Billing's
retirement from business in 1724 at the age of sixty, if he
began his apprenticeship at the usual age of fourteen.

The form, which has been thrown on the wheel, has
more in common with lead-glazed earthenwares than
delft. Barrel-shaped mugs in delftware are rare, although
they were made at several delftware factories. The form
may have been specially chosen as appropriate to a
carpenter.

For a barrel-shaped mug dated 1634, see no. 69.

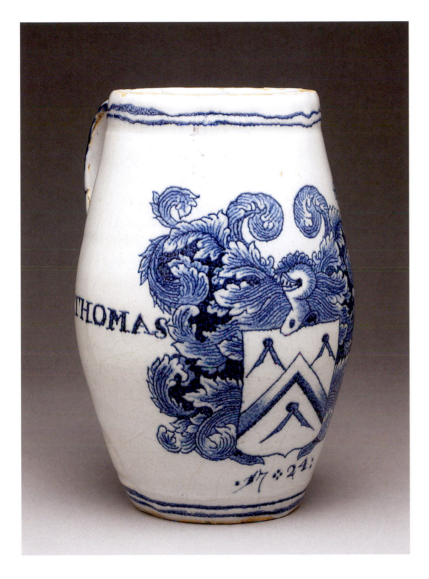 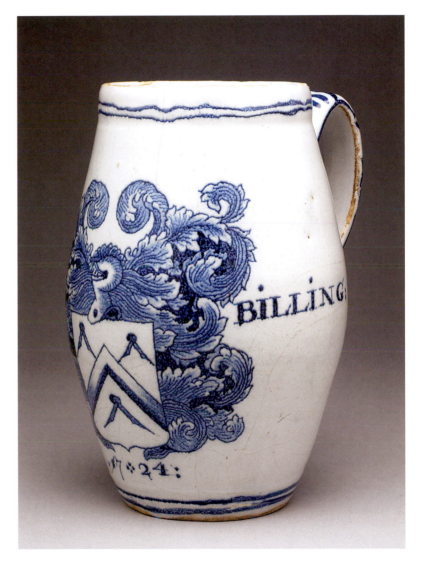

54 Mug, 1728

Made in England
Inscribed: 'H/RM' and '1728'
Height: 17.7 cm
Reg. no. 1887,0307.E40; presented by A.W. Franks, 1887
Hodgkin and Hodgkin 1891, no. 391; Hobson 1903, E 40; Lipski and Archer 1984, no. 815

This mug is exceptionally large and was probably intended for communal use. The shield imitates a coat-of-arms and the crest surmounting it is amusingly rendered by a boot on top of a basket. It is possible that the mug celebrates the marriage of a cobbler who would not have been able to bear arms and probably did not belong to a Livery Company. The basket could stand for his wife, but the identity of the couple is likely to remain unknown.

The Chinese-inspired decoration of a peacock among flowering branches is typical of English delftware dating from the 1720s. However, no place of manufacture can be securely given to this mug in the absence of any fragments found on a London, Bristol, Brislington or Liverpool delftware pottery site operating at this period.

Foot cracked.

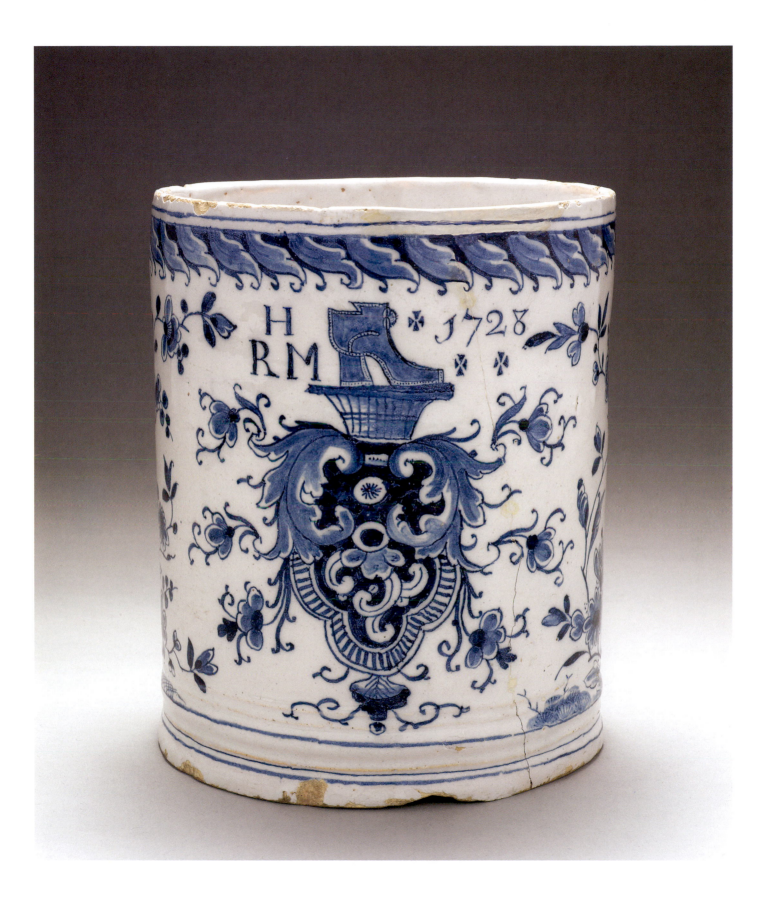

55 Bowl, about 1750-60

Made in London
Inscribed: 'WILLIAM GOODENOUGH GARDENER AT BARNS IN SURRY' inside the bowl
Diameter: 26.4 cm; height: 10.7 cm
Reg. no. 1887,0307.E82; presented by A.W. Franks, 1887; black printed labels 'Old English Pottery' and 'Lot 20'
Hobson 1903, E 82

Running round the bowl are painted rural scenes: a house; a man wearing a hat, pushing a wooden wheelbarrow loaded with three baskets towards a woman with a hoe and a seated man with a spade; and a woman with a basket on her head, near a plantation of trees at the edge of planted beds. She is accompanied by a boy carrying a tool over his shoulder. Behind her are three long rectangular beds. The garden appears to be walled, with a door.

Inside the bowl, the rim of which is painted brown in imitation of Chinese porcelain, is painted a shield of arms, which corresponds to that of the Worshipful Company of Gardeners, correctly described as follows: '*The field a landscape, the base variegated with flowers; a man proper, vested round the loins with linen argent digging with a spade, all of the first*'. The crest '*on a wreath, a basket of fruit, all proper*'. The supporters are two emblematical female figures with cornucopiae, representing plenty. The motto has been omitted, although there is a ribbon below the shield. The arms were used after the Company had gained its charter in the early seventeenth century, although they were not officially granted until the twentieth century. The Company bestowed freedom upon the completion of an apprenticeship, by patrimony or by redemption (i.e. purchase). Its writ covered the City of London and six miles thereabouts. It was concerned with 'the trade, craft, or misterie of Gardening, planting, grafting, setting, sowing, cutting, arboring, rocking, covering, fencing and removing of plants, herbs, seeds, fruits, trees, stocks, setts and or contriving the contrivances of the same'.

It seems likely that the bowl was commissioned by or for William Goodenough, who was probably a market gardener of some standing, perhaps when he was made a liveryman of the Gardeners' Company, or became one of its office-holders even though his name cannot now be traced in the records of the Company. Barnes, which is in west London, is part of a network of adjoining areas such as Hammersmith and Mortlake, all close to the River Thames, which were famous for their market gardens in the eighteenth century.[1] The William Goodenough mentioned under the date 1828 in the Rate Book for Barnes, where he is described as a market gardener, may be a descendant of William Goodenough, whose child Robert by his wife Mary was baptized on 18 August 1746 and was buried less than two weeks later on 30 August. Their daughter, Ann, was baptized on 25 June 1749 and was buried on 17 September that year. Mary Goodenough was buried on 21 June 1771 and William Goodenough on 13 February 1774.[2] William Goodenough is also recorded as Surveyor of the Highways and Poor Rate Assessor from 1754 to 1765 and as having given 10s 6d towards the parish church clock.[3] William Goodenough may have lived in Goodenough's Lane, now Grange Road, where a house known as The Grange was leased from the Hoare family in 1828. The Goodenough family business seems to have ended between 1841 and 1851.[4]

The lettering on the bowl is particularly well executed, and may perhaps have been painted by a letter-cutter rather than by the delftware painter who was responsible

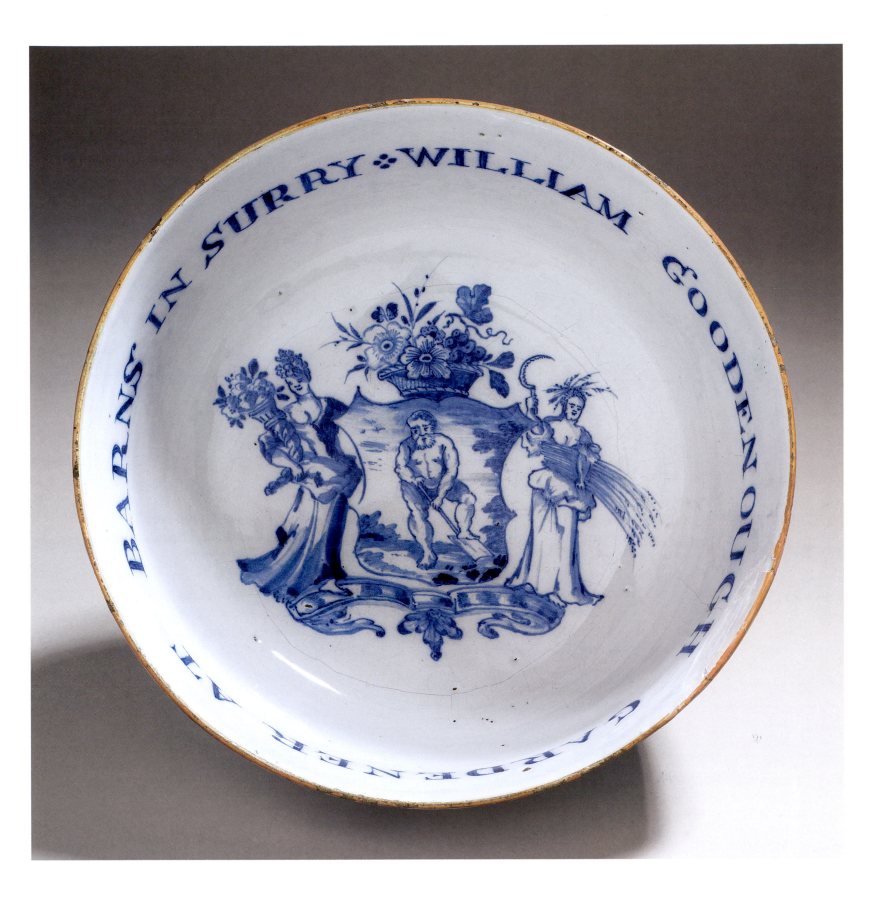

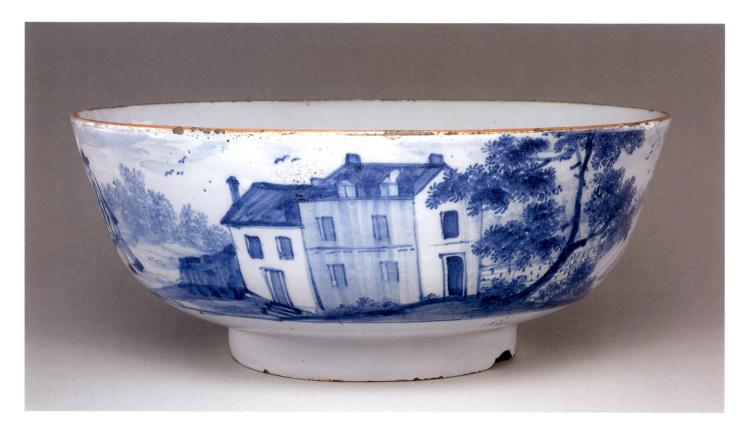

for the attractive rural scenes.

The foot of the bowl is damaged; rim restored; crack around base.

Another bowl now in the Allen Gallery, Alton, Hampshire, which is dated 1755,[5] painted in the centre with the arms of the Worshipful Company of Gardeners, inscribed in blue in a ribbon below the arms 'In the Sweat of thy Brow/Shalt thou Eat thy Bread', bears an amusing drinking inscription inside the rim: 'Immortal Punch That Elevates The Soul It Makes Us Demi Gods When O'er A Flowing Bowl'. The original owner of this bowl, painted on the exterior with Chinese landscapes in blue and manganese, is unknown; at some point, not long before 1984, it was in the collection of Tony Martin, Looe, Cornwall. A mug with the arms and the initials 'S/SM', dated 1731, is in the collection of the DeWitt Wallace

Decorative Arts Museum, Colonial Williamsburg, Virginia.[6] A plate in a private collection, also painted with the Gardeners' arms, is inscribed 'E/TW/1747'; two further matching plates are recorded, demonstrating that pieces, especially plates, were often ordered in sets.[7] In a period when gardening was becoming ever more popular, it is intriguing that several pieces survive bearing the arms of the Worshipful Company of Gardeners.

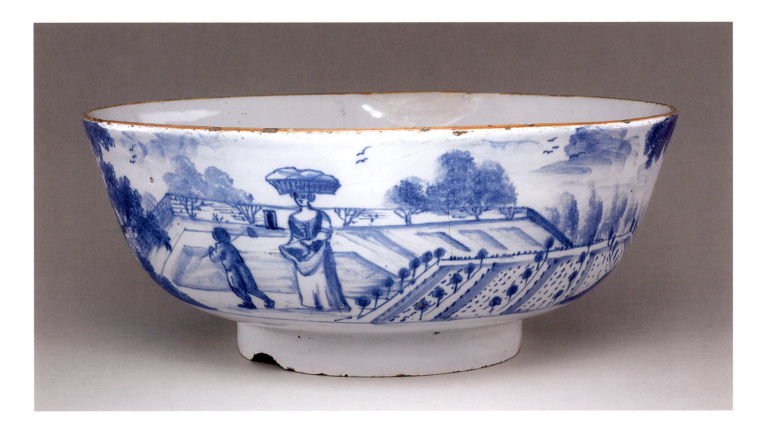

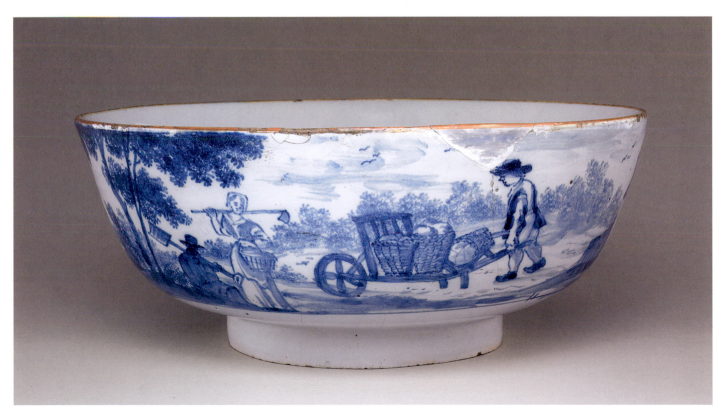

56 **Plate**, about 1760

Made in Liverpool
Diameter: 25.4 cm
Reg. no. 1887.0614.1; presented by Henry Willett, 1887
Hobson 1903, E 125

The complex decoration on this plate might suggest that it was printed rather than painted.[1] However, close study indicates that it has in fact been painted with a fine brush, a technique practised by skilled artists in the eighteenth century.[2] Rather than being printed from a copper plate, the complex armorial might have been drawn on a piece of paper which was then pricked and powdered pigment pounced through the holes.

The coat-of-arms below the design is that of the Premier Grand Lodge or 'Moderns', which imitates the arms of the stonemasons' guild of the City of London, and is surmounted by 'G' in a triangle within a glory representing Geometry and the 'Great Architect of the Universe'. The motto 'AMOR HONOR ET JUSTITIA', 'Love, honour and justice', can be paralleled on other Masonic items of this date. In the centre are: the rough and smooth ashlars, the chequered pavement, the candlesticks of the master and warden and the volume of the sacred law. These are the tools of craft masonry. Surmounting the cartouche is a master holding compasses, at the left is a beehive representing industry next to a set square. Either side of the cartouche are the senior and junior warden of the lodge next to their jewels of office, the level and plomb which are supported on brackets from which are suspended the crossed keys, the badge of the treasurer, and crossed quills, the badge of the secretary. Issuing from the cartouche are columns representing the orders of architecture, alternating with fronds.[3]

Masonic prints, but not this particular version, are found on both Liverpool and Worcester porcelains, as well as on creamwares from the mid-eighteenth century.[4]

Only one other plate like this is known. First recorded in 1928,[5] when its ownership was not noted, it was presumably the piece sold from the possession of Malcolm Mactaggart in 1959.[6] Its present whereabouts are unknown. It is referred to by Archer as part of the group of printed pieces.[7] However, careful examination reveals that the decoration on this plate differs in some minor details from that on the Museum plate, suggesting that it was done by hand rather than by a printing process.

Masonic delftwares are uncommon, although Leslie Grigsby has traced a plate with the Masons' arms and dated 1737,[8] inscribed 'Wincanton' on the back,[9] several pieces with Masonic symbols, and a further group with inscriptions.

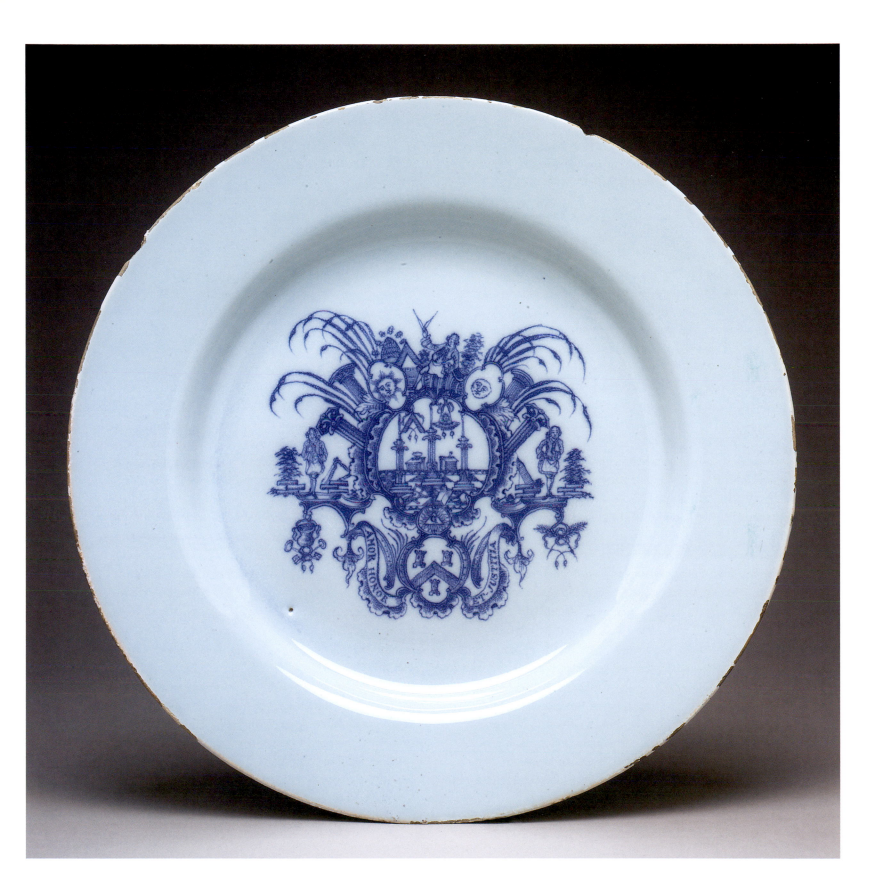

57 Plate, 1761

Made in Limerick, Ireland, factory of John Stritch and Christopher Bridson
Inscribed: 'Edmond Sex. Pery Esqr' in manganese on the front and 'Made by John Stritch/Limerick 1761', painted in blue on the reverse
Diameter: 22.7 cm
Reg. no. 1942,1208.1; presented by the National Art-Collections Fund (The Art Fund), 1942; Mrs Wilson Fitzgerald sale
Honey 1942, pl. LVIII; Tait 1957, pp. 53–4; Garner and Archer 1972, p. 72, pl. 131A; Francis 2000, p. 160

The coat-of-arms, printed in manganese and coloured in yellow and turquoise on a blue-grey ground, is that of Edmond Sexton Pery, later Viscount Pery (1719–1806), elected Member of Parliament for Limerick in 1760 and later Speaker of the Irish House of Commons (1772–85).

The three peony sprays on the border are printed in manganese and coloured in yellow and turquoise, and the rim is painted red-brown (rubbed and worn in many places). Part of the coat-of-arms, painted black, has been overfired and the glaze has bubbled.

Only five plates survive from the Limerick pottery,[1] which was founded before June 1761 and closed down in late 1763 or early 1764.[2] Three of these plates were first noted by W.B. Honey in 1942,[3] when they were purchased by a Mr H.E. Bäcker at a sale of the property of Mrs Wilson Fitzgerald of 42 Wilton Crescent, London SW. The Wilson Fitzgerald family apparently had connections with County Clare. There is another plate with the same arms but without the inscribed name in the National Museum of Ireland, Dublin, and a third with the arms of Francis Pierpoint Burton of Buncraggy, County Clare, who was also elected to the Irish House of Commons in 1760, as a Member for County Clare. A further two are decorated with the arms of the Fitzgeralds of Desmond, probably for Richard Fitzgerald, 22nd Knight of Glin, and with an unidentified coat-of-arms.[4] The plates were made with a view to securing the support of the Irish House of Commons and the Dublin Society, whose premium Stritch obtained in 1762.

The plates are the only known examples of transfer-printing on Irish delftware; in all only eight pieces of delftware bearing prints have been recorded.[5] Henry Delamain claimed in 1753 that he had 'purchased the art of printing earthenware', but so far there is no proof that he could and did print on pottery. In his discussion of these plates, Francis comments on the red-brown edge on the Limerick plates, which he considers may have been influenced by Bow porcelain made in London, where transfer-printing was done, and discusses the idea put forward by Mairead Dunlevy of the National Museum of Ireland that the plates might have been made in Dublin and decorated at the Limerick concern, a theory that he does not entirely discount.[6] The question of whether Stritch obtained the secret of transfer-printing from John Brooks, a Dublin engraver who is thought to have developed the process more than ten years earlier, or from Michael Hanbury, another Dublin engraver who was in fact in the city at that time,[7] or even from another source, has not yet been determined.

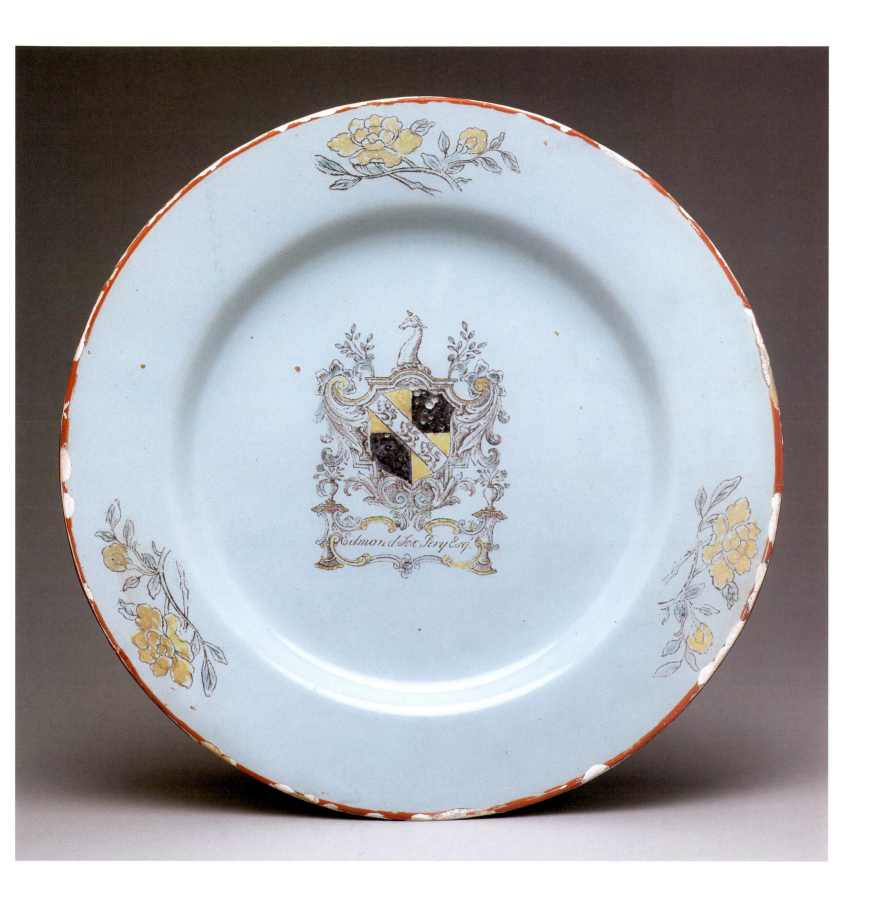

58 **Plate**, 1776

Made in England, perhaps at Mortlake pottery, Surrey
Inscribed: 'Joyn Loyalty and Liberty' on the front and '1776' on the reverse
Length: 21.8 cm
Reg. no. 1932,0314.1; presented by J.E. Pritchard, 1932
Tilley 1968, p. 129, fig. 12

In the centre of the plate is painted the coat-of-arms with supporters and motto of the Worshipful Company of Joiners and Ceilers: *gules a chevron argent between in chief two pairs of compasses extended at the points and in base a sphere or on a chief of the second a pale azure between two rose of the field barbed and sealed proper the pale charged with an esacallop also of the second* with the crest [*upon a helm on a wreath or and azure*] *a demi savage proper wreathed about the head and waist with leaves vert holding in the dexter hand over the shoulder a tilting spear or headed argent*. The arms were

granted in 1571; the origins of the company go back further. The motto 'Join Loyalty and Liberty', which has associations with John Wilkes (see no. 27), who was Master of the Company in 1774, dates from 1769 when it was substituted for an earlier motto. This is the latest of all delftwares bearing the arms of a Livery Company.

A matching plate in the Museum of London has a label on the back inscribed 'Specimen of china formerly in possession of a Mr. Gurney potter of Mortlake Surrey & supposed to have been made by him ...' There was a Joseph Gurney, who was apprenticed as a Joiner in 1734 and made free in 1749; and a Mr Gurney is recorded as having a good position at the Mortlake pottery in around 1820. His forebears may also have worked at the pottery, established in 1745 by John Sanders and subsequently carried on by his son William from 1752 until the mid-1780s.[1]

The plate has been repaired with rivets, probably before 1932 when it was acquired by the Museum.

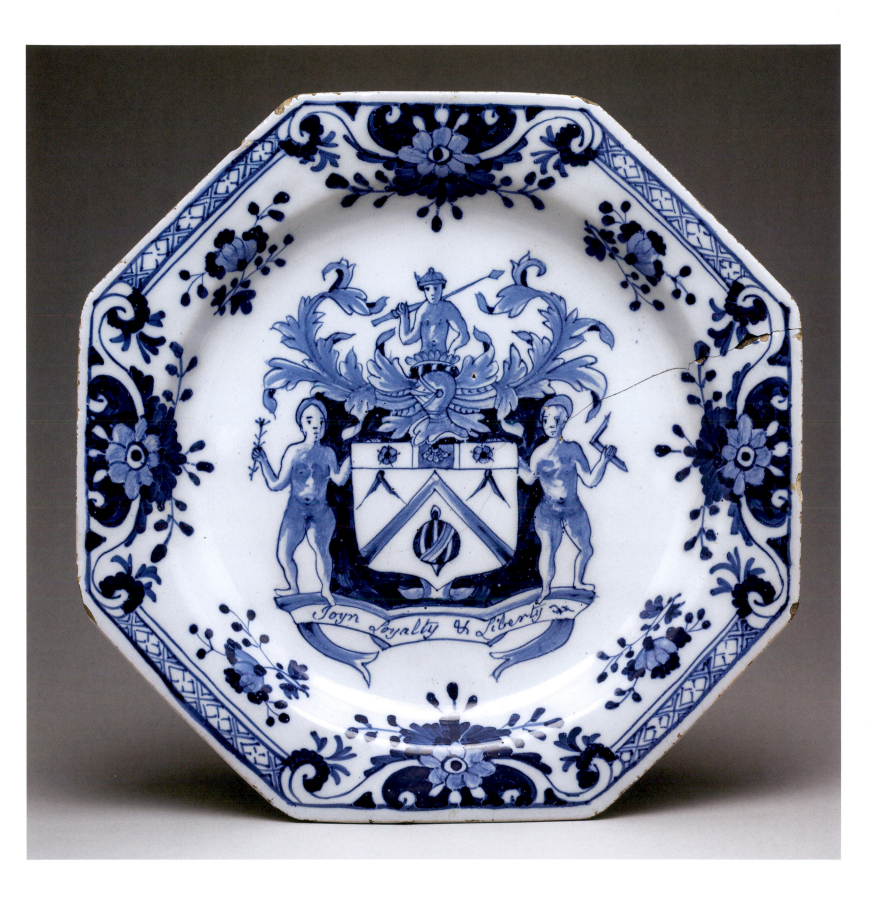

59 **Three storage jars**, first half of the seventeenth century

1 Made in Aldgate or Southwark, London, 1600–50, or in the
Netherlands
Height: 9.4 cm
Reg. no. 1899,0508.52; purchased, 1899; formerly in the
collection of Revd S.M. Mayhew
Hobson 1903, E 90; Archer 1973, no. 9

The unglazed base is inscribed in black ink 'Old Delft/
St Martins 90', perhaps indicating the time and place of its
discovery.

The squat form of this jar, which has thick, bubbled
glaze on the inner surface, with its distinctive Italianate
scroll decoration, derives from the Italian *albarello* or drug
jar. As Michael Archer pointed out in 1973, jars like this
were made in the Low Countries as well as in England; in
the absence of archaeological evidence it is impossible to
be certain where this pot was made. Like the other jars, it
may well have been used to store dry drugs, ointments or
cosmetics, but could have held other substances, such as
spices or conserves.[1] The jars were sealed with leather
shrunk to shape, or with wax-coated paper, parchment or
cloth tied around the rim. In the early years of the
delftware industry in London they were a mainstay of
production to judge from the large number of surviving
examples, many of them undecorated.[2]

2 Possibly made in Southwark, London, about 1600–50
Height: 5.8 cm
Reg. no. 1856,0701.1649; purchased from the collection of
Charles Roach Smith, 1856, found in London
Hobson 1903, E 92

The decoration of blue arcs enclosing pyramids in yellow
between blue bands is found in different colour
combinations and with slight variations on other small
pots like this example, which may be a waster as it has an
irregular foot and neck and a scar on the side. It could
therefore have been discarded as unsaleable.

3 Possibly made in Southwark, London, 1600–50
Height: 5.3 cm
Reg. no. 1856,0701.1646; purchased from the collection of
Charles Roach Smith, 1856, found in London
Hobson 1903, E 95

Banded decoration in yellow and blue like this cannot be
securely ascribed to any particular pottery in London. The
glaze is mottled blue inside the pot and the foot is
irregular.

60 **Drug pot**, about 1630

Made in Southwark, London, probably at Christian Wilhelm's Pickleherring pottery
Height: 10.8 cm
Reg. no. 1899,0508.49; purchased, 1899, formerly in the collection of the Revd S.M. Mayhew, found in London
Hobson 1903, E 106; Tait 1961, pp. 26–7, fig. 30

This small drug jar, shaped rather like an Italian *albarello*
(drug jar) is painted in blue with the same type of so-called
'bird-on-the-rock' pattern as the jug dated 1628 (no. 66),
which was acquired by the Museum two years earlier in
1897. It is also related to the posset pot and cover dated
1632 (no. 68) in the Museum collection since 1887. The
discolouration is likely to be the result of the pot having
been buried, but its earlier history is unknown. It has a
hole in the base, and so perhaps was a waster, or pot that
was spoiled in the final firing, although biscuit wasters are
more usual, and so was thrown away and dug up much
later.

There was evidently a huge demand in the sixteenth
and seventeenth centuries for pots to hold various
different preparations for sale by apothecaries and others,
as a large number of straight-sided pots like this, as well as
spouted vessels for syrups, have survived. From the mid-
seventeenth century, many were inscribed with the names
of drugs (see no. 61) and others had elaborate decoration
(see no. 50, for instance). Wet and dry drug jars were the
chief item of production in some delftware potteries
during the seventeenth and eighteenth centuries.[1] For a
discussion of this subject see Archer 1997, pp. 377–80.

61 Two dry drug jars, a pill jar and two wet drug jars, mid-seventeenth to early eighteenth century

1 Dry drug jar
Made in England, 1683
Inscribed: 'C.ABSYNTHII' in a label and 'TG /1683'
Height: 17.7 cm
Reg. no. 1887,0307.E74; presented by A.W. Franks, 1887
Hobson 1903, E 74; Lothian 1955, p. 733, fig. 10; Lipski and
Archer 1984, no. 1651

The drug *conserva Absinthii*, or conserve of wormwood,
was described by John Quincy in *Pharmacopoeia Officinalis
et extemporanea, or, a compleat English Dispensory*, London,
1718, as a 'Stomatick', 'good in all Disorders of the *Liver*',
which 'abates Pains and Wind in the Stomach and
Bowels'. Although wormwood in its pure form, prepared
from the flowering tops of *Artemisia absinthium*, is
poisonous, it is still in medical use.[1]

The initials 'TG' are probably those of the owner of the
pharmacy for which the jar was made and thus of the
person who formulated the drug kept in this dry drug jar.
The motif above and below the label is known as the 'angel
with outspread wings', which is first recorded on a drug jar
dated 1659 and is still common on examples dating up to
the late seventeenth century. The angel's head is almost
always shown full-face, rather than in profile as here.

2 Wet drug jar
Made in London, 1660
Inscribed: 'STVSSILAGIN' in a label and 'RT/1660'
Height: 21.1 cm
Reg. no. 1887,0307.E72, presented by A.W. Franks, 1887

Hodgkin and Hodgkin 1891, no. 305; Hobson 1903, E 72; Lothian
1955, p. 732, fig. 1; Lipski and Archer 1984, no. 1600

Syrup of coltsfoot (*syrupus Tussilaginis*) was used to treat
coughs and other lung conditions. It was prepared using
the juice from the leaves of coltsfoot (*Tussilago farfara*),
boiled up with syrup. The motif above the label is known
as the 'angel with outspread wings' (see above).

Handle missing.

3 Pill pot
Made in London, 1675
Inscribed: 'P:IMPERIAL' and 'EP/1675'
Height: 9.2 cm
Reg. no. 1957,1201.21; presented by A.D. Passmore, 1957;
according to Tait,[2] this drug jar was said to have been found in
the River Thames, London, in about 1875 and was in the
collection of Mr Freeth, of Calcutt Farm, Cricklade, from whom
Mr Passmore purchased it in 1906.
Tait 1958, p. 82; Tait 1962, pp. 41–2, pl. XVIa; Lipski and Archer
1984, no. 1636

Pilulae Imperialisor, Imperial Pills or Pills of the Emperor,
were used as an aperient or laxative. They were made by
combining syrup of violets with aloes, rhubarb, agaric,
senna, cinnamon, ginger, nutmeg, clove, spikenard and
mastic.[3] The resulting mass was rolled, cut and rounded to
form pills.

A drug jar of identical size and design, dated 1675 and
with the same initials 'E.P.', inscribed 'T: ALHANDAL',

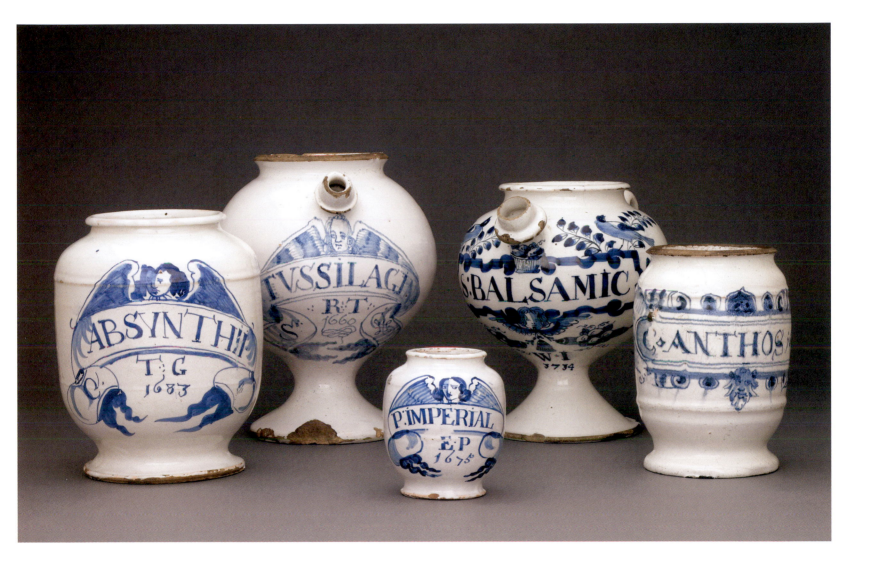

which was clearly part of the same set, was sold from the collection of Geoffrey C. Howard in 1956.[4]

For the motif above the label, see above.

Apothecaries might have more than seventy jars with matching cartouches, ranging from pill pots to large display jars. The largest matching set is in the Wilkinson Collection, now at the Thackray Medical Museum, Leeds.[5]

4 Wet drug jar
Made in London, 1714
Inscribed: 'S BALSAMIC' and 'WI /1714'
Height: 18.7 cm
Reg. no. 1887,0307.E75; presented by A.W. Franks, 1887
Hodgkin and Hodgkin 1891, no. 386; Hobson 1903, E 75; Lothian 1954, p. 673, fig. 3; Lipski and Archer 1984, no. 1665

Syrupus balsamicus, or balsamic syrup, is prepared from *Myroxylon balsamum,* originally known as *Myroxylon toluifera,* from the province of Tolu, near Cartagena, Colombia. It is boiled up with water, strained and then boiled with sugar to make a syrup, which is used for coughs.

The motif of birds and leaves painted at the edge of the label and a flower basket in the centre is associated with drug jars made in the first decades of the eighteenth century.

5 Dry drug jar
Made in Southwark, London, perhaps Rotherhithe pottery, 1652
Inscribed: 'C.ANTHOS 1652'

Height: 15 cm
Reg. no. 1887,0307.E71, presented by A.W. Franks, 1887
Hodgkin and Hodgkin 1891, no. 281; Hobson 1903, E 71; Lothian 1950, figs. 1B, C; Lothian 1953, p. 2, no. V, a, b; Lothian 1955, p. 566, fig. 2a, 2b; Drey 1978, pl. 67A; Lipski and Archer 1984, no. 1595; Grigsby 2000, D397

Conserva Anthos, or conserve of rosemary, was described in 1652 by Nicholas Culpeper in *The English Physitian* (London, 1652) as 'singular good to comfort the Heart, and to expel the contagion of the Pestilence'.

The motif to either side of the label is known as 'the pipe-smoking man', although it may in fact be a man sticking out his tongue. It was first recorded on a mug dated 1634 (see no. 69); it occurs most commonly on jars dating to the 1650s but is far rarer than other motifs such as the 'angel with outspread wings'. A fragment from a drug jar showing part of a head and part of a cartouche, excavated at Rotherhithe (not seen by the writer), might suggest that the Museum jar was made at Rotherhithe.[6]

A small squat jar with the same inscription and '52', presumably for the year of manufacture, 1652, is in the Museum of the Royal Pharmaceutical Society of Great Britain,[7] but the authenticity of this piece has been questioned.

62 **Barber's bowl,** about 1710–20

Made in England, possibly at Brislington
Inscribed: 'SIR YOVRE QVARTER IS VP'
Diameter: 27.2 cm
Reg. no. 1887,0210.131; purchased from the collection of Henry Willett, 1887
Hodgkin and Hodgkin 1891, no. 418; Hobson 1903, E 43; Archer 1997, F.53; Grigsby 2000, D413

At the left, on the broad rim of the bowl, is a depression for a soap ball. The customer held the curved indentation to his neck, the bowl serving to hold water and soap to make a lather for shaving.

The painted decoration depicts the barber's implements: a comb, scissors, a cutthroat razor, two shaving brushes, two washballs (soap), a lancet (barbers were often also surgeons and could let blood) and what looks like a small comb, perhaps for a moustache.

The inscription refers to payment due from those regular customers who settled their accounts quarterly. It is also a pun on the term for clemency or mercy.

There is a similar barber's bowl with the depression on the upper right side and slightly different barber's implements in the Victoria and Albert Museum collection, acquired in 1869 and attributed to Brislington.[1] Another, which is almost identical to the Museum example, was sold on the London market in 1993.[2]

The Worshipful Company of Barber-Surgeons was established in 1540. It was not until 1745 that the surgeons broke away to form their own Livery Company.

63 Five ointment pots

Made in London, late eighteenth to early nineteenth century

1 Inscribed: 'Hastings & White/Hay17 Market', painted in blue, about 1825
Diameter: 6 cm
Reg. no. 1887,0210.129; purchased from the collection of Henry Willett, 1887
Hobson 1903, E 79; Lothian Short 1976, p. 70, pl. 31c

This small ointment pot is much rarer than many other pots of this type. Used by apothecaries, dentists and perfumers for ointment, bear's grease and tooth powders, pots with inscriptions like this one were usually, but not always, made for London retailers (see below). The business originally owned by J. Hastings, and listed in *The Post-Office Annual Directory* for 1808 as 'Chemist and Druggist' at 17 Haymarket, London, had obtained royal patronage by 1811 under the name I.H. Hastings. It is listed in *Holden's Annual Directory* for that year as 'chemist to their Royal Highnesses, the Prince of Wales, Princess Charlotte of Wales and the Duke of Kent'. The firm had become Hastings & White by 1816, when it is recorded in *Kent's Original London Directory* at the same address.[1]

2 Inscribed: 'Grindle/Pall Mall', painted in blue, probably about 1790–1800
Diameter: 5.7 cm
Reg. no.1896,0201.59; presented by A.W. Franks, 1896
Hobson 1903, E 85; Lothian Short 1976, p. 70, pl. 31b

John Grindle is listed in *The London Directory for the Year 1790* as 'chemist to the Prince of Wales', at 2 Haymarket,

London. The royal patronage seems to have lapsed by 1794 when the address is listed in *Kent's Directory for the Cities of London & Westminster and the Borough of Southwark*. By 1808 the business had moved to 132 Pall Mall, where it is listed in *The Post-Office Annual Directory*. The firm was still in existence in 1851 although the premises had been moved to 122 Pall Mall by 1841.[2]

The foot and rim are damaged.

3 Inscribed: 'DELESCOT', painted in blue, about 1800–10
Diameter: 5.7 cm
Reg. no. 1896,0201.58; presented by A.W. Franks, 1896
Hobson 1903, E 86

Delescot, an apothecary at 19 Duke Street, Pall Mall, London, patented a 'Conserve of Myrtle Opiate' in 1749. Pots inscribed with his name are known in two sizes: this is the larger. The opiate is still listed in the House of Commons *Journal* of 8 April 1830, which gives the rates of duty for all the patent medicines sold at this time. Duke Street was demolished in 1835, when Lower Regent Street and Waterloo Place were built.[3]

Rim damaged, loss of glaze on pot.

4 Inscribed: 'White Chemist 8 Haymarket', painted in blue, about 1800
Diameter: 6.1 cm
Reg. no. 1887,0210.128; purchased from the collection of Henry Willett, 1887
Hobson 1903, E 78; Lothian Short 1976, p. 70, pl. 31d

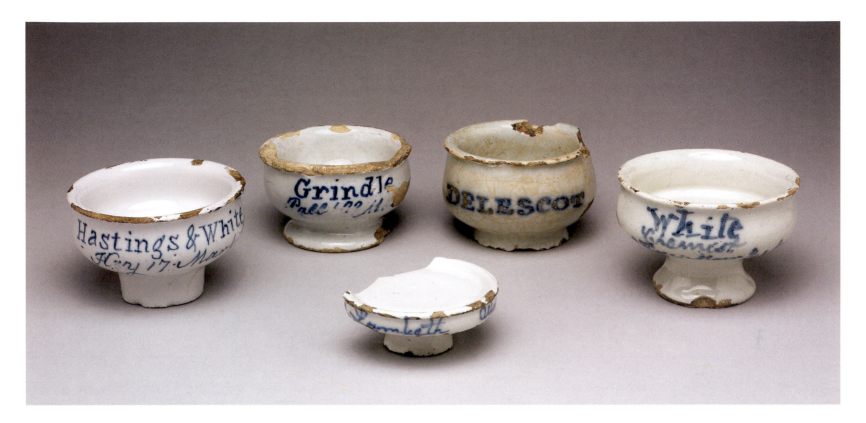

William White, initially at 8 Haymarket, operated as Hastings & White at 17 Haymarket, London in 1816 (see no. 1). In *Kent's Original London Directory* for 1827 he is listed as 'chemist to His Majesty' at 8 Haymarket. Almost two decades later he was apparently still in business as he appears in the commercial section of the *Post Office London Directory* for the year 1846. White enjoyed the patronage of King George IV (1762–1830; reigned 1820–30) and Queen Victoria (1819–1901; reigned 1837–1901) according to the trade directories.

Although this appears to be a rare pot, there are other examples in private possession.[4]

Foot damaged.

5 Inscribed: 'Lambeth All S Folgha-', painted in blue, about 1816–25
Diameter: 5.1 cm
Reg. no. 1887,0307.E80; presented by A.W. Franks, 1887
Hobson 1903, E 80

William Singleton Folgham inherited the recipe for Singleton's eye ointment, based on a formula devized by a Lambeth doctor, Thomas Johnson.[5] The ointment was sold by Thomas Singleton (1700–1779), who was based at Lambeth Butts, as early as the 1770s, remaining on the market through Thomas's son, William, from 1779 to 1807. An undated handbill advertizes 'Dr Johnson's Yellow Ointment' for sale by William Singleton of No. 2 Union Place, Lambeth at the high price of one shilling and nine pence. The handbill demonstrates the wide distribution of the ointment from Exeter to Yorkshire.[6] Singleton's daughter Selina continued the trade, passing it in 1816 to her son by Timothy Folgham (died 1805), William Singleton Folgham, who died in 1825. Selina later married the potter Stephen Green, who inherited a share of the business on her death in 1831 and later purchased the rest, enjoying considerable success with the product.

Broken.

64 Two honey pots and a storage pot, about 1845

Made in Vauxhall, London, Glasshouse Street pothouse, about 1845
Height: 14.9 cm; 8.5 cm; 5.4 cm
Reg. no. 1888,1110,21 (large honey pot with handles) and 22; OA 7638 (storage pot); honey pots presented by A.W. Franks, 1888,
formerly in the Octavius Morgan collection;[1] provenance of storage pot unknown
Hobson 1903, E 164, E 165

The label on the base of the large honey pot with handles, inscribed in ink, gives useful information about these pots: 'Honey Pot/made at Vauxhall/Pottery about 1845-/when this part of the ma/nufactory was given up./Honey called "minorca" honey was sold in these pots-/but whether either pots/ or Honey saw/ Minorca may be/questioned.'

These pots represent the final phase of delftware production, which had declined from the last decades of the eighteenth century until only a few concerns were still in production in the nineteenth century. Delftware, which is fragile and porous by comparison with cream-coloured earthenware, was made for little except ointment pots and other wares for the pharmacy, and some utilitarian domestic wares. Glazed turquoise inside, as well as on the upper part of the exterior surface, these pots were made at the Glasshouse Street pothouse, Lambeth, which had three incarnations.[2] The map published by John Roque in 1746 shows the 'Pot House' (see fig. 2), the site of the factory. The pottery produced tin-glazed wares in its last few years, between 1823 and 1846, when it was under the ownership of John Wisker, who died in 1835. For the next eleven years it was managed by Alfred Singer. The site was excavated in 1980, 1987 and 1989 and has recently been written up.[3] Ointment pots with a dark blue glaze on the outer surface and pale blue on the inside, unglazed wine and butter coolers, and tiles were found, but no pots like these seem to be recorded.

Minorcan honey from the Balearic Islands was famous from the fifteenth century and was exported in considerable quantity in the nineteenth century. It was considered the best foreign honey and retailed in London at two shillings and sixpence per pound, considerably more than native honey.[4] Honey was used medicinally in the nineteenth century, as it is today, and a white earthenware honey jar with cover, decorated with a blue marbled pattern, which probably dates from around the time of these turquoise pots, is in the collection of the Wellcome Institute for the History of Medicine.[5] The turquoise pots could well have been used in a pharmacy rather than in the home.

65 Tankard or jug, about 1560–75

Made in the Low Countries, probably Antwerp; silver-gilt mounts hallmarked for London, 1581; maker's mark of a fleur-de-lis and the initials 'WHE'
Height: 24 cm
Reg. no. 1987,0702.1; acquired with funds from the National Heritage Memorial Fund, 1987; formerly in West Malling Church, Kent, sold Christie's, 19 February 1903, lot 87 to Crichton for 1,450 guineas; acquired by J.A. Holms and subsequently in the collection of Sir John Crichton-Stuart, 6th Marquess of Bute
W.A. Scott Robertson, *Church Plate in Kent*, London, 1886, p. 53, engraving on p. 19; W.J. Cripps, *Old English Plate, ecclesiastical, decorative and domestic, its makers and marks*, London, 6th ed., 1899; engraving on p. 281; Sir Charles Jackson, *A History of English Plate Ecclesiastical and Secular*, London, 1911, p. 779, fig. 1012; Honey 1933, p. 36; Hume 1977, pp. 2–3; T. Wilson in 'Recent acquisitions of Post-Medieval Ceramics and Glass in the British Museum's Department of Medieval and Later Antiquities (1982–87)', *Burlington Magazine*, vol. CXXX, no. 1022 , May 1988, p. 399; Hughes and Gaimster 1999, pp. 61–2, fig. 3.3

The tankard has been known since the late nineteenth century, when it was in West Malling Church, Kent. It was sold in 1903 and has given its name to this group of jugs. The practice of mounting in silver precious Chinese porcelain and Rhineland stoneware pieces was widespread in the sixteenth century,[1] but few tin-glazed earthenware pieces were furnished with valuable mounts in this way. The mounts, which are dated from as early as 1549–50, are generally an indication of how highly the pieces were prized. The Museum tankard has evidently been considered a rarity since the late sixteenth century, and at times in its history has been thought to be amongst the earliest of all tin-glazed earthenware made in England.[2] However, recent opinion favours a Low Countries origin. At one time no comparable pieces were known from Low Countries sites, and some had been found in London and elsewhere; fragments have subsequently been discovered in Antwerp and a document of 1549 has been shown to refer to their production in Antwerp. Neutron activation analyses (which did not include samples from this jug) confirmed that the composition of pieces of this class corresponds to an Antwerp production centre.[3]

There are four further mounted jugs with mottled glazes in the Museum collection (see below).[4]

 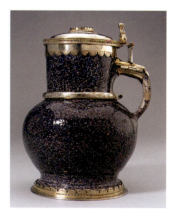

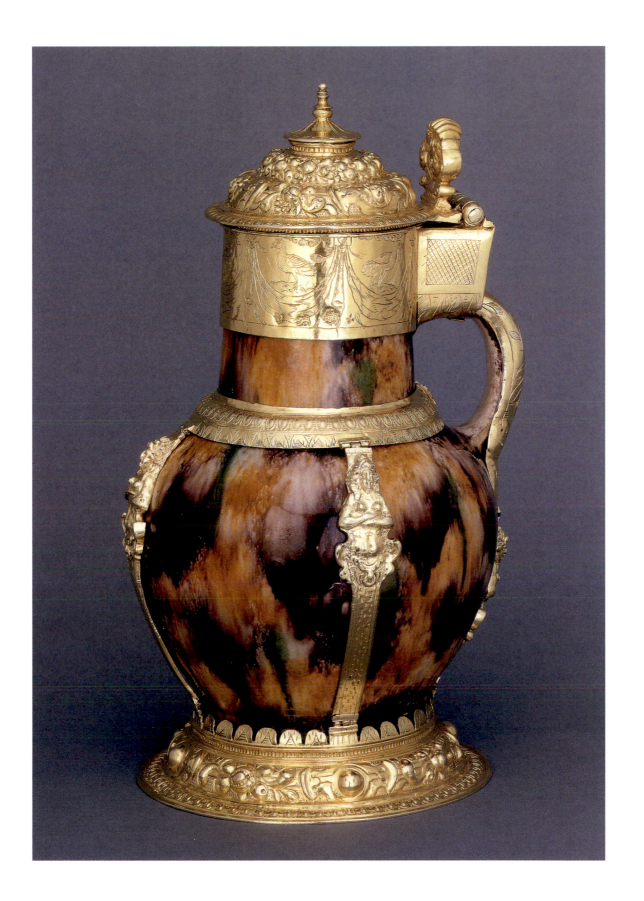

66 Wine bottle or jug, 1628

Probably made at Christian Wilhelm's factory, Pickleherring Quay, Southwark, London
Inscribed: '1628' above a paraph, painted in blue below the handle
Height: 18.4 cm; width (max. incl. handle): 14.3 cm
Reg. no. AF 3204; bequeathed by A.W. Franks, 1897
Tait 1960, p. 37, figs 3a, b; Imber 1968, p. 112 and pl. 47; Morgan 1977, p. 19, fn 4; Lipski and Archer 1984, p. 309, fig. 1251

Jugs like these were probably used to decant and serve wine from casks, as they are similar in shape to stoneware examples made in the Rhineland, Germany. These were copied in England at John Dwight's factory in Fulham in the late seventeenth century. Delftware examples are far rarer, but there is a very similar jug bearing the same date in the Fitzwilliam Museum, Cambridge,[1] and another dated 1628 was in the Goldweitz Collection,[2] while further examples are located in the Museum of London,[3] the

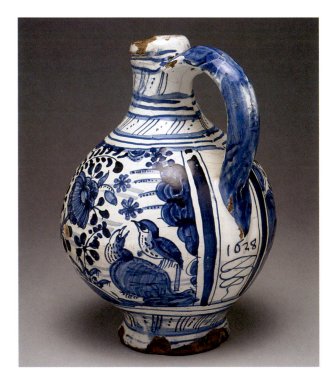

Morgan Collection (now in the Longridge Collection, USA),[4] and the Rous Lench Collection.[5] There is another in the Longridge Collection,[6] and a sixth example was found in 1998 during excavations by London Underground for the Jubilee Line, suggesting that these jugs might have been made in some quantity. As delftware is much more fragile than stoneware, it is perhaps not surprising that few have survived.

The painted design has become known as the 'bird on rock' pattern and is loosely based on Chinese blue-and-white porcelain of the late Ming Dynasty (1368–1644). It was evidently popular as it persisted until the early 1640s, on the evidence of other dated pieces, fulfilling a demand for imitations of the precious porcelains. Kiln wasters, or parts of pots that had been damaged during the making process, have been found at Potter's Fields, Southwark,[7] suggesting that they were made nearby. Although the motif is now firmly associated with Christian Wilhelm's pottery, its origin was thought by the Museum authorities up to the mid-twentieth century to be possibly French.[8]

The date on this piece shows that it is probably an early production of Christian Wilhelm's pottery, located close to Pickleherring Quay, Southwark, on the south bank of the Thames. In 1628 Wilhelm, an immigrant from Germany or the Low Countries, was granted a patent for fourteen years for the manufacture of 'galliware', or tin-glazed earthenware, which he had been making in London since at least 1618.

Three chips to foot, loss of glaze to top of neck.

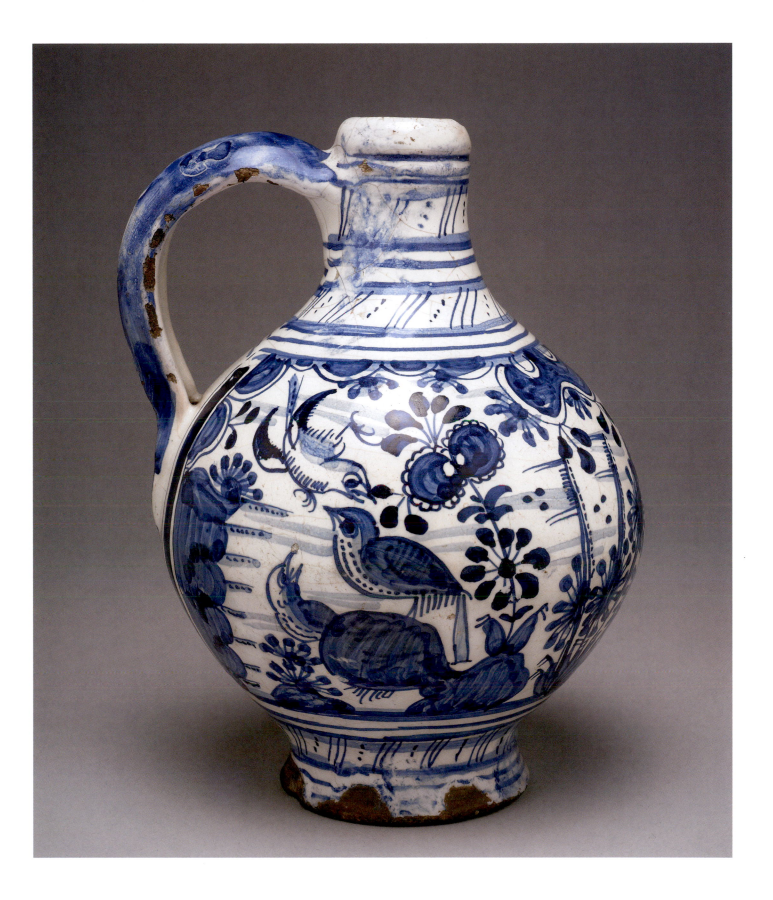

67 **Fuddling cup**, about 1630–40

Made in Southwark, London
Height: 7.8 cm; width (max.): 11.8 cm
Reg. no. 1887,0201.121; purchased from the collection of Henry Willett, 1887
Hobson 1903, E 2

Inside each of the three cups, down below, is a circular pierced hole, except in one cup where the hole was not properly pierced through when the piece was at the leather-hard stage before firing. The cups held liquor and were intended to confuse the drinker who drank more than he anticipated, and so was 'fuddled'. The term 'fuddling cup' has not been found in seventeenth-century inventories, but could have been in use nevertheless. Dated examples of cups like this are known between 1633 and 1649. Some examples have four, or even five cups and some, such as Staffordshire and West Country slipware examples, have ten.[1] Fuddling cups were also made in porcelain both in England, at Bovey Tracey, Devon,[2] and on the Continent, at Höchst, Frankfurt am Main, Germany, and no doubt elsewhere.

The glaze, as on many other contemporary white delftware pieces, has a pinkish tone.

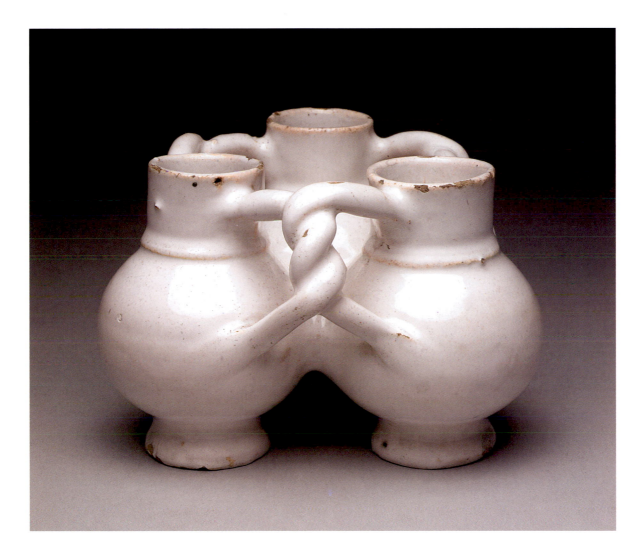

68 Posset pot and cover, 1632

Probably made at Christian Wilhelm's pottery, Pickleherring Quay, Southwark, London
Inscribed: '1632' painted in blue under the handle and '1632' above a paraph inside the cover
Height (incl. cover): 21 cm; width (max. incl. handles): 22 cm
Reg. no. 1887,3-7.E101; presented by A. W. Franks, 1887
Hobson 1903, E 101; Tait 1960, p. 38, fig 8 a, b; Warren 1983, p. 835, figs. 2,3; Lipski and Archer 1984, p. 200, fig. 887

Two-handled pots and covers with a spout at the front, like this example, which has a pinkish glaze and a concave base, were used for drinking posset, a warm milky drink made with ale or wine to which sugar and spices were often added. As the warmed

milk curdled, the curd rose and the whey, which contained the alcohol, could be drunk from the spout. It was a delicacy, and was also used as a remedy for colds and other illnesses, as well as on festive occasions. The existence of large elaborate posset pots as well as plain undecorated ones shows that they were used both publicly and privately.[1]

There is another similar pot and cover inscribed 'Stephen Gardner 1631' in the Glaisher Collection at the Fitzwilliam Museum, Cambridge, and further examples are in the Boymans-van Beuningen Museum, Rotterdam and the Longridge Collection, USA (formerly in the Lipski and Kassebaum collections).[2] On each of these the painted decoration inspired by late

Ming porcelain is in a band enclosed by lines and a geometric motif, and appears to be a variation on the 'bird-on-rock' pattern, which is painted on the jug, no. 66, and the drug pot, no. 60, and in a rather schematic form on no. 73. The same pattern is used on a jug with a pewter mount in Manchester Art Gallery.[3]

The upper part of the knop has been broken off, the upper part of the spout is missing and the rim of the cover is damaged.

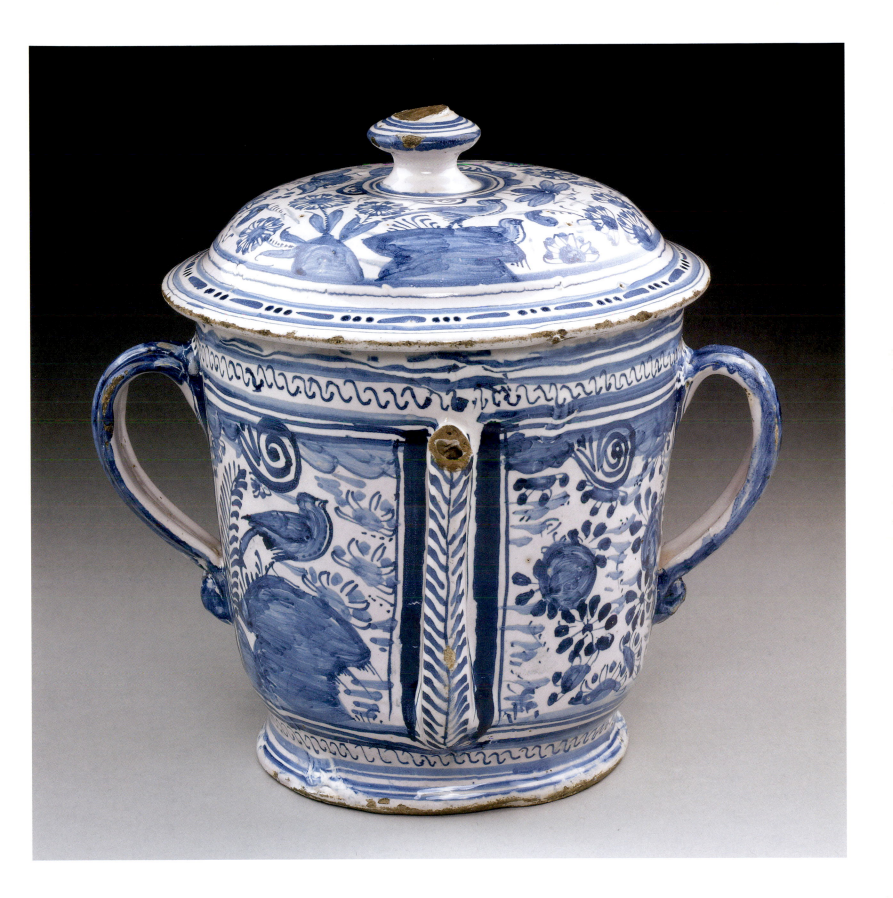

69 Mug, 1634

Made in Southwark, London
Inscribed: 'JOHN LEMAN 1634'
Height: 13.2 cm
Reg. no. 1887,0210.117; purchased from the collection of Henry Willett, 1887
Church 1884, p. 38; Hodgkin and Hodgkin 1891, no. 231; Hobson 1903, E 37; Lipski and Archer 1984, no. 714

The barrel-form mug has been turned at the neck as a form of decoration. Barrel-shaped mugs without the turned neck, or with only two raised rings on the neck, were made at several delftware factories in London between 1624 and 1642 in a range of slightly differing forms and with varying decorative schemes.[1] For an example painted with the arms of the Worshipful Company of Carpenters, see no. 53.

The emblem of the so-called 'pipe-smoking man', or man with a protruding tongue, found at either end of the label containing the inscription, appears early on drug jars with inscriptions. Below the grotesque bearded head is a thistle and above it a stylized plant. This is one of the earliest uses of this peculiar decorative motif, which becomes more common on drug jars made during the Commonwealth period (see no. 61).

The identity of John Leman remains uncertain, but he may perhaps have been the Suffolk squire born in 1633, whose family had strong connections with the City, as suggested by the late Frank Britton. Sir John

Leman was a member of the Worshipful Company of Fishmongers and became Master in 1624. He served as Sheriff of the City of London and was elected Lord Mayor in 1616–17. There is a Leman Street north of the Tower of London, which is said to derive its name from this family. He died in 1632, without issue. Brampton Manor in Suffolk, which he had purchased in 1606, passed to his nephew, Thomas Leman, and then to John Leman in 1643. John Leman died in 1670. It is possible, as suggested by Frank Britton,[2] that the mug may have been a christening present.

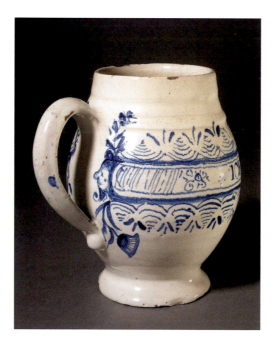
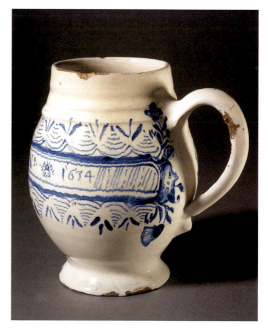

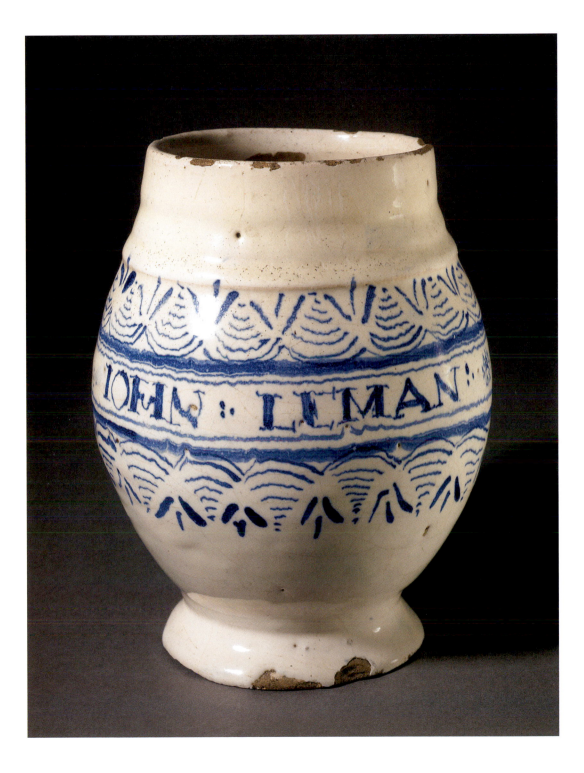

70 **Three wine bottles**, 1639–41

1 Made in Southwark, London, 1639
Inscribed: 'B/IF/1639'
Height: 13.2 cm
Reg. no. 1896,0807.9; presented by A.W. Franks, 1896
Hobson 1903, E 15; Lipski and Archer 1984, no. 1255

The earliest dated delftware wine bottle is inscribed 'B/WM/1621'.[1] As Lipski and Archer pointed out in their discussion of 'Redecoration and later inscriptions', plain white bottles were embellished from at least 1891.[2] On balance, this example is considered to be genuine as it shows no signs of having been refired. Undecorated wine bottles, which must have been far more common than the inscribed ones, are now rare (see fig. 9).[3] The initials, probably those of a couple, remain unidentified.

Foot damaged; chips to rim.

2 Made in Southwark, London, 1640
Inscribed: 'E*C/1640'
Height: 15.7 cm
Reg. no. 1896,0807.10; presented by A.W. Franks, 1896
Hobson 1903, E 17; Lipski and Archer 1984, no. 1258

3 Made in Southwark, London, 1641
Inscribed: 'RENISH WINE' and 'S/RE', '1641'
Height: 13.2 cm
Reg. no. 1887,0307.E18; presented by A.W. Franks, 1887
Hodgkin and Hodgkin 1891, no. 235; Hobson 1903, E 18; Lipski and Archer 1984, no. 1270; Grigsby 2000, no. D221

The decoration on this wine bottle is exceptional and in view of Michael Archer's remarks on the redecoration and adding of inscriptions to delft wine bottles, it should perhaps be regarded with some caution, despite the fact that it has been in the Museum collection since 1887. It has numerous firing faults, such as blisters, in the glaze and it seems unlikely that such an imperfect bottle would be allowed to leave the factory where it was made. However, a wine bottle inscribed 'P/RM/1642' in the Longridge Collection, USA, with a rather similar cartouche with grotesques does not exhibit signs of faulty firing.[4]

The initials 'S/RE' most likely stand for a couple, but they have not been identified.

The inscription 'Renish wine' denotes white wine from the Rhineland, Germany, which was particularly popular in England and was imported in large quantities from the tenth to eleventh centuries. Grigsby remarks that this wine was drunk for medicinal reasons, at least from the early seventeenth century, as it provoked urine.[5] Brown stoneware bottles, which are the same shape as the later English delftware examples, were used in Germany, but not necessarily for wine. Stoneware vessels came to England as early as the fourteenth and fifteenth centuries as part of the Dutch carrying trade along with barrels of Rhenish beer and wine.[6] The number of finds on the Thames foreshore and elsewhere indicates that stoneware bottles of the seventeenth century were in frequent use.[7]

For other wine bottles see nos 4, 40, 48 and 66.

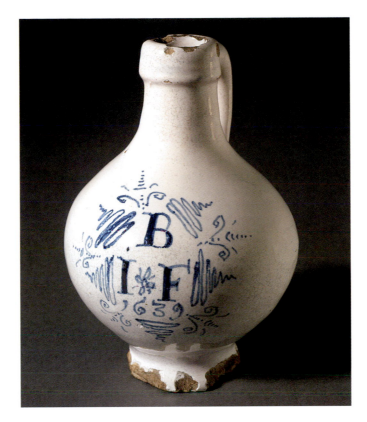

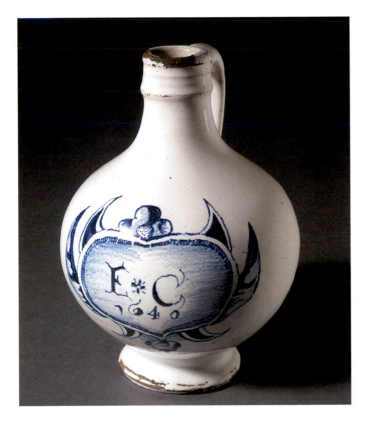

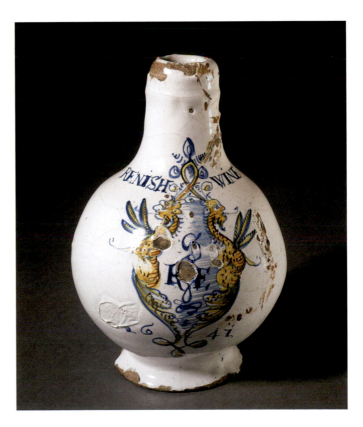

71 Jug, 1641

Made in London, Southwark
Inscribed: 'RICHARD BIRCHET 1641 DRINKE TO THY FREND BUT REMEMBER THY ENDE 1641'
Height (not incl. mount): 24.6 cm
Reg. no. Pot. Cat. E 35; presented by Augustus Wollaston Franks, 1892, formerly in the Hollingworth Magniac Collection
(printed collection label on base), sold Christie, Manson & Woods, 7 July 1892, lot 462
Hobson 1903, E 35; Lipski and Archer 1984, no. 718

This handsome jug with its mottled manganese ground, its rim and foot painted blue, is mounted with a later silver mount dated 1860,[1] the lid containing a Charles II guinea. It may have been mounted for the collector Hollingworth Magniac. The two bands enclose carefully written inscriptions expressing religious sentiments close to those found on slipware drinking vessels from the area around London.

The identity of Richard Birchet remains unknown, but he is likely to have been a wealthy London merchant.

No other jug like this is known.

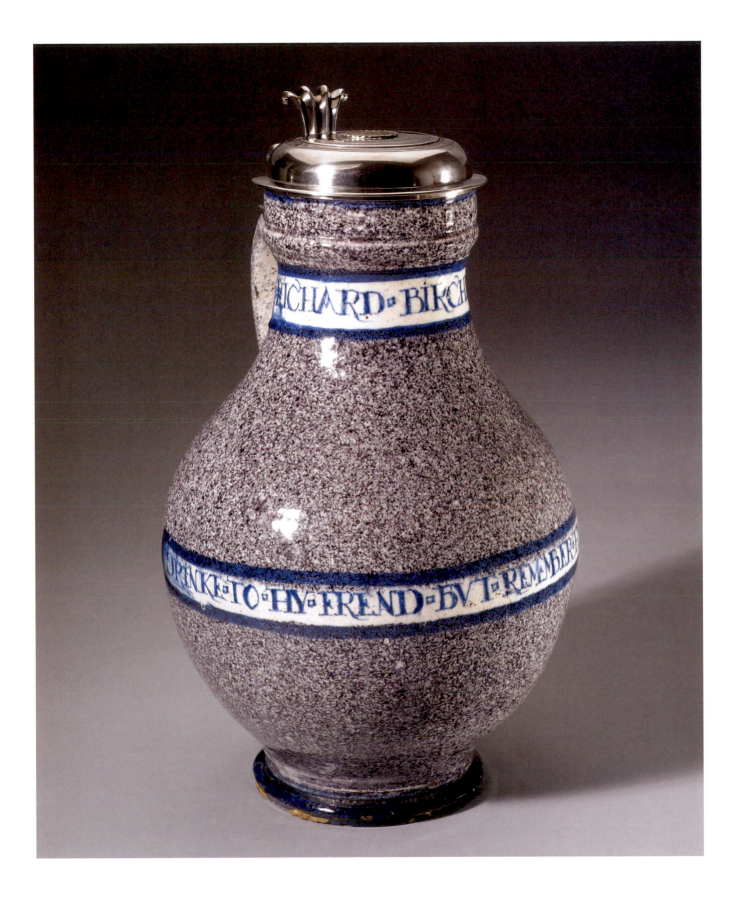

72 Cistern, 1641

Made in Southwark, London
Inscribed: 'GF/1641' enclosed by paraphs except below; '1641' on the back above a paraph
Height (to top of lug): 20.5 cm; width: 19.6 cm; depth (max.): 16.5 cm
Reg. no. 1887,0210.125; purchased from the collection of Henry Willett, 1887
Church 1884, p. 38; Hodgkin and Hodgkin 1891, no. 237; Hobson 1903, E 103; Lipski and Archer 1984, p. 341, fig. 1510; Austin 1994, no. 715

This object, which has a flat back, is hollow and has a (damaged) spout on a lion's mask at the front, is thought to be a wall or table cistern. The lion's mask has a hole which was no doubt intended for a spigot. It is one of only four delftware examples recorded, all decorated predominantly in blue, and although incomplete represents a remarkable survival.

The cistern appears to have been made in a mould. As there are signs of a firecrack, the base was probably made separately and then fixed to the rest with liquid clay at the leather-hard stage before firing. This might have created a slight area of weakness so that a crack has opened up. The bands in relief at the top, in the middle and at the base suggest that it is intended to imitate a metal vessel. A hole for suspension on the remaining lug at the back implies that it was hung on a wall, but no evidence survives for the use of such cisterns. It is unclear whether there was a crosspiece from one lug to another, as there is some evidence of damage to the inner side of the complete lug, which projects from the main part of the lug. The damaged lug also has a slight projection on its inner edge.

Another example in the DeWitt Wallace Decorative Arts Museum, Colonial Williamsburg, Virginia, which was acquired in 1979, is dated 1644 and bears the initials 'CR'.[1] It has straight faceted sides, a flat cover with a bird finial and a flat back with a raised shaped slab at the back with crenellated edge. There is a loop on the back for hanging. Painted in blue with a 'bird-on-a-rock' design in Chinese taste, it has two lion masks at the front, the lower

one of which has a hole for a spigot; the crown and initials are painted yellow.

A third cistern, which is dated 1638, is in The Potteries Museum and Art Gallery, Hanley, Stoke-on-Trent.[2] This is more elaborate, having two pillars at the front and the remains of a perforated gallery. Its decoration is also exceptional. The landscape scenes painted in a Continental style in blue, manganese and orange include allegorical figures representing life and death.

In a similar vein is the earliest dated example, inscribed 'ANNO/DOMINI/1630' on the back, which has two areas of damage where an attachment such as a loop might once have been. This piece, on the market with Garry Atkins in March 2007 and now in a private collection, also has pillars at the front, on top of which are lion masks. The pillars rest on a base painted to resemble a chequered floor. On the apron at the front is another lion mask, and there is a further mask at the front on each side. The cistern has been restored. The finely painted decoration of bearded men in long robes on either side, one holding a key and the other a watering can, perhaps done by an immigrant craftsman, is probably symbolic.

Although these cisterns are all exceptional for English delftware, a Continental prototype exists. Called a 'Wasserbehälter' or water container, a cistern with pillars holding up an arch at the front and a crenelated gallery was exhibited in Frankfurt in 1988.[3] However, this piece is in fact of Dutch manufacture.[4] The English examples of 1630 and 1638 are probably based on Dutch prototypes.

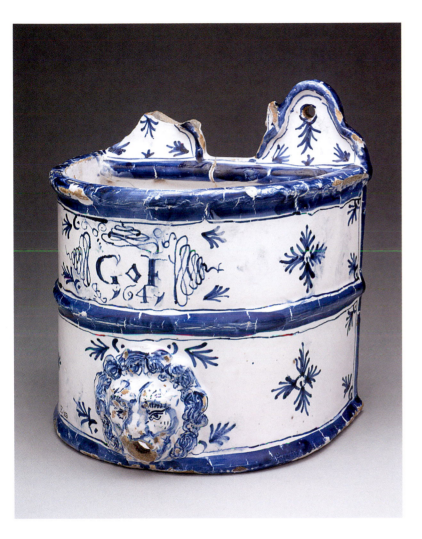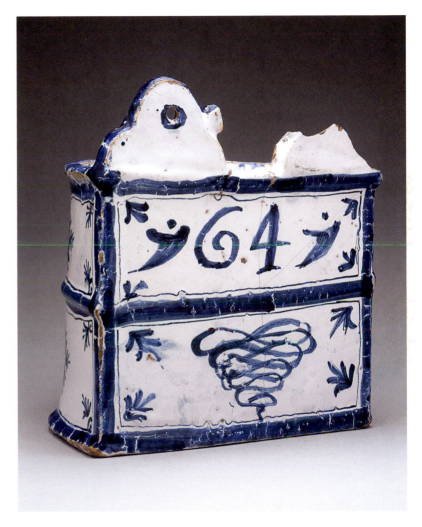

73 **Mug**, 1644

Made in Southwark, London
Inscribed: 'THOMAS BALARD/1644'
Height: 16.4 cm; diameter: 7.2 cm
Reg. no. 1960.0403.1; sold Sotheby's, 22 March 1960, lot 14, by Eric B. Porter, who apparently acquired it in about 1950 at Messrs Read and Sons Auction Rooms, Fishergate, Preston, Lancs[1]
Lipski and Archer 1984, no. 722

The deep neck, to which the wide strap handle is attached at its upper end, has been carefully painted with stylized scrolls enclosed by lines, and the lettering, although perhaps less self-assured than on the 'Edward and Elizabeth Searle' mug (no. 76), is well executed. The decoration on the body of the mug is known as the 'bird-on-a-rock' pattern and is based on Chinese blue-and-white porcelain of the late Ming Dynasty (1368–1644). It is found on several other pieces in the collection, see nos 60, 66 and 68.

Thomas Balard (or Ballard) has not been traced.

74 Flask, 1648

Perhaps made in Southwark, London
Inscribed: 'IG/1648' above a paraph
Height: 16.4 cm
Reg. no. 1921,0727.2; Sir John Evans KCB, FRS, sold at Christie, Manson & Woods, 14 February 1911, lot 49;[1] presented by Lady Maria and Dame Joan Evans, 1921
Lipski and Archer 1984, no.1503

The authenticity of this flask has been called into question. In October 2008 Michael Archer, on examining the piece, commented on its poor workmanship and speculated on whether it might be a fake. Its sides are not completely flat, the front is concave, the back convex, the front surface is uneven and the decoration is on one side only. The glaze is somewhat thick and the painting is in a rather 'sticky' blue. There seem to be no other flasks of this shape.

It was once attributed to France, and later to Lambeth.[2]

One handle is restored.

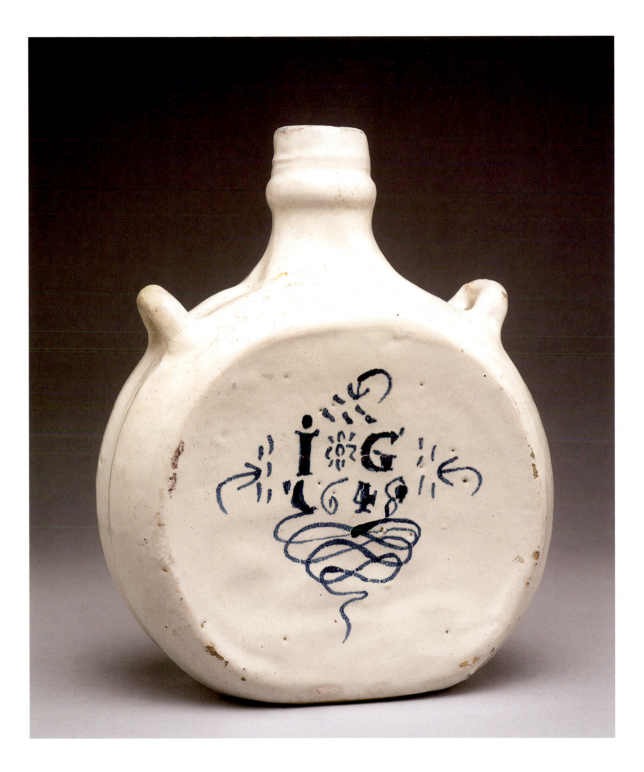

75 Goblet, 1650

Made in Southwark, London, at the Pickleherring pottery
Inscribed: 'WILLIAM LAMBOTh/1650'
Height: 11.5 cm
Reg. no. 1887,0210.119; purchased from the collection of Henry Willett, 1887
Church 1884, p. 36; Hodgkin and Hodgkin 1891, no. 275; Hobson 1903, E 14; Imber 1968, p. 113; Archer 1973, no. 32;
Lipski and Archer 1984, no. 869

Goblets like these copy metal chalices used in churches for Communion wine, but were evidently for secular use. They are relatively rare, most dating from the 1650s.[1] This is the earliest recorded dated example. One of two goblets in the DeWitt Wallace Decorative Arts Museum, Colonial Williamsburg, Virginia, has an out-turned rim and is elaborately painted with the arms of the Worshipful Company of Coopers.[2] Its inscription, 'HE THAT HATH THIS CUP IN HAND DRINKE UP THE BEERE LET IT NOT STAND 1656', tells us the drink that these goblets were used for. Most other surviving goblets are more plainly decorated.

The bird with outstretched wings, standing over a recumbent figure, represents 'The Bird and Bantling', which we would now call 'The Eagle and Child', the name of a pub in Tooley Street, Southwark. Fragments from the nearby Pickleherring pottery have been excavated in Tooley Street.[3]

There is a stoneware bottle in a private collection made by John Dwight, which bears the 'Eagle and Child' motif.[4]

The area of glaze missing on the foot indicates a manufacturing defect rather than damage to the object.

76 **Mug**, 1650

Made in Southwark, London, probably at the Pickleherring pottery
Inscribed: 'EDWARD: SEARLE: AND: ELIZABETH: 1650'
Height: 10.9 cm; diameter 9 cm
Reg. no. 1952,0402.1; given by H.L. Humphreys, 1952
Lipski and Archer 1984, no. 728; Grigsby 2000, D87

This bulbous mug with its large strap handle, which was probably intended to hold a pint of beer, is typical of Southwark delftware. The assured painting of a landscape scene and ships is in a Continental style and is likely to be the work of an immigrant craftsman, probably from Holland or the Low Countries. As pointed out by Leslie Grigsby, it bears some relationship to the painting on the series of pieces in the same group as the dish, no. 100, when the rather idiosyncratic buildings are compared with each other.[1] There are a number of pieces painted with the same type of buildings and ships, identified by Lionel Burman as either a Dutch Buss or a Dutch Fluit, the first a fishing vessel, the second a long-distance cargo vessel. Both types were apparently often seen on the River Thames and were known elsewhere in England.[2] One comparable mug, which is taller than the British Museum

example,[3] is dated 1645 and is in the National Museums Liverpool. It is inscribed with the name 'John Williamson'. A related plate in the Fitzwilliam Museum, Cambridge, is dated 1649.[4] A posset pot, dated 1651 and bearing the charming inscription 'William Carter and Ann/The Love I.O. and/Cannot Showe', is similarly decorated.[5] A recently discovered moulded dish painted with the arms of Markham impaling Faringe, on the London market in 2008,[6] is decorated with the same type of ship, which can also be seen on a dish inscribed 'The Clarkes' in the Brighton Museum and Art Gallery.[7]

The carefully painted inscription may perhaps commemorate a wedding. The late Frank Britton traced the baptism of a daughter of Edward and Elizabeth Searle at St Martin-in-the-Fields, London on 16 June 1652.[8]

Chips to rim and footrim.

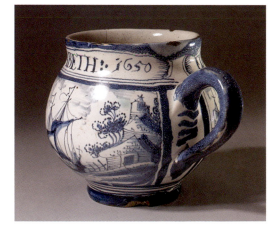 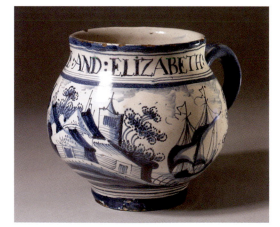

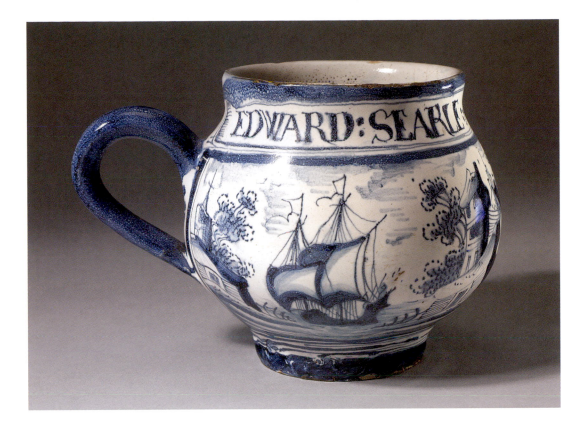

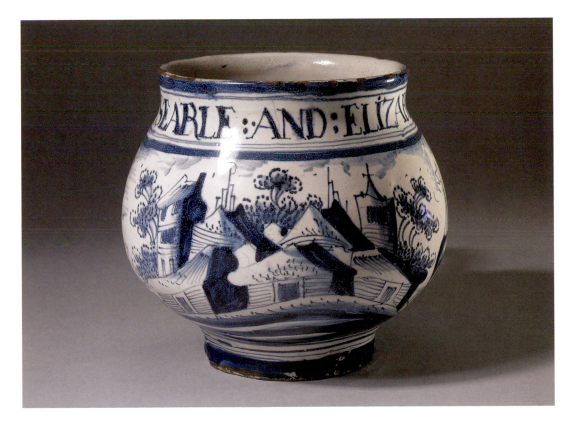

77 **Mug**, perhaps about 1655–60

Made in Southwark, London
Inscribed: ': Drink: and: wellcome: sur:' in blue
Height: 7.8 cm
Reg. no. 1887,0210.118; purchased from the collection of Henry Willett, 1887
Hodgkin and Hodgkin 1891, no. 417, illus.; Hobson 1903, E 41; Imber 1968, p. 114; Austin 1994, p. 104, no. 88; Archer 1997, p. 245

A white glaze was used on this mug before it was sprinkled with powdered manganese to achieve the speckled purplish ground. The white area containing the inscription would have been masked. Cobalt was used for the blue lettering. Speckled grounds were popular for several decades in the seventeenth century, particularly for drinking vessels, and drinking inscriptions of different kinds are often found on English delftwares dating from the seventeenth and eighteenth centuries. Most of these have a social dimension: here the inscription can be seen as referring to the duty of hospitality.[1] A similarly decorated example in the DeWitt Wallace Decorative Arts Museum, Colonial Williamsburg, Virginia, is inscribed 'Be Not Drunke'.[2] Austin has pointed out that two cups of the same size and shape, excavated at the Pickleherring pottery site in Southwark, have been published by Ivor Noël Hume.[3]

There is a mug of similar form and dimensions in the Museum of London, apparently 'found in a cesspool at Broadway, Hammersmith'.[4] An unglazed earthenware mug found in Tooley Street, London in 1907 is in the British Museum collection.[5]

Rim and glaze on handle chipped; crack extending from rim.

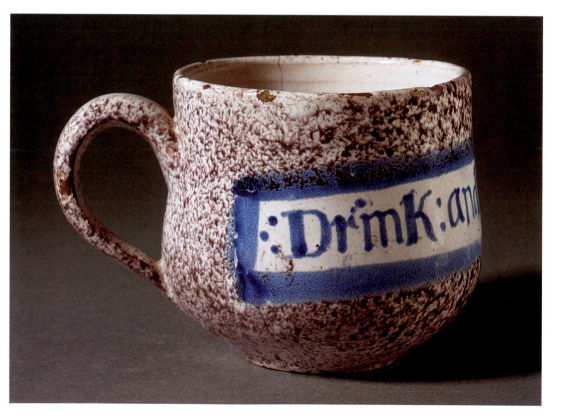

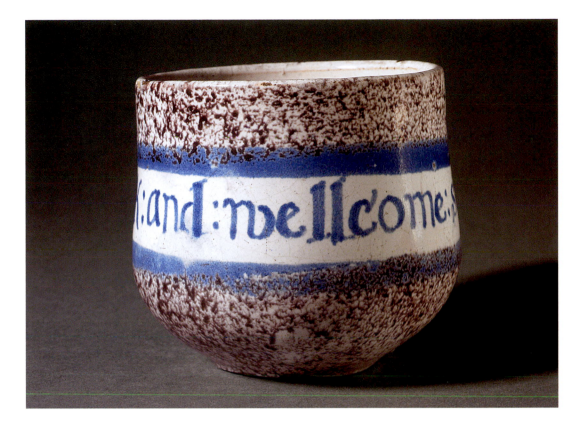

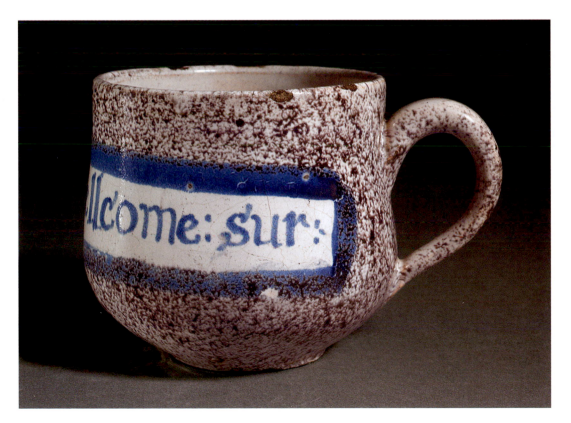

78 Posset pot, 1657

Made in Southwark, London
Inscribed: 'B/ED/1657' above a paraph on each side of the spout
Height: 13 cm; width (max. incl. handles): 14.6 cm
Reg. no. 1887,0210.124; purchased from the collection of Henry Willett, 1887
Church 1884, p. 38; Hodgkin and Hodgkin 1891, no. 295; Hobson 1903, E 10; Lipski and Archer 1984, no. 893

For posset, see no. 68.

 This posset pot was made only twenty-six years after the earliest dated example,[1] and represents one of the simplest of the many forms that were in use until just beyond the middle of the eighteenth century. Although plainly decorated, it is likely to have been used for social occasions as it bears the initials of a husband and wife. The repetition of the initials is an unusual feature. The pot may have been made on the occasion of a marriage, or to commemorate a wedding.

 Cover missing. Spout incorrectly restored. Glaze missing, especially on rim.

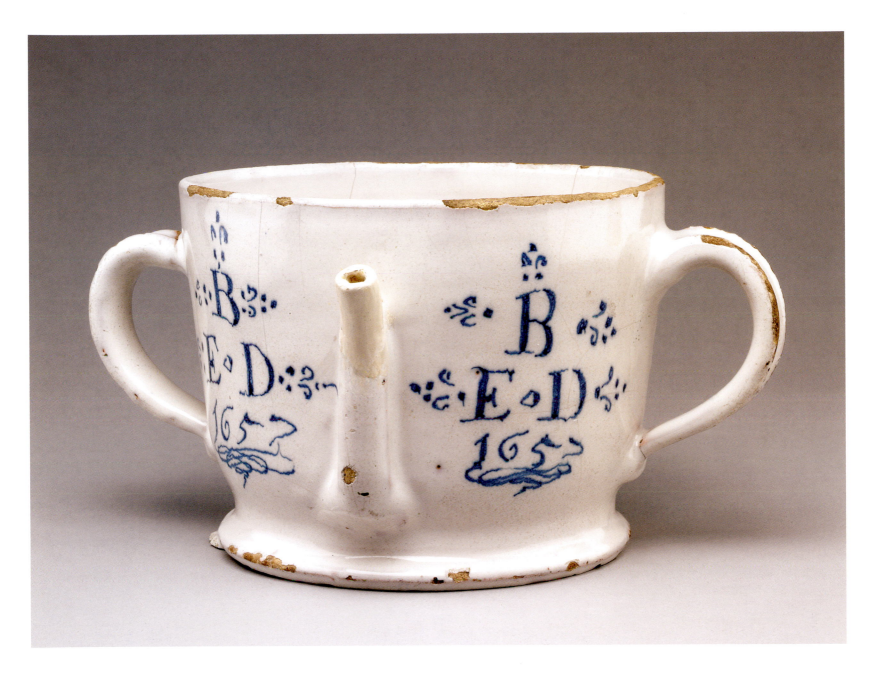

79 **Posset pot and cover**, 1668

Made in Wapping, London, at the Hermitage pottery, or perhaps at Brislington, near Bristol
Inscribed: 'IC/1668' on back and front
Height (incl. cover): 20 cm
Reg. no. 1909,0605.3; presented by Alfred Aaron de Pass through the National Art-Collections Fund (The Art Fund), 1909
Lipski and Archer 1984, no. 896

For posset, see no. 68.

The straight-sided form of this posset pot, which does not have a spout, is relatively uncommon, although there is another in the Ipswich Museum[1] with a more convincing cover (the cover of the British Museum piece is probably a replacement)[2] and letters and the date 1669, within a shield with leaves springing from it, which is so similar to the Museum pot as to have possibly come from the same workshop, if not from the same painter. The main difference is that the decoration on the Ipswich Museum pot is painted over the spout.

For a piece dated 1666, similarly potted and with comparable painted decoration in blue, see no. 104.

Finial restuck.

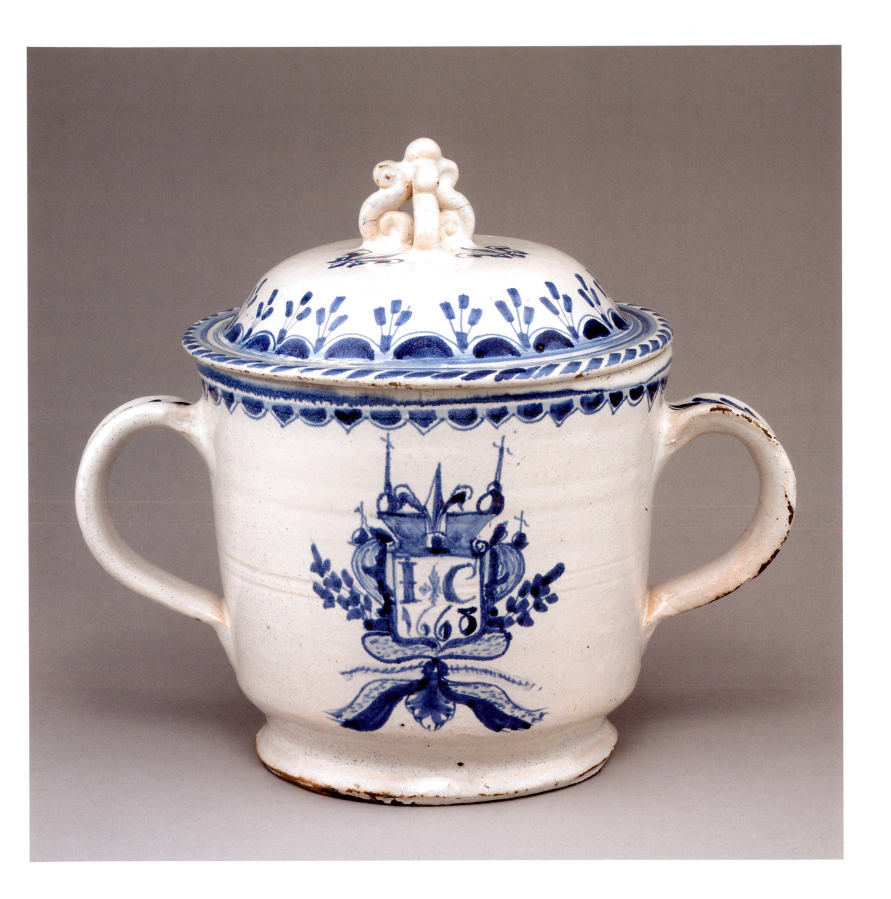

80 Posset pot and cover, 1670

Made in Southwark, London
Inscribed: 'AB/1670'
Height (to top of finial): 16.5 cm
Reg. no. 1887,0210.126; purchased from the collection of Henry Willett, 1887
Lipski and Archer 1984, no. 900

For posset, see no. 68.

This posset pot, painted in cobalt blue and manganese purple with scenes in the Chinese style, was evidently thought to be French in the late nineteenth–early twentieth centuries as it was not included in Hobson's *Catalogue of English Pottery in the British Museum*, published in 1903. An old document records an attribution to Rouen, France, and describes the pot as in the Dutch style.[1] Although at times it can still be difficult to distinguish between the products of England and Holland, this posset pot is now firmly attributed to Southwark, London. Its decoration is paralleled on other pieces, including a posset pot lacking its lid but of broadly similar form inscribed 'AM/1676', which was in the Zeitlin Collection, USA.[2]

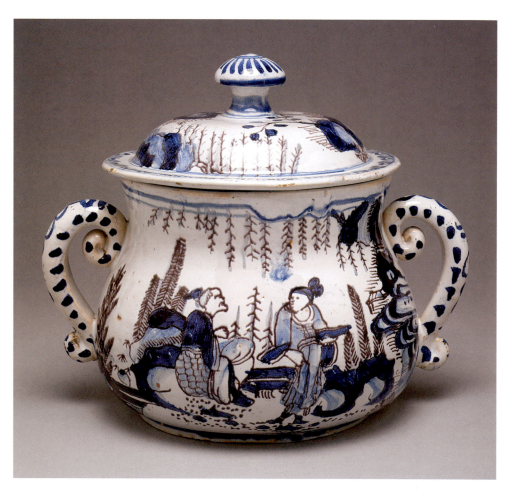

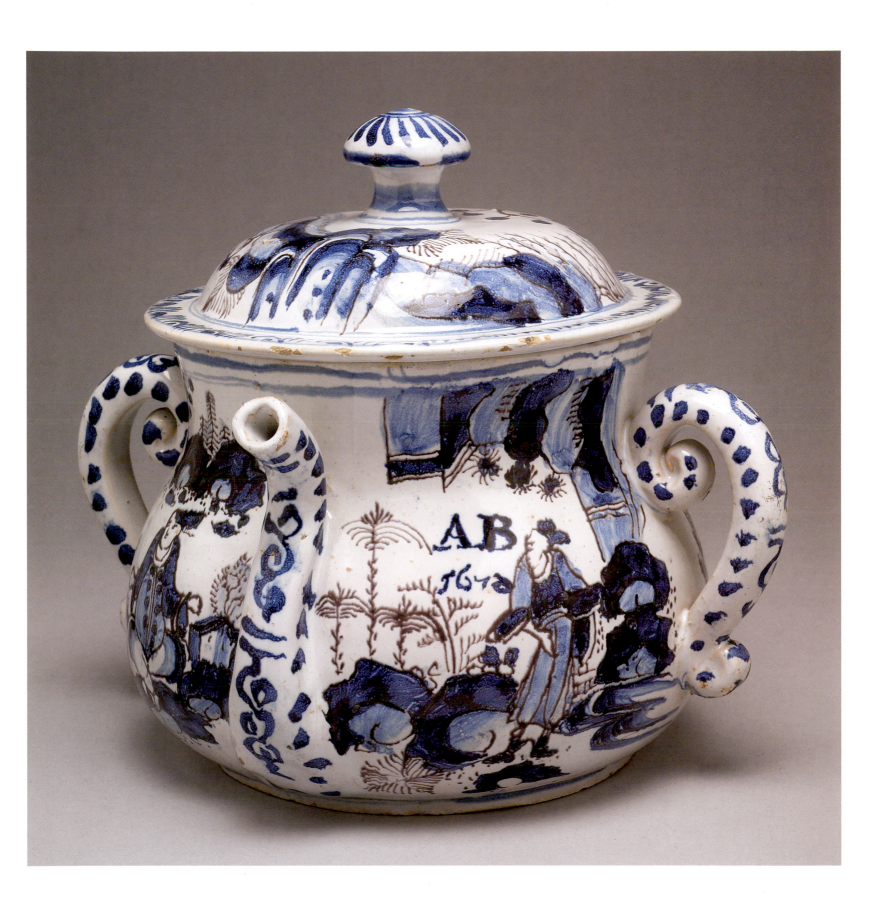

81 Posset pot, 1677

Made in London
Inscribed: 'AY/1677' to either side of spout
Height: 13.9 cm; width (max. incl. handles): 24.1 cm
Reg. no. 1891,0318.1; presented by Lady Charlotte Schreiber, 1891
Hobson 1903, E 141; Lipski and Archer 1984, no. 907

For posset, see no. 68.

The decoration of the posset pot is loosely painted in a style ultimately based on Ming Transitional Chinese porcelain dating from around 1620–80. It may have been done by the same painter who decorated the straight-sided posset pot, dated 1674, in the Longridge Collection, USA,[1] made for a member of the Worshipful Company of Merchant Taylors, as some of the large serrated leaves and columbine-type flowers are very similar. In addition, the spouts on both pots are painted with a similar scroll motif. Leslie Grigsby has attributed this pot to London, as some delft fragments with decoration after the same source have been found there.

In the century since R.L. Hobson wrote in the *Catalogue of English Pottery in the British Museum*, 1903, 'This piece, which has the characteristics of Bristol delft, must be regarded as of doubtful attribution because of the early date; it may possibly be French', knowledge of the development of English delftware has advanced to the extent that few pieces have problems of attribution (but see nos 10, 36, 39, 59, 74 and 85). Yet it is still only occasionally possible to be entirely sure which pottery made a certain pot. Archaeological work carried out in the last thirty to forty years, especially in London, has shed light on the production of more than a dozen factories, but much more work needs to be done before objects such as this posset pot can be securely attributed to a specific factory in London.

Cover missing.

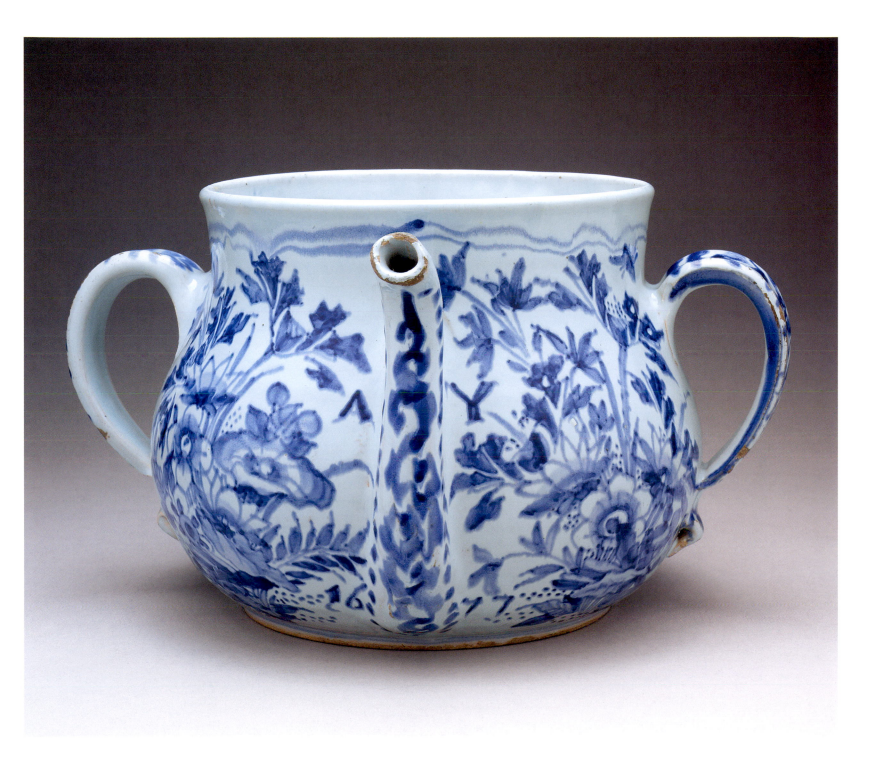

82 **Caudle cup**, 1688

Made in London
Inscribed: 'B/IA', and '1688'
Height: 8.9 cm; diameter: 10 cm
Reg. no. 1943.0702.1
Lipski and Archer 1984, no. 921

The purpose of this cup, which resembles an ancient
Chinese bronze ritual vessel called a *gui*,[1] is not certain but
it may have been used for a hot milky drink called caudle,
made with milk, alcohol and spices and often given to
invalids. However, its size suggests that it was not
intended for one person.

The painted decoration of oriental ladies and a figure
in a garden with a zig-zag balustrade is in the Chinese
style.

Cover missing. Both handles have been restored.

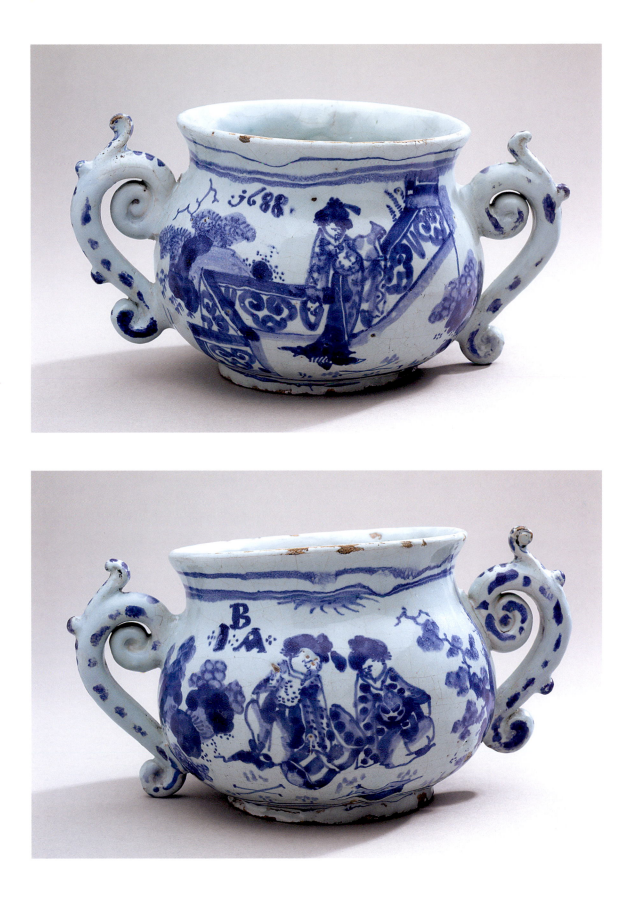

83 Posset pot, 1694

Made in London
Inscribed: 'E/BE' and '1694' at either side of the spout
Height: 16.1 cm
Reg. no. 1957,1201.17; presented by A.D. Passmore, 1957
Tait 1958, p. 82; Wills 1967, p. 437, fig. 6; Lipski and Archer 1984, no. 929

For posset, see no. 68.

The painting of birds on branches and peonies, as well as the decoration on the border and spout, are based on Chinese porcelain of the late Ming dynasty (1368–1644).

To judge from surviving examples, this type of decoration was popular on posset pots made in the last decade of the seventeenth century.

Top of spout and cover missing; numerous losses of glaze.

84 Posset pot, 1696

Made in London or Bristol
Inscribed: 'H/T*T/1696' on the base
Height: 18.1 cm
Reg. no. 1904,0611.1; presented by Alfred Aaron de Pass, 1904
Wills 1967, p. 439, fig. 14; Lipski and Archer 1984. no. 933

Snake handles are found on posset pots dating from around twenty years earlier than this example, but the straight, rather than out-turned, neck and the domed foot are unusual,[1] as is the scene of animals in a landscape painted on one side. The other side, and the border and foot, are more conventionally painted with birds and foliage in the Chinese style. Another posset pot, apparently of the same form but larger and undated, which is decorated in blue, green and orange-red with bird and flower motifs, is in the Longridge Collection, USA, together with a slightly smaller example.[2] Both have been attributed to Bristol on the grounds of their painted decoration.

Cover missing. Part of the foot, base of one handle and top of spout missing; rim chipped; glaze flaked off, especially on the foot.

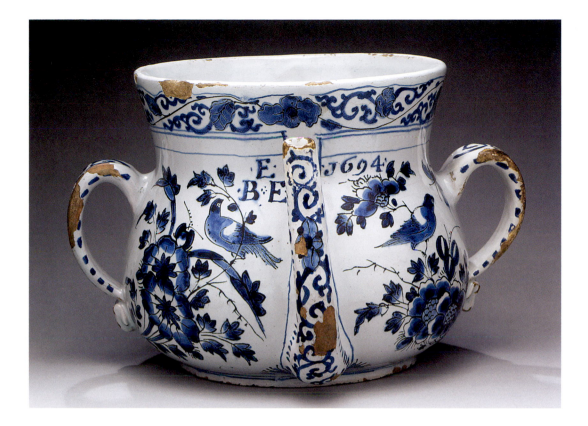

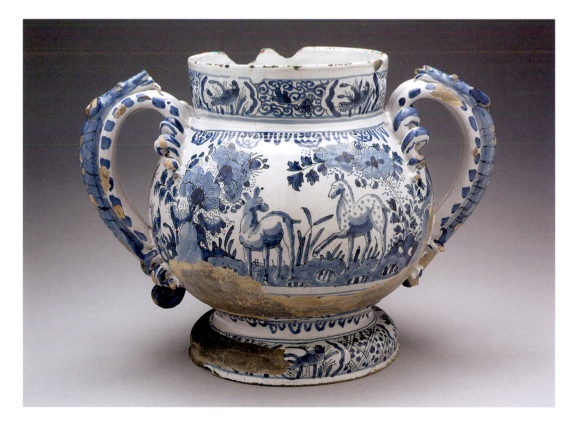

85 Punch bowl and cover, 1697

Made in London or possibly in Holland
Inscribed: 'H/TT' below the handle on one side and '1697' below the handle on the other side
Height: 38.1 cm; diameter of bowl: 31.4 cm
Reg. no. 1911,0712.2; presented by Max Rosenheim through the National Art-Collections Fund (The Art Fund), 1911
Wills 1967, p. 439, fig. 11; Lipski and Archer 1984, no. 1042; Grigsby 2000, D306

This magnificent and finely painted punch bowl, one of the largest known, was clearly intended for ceremonial use. The upper part, which probably originally had a cover, may have been intended to hold spices such as nutmeg to put in punch. This alcoholic drink had been introduced in England by the early 1630s.[1] It was originally based on wine or brandy, succeeded in the middle of the century by rum from Jamaica, together with fruit or fruit juice, lemon, sugar and spices. Various vessels were made to serve it, including examples in silver, cream-coloured

earthenware, salt-glazed stoneware as well as glass. The earliest delftware punch bowl is dated 1681 and the latest 1779. However, punch continued to be popular well into the nineteenth century and is still drunk on festive occasions, especially in North America.

Only one punch bowl, now in the Longridge Collection, USA, which is dated 1708, is comparable in form, although it is larger and has two pierced galleries.[2] Inside, it too has a figure of Bacchus on a barrel, not holding grapes as here but facing left and balancing a glass on his outstretched left hand. The painted scenes on this bowl include buildings and a hunting scene. The tavern scenes on the Museum bowl are finely executed and may well be the work of a Dutch painter, probably working in London.[3] The style of the painting can be compared with the scene on the large dish dated 1698, no. 39. Both the dish and the punch bowl have at various times been thought to have been made in Holland,[4] both on account of their exceptional size and because of their decoration, but it seems more likely that they may be part of a group of

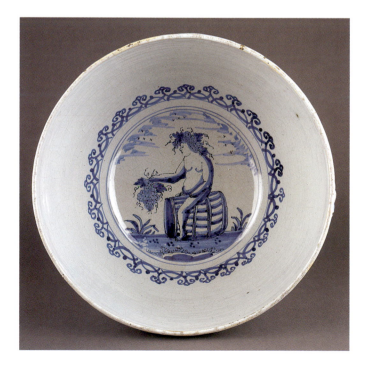

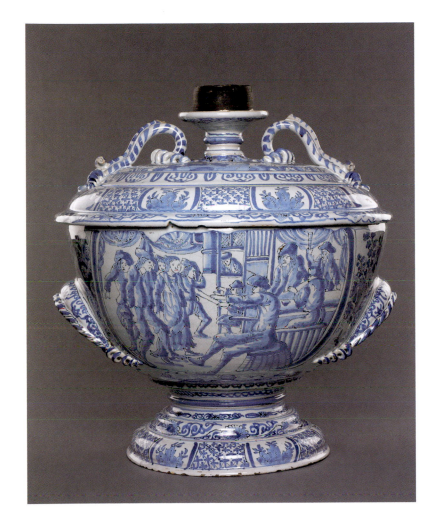
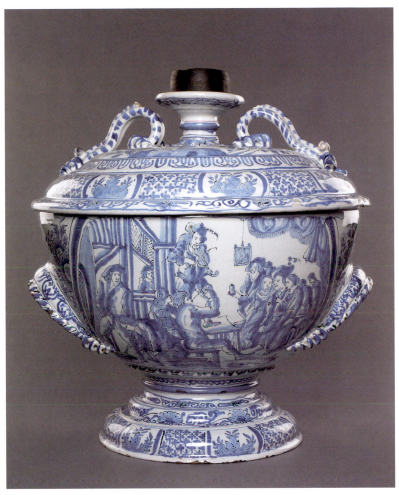

pieces made at the end of the seventeenth century in London, which deserves further research. A plate in the Chipstone Collection, Milwaukee,[5] which is dated 1701 and painted in blue with a couple in Dutch style, could be part of this group. In particular the unusual border motif of plants springing from rocks, enclosed within ovals, is common to the dish and to the punch bowl, where it appears both on the cover and on the foot.

The initials 'HTT' painted below one of the handles, next to a rather crudely painted seated cupid, suggest that this is a piece made for a marriage, or perhaps to commemorate an anniversary. It is perhaps not inconceivable that it was made for a brewer, or tavern-keeper, and his wife.

For putti painted on a jar dated 1700 with the initials 'H/WS', see no. 107.

The punch bowl is undoubtedly one of the finest pieces in the Museum's delftware collection.

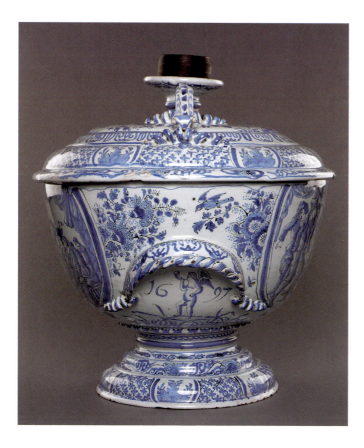

86 Four cups

1 Probably made in London, Lambeth, about 1700–10
Height: 6.9 cm; diam: 5.5 cm
Reg. no. 1924,0619.1; presented by R.L. Hobson, 1924[1]

This cup is of thistle form and derives from a form known as a *capuchine*, used for coffee or chocolate from the late seventeenth century, which was based on a silver prototype.[2] The name may derive from the monk's hood or *capuche,* or from the Capuchin order of monks, whose brown habit was pulled in with a cord around the waist to give a shape rather like these cups.

Both coffee and chocolate, introduced in England in the mid-seventeenth century, had become popular by the beginning of the eighteenth century, even though their use was still expensive enough to be restricted to the better-off.

A similar delftware cup, painted in red, green and blue with flowers and a geometric motif, attributed to Lambeth, London, and dated around 1700–15, is in the Victoria and Albert Museum,[3] together with another painted in red, blue, green and yellow, with Chinese figures walking towards a vase, attributed to the factory of William Chilwell II at Vauxhall, London.[4] An example painted in blue, dated to around 1700–10, in a private collection is known.[5] Capuchines were made in both slipware[6] and red and brown stoneware in the early eighteenth century.[7] One of the earliest is made of grey clay with marbled black and brown streaks, attributed to the potter Francis Place, whose pottery is thought to have operated at Dinsdale, Co. Durham around 1678–94.[8] Cups like these do not have saucers. A trade card for the stoneware maker James Morley of Nottingham includes an image of 'A Capuchine',[9] showing that these cups were also made in stoneware. An example measuring 5.6 cm in height was in the London trade in July 1975.[10]

There are visible marks inside the Museum cup showing that it was thrown on the wheel, and the handle, which is perhaps rather large for the size of cup, is slightly tapered. The decoration of stylized flowers is considered typical of Lambeth products of this period.

Slight damage to the rim and foot.

2 Probably made in London, perhaps around 1746
Height 5.9 cm; diameter 5.6 cm
Reg. no. 1981,0101.76; bequeathed by Miss Constance Woodward, 1981

The decoration of two shield-shaped cartouches enclosing a flower and a roundel, either side of the handle, and between them a rose enclosed within a circle, as well as the brown rim, exhibit Chinese influence. Chinese porcelains were coming into Britain in quantity during the first half of the eighteenth century, and most well-to-do families ate dinner from Chinese porcelain services. It is just possible, but not very likely, that the rose may have a Jacobite significance. Two plates inscribed to Mary Midcalf and dated 1746 are painted with a similar rose.[11]

Slight damage to rim and repair to crack.

3 Made in England, about 1750–60
Height: 5.8 cm
Reg. no. 1909,0812.1; presented by C.R. Jennings, 1909

Straight-sided cups like these are usually thought to have been used for drinking coffee. They are as rare as teacups and tea- or coffee-pots, since porcelain was far more suitable for hot liquids. Imports from China meant that porcelain tea wares could be readily obtained even before china was manufactured in Britain from the mid-eighteenth century. Silver was the favoured material for teapots, sugar bowls and creamers.

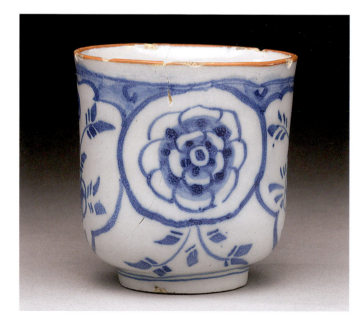

The scene of rocks, a tree, a building and flying birds is typical of the type of Chinese-style decoration found on contemporary British porcelains.

Rim chipped.

4 Probably made in Liverpool, about 1750–60
Height 5.5 cm; diameter 5.6 cm
Reg. no. 1957,1201.22; presented by A.D. Passmore, 1957

Two sizes of coffee cup like this are known, of which this is the smaller. The handle is quite broad and tapers as it extends downwards; its terminal extends right down to the foot of the cup and has been neatly pushed into place, no doubt when the piece was at the leather-hard stage before firing.

A spoon tray painted with the same pattern was in the London trade in 1985.[12]

A fragment, which may be from a posset pot rather than a cup like this,[13] found at Patrick's Hill pothouse site, Liverpool,[14] is painted in colours with a similar pattern of a banded hedge, which is distantly based on a painted design on Japanese seventeenth-century Kakiemon porcelain. The pottery was owned around 1750–60 by John Dunbibbin. Announcements in the London *Daily Advertiser*[15] from 10 June 1757 and 9 July 1760 show that Dunibibbin was selling his wares through a warehouse at Hay's Wharf and then at The Borough, Southwark, London.

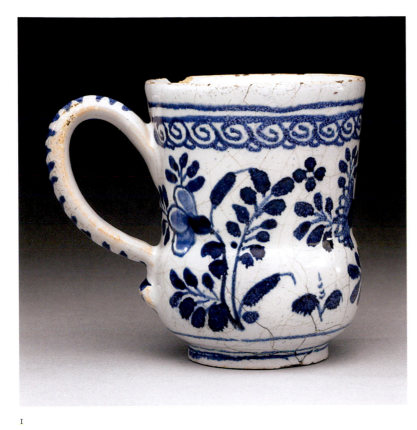

1

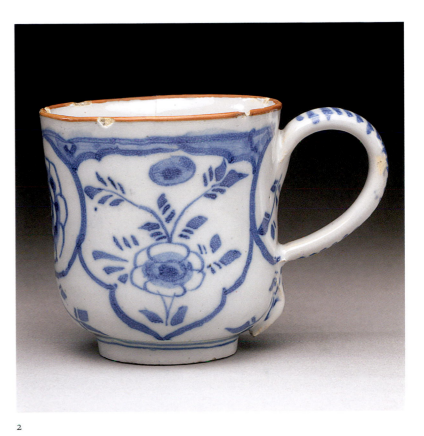

2

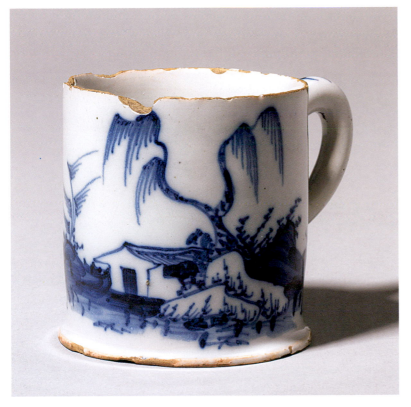

3

4

87 Punch bowl, 1724

Made in England, probably in London
Inscribed: 'T.S:/1724' around a heart
Diameter: 31.2 cm
Reg. no. 1981,0101.75; bequeathed by Miss C.M. Woodward, 1981

This bowl was presumably made as a love token, possibly on the occasion of an engagement or wedding. Punch bowls were made from the 1680s. Like the majority of dated examples from the 1720s (see no. 88), the Museum bowl is deep with flared sides.

The decoration on the outside of the bowl is in the Chinese style and is based on porcelain of the late Ming Dynasty (1368–1644).

88 Punch bowl, 1728

Made in England, perhaps in Brislington, or London
Inscribed: 'Drink Faire/Don't Sware/1728'
Diameter: 29.7 cm
Reg. no. 1887,2010.134; purchased from the collection of Henry Willett, 1887
Hodgkin and Hodgkin 1891, no. 547; Hobson 1903, E 157; Lipski and Archer 1984, no. 1079

Punch bowls varied in size and this large bowl was clearly intended for communal use on festive occasions. Its chinoiserie decoration in irregularly shaped panels is based on late Ming Chinese porcelain by way of Dutch delft and is painted in a particularly strong blue. The pattern is found on bowls dated 1724,[1] another dated 1729,[2] and a third fragmentary bowl dated 1731.[3] The inscription reminding the drinker that moderation was desirable in 'polite' company first appears on a punch bowl dated 1722 and painted with a pseudo-Chinese pattern, while the latest example dates from 1737.[4] Some of the inscriptions are carefully painted, as here; others are somewhat carelessly done. Most are 'framed' by groups of lines, as here. The bowl was made before the middle of the century, when manners were no doubt more lax, and was probably owned by a member of the 'middling' class, such as a merchant.[5]

A bowl in the V&A, London, with similar decoration on the outside and flowers and scrolls inside has been attributed to the Brislington factory on the basis of a fragment said to have come from there in the same museum.[6] However, the attribution of this bowl to any particular factory, or even area, still remains in doubt.

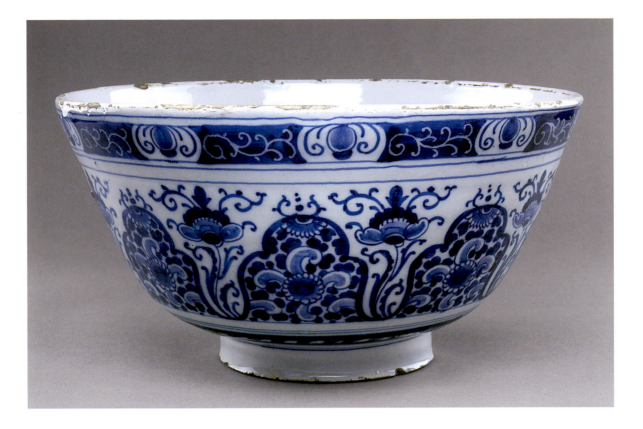

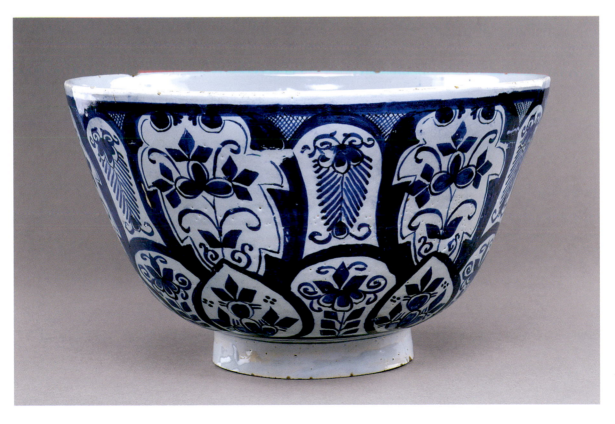

89 **Tray**, 1729

Made in England
Inscribed: 'S/RR/1729'
Length: 42.7 cm; width: 34.6 cm
Reg. no. 1887,0307.E47; presented by A.W. Franks, 1887
Hobson 1903, E 47; Lipski and Archer 1984, no. 1555; Archer 1997, p. 345

The tray, which has slightly sloping sides and was no doubt intended for tea things, rests on eight shaped feet. The painted scene shows Flora, goddess of Summer, reclining, surrounded by three cupids and vases of flowers with phoenixes flying overhead, enclosed by a fence in the Chinese style. The flowers and the phoenixes, as well as the border decoration, are all influenced by Chinese porcelain of the Ming period.

The scene may be based on a print after Pierre Mignard (1610–1695) in the Musée du Louvre, Paris, in which the goddess is shown reclining on a couch attended by two draped angels who shower her with flowers; there are various putti in the background.[1]

The initials on the reverse may indicate that this tray was made on the occasion of a wedding, or perhaps to commemorate one.

Trays are rare in any ceramic material. Large flat pieces of clay are difficult to fire without distortion and, in any case, metal trays were far more practical. The glaze on the back of the tray is unevenly applied, perhaps indicating some difficulty in the making process. A second tray, which is undated but probably made around 1725, was in the London trade in 1990.[2] It is painted in blue with stylized oriental motifs including two flying birds, each near a curtain, and in the centre a fanciful Chinese lakeside scene within an elaborate frame of blossom on a blue ground and scrolls enclosing diaper motifs. Another of octagonal form is dated 1736.[3] Although the border decoration is comparable, as it too is based on an oriental model, in this case Japanese, the vigorously painted hare-hunting scene on this example is quite unlike the decoration on the Museum tray.

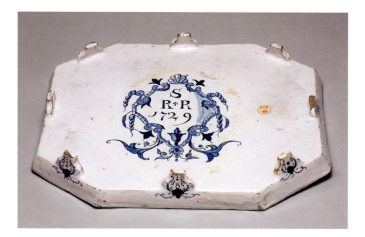

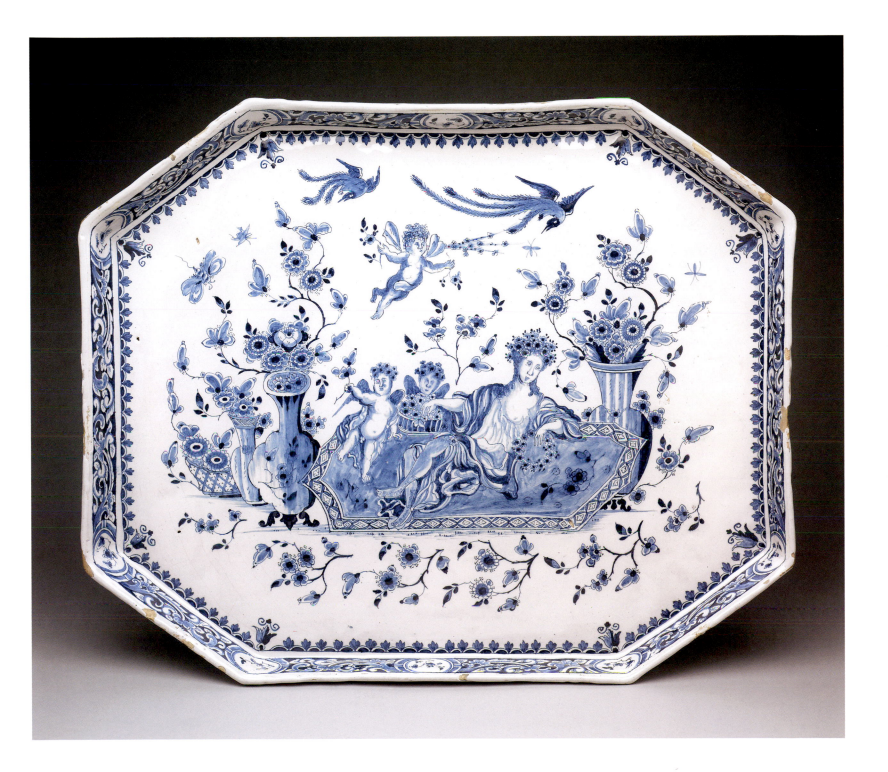

90 **Puzzle jug**, about 1750

Probably made in Liverpool
Inscribed: 'Sr if this be th' first you've seen I'le lay/The wager Which you'll please to say/That you drink not this liquor all/Before that some from th' Jug shall fall'
Height: 19.6 cm
Reg. no. 1887,0210.133; purchased from the collection of Henry Willett, 1887
Hobson 1903, E 161

For puzzle jugs, and an early delftware puzzle goblet, see no. 49. Despite their apparently simple form, these jugs were virtuoso productions since the potter had to throw a hollow handle linking the container with a hollow ring at the rim of the jug, interrupted by the hollow spouts.

In the mid-eighteenth century puzzle jugs were a speciality of the delftware factories in Liverpool, and seem to have been popular to judge from the number surviving. The National Museums Liverpool has what is undoubtedly the largest collection of delftware puzzle jugs, with a variety of inscriptions. The most common of these, of which the British Museum once had an example painted in blue (see p. 300, no. 22), is 'Here Gentlemen Come try your skill/I'll hold a Wager if you Will/That you don't Drink this Liquor all/Without you spill or let some fall'.[1] Other inscriptions, such as the unusual one on this jug, are variations on this theme.

If this be th' first you've seen
The wager Which you'll please to lay
That you drink not this liquor all
Before that some from th' Jug

91 **Bowl**, 1753

Made in Dublin, at Henry Delamain's factory[1]
Inscribed: 'Clay got over the/Primate's Coals/Dublin 1753' on the base
Diameter: 42.1 cm
Reg. no. 1960.0702.1, sold Sotheby's, 24 May 1960, lot 134, formerly in the collection of Rose Thompson, probably by direct descent from the Fitzpatrick family[2]
Anon (probably Hugh Tait) 1961, p. 12, figs; Raley 1963, p. 106, figs 4, 5; Longfield 1971, p. 41 and pls 4, 4a; Archer and Hickey 1971, cat. no. 5; Archer 1973, cat. no. 135; Lipski and Archer 1984, p. 268, no. 1136; Francis 2000, p. 51, fig. 56 a, b, c

This exceptionally large punch bowl, amusingly painted inside with swimming fish imitating those inside Chinese porcelain fishbowls and decorated with flowers in the Chinese style and landscapes within oval reserves on a powdered manganese ground, is the key document for the manufacture of delftware in Ireland by Henry Delamain.

Delamain (1713–1757), a former captain of troops in the service of the Duke of Saxe-Gotha,[3] purchased the World's End pottery, Dublin, from David Davis in 1748 for £580 and enlarged it, building kilns and a mill for grinding flint and metals.[4] On 1 November 1753 he presented a petition to the Irish House of Commons, which included the following claim: 'That the petitioner after many repeated experiments has discovered the secret of glazing delft wares, with coals, and painting and glazing that ware.' The bowl is proof that he had indeed succeeded. A record of Delamain's outlay, which included the cost of 'bringing workmen from England and other parts, maintaining and paying wages until works were perfected etc', which came to £730, is preserved in the *Appendix* to the *Irish House of Commons Journals*.[5] The cost of the coal-firing experiments was reckoned at no less than £1,860. This excluded the £630 spent 'for building nine kilns of different construction to discover the method of burning with coal'. His total outlay came to £6,311 11s 2½d. The Irish Parliament made a grant of £1,000, so Delamain appealed to the English House of Commons on 21 January 1754 in order to try and recoup his outlay.[6] This apparently came to nothing, although a notice in the *London Gazette* gave an address in London where models of his kilns could be obtained.[7] The *Public Advertiser* of 16 February 1754 stated, 'We hear that Mr Delamain the inventor of the kiln for burning white glazed earthenware with pit-coal instead of wood, has lodged a model of his kiln with the ingenious Mr Saunders, Potter of Vauxhall ...'[8] A brick-built kiln, excavated at the Glasshouse Street pothouse, London, could be part of Delamain's experimental coal-fired kiln.[9]

The inscription on the base of the Museum bowl probably refers to coal from what were known as the 'Primate's Pits' in County Tyrone, whose owners included the Lord Archbishop of Armagh, the Archbishop of Tuam, Viscount Charlemont and others.[10] This coal, near the surface and overlaid by fireclays, would have helped the pottery made with it to withstand boiling water. By the 1750s the fragility of delftware was beginning to affect sales as affordable stonewares and creamwares were increasingly available.

This lightly speckled manganese ground appears to be unique for Irish delftware. The flower decoration on the outside of the bowl is also exceptional on Dublin delft.

Foot chipped, glaze losses to rim.

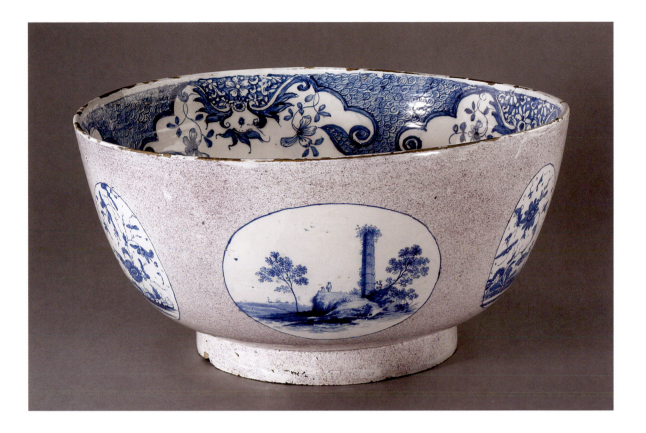

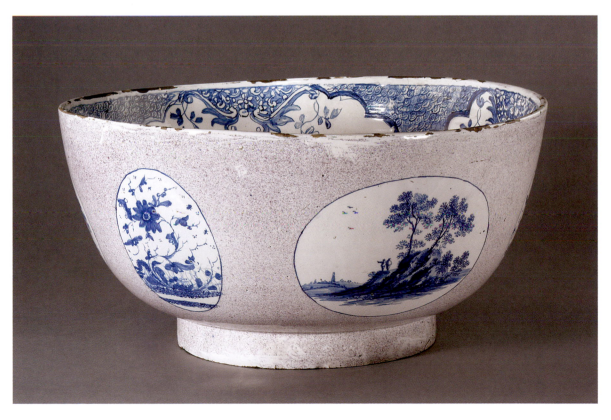

92 Bowl, 1754

Made in Liverpool

Inscribed: 'Richard Wyatt, Appellsham/ Prosperety to the Flock/ may [th]30 1754'

Diameter: 35.8 cm; height: 14.7 cm

Reg. no. 1887,0210,136; purchased from the collection of Henry Willett, 1887

Hodgkin and Hodgkin 1891, no. 552; Hobson 1903, E 146; Lipski and Archer 1984, no. 1141 and col. pl. XIV; Allen 1986, p. 855; Archer 1996, pp. 110–12, figs 1, 2

This splendid punch bowl, which has a noticeably deep foot and is painted with the same view on both sides, was made for a sheep farmer at Applesham, Sussex. This was once a small hamlet in the parish of Coombs on the South Downs, mentioned in the Domesday Book, which was commissioned by William the Conqueror in 1086. Sheep farming seems to have begun there in the late Middle Ages and by the mid-eighteenth century there were large numbers of sheep; even today sheep farming is a feature of the area.

Although one might think that a bowl like this would be unique and possibly made for a special occasion, there is another very similar bowl, which was in the possession of a descendant, Mrs R.J.P. Wyatt, in 1984.[1] A further punch bowl, inscribed 'William Wyatt/in Flansham/one

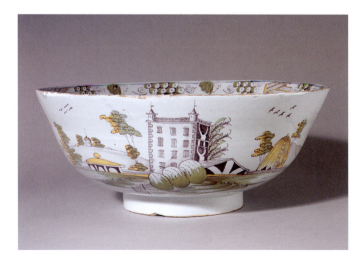

More Bowl may:30:1754', is part of the same series.[2] It is painted with a different scene, but belonged to a member of the same family and has remained in family possession. Flansham is two miles east of Bognor Regis, Sussex. A third bowl, painted in the same style with a shepherd seated in a landscape beside a recumbent sheep and inscribed 'Prosperity to the Flock/Edward Bennitt/June [th]11 1754',[3] was formerly in the collection of N. Thomas, Eton. It was sold on the London market in April 1984.[4] It was most recently recorded in the Dolz Collection, Washington, DC.[5] These four bowls are likely to have been decorated by the same painter. The scenes on the outer surface are particularly similar to each other.

It is likely that the bowls were commissioned, quite possibly all at the same time because the dates are very close, probably from the representative of one of the Liverpool potteries (it is not possible to attribute this bowl to a particular factory in the present state of knowledge), who may have attended a local fair looking for custom. An alternative hypothesis, advanced by Margaret Macfarlane,[6] is that the bowls may have been commissioned through a local grocer, such as Thomas Turner, who had contact with a wide range of London warehousemen,[7] and other traders, including a chinaman. There were no doubt others like him who were in contact with Liverpool suppliers.

The bowl has been broken and repaired.

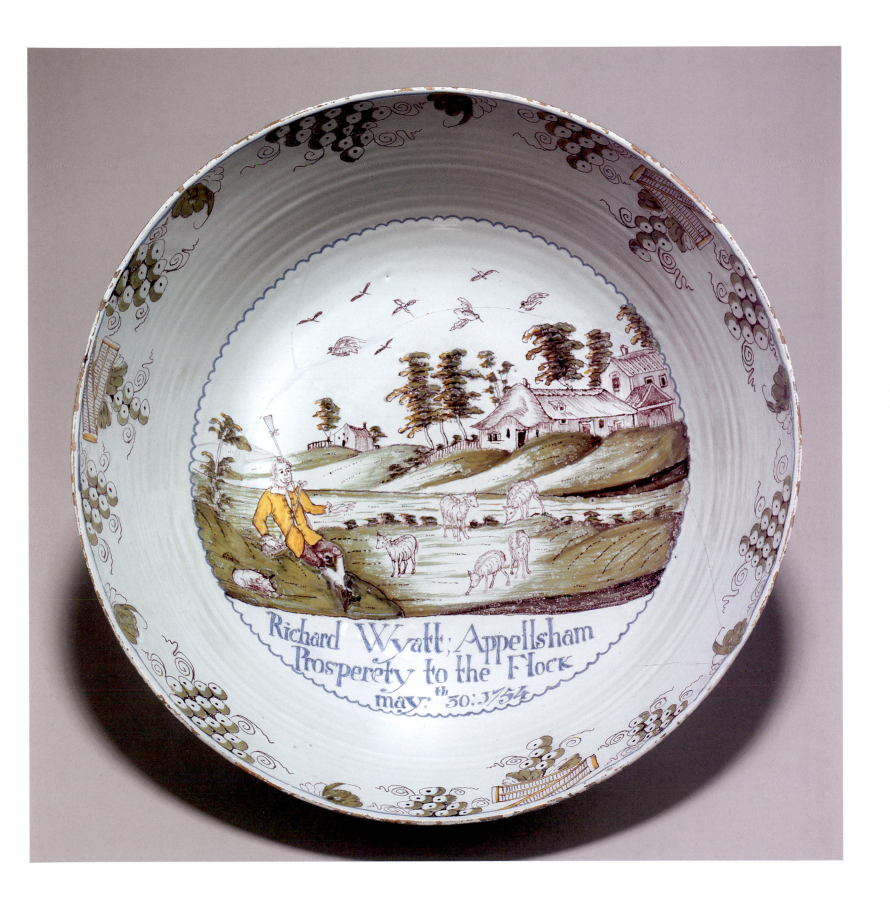

Richard Wyatt; Appellsham
Prosperety to the Flock
may: 30: 1754

93 Punch bowl, 1755

Probably made in London
Inscribed: 'WC/1755' on the base
Diameter: 15.8 cm; height: 14.9 cm
Reg. no. 1887,0307.E114; presented by A.W. Franks, 1887
Church 1884, p. 71; Hobson 1903, E 114; Lipski and Archer 1984, no. 1161; Archer 1997, F.27

All through the eighteenth century delftware bowls were made with a pedestal foot but this type is by far outnumbered by those of conventional form. The scene painted on the outside of the bowl depicts figures in a landscape. Inside the bowl is a small coastal sailing vessel within a circle and three groups of flowers in the oriental style. The ship, which has two masts, is probably a lugger and may be Dutch.[1] It was perhaps used for fishing. On the base are the initials 'WC' above the date 1755 within a circle. A pedestal punch bowl in the Victoria and Albert Museum, painted with a bird among flowers inside the bowl and a pattern of floral and diaper design on the outer surface, is dated 1746.[2] Michael Archer considers that the painting of the figures on the British Museum bowl can be attributed to a London factory. It is just possible that it was painted by a Dutchman who was familiar with vessels from his own country.

There are many depictions of ships inside punch bowls; nearly all of them have an inscription that includes the name of the vessel, and sometimes its master, as well as, in many cases, a date (see no. 94).

The white enamel decoration inside the bowl is in the technique known as *bianco-sopra-bianco*. Although the phrase translates as 'white-on-white', the decoration is usually in a very pure white on a glaze coloured pale blue, or sometimes even grey-blue, which makes the white stand out. *Bianco-sopra-bianco* is thought to have come to England from Sweden, from the Rörstrand factory via a workman named Magnus Lundberg, who was running a pottery warehouse in Bristol in 1750 and has been identified as working in Richard Frank's Redcliff Back pottery, Bristol in 1757. It is possible that he worked in London in the late 1740s, as several pieces of this period which are attributed to London are decorated in this technique. Although it has become particularly connected with the delftware factory at Bristol, it was practised not just there and in London, but also in Liverpool. For further information on the technique, see Britton.[3]

Chip and glaze losses to rim.

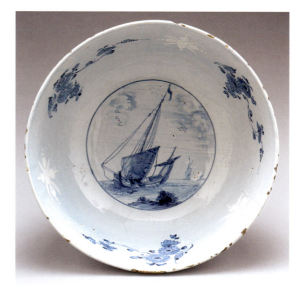

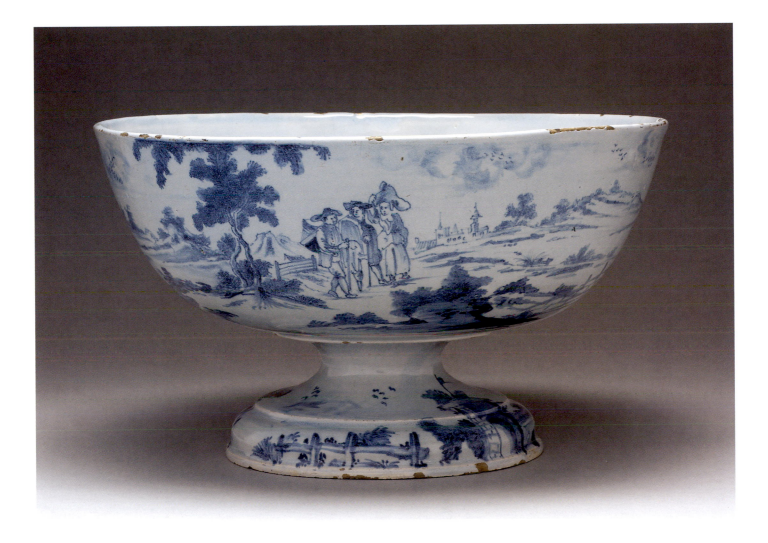

94 **Punch bowl**, about 1760

Made in Liverpool
Inscribed: 'Success to the Expedition/Capt Nicholass Walter'
Diameter: 26.7 cm
Reg. no. 1931,1014.1; purchased, 1931, formerly in the collection of R.G. Mundy
Mundy 1928, pl. 49 (1)

The ship has been identified as a brigantine, or two-masted vessel with square sails on the foremast, fore and aft on the main and topsail. It is flying the red ensign used later by the Royal Navy between 1797 and 1801. It is probably a small despatch vessel.[1] The identity of Captain Nicholas Walter remains unknown. A rare plate painted with a two-masted sailing ship flying the red ensign is in the Merseyside Maritime Museum.[2]

The decoration of leaves and flowers is loosely influenced by flowers painted on Chinese porcelain.

Ship bowls were made in delftware in various sizes,[3] probably ordered by or for the captain of a named vessel. A rum ration was issued to sailors in the Royal Navy as a matter of course until quite recently as a protection against scurvy,[4] and rum was often used in punch. Examples are also known in porcelain, including Bow and cream-coloured earthenware.[5] A plate inscribed 'Success to the Iohn & Mary/Iohn Spencer' is in the Fitzwilliam Museum, Cambridge.[6]

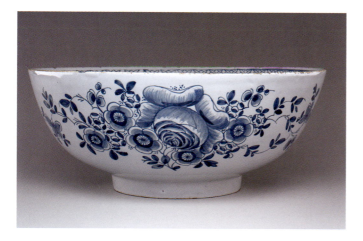

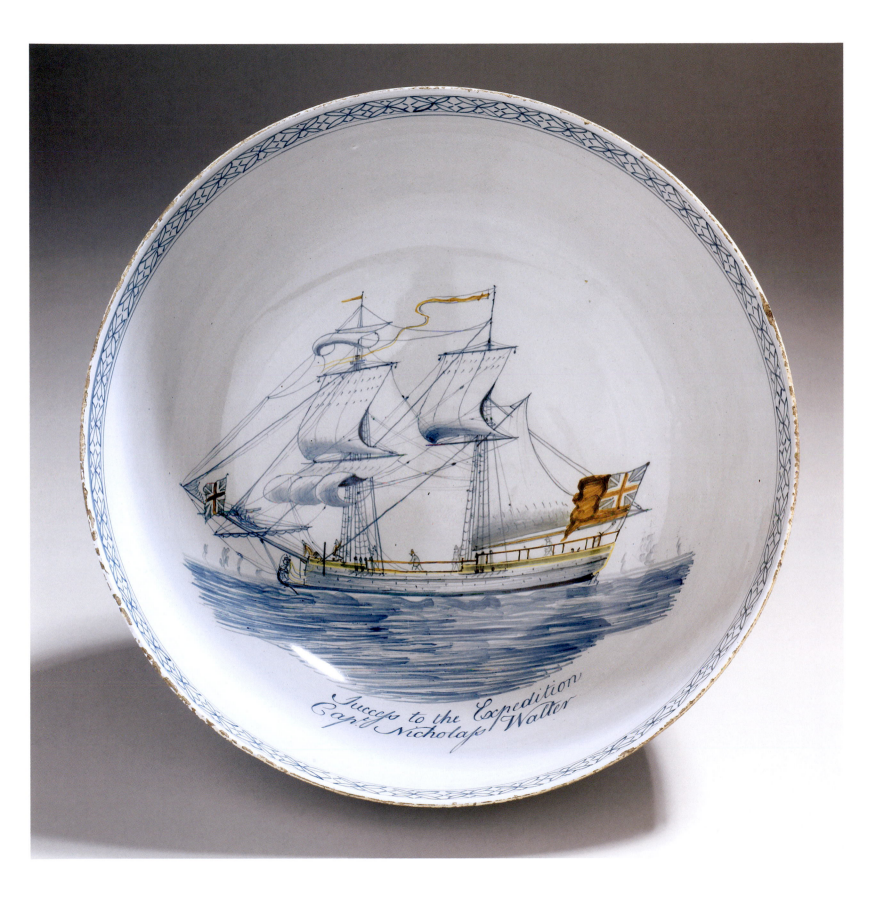

95 Teapot, about 1760

Made in Liverpool, or perhaps made in Staffordshire and glazed and painted in Liverpool
Height (to top of knop): 9.9 cm; width (max. incl. handle and spout): 14.9 cm
Reg. no. 1981,0101.366; bequeathed by Miss Constance Woodward, 1981

This teapot, unlike other pieces in this book, is made of stoneware covered with a tin glaze rather than earthenware.[1] This material is a refractory body that will withstand far higher firing temperatures than earthenware, since its composition includes white-firing ball clay and calcined flint. In general the Liverpool enterprises made both delft and porcelain from about 1750–60; stoneware teapots like this one and several other examples are exceptional, and may be experimental, despite the existence of a group of surviving pieces. It has been suggested that as the shapes of many of these tin-glazed pieces (see below) are typical of Staffordshire productions, they may have been bought in undecorated by the Liverpool delftware potters, who then glazed and painted them.[2] Alternatively, and perhaps more plausibly, potters from Staffordshire may have migrated to Liverpool.[3] However, Alan Smith noted several tin-glazed stonewares similar in shape to Liverpool porcelains, and argued that stonewares were in fact made in Liverpool in the mid-eighteenth century.[4] On various examples the glaze has 'crawled', leaving bare small areas where the stoneware body can be seen. On the Museum teapot the bare areas do not appear to have been salt glazed. These teapots are likely to have been an attempt to make a heat-resistant vessel, rather than one which would 'fly' (shatter), as would be the case with a delftware example, at a time when tea was becoming increasingly drunk by a wide spectrum of British society. Some fragments of tin-glazed stoneware have been found at the site of Alderman Shaw's

pottery off Dale Street, Liverpool, providing some evidence that this rather rare type of pottery was made there.[5]

There are a small number of tin-glazed stoneware teapots known, including one of tapering form with a flat lid and button knop, painted with a pagoda on a hill, in the V&A, London,[6] and another of globular form with a turned knop, painted with floral sprays in blue, in National Museums Liverpool.[7] This collection also includes a further teapot and cover, which is unglazed inside,[8] a coffee-pot with crabstock handle and spout in the form of a serpent in a typical Staffordshire idiom, decorated in blue with a landscape with a sheep and two figures,[9] another coffee-pot and cover painted with a figure in Chinese style, and a landscape[10] and two cups, painted with flower sprays in blue, which are much heavier in the hand than tin-glazed earthenware cups of similar size, and are likely to be made of stoneware.[11] A cream jug is in the Potteries Museum, Stoke-on-Trent, and two coffee-cups are in a private collection. These pieces are all of tin-glazed stoneware decorated in Chinese style.[12] Further examples are in the Fitzwilliam Museum, Cambridge,[13] the Burnap Collection in the William Rockhill Nelson Gallery, Kansas City, Missouri,[14] which is of the same form as the Museum example, and in the London trade in 1981.[15] A teapot with a pointed knop and moulded spout, painted in colours with a version of the 'Hundred Deer' design, is in the Warren Collection at the Ashmolean Museum, Oxford.[16] Other pieces were discussed by Alan Smith in 1978.[17] For the only dated example, see note 1.

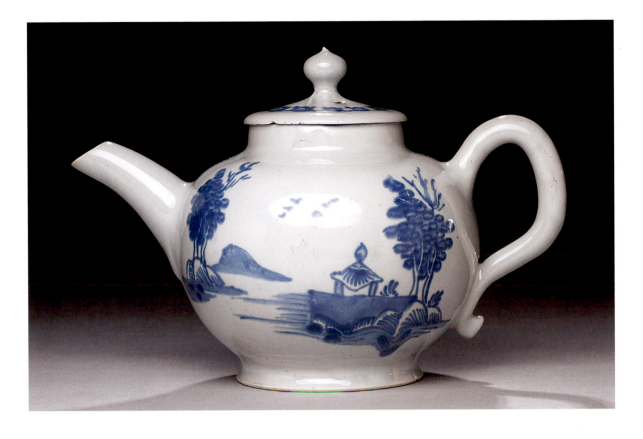

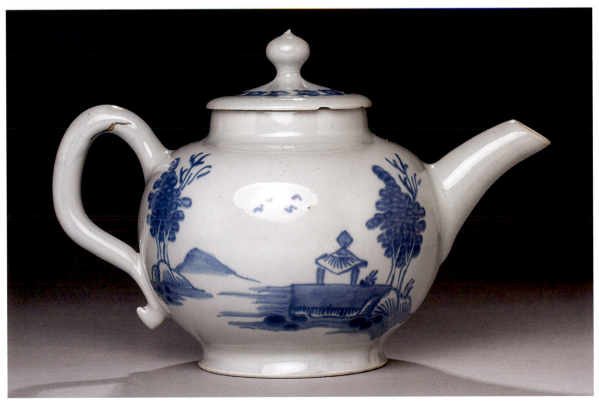

96 **Two tea canisters**, around 1760

1 Probably made in Bristol, at Richard Frank's factory
Inscribed: '23' painted in blue inside the neck
Height: 10.7 cm; width (max.): 9.4 cm
Reg. no. 1887,0307. E142; presented by A.W. Franks, 1887
Hobson 1903, E 142; Ray 2000, no. 42

Tea canisters were made in many different materials and
shapes from the late seventeenth century onwards as tea
became a favoured beverage in England. A slipcast red
stoneware canister made by the Elers brothers around
1695 belongs to the Hampshire Museums Service.[1] The
octagonal form with canted corners is likely to be based on
a silver original. An example decorated with diaper panels
and plants in the Chinese style, dated 1753 on the cover
and base, was on the London market in 2005.[2] Few pottery
canisters retain their lids.

Several canisters survive from a group of this shape,
finely painted in blue with standing figures on a parquet
floor.[3] The figure carrying a basket on her head is
evidently a tradeswoman, and is probably based on a print
showing different 'Cries' of London. The scene has been
placed rather too high on the panel, revealing the
difficulties encountered in adapting prints to unusually
shaped objects. The decoration on the side panels evidently
derives from a Chinese prototype.

The significance of the numeral painted inside the
neck is unknown. It may be a number used to match the
canister to its lid, now lost.

The neck is chipped.

2 Probably made in Bristol, at Richard Frank's factory, about 1760
Mark: '5' painted in blue inside the neck
Height: 10.6 cm; width (max.): 9.2 cm
Reg. no. 1887,0307. E 143; presented by A.W. Franks, 1887
Hobson 1903, E 143

The painting on this tea canister, which has an unglazed
base and lacks its lid, is particularly finely executed.

The significance of the symbol inside the rim is
unknown (see above).

Although tea, first drunk in Britain in the mid-
seventeenth century, became progressively less and less
expensive during the 1700s, it always remained something
of a luxury and was highly taxed throughout the eighteenth
century. Porcelain tea canisters would have been well
beyond the reach of the poor, and even stoneware and
creamware examples, which were often made in moulds
and were not necessarily hand-painted, found a ready
market only with those who were comfortably off.

Information about the cost of these tea canisters and
who might have purchased them has not yet come to light.

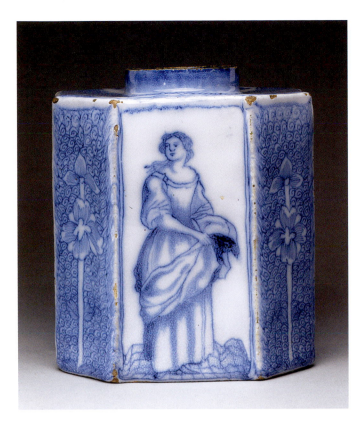
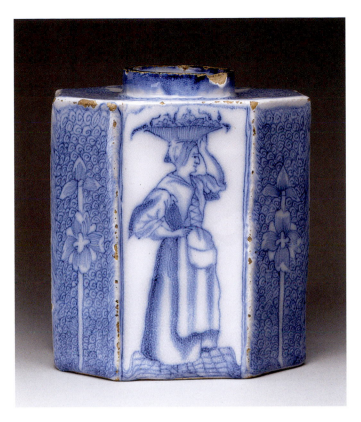
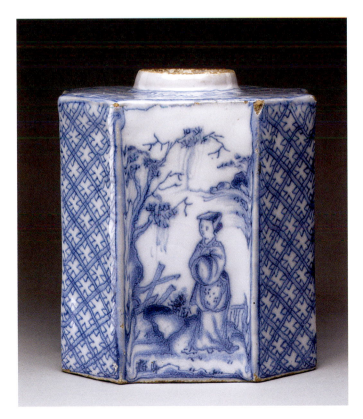
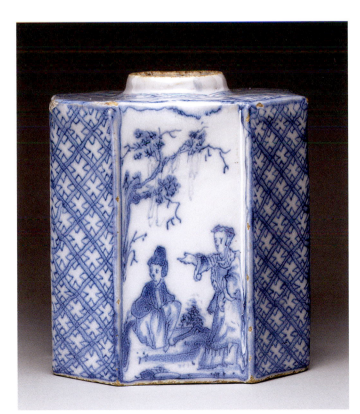

97 **Two bin labels**, 1795–1800 or perhaps later

Made in London, possibly William Sanders's factory at Mortlake, Surrey
Inscribed: 'CYDER' in blue; inscribed: 'SACK' in blue
Height: 6.7 cm; length: 13.5 cm (cider label); height: 7.3 cm length: 13.1 cm (sack label)
Reg. no. 1887,0307.E33 (cider); presented by A.W. Franks, 1887; Pottery Cat. E34 (sack); possibly in the collection of Dr Diamond;[1] presented by A.W. Franks, probably in 1887 (see below); on the reverse of the 'Sack' bin label is a black printed label from a sale catalogue: '[lot] 472 SHAKESPEARIAN SACK-BOTTLE, WITH INSCRIPTION AND DATE 1647 in blue – *7in. high*'; and a still older label inscribed '"Sack"in blue, probably of the time of Shakespeare – *rare*'. This printed label is annotated 'March 18 1875, Bohn's sale, 1st part'; a second manuscript inscription reads: 'See Walpole's Catalogue page 9 from Strawberry Hill'
Hobson 1903, E 33 and E 34

Wine and other alcoholic drinks were stored in bottles with corks from the mid-seventeenth century, and brick and stone bins were built in cellars to house bottles. A handbook by John Davies, *The Inn Keepers' and Butlers' Guide,* published in 1806, advises butlers to buy 'a few dozen delph labels with the names of the different wines you keep, to hang from the top of the bins or on the outward ends of casks'.[2]

Cider is made from either fermented apples or fermented pears and in Britain is an alcoholic drink. It was known in England in the thirteenth century, although it was not popular until the sixteenth century, when it first appears in the written record. Once produced on farms in several parts of southern Britain, commercial production is now mainly confined to Hereford and the West Country, although Norfolk and Suffolk ciders are gaining in popularity.[3]

For sack, see no. 4.

The label for 'Cyder' is rarer than the label for 'Sack'. The latter has been published as having once been in the collection of Horace Walpole, on the basis of the label stuck to the back and having been acquired by the Museum from A.W. Franks in 1875, but this label is misleading. It gives an incorrect date for the piece, and merely mentions that Walpole owned a wine bottle inscribed 'Sack'; this can be traced in his collection, but there is no record of him having owned a bin label, which would in fact have been made during his lifetime, the bottle being dated over a century earlier. The reference to Bohn's 1875 sale does not indicate Franks's purchase of the bin label at that time, let alone its presentation to the Museum in that year.

A series of eight bin labels for different types of wine and for beer is in the DeWitt Wallace Decorative Arts Museum, Colonial Williamsburg, Virginia,[4] and eighteen similar bin labels were sold from the Harveys Wine Museum Collection in 2003.[5] None of these labels is inscribed 'Cyder' or 'Sack'. This collection also included numerous creamware bin labels, some of them circular in form and others that seem to be of the same shape as the delftware labels. There were also five lead bin labels, probably nineteenth century in date. In March 2005 there were fourteen bin labels on the London market,[6] including one for 'Cyder'. Two delft bin labels inscribed 'J/Red Cape' in blue and 'Hock' painted in manganese are in the Allen Gallery, Alton, Hampshire.[7] Ten bin labels, of which three are inscribed in manganese, are in the National Museums Liverpool;[8] these include the rare inscriptions 'Tent', 'Peppermint' and 'Wormwood'.

Michael Archer states that biscuit fragments of wine bin labels were found on the site of the Sanders pottery at Mortlake, in operation from around 1750 to after 1820.[9]

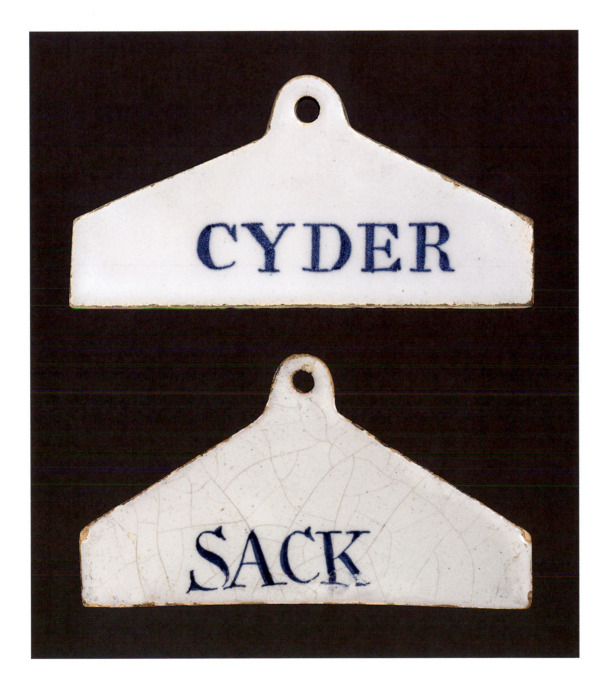

98 Posset pot and cover, (spurious date) 1741

Made in Bristol, about 1725
Inscribed: 'A.G./Bristoll./1741'
Height (to top of finial): 22 cm; height (to top of pot without cover): 14.9 cm
Reg. no. 1900,1218.1; purchased from the collection of G.R. Harding, 1900
Hobson 1903, E 110; Garner and Archer 1972, p. 39 and pl. 57B; Warren 1983, p. 841, fig. 16; Lipski and Archer 1984, no. 1800

For posset, see no. 68 and for other posset pots, see nos 78–81, 83–4.

The cover does not belong to the posset pot.

Bubbling of the glaze on the foot indicates that the inscription was added after the pot was made. When examined in the British Museum Research Laboratory in May 1969 under low magnification, it was noted that the inscription had 'been applied by painting on the surface of the fired glaze rather than on a raw glaze ... It was also noticed that the uprights of the letters had been carefully painted in with a material which proved to be soluble in dilute acid. Apparently, this is to disguise the fact that the uprights are composed of several thin, carefully drawn strokes, which did not run together on firing the enamel'.[1] Extensive bubbling of the glaze on the side of the pot without the spout also indicates that it was refired. The date when the inscription was added remains unresolved, although it seems likely that it was in the later part of the nineteenth century as collectors began to prize such pieces.

The painted decoration on the pot is dateable to around 1725, and that on the cover is around the same date, or perhaps a decade later.[2]

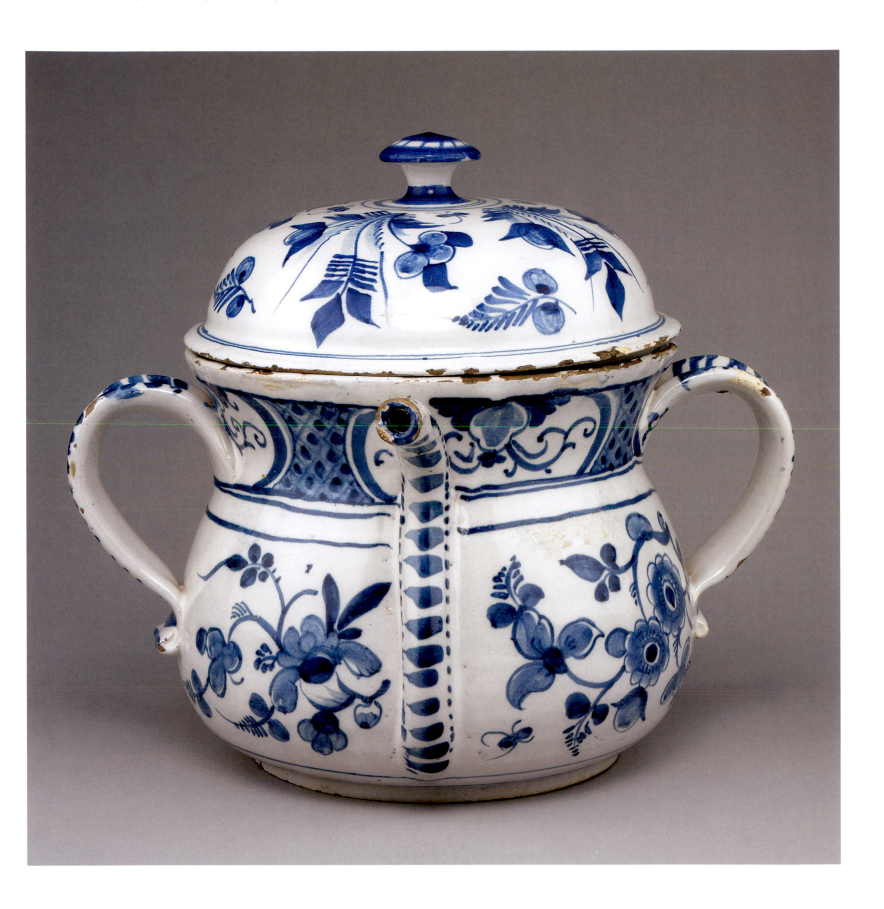

99 **Dish**, 1629

Origin uncertain, possibly made Southwark, London, at the Pickleherring pottery, or on the Continent
Inscribed: 'TR' in monogram, '1629'
Diameter: 27.8 cm
Reg. no. 1887,0210.146; purchased from the collection of Henry Willett, 1887
Tait 1961, p. 22 and pp. 26–7, figs 34, 35; Lipski and Archer 1984, no. 89

The moulded shape of this dish, which is based on dishes made at Faenza, Umbria, Italy, from around 1520,[1] seems to be unique in English delftware, and the decoration is unusual. It is clearly influenced by Italian tin-glazed wares (maiolica) but the style of painting cannot be paralleled. Early in the twentieth century it was attributed to Turin.[2] It seems possible that it might have been made in the Low Countries, but this origin has been discounted by Dr Jan Daniël van Dam, as the date is too early.[3] The other alternatives are that the dish was made and decorated in London by a Dutch potter, or that it was perhaps made elsewhere in Europe. It is notable that the form of the initials and date, and their arrangement, are unusual for English delftware.

Some doubts have been expressed about the age and origin of this dish.[4]

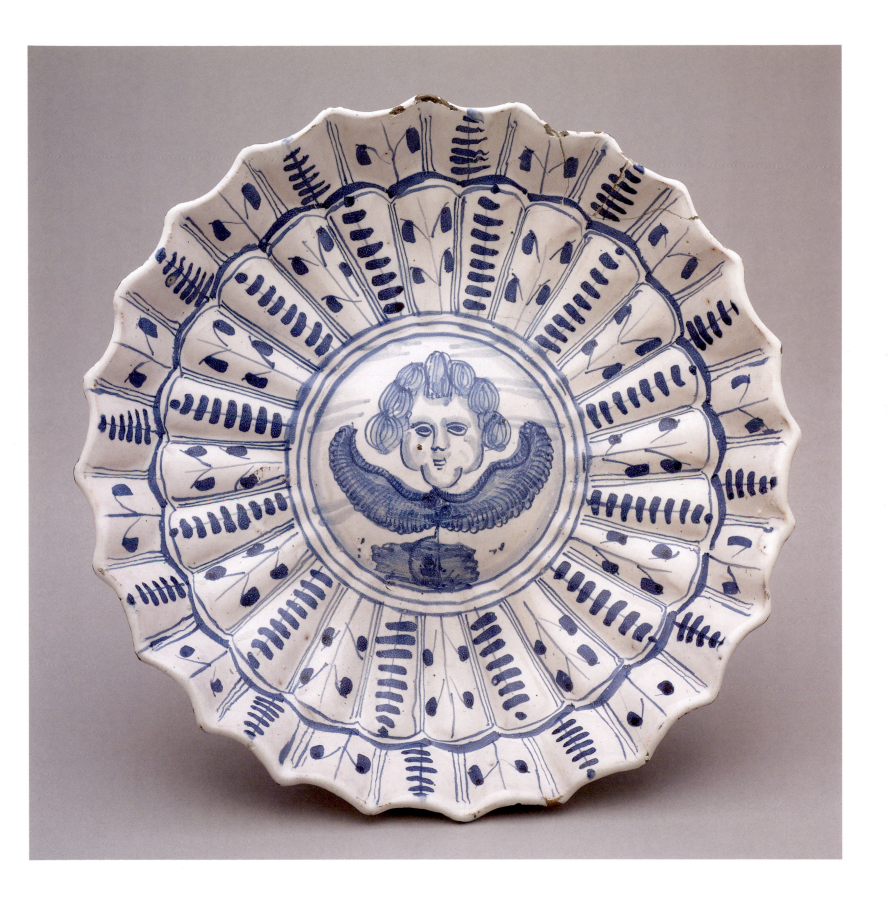

100 **Dish**, about 1645–60

Probably made in Southwark, London, at the Pickleherring or Rotherhithe pottery
Diameter: 36.9 cm
Reg.no. 1970,1002.1; purchased, 1970
Unpublished

The style and palette of this dish are unusual, and the figures have a distinctly Dutch appearance. However, there seem to be no parallels in Dutch delftware for this piece.[1] There are several other parallels, notably a 'blue dash' charger painted in colours with buildings in a landscape in the Longridge Collection, USA,[2] which must be by the same painter. The blue and green trees, the brown and yellow buildings with characteristic towers, the grass in green and blue, and the patches of earth in yellow and brown, as well as the way the clouds are painted, match each other closely. The dish dated 1657 in the Victoria and Albert Museum, which Grigsby has linked to the Longridge dish, and which is discussed in detail by Michael Archer,[3] is less similar, and this dish does not have blue dashes on the rim. Another dish in the Longridge Collection, which is painted with a horseman, and a third dated 1650 and painted with Adam and Eve are certainly part of the same group as the British Museum dish.[4] A dish in the Bristol City Museum and Art Gallery with blue dashes on the border is painted with somewhat similar buildings, a ship and fields in the foreground with the same distinctive brown lines over yellow. There is also a yellow line enclosing the scene as on the Museum and the Longridge dishes. A blue dash charger in the Reading Museum, painted with a king on horseback (probably William III), exhibits some similarities to pieces in this group, but may be rather too late in date to be considered as belonging to it.[5]

There is no doubt that the dishes form a coherent series, and that they have some non-English features, particularly in the grouping of the buildings painted on several of them. If they can be dated to the mid-1650s, then it is quite possible that they were painted by someone who had been trained in the Low Countries and had come to work in London. Some mugs and jugs with scenes in blue of ships and buildings (which include nos 47 and 76), considered by Leslie Grigsby to be close in style to the chargers,[6] are less easy to compare in the absence of the particular palette that seems to characterize this group. However, her comment that several painters were involved in the decoration of this group is pertinent.

For a profile of this dish, see p. 300.

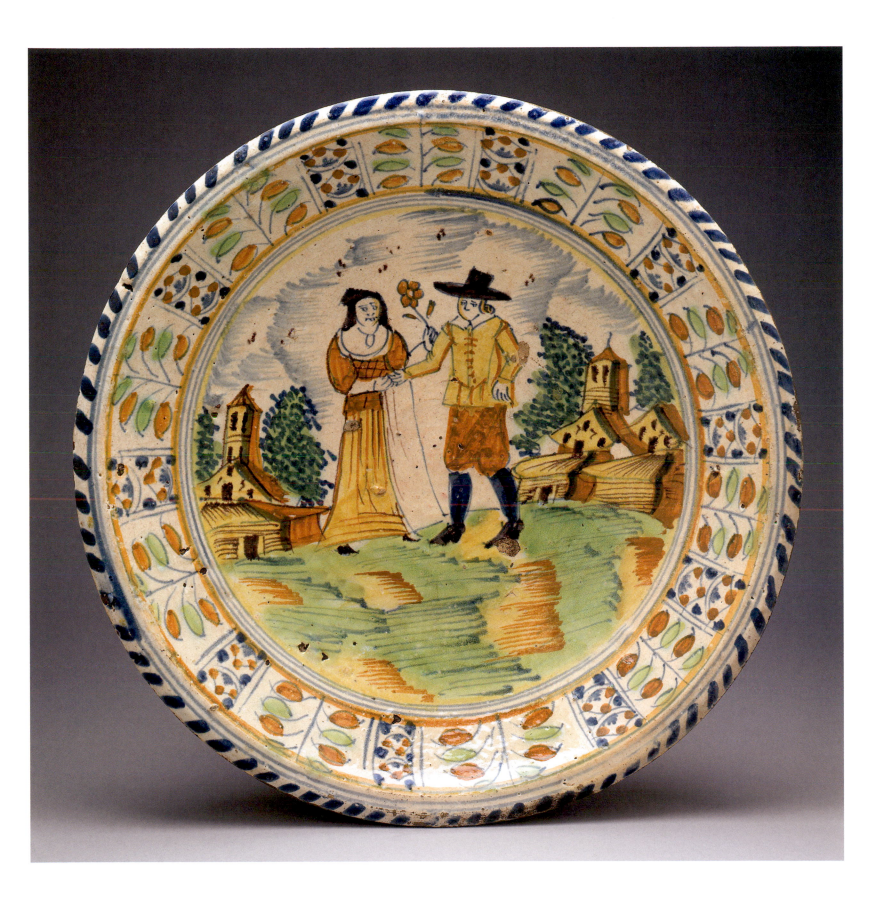

101 **Salt**, mid-seventeenth century

Made in Southwark, London
Height: 15.3 cm; width (max.): 11 cm
Reg. no. 1899.1011.1; presented by J.C. Robinson,[1] 1899
Hobson 1903, E 102; Archer 1973, no. 21

This salt is highly unusual. Its complex architectural moulding is close to that of sixteenth-century lead-glazed earthenware pedestal salts attributed to the School of Fontainebleau. A pair of pedestal salts attributed to the circle of Bernard Palissy, measuring 12.5 cm in height, were sold at Christie's New York, Important Italian Maiolica from Arthur M. Sackler's Collection, 1 June 1994, lot 55. These were in the collection of Henry T. Hope at 'Deepdene' and passed through his grand-daughter to the 6th Duke of Newcastle at Clumber, Nottinghamshire. They were in the Hope Collection when they were exhibited at South Kensington in 1862.[2] As their moulding is identical to that of the delftware example, and they are thought to be of sixteenth-century date, it is likely that the delftware example, of which there is another example painted in blue,[3] was moulded directly from a model of this type, possibly made in bronze.[4]

The iconography of the moulded decoration is linked to the sea. On each side are mermaids lying over an arch, their heads resting on a shell. Below the arch is a pediment, below which is a male bust in a ruff. At each side of the bust is a dolphin in low relief. In the lower zone are female terms in relief at each corner. These flank a figure of Neptune seen in profile and enclosed by a frame, his right arm raised and his left holding the reins of one of two seahorses, which swim in the sea at his feet. At the base are mouldings imitating the lower part of a column. The glazed base is flat and recessed from the unglazed foot. There is a circular hole near one corner of the base. On top is a central circular well within a raised rim decorated with yellow and brown dashes. The well is painted with circles and radiating stylized flowers. At each corner is a male grotesque mask moulded in low relief.

One side is restored, and there is a crack near the restoration and a hole in the base. There are several chips to the foot and numerous losses of glaze overall.

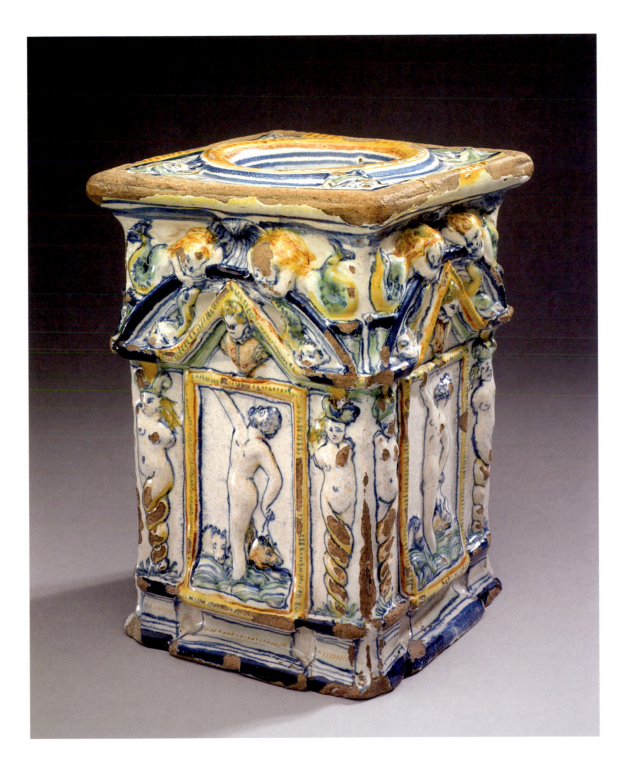

102 **Salt**, about 1660–80

Made in Southwark, London
Height (max.): 13.4 cm; diameter (of bowl): 15.6 cm
Black printed label stuck on base: 'Lot 19'
Reg. no. 1887.0307.E5; presented by A.W. Franks, 1887
Hobson 1903, E 5; Archer 1973, no. 31

Gold and silver vessels for presenting salt ceremonially at the table were little used by the mid-seventeenth century, and smaller salts for individual use were being made from the reign of Charles I (1600–1649; reigned 1625–49). The three scrolls, which had been a feature of earlier metal salts so that the vessel could be used as a stand for a dish at the end of the meal, were retained in the delftware version. Tin-glazed examples can be dated to the second half of the seventeenth century. An inventory dated 1699 from the Pickleherring pottery lists 'curles salts', 'white

plain salts',[1] and 'new fashioned salts' in two sizes. This example has a noticeably pink glaze, which is a feature of seventeenth-century delftware made in London (see nos 67 and 68).

Everyday undecorated salts like this do not survive in great numbers and only a few other similar intact examples have been recorded.[2] An unusual blue and purple marbled example is in the Fitzwilliam Museum, Cambridge.[3] However, salts like this have been found at several London sites, including one at Southwark where waste from the Pickleherring concern was dumped.[4]

There is some archaeological evidence that salts with scrolls or 'curles' were in use in North America in the seventeenth century, as fragments have been excavated at Jamestown Island, Virginia.[5]

103 **Salt**, about 1680–90

Probably made in London at Southwark or Lambeth
Height (to top of scroll): 12.2 cm; diameter (of bowl): 14.3 cm
Reg. no. 1888,11-10,20; presented by A.W. Franks, 1888; formerly in the collection of Octavius Morgan, 1888[1]
Hobson 1903, E 8; Tait 1998, p. 13, fig. 3

Salts of this form are rare survivals, although their metal prototypes, introduced from the Continent in the first third of the seventeenth century, are known. For a white example and a discussion of salts, see no. 102.

The blue ground splashed with white spots copies a type of blue-ground decoration particularly popular at the faïence factory in Nevers (Nivernais), France, from the mid-seventeenth century, and was also in production on German and Dutch tin-glazed wares. The type is known in France as 'bleu Persan', recalling the Persian tin-glazed

wares that inspired it,[2] and the splashed decoration has been called 'à la bougie', probably because of the dripped candle wax effect. In England it seems to have been used on less grand pieces, including plates,[3] fluted bowls,[4] jugs, mugs[5] or

porringers,[6] rather than on more spectacular items such as cisterns,[7] which were painted with chinoiserie scenes. However, a large vase with twisted handles in the Museum of London has this type of splashed decoration,[8] as does a large fluted dish in the Longridge Collection, USA.[9]

Only two other English delft blue-ground salts like this have been traced.[10] On the example in the Cecil Higgins Museum, Bedford, although the scrolls are spotted, the well, rim and foot are painted in white with stylized plants and scrolls.

Delftware decorated with a dark blue ground was made at several London factories as well as probably in Brislington, near Bristol.[11] Attribution of pieces with this decoration to a specific factory is not possible in the light of present knowledge, but it does seem likely that this salt is of London manufacture and was destined for the metropolitan market.

Upper part restored, two scrolls restuck.

104 **Dish**, 1666

Made in London, at the Hermitage pottery, Wapping, or perhaps at Brislington, near Bristol
Inscribed: 'SH 1666'
Length: 19.8 cm
Reg. no. 1887,0307.E45; presented by A.W. Franks, 1887
Church 1884, p. 38; Hodgkin and Hodgkin 1891, no. 322; Hobson 1903, E 45; Lipski and Archer 1984, no. 1036; Archer 1997, F.2

An extraordinarily wide range of delftware vessels was made in England, particularly during the second half of the seventeenth century. However, the only parallel found for this moulded two-handled dish, the function of which is uncertain, is a painted example in the Victoria and Albert Museum, London. This has been attributed by Michael Archer to Brislington on the grounds of its decoration,[1] which corresponds with a group of pieces identified as coming from Brislington, so it is possible that the British Museum piece was also made there, even though it is differently decorated. It is worth noting that the painting on the Museum dish is not dissimilar to the decoration on the posset pot dated 1668, no. 79, which has been attributed to the Hermitage pottery, Wapping.

While Louis Lipski described the dish as a 'sauceboat', Archer was unhappy with this identification.

105 **Plate**, about 1690

Possibly made in Bristol
Diameter: 20.9 cm
Reg. no. 1932,0314.2; presented by J.E. Pritchard FSA, 1932; an ink inscription on a label on the back of the dish reads:
'BRISTOL DELFT PLATE/BRISTOL.1903./found under the flooring of an 18th cent. house during/ demolition'
Burlington Fine Arts Club, 1913–14, p. 82, Case D , no. 13

The dish, which is moulded and has an octagonal foot, is almost flat, with three 'scars' from kiln supports on the back of the rim.

Octagonal plates first appear in the late 1670s. The painted decoration is loosely influenced by Chinese blue-and-white porcelain.

106 **Dish**, late seventeenth century

Made in London
Diameter: 34.6 cm
Reg. no. 1927,0615.1

Dishes like this, painted with tulips, were sold in some quantity from at least 1676,[1] and in several different sizes, of which this appears to be the largest.[2] They are likely to have been used for decorative purposes. The decoration, which exists in many variations, ultimately derives from sixteenth-century Turkish dishes with tulip motifs, but is more likely to have imitated Dutch delftware dishes made in the late sixteenth century during the period of 'tulipomania'.[3] Tulips were introduced to Western Europe from Turkey in the sixteenth century and were enormously popular in both Holland and England in the seventeenth century, remaining a favourite Spring flower in both countries. Most English delft dishes painted with tulips have a 'blue dash' border. This one is tin-glazed on the back.

The dish has been repaired.

107 Jar, 1700

Made in London
Inscribed: '1700' and 'H/WS'
Height: 13.7 cm
Reg. no. 1943,0203.3; presented by the National Art-Collections Fund (The Art Fund), 1943
Lipski and Archer 1984, no. 1548; Ray 2000, no. 19

The precise purpose of two-handled jars like this remains uncertain. It has been suggested that they were for spices, even though none of the surviving examples, some on a pedestal foot, have lids. Chinese stoneware ginger jars are of broadly similar form and they were sealed with cork lids, or cloth, tied around the neck with string. Judging from dated delft examples, the delft jars were made in England during the last decade of the seventeenth and first decade of the eighteenth century.

On one side the painted decoration depicts a putto blowing a horn, which is reminiscent of the putti found on Italian maiolica. The scene on the other side of a putto holding a flowering branch is much influenced by Ming porcelain. For putti below the handles on a punch bowl and cover dated 1697, with the initials 'H/TT', see no. 85.

It is not often possible to attribute delftware to particular painters, but there are so many similarities between the painting on this jar and the decoration on a two-handled pot in the Fitzwilliam Museum, Cambridge, which is also dated 1700 and is inscribed 'IH',[1] that it seems highly likely that they were painted by the same artist.[2] The groups of four dots, the circles made up of dots enclosing a single dot, and the leafy plants and the putto shown with a male organ, holding various attributes are all very similar. A posset pot on three feet dated 1699, also in the Fitzwilliam Museum, Cambridge, and a two-handled pot dated 1701 once belonging to a Northamptonshire collector, may also belong to this group,[3] to which a plate dated 1708 with the initials 'K/EE', which was in the

London trade in 1993, could perhaps be added.[4]

The band of decoration around the neck of this vase can be compared with the motifs in panels on the rim of the cover and on the foot of the punch bowl dated 1697 (see no. 85).

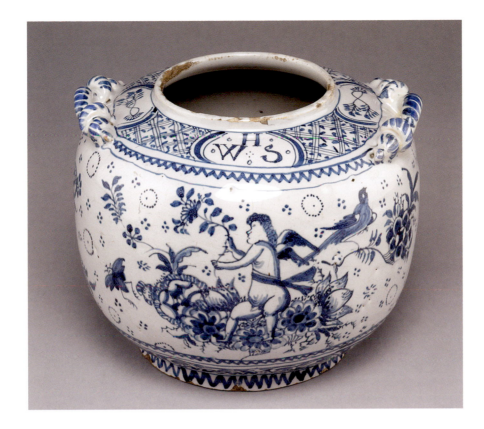

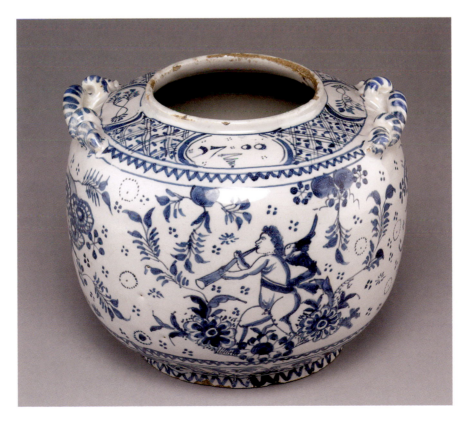

108 **Plate**, 1711

Made in London, possibly at the Hermitage pottery, Wapping[1]
Inscribed: 'P/W.M/1711'
Diameter: 22.4 cm
Reg. no. 1887,0307.E132; presented by A.W. Franks, 1887; formerly in the collection of J.F. Ford[2]
Church 1884, p. 71; Hobson 1903, E. 132; Lipski and Archer 1984, no. 261

There are three stilt marks on the back of the plate, which is cracked and has some damage to the rim. It was once thought to have been made in Bristol, but the late Frank Britton suggested in 1994 that it was made at the Hermitage pottery, Wapping, on the grounds that the initials may refer to the marriage of William Pardoe, a tailor, and Mary Wright, both of the parish of Christ Church, Spitalfields, London, on 6 November 1711.[3] Pardoe was apprenticed to the Clothmakers' Company on 7 April 1703 for seven years. An apprentice was not permitted to marry without the consent of his master, but in this case the period for which Pardoe was bound had expired, even though he was not made free until July 1713. The Pardoes lived east of the City of London and north of the river; the Hermitage pottery was the only one operating in this area.

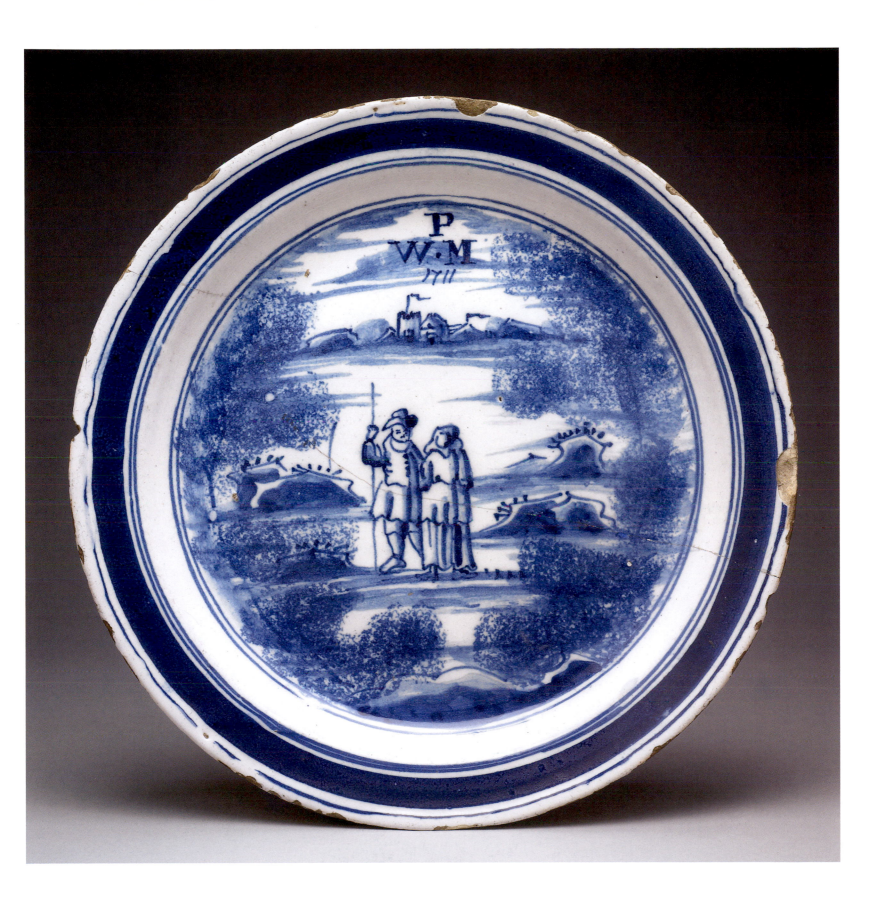

109 Set of 'Merryman' plates, 1736 and 1742

Made in England

1 Inscribed: '(1)/What is a/merry Man /1736'
Diameter: 21.7 cm
Reg. no. 1888,1110.19; presented by A.W. Franks, 1888, formerly in the Octavius Morgan Collection;[1] label inscribed 'Given to me by Mr Edkins AF 1898', so possibly formerly in the William Edkins Snr Collection
Hodgkin and Hodgkin 1891, no. 395, p. 106; Hobson 1903, E 55; Burton 1904, fig. 14, opp. p. 60; Lipski and Archer 1984, no. 412
Repaired.

2 Inscribed: '(2)/Let him do/What he Can/1742'[2]
Diameter: 22.7 cm
Reg. no. 1887,0307.E56; presented by A.W. Franks, 1887
Church 1884, p. 38; Hodgkin and Hodgkin 1891, no. 397, p. 107; Hobson 1903, E 56; Lipski and Archer 1984, no.481
Repaired.

3 Inscribed: '(3)/To Entertain/his Guests/1742'
Diameter: 22.3 cm
Reg. no. 1887,0307.E57; presented by A.W. Franks, 1887
Church 1884, p. 38; Hodgkin and Hodgkin 1891, no. 398, p. 107; Hobson 1903, E 57; Lipski and Archer 1984, no. 481A

4 Inscribed: '(4)/With wine & /Merry Jests/1742'
Diameter: 22.8 cm
Reg. no. 1887,0307.E58; presented by A.W. Franks, 1887
Church 1884, p. 38; Hodgkin and Hodgkin 1891, no. 399, p. 107; Hobson 1903, E 58; Lipski and Archer 1984, no. 481B

5 Inscribed: '(5)But if his/Wife do frown/1742'
Diameter: 22.6 cm

Reg. no. 1887,0307.E59; presented by A.W. Franks, 1887
Church 1884, p. 38; Hodgkin and Hodgkin 1891, no. 400, p. 107; Hobson 1903, E 59; Lipski and Archer 1984, no. 481C

6 Inscribed: '(6)/All merriment/Goes Down/1742'
Diameter: 22.9 cm
Reg. no. 1887, 0307.E60; presented by A.W. Franks, 1887
Church 1884, p. 38; Hodgkin and Hodgkin 1891, no. 401, p. 108; Hobson 1903, E 60; Lipski and Archer 1984, no. 481D
Rim repaired.

These so-called 'Merryman' plates were obviously popular for a long period, since a set dated 1682 is known.[3] They were copied from Dutch examples, some of which had English inscriptions and were made for export.[4] There are two Dutch hexagonal 'Merryman' plates in the Museum collection, which were catalogued as English by R.L. Hobson in 1903.[5] Plates with German rhymes were also made. Such rhymes were used even before the seventeenth century on wooden trenchers. They have a link to the notion of 'the world turned upside down' and the reversal of the traditional order, when women exercized authority and scolded their husbands as they enjoyed their pleasures.[6]

It is not known whether dishes like these were for display or for use, but as they are quite plain they may have been intended for use, perhaps when entertaining guests. On the other hand, the number surviving may indicate that they were for display only.

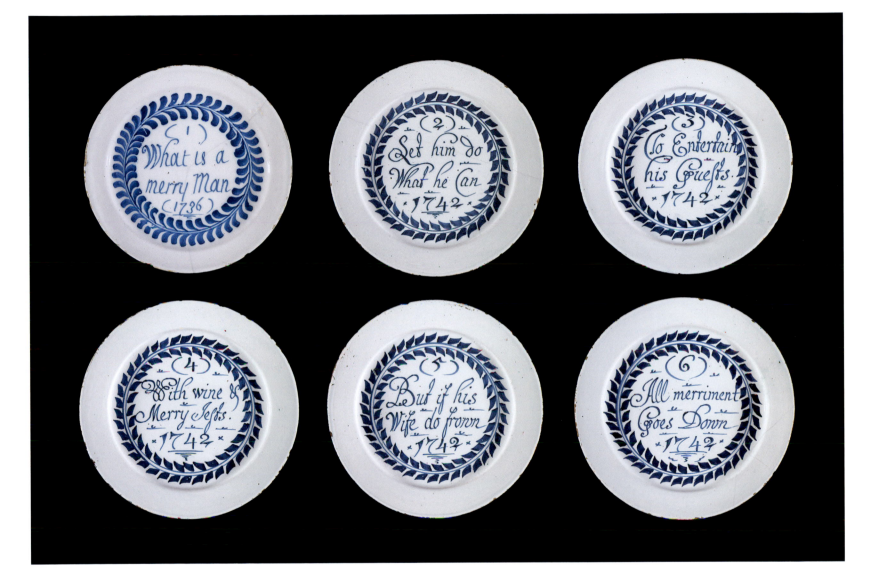

110 **Plate**, 1748

Made in England, possibly in Bristol, or Ireland, possibly Dublin, World's End, at John Crisp's pottery
Inscribed: 'C/IE/1748'
Diameter: 22.8 cm
Reg. no. 1938,0314,33; bequeathed by Wallace Elliot, 1938 (collection label numbered '357' in ink); formerly in the Gosford Castle Collection (collection label printed in black and numbered ?'432' in ink)
Tait 1957, pp. 52–3, figs 17,18; Longfield 1971, p. 39 and pls 3, 3a; Lipski and Archer 1984, no. 521; Archer 1997, B.128; Francis 2000, pp. 41–2

There are six known plates of this pattern with the same inscription (see below). The Gosford Castle Collection in County Armagh, Ulster, from which this plate comes, was sold after the death of the 4th Earl of Gosford on the premises in a sale that lasted nearly three weeks and began on 21 April 1921. Although there is no evidence, it has long been thought that the initials on the back of this plate are those of John Crisp, owner of the World's End pottery from before 1747 to early 1749 and his wife Elizabeth, and that the plate commemorates their marriage in 1748.

However, as Peter Francis has pointed out, the date of John Crisp's marriage is unknown, as is the name of his wife.[1] He argues that as the assemblage of Dublin delftware has grown, these plates have come to seem 'unlike all other known examples of Dublin delftware' and in 1997 Michael Archer wrote that, aside from the source from which they came, 'there are no grounds, stylistic or otherwise, for connecting these plates with Dublin'.[2] However, they cannot be directly compared to known products of other delftware factories. Production difficulties, which might possibly be more characteristic of an Irish concern, are indicated by the three stilt marks on the back of the plate and the numerous pinholes to the glaze on both back and front of the plate.

Archer has suggested that this plate may have been made in Bristol on the grounds of its unusually shaped border, which he signals as being related to Bristol examples, although it is by no means identical.[3] There are five other similar examples: in the Victoria and Albert Museum, London, the Potteries Museum and Art Gallery, Stoke-on-Trent, National Museum of Ireland, Dublin, and two in private collections.[4]

The painted pattern of rocks and chrysanthemums in the Chinese style is based on late Ming (i.e. seventeenth-century) porcelain decoration.

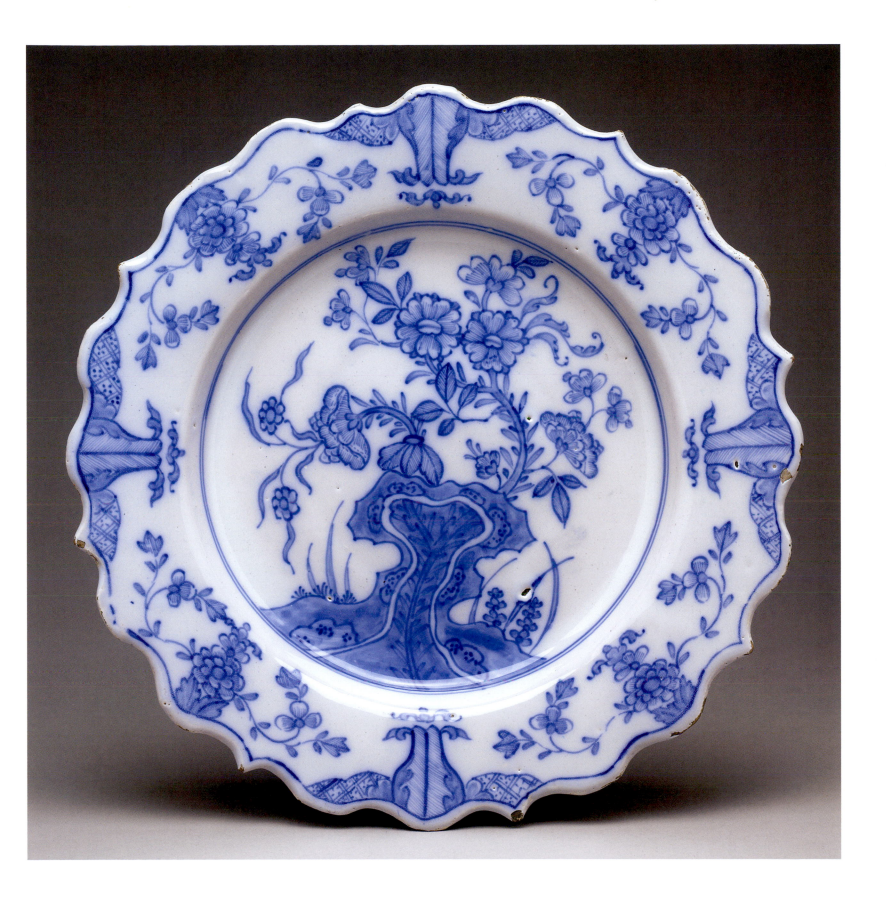

III **Plate**, 1748

Made in Lambeth, London
Inscribed: 'S/IM' on the front and 'S/IM/1748'
Diameter: 22.2 cm
Reg. no. 1960,1201.1; presented by Miss E.G. Overfield, 1960
Lipski and Archer 1984, no. 524A

There is a plate from the same set in a private collection in the USA.[1] An undated dish with with a scalloped rim has the same border decoration of leaves scratched through the glaze, and four flowers and a Chinese figure in a landscape of flowering branches, is in the collection at the DeWitt Wallace Museum of Decorative Arts, Virginia.[2] Another plate in the same collection is similarly decorated, in this case with a Chinese figure carrying birdcages, near bamboo and a tree, but the border has a manganese-purple ground, rather than a blue one.[3] A shard with a similar motif to that found on the border of the British Museum plate was discovered at the Chiswell-Bucktrout House, Williamsburg, indicating that plates like these were in use in the area during the second half of the eighteenth century.[4]

The inspiration for the scene was no doubt Ming porcelain, which was hugely popular in England in the first half of the eighteenth century.

The identity of the couple for whom this plate was made, perhaps to commemorate their marriage, is unknown.

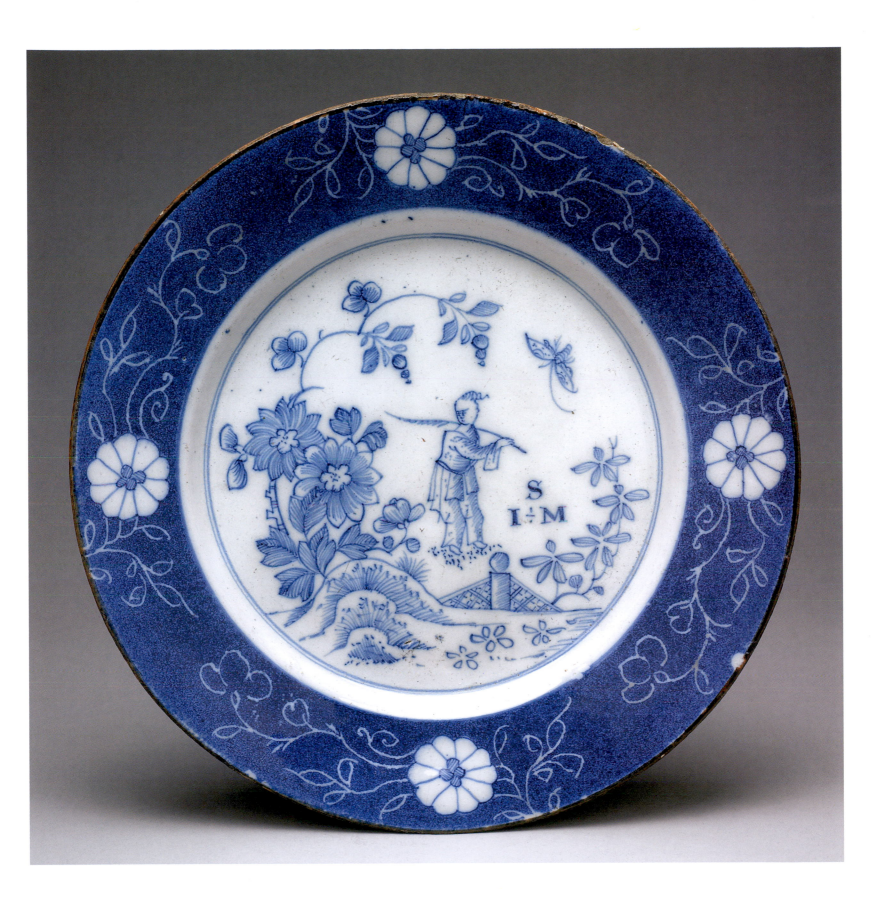

112 **Four plates**, about 1750–60

1 Made in Bristol, at the Temple Back factory, about 1750–60
Diameter: 23.2 cm
Reg. no. 1887,0616.4; presented by William Edkins Snr, 1887;
paper label on reverse inscribed 'Bristol delftware June 1887
W.Edkins'
Hobson 1903, E 123

This design, one of the most charming of all the Chinese-style patterns that enjoyed enormous popularity on delftware, as on other contemporary ceramics such as stoneware, is found on plates of different shapes, in different colours and with different border patterns.[1] It is rarest on plates with a powdered manganese ground, as here.

William Edkins Senior, a collector living in Bristol in 1885 whose sale was held in 1874,[2] was a descendant of Michael Edkins, a painter who worked for Richard Frank at Redcliff Back pottery before setting up on his own.[3]

2 Probably made in Bristol, about 1750
Diameter: 22.2 cm
Reg. no. 1921,0216.22; presented by Mrs M. Greg in memory of
Thomas Greg, 1921[4]

Powdered manganese has been puffed from a container onto the white glazed leather-hard plate before firing to achieve the purple ground. The ground and the border motifs painted in brown are similar to those on a plate in the Victoria and Albert Museum,[5] except that the motifs

are in red and are less carefully painted. The dashes and crosses on the reverse of the V&A plate are lacking here. Another dish in the Bristol City Museum and Art Gallery, described as having a 'pink powder ground' with red (for the motifs), is similarly decorated and has the same markings on the back.[6]

The dish has been repaired with metal rivets.

3 Made in London, perhaps at William Griffith's Lambeth High Street pottery,[7] about 1750
Diameter: 22.5 cm
Reg. no. 1921.0216.21; presented by Mrs M. Greg in memory of
Thomas Greg, 1921[8]

The unusual coffee-coloured or 'dead leaf' ground has been achieved by puffing powdered iron onto the surface of the unglazed leather-hard pot before firing. Cobalt oxide was used for the decoration of Chinese-style birds and flowers. To judge from surviving pieces, the brown ground, probably copied from Chinese Kang-Xi period porcelain with a brown ground, known as Batavian ware from the port in Java through which it was trans-shipped to Europe, was clearly much less popular than powdered manganese used for purple or powdered cobalt used for blue. A tile with this rare ground, now in a private collection, was sold at Moore, Allen & Innocent, 25 September 2008.[9] Next to yellow, powdered green grounds obtained from copper are the rarest of all.[10] These coloured grounds were all used in combination with

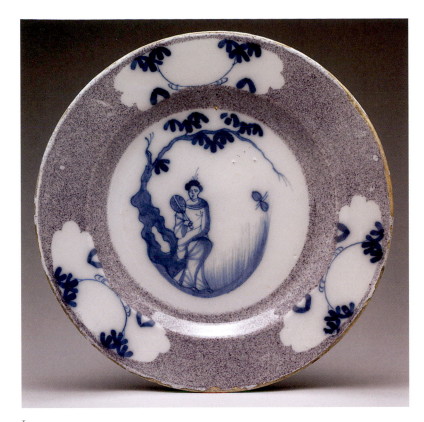

1

2

3

4

painted decoration in the Chinese style.

The attribution to William Griffith's pottery in Lambeth is based on a sherd found in Lambeth by Professor Garner, which matches a powder-brown ground plate in the Victoria and Albert Museum.[11] The border decoration on that plate is floral, while a powder-green plate also in the V&A has very similar bird motifs on the border and matching bamboo and flowering plant decoration in the centre.[12] A plate with a similar brown ground, decorated in the same style, is in the DeWitt Wallace Museum of Decorative Arts, Colonial Williamsburg, Virginia,[13] as is another version of the pattern, which has five reserves only of different shape to those on the British Museum plate.[14]

There are three stilt marks on the back of the plate, which has a damaged rim.

4 Made in London, probably William Griffith's Lambeth High Street pottery, about 1750
Diameter: 22.7 cm
Reg. no. 1961,1102.166; bequeathed by W.P.D. Stebbing

The decoration on this plate is rather crudely painted, and the border motifs have been scratched through the manganese glaze and coloured yellow. There is one in the Victoria and Albert Museum,[15] which has a bird as well as insects and flowers and has been attributed on the grounds of its incised decoration to the factory at Lambeth High Street, where related fragments were found.

The border motifs used on these plates were used in various combinations for decorative schemes that evidently enjoyed some popularity in the mid-eighteenth century, judging from the number of surviving examples. A plate in the Colonial Williamsburg collection has simplified leaf and flower sprays incised on the powdered manganese border and filled in in yellow;[16] but the decoration in the well is quite different from that on the Museum plate.

The rim is extensively chipped.

113 Plate, 1754

Made in England, possibly at Lambeth
Inscribed: 'Iohn Saunders/1754'
Diameter: 22.2 cm
Reg. no. 1891,0524.6; purchased 1891, previously in the collections of G.R. Harding and William Edkins Snr, probably the one sold from the William Edkins Collection by Sotheby, Wilkinson & Hodge, 21 April 1874 and two following days, lot 154
Church 1884, p. 69; Hodgkin and Hodgkin 1891, no. 468; Hobson 1903, E 135; Lipski and Archer 1984, no. 581A

The decoration in the Chinese style includes a tree peony painted in the centre of the plate, a vase containing a peacock feather and what is probably a book tied with a ribbon, which has been misunderstood by the painter.[1] The veins on the large fleshy leaves have been scratched through with a sharp point before the painted decoration was fired.

It is just possible that the plate was made for the owner of the delftware pottery at Glasshouse Street, Lambeth, who is documented from 1743, recorded as having a model of Delamain's coal-fired kiln (see no. 91) and who also made porcelain.[2] However, it was firmly attributed to Bristol when sold from the William Edkins Collection in 1874 (see above), Edkins being a descendant of the pot painter Michael Edkins.

There is another plate from the same set, once in the Garner Collection.[3] Sets of plates seem to be relatively common, to judge from surviving examples (see nos 110–11, 116–18, 121).

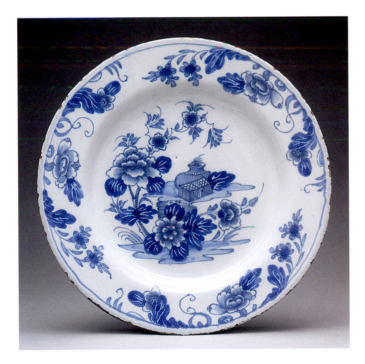

114 **Bowl**, about 1752–7

Made in Dublin, at Henry Delamain's pottery
Diameter: 21.5 cm; height 8.3 cm
Reg. no. 1888,1110.33; presented by A.W. Franks, 1888; formerly in the collection of Octavius Morgan[1]
Longfield 1971, p. 44 and pl. 6; Archer and Hickey 1971, cat. 28; Archer 1973, no. 136

Circular baskets with pierced sides like this may have been intended for fruit. Many of those painted in the typical Dublin delftware style have a design of 'touching' circles, while this one has intersecting circles, a form that seems to have remained unrecognized for some time, despite the presence of this piece in the Museum collection since 1888. It was not included in Hobson's *Catalogue of English Pottery,* published in 1903, as it was thought to be Dutch. Its correct place of manufacture was not published until 1913, when Westropp illustrated a similar bowl painted with a landscape, which is inscribed 'Dublin' on the base.[2] A small bowl with a pierced rim, which is painted with a landscape scene in blue and inscribed 'Dublin' on the base in blue below a harp, is in the collection of Manchester Art Gallery.[3] For Delamain's factory, see no. 91.

Other examples of finely painted scenes on Irish delftware have been recorded.[4]

Two circular holes in the footrim might suggest that the bowl was hung up.

Slight restoration to the rim.

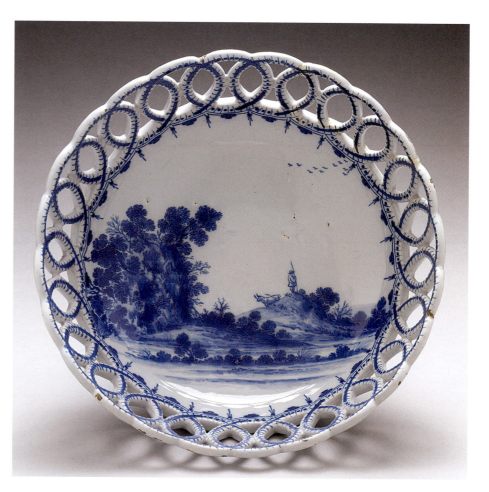

115 **Plate**, about 1759–67

Made in Dublin, at Henry Delamain's pottery
Diameter: 26 cm
Reg. no. 1906,1107.1; presented by Max Rosenheim, 1906

The form of the plate, the manganese decoration, the style of the landscape painting and the border motifs are all typical of plates made at Henry Delamain's factory. There are three noticeable stilt marks on the back of the plate left by the support used to separate it from others in the kiln, so that they would not stick together during the glaze firing. One area of the back of the plate is bare of glaze. On the front of the plate is a pinhole in the glaze. These defects indicate that the pottery was unable to produce wares of the very highest quality, although the landscape painting, of a type once attributed to Peter Shee, is highly skilled.

Other similar examples are recorded.[1]

The plate, like no. 121, was thrown and then cut to shape, as can be determined from its base.

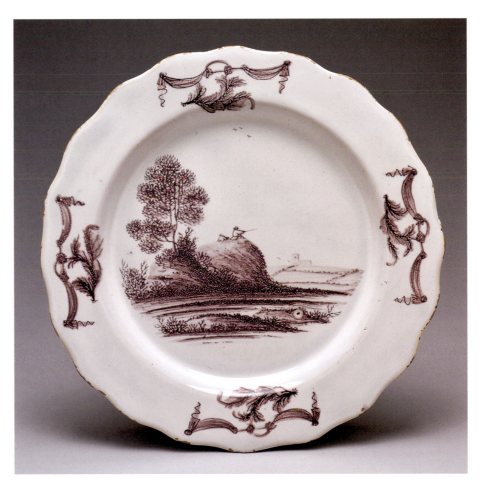

116 **Plate, 1760**

Made in Bristol, at Richard Frank's Redcliff Back factory, painted by Michael Edkins
Inscribed: 'E/M+B/1760'
Diameter: 22.6 cm
Reg. no. 1887,0616.3; presented by William Edkins Snr, 1887
Hobson 1903, E 113; Tait 1957, p. 51

The scene on this plate, although it looks Chinese, is unlikely to have been copied from any Chinese original. It is a Western invention, which the Chinese porcelain decorators copied for export wares made during the eighteenth century.[1]

A plate in the Victoria and Albert Museum, London, is decorated with almost exactly the same painted scene of a Chinaman by a fence, with cattle and two quail in the foreground, and bears the same initials on the back.[2] It was presented by William Edkins Sr to the Museum of Practical Geology before 1871 and transferred to South Kensington in 1901. As Michael Archer notes, Hugh Owen, the ceramic historian, recorded an interview with William Edkins in 1859 during which he stated that in 1760 his grandfather, Michael Edkins, had painted a set of plates with an oriental scene and his initials and those of his wife Betty.[3] One plate was given by W. Edkins to the Museum of Practical Geology, the other to Owen. Edkins said that his grandfather had painted them shortly before he ceased to work for Richard Frank at the Redcliff Back pottery. This is considered to be plausible, and it is known that Elizabeth

Edkins signed herself 'Betty' in the marriage register. The British Museum plate is evidently part of this set and does not seem to have belonged to Owen.

There is a paper label on the back of the plate inscribed in ink: 'This plate "one of a Dessert Service" was painted by my Grandfather Michael Edkins at Richard Frank's Delft-ware factory on Redcliffe Back, Bristol./The initials E/MB are those of Michael Edkins and his wife Betty./Wm. Edkins May 18.th 1887'. Another label is inscribed in black ink: 'W.m Edkins/to/A.W. FRANKS./May 20th. 1887'.

The plate is cracked; glaze losses to rim.

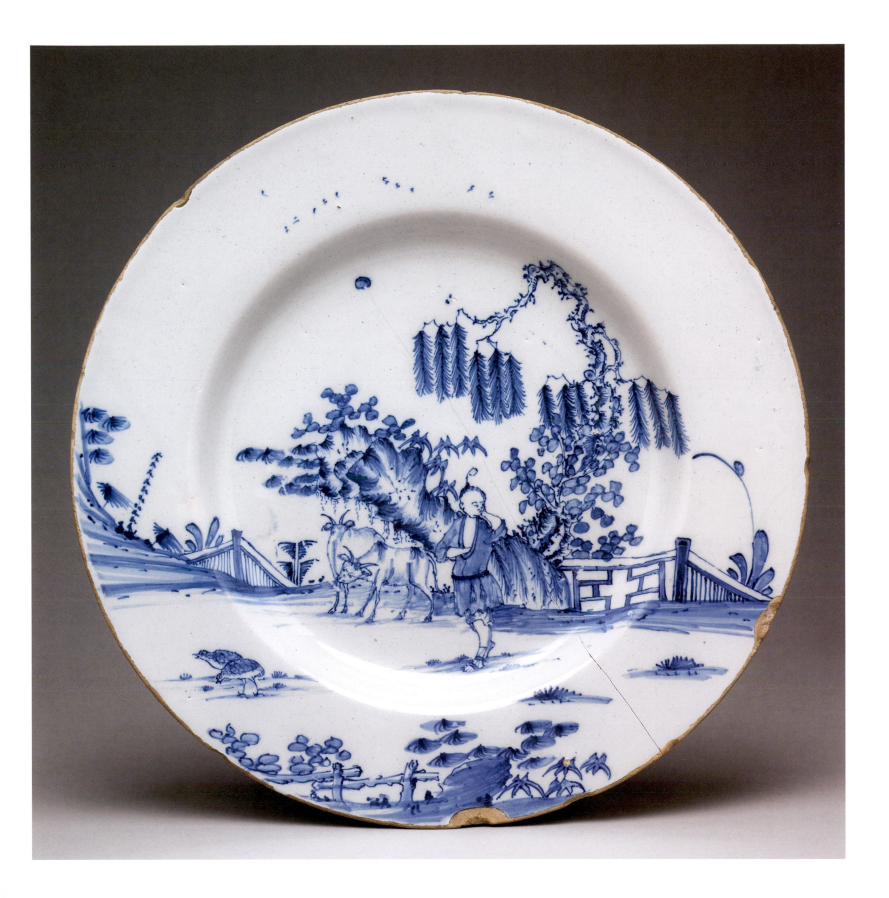

117 **Plate**, 1760

Probably made at Richard Frank's Redcliff Back pottery, Bristol
Inscribed: 'Cornelius Dixon/Norwich/1760'
Diameter: 22.9 cm
Reg no. 1887,0210.145; purchased from the collection of Henry Willett, 1887
Hodgkin and Hodgkin 1891, no. 475; Hobson 1903, E 136; Lipski and Archer 1984, no. 608A

There is a similar plate in the Victoria and Albert Museum, London, with a matching inscription, as well as two further plates with the same design, one with the same inscription and one inscribed 'Charles Cordy, Norwich 1760' (see below).[1] Cornelius Dixon, who was the son of John and Amy Dixon, was baptized on 14 November 1725 at St George's Church, Norwich.[2] The marriage of Cornelius Dixon and Ann Hastings on 9 October 1759 at St Michael Plea probably refers to the owner of the plate. No further information has come to light about Dixon, but

as he and his parents lived in the same parish as Charles Cordy (see below) they may have known each other.

Other plates with related decoration inscribed on the reverse with the name 'Charles Cordy', 'Norwich' and the dates 1758 and 1760 are recorded.[3] Further examples made for Charles Cordy in 1760 are known in a private collection.[4] Cordy has been traced in Norwich records, and is described as a sawyer, who was a freeholder and eligible to vote in the national election of 1761.[5]

The so-called *bianco-sopra-bianco* decoration (literally 'white-on-white', see nos 93, 117, 126) of flower sprays and leaves alternating with diaper panels, painted in white over the tin glaze,[6] and the shape and decoration of the plate suggest a Bristol origin. Evidently there were clients for sets of plates with Chinese landscape scenes in Norwich and they may have placed orders at fairs or through travellers.

The plate is cracked.

118 **Plate**, about 1760

Made in England, possibly in Bristol
Inscribed: 'Jacob and Rebecca Anobas'
Diameter: 29.7 cm
Reg. no. 1887.0210.143; purchased from the collection of Henry Willett, 1887
Hodgkin and Hodgkin 1891, no. 498; Hobson 1903, no. E 120

This dish may be one of several that document the presence and affluence of Jewish merchants in eighteenth-century Britain and beyond on account of the first names and the unusual family name, which could be of Spanish (Sephardic) origin. It has been suggested that the name is in fact 'Arobas', or 'Arobus' (an alternative spelling of 'Arobas'), a Sephardic name of Portuguese origin, rather than 'Anobas'. A Jacob Arobus is documented as a shopkeeper in Barbados during the eighteenth century and may well have had links with Bristol.[1] A merchant named Simeon Massiah is also listed,[2] and may have had a family relationship with the 'Mordecay Massiah', whose name appears on a plate dated 1750, painted in blue with a landscape scene in Chinese style (fig. 16).[3] The Massiah family recorded in Barbados in the seventeenth and eighteenth centuries had links with London,[4] and conceivably also with Bristol in connection with the West Indies trade. The Jewish community in Barbados, which was based in the towns, was thriving during the eighteenth century. A visitor from New Jersey commented in 1741 on the 'great trade' carried out by the Jews there.[5]

Another dish dated 1760 and inscribed 'Anke Jacobs',[6] also painted with a Chinese scene and with a border divided into three zones, could perhaps also be part of a series for Jewish clients.[7] Two further plates, one inscribed 'Ben,[n] & Deborah Nunes' and the other inscribed 'Abraham and Sarah Brandon',[8] which were destroyed in the Second World War (see p. 302, nos 16 and 17), were probably made for people from the same community.

A plate dateable on archaeological evidence to the 1720s, which was found on the site of 12–14 Mitre Street, London, is decorated with an inscription in Hebrew characters, proving beyond doubt that Jews in London used locally-made delftware in their households.[9]

The Jewish community in Bristol, where this dish may have been made, was one of the earliest in England, although it was one of the smallest, and was probably in existence in the twelfth century.[10] Jews were expelled from England in 1290, but began to return in the seventeenth century. By the middle of the eighteenth century there was a synagogue in Bristol and the community grew steadily. The synagogue, used between 1756 (and probably before) and 1786, was situated in Temple Street, near at least two delftware potteries: one run by Thomas Cantle and later William Taylor, and another run by Richard Frank. The succeeding Bristol synagogue opened in 1786 and was paid for by Lazarus Jacobs, who had emigrated from Frankfurt-am-Main, Germany, around 1760 and became one of Bristol's best-known glassmakers. He employed the painter Michael Edkins, who had worked at Richard Frank's factory when young.[11]

Fig. 16 Plate, inscribed 'Mordecay Massiah 1750'. Diameter 23 cm. Private Collection

The decoration painted in the centre of the dish is particularly evocative of the Ming porcelain from which it is derived. A similar figure of a lady with a fan under a bamboo tree, without the child and flying bird, is painted in a much more stylized manner on several plates in the Victoria and Albert Museum, London.[12]

Another dish inscribed 'Jacob & Rebecca Anobas', painted with an interior scene of a vase on a table and a Chinese figure, enclosed by an irregularly-shaped reserve, is in the Bristol City Museum and Art Gallery.[13] This piece is further evidence that plates were made in sets, not necessarily with matching decoration. These sets were probably created to order. If they were for use rather than for display, the plates probably had a ceremonial, rather than a purely domestic, function.

Rim restored; long crack, loss of glaze to base.

119 Plate, about 1760

Made in Bristol, probably at Richard Franks's Redcliff Back pottery
Diameter: 22.6 cm
Reg. no. 1887,0616.2; presented by William Edkins Snr, 1887; a paper label on the reverse is inscribed 'English Bristol delftware painted by Bowen in 1761. Vide H. Owen's Two Centuries of Ceramic Art in Bristol Page 337. W. Edkins June 1887'
Hobson 1903, E 129

There are two plates in the Bristol City Museum and Art Gallery and Museum that correspond closely to this plate, especially in the characteristic treatment of the trees and the figures.[1] These and other related plates have been attributed to John Bowen on the basis of a plate dated 1761 and signed 'Bowen fecit', illustrated in an engraving in H. Owen, *Two Centuries of Ceramic Art in Bristol,* published in 1873, but apparently destroyed in the fire at the Alexandra Palace, London, in 1873 where they were exhibited. John Bowen may have worked at Redcliff Back, although there is no known documentation of his presence there.[2]

Scenes painted in blue covering the entire plate are typical of plates attributed to Bristol.

For the donor, William Edkins, see no. 116.

120 Plate, about 1760–5

Made in Bristol
Diameter: 22.8 cm
Reg. no. 1981,0101.69; bequeathed by Miss Constance Woodward, 1981

There are many variations on this Chinese-style landscape pattern on dishes with scalloped or plain rims, which are decorated with different patterns in the so-called *bianco-sopra-bianco* technique. Literally translated from Italian this means 'white on white', but in fact the white patterns are painted in white onto a bluish or pale blue glaze, the contrast being particularly pleasing. Probably based on slip-painted patterns on Chinese porcelains, *bianco-sopra-bianco* seems to have been brought to England from the Rörstrand factory, Sweden, by a certain Magnus Lundberg, who was employed at the Bristol factory run by Richard Frank in the 1750s and 1760s.[1] The technique seems to have been known before 1758, the date of the first edition of R. Dossie's *Handmaid to the Arts.* In the second volume is a passage headed 'Preparation for an enamel for earthen-ware for painting white upon a white ground', which involves calcined tin.[2] Some dishes have the blue Chinese-style pattern around the edge of the well as here, or even framing the decoration in the centre, while others are left plain. A dish in the Bristol City Museum and Art Gallery is similar to the British Museum example.[3]

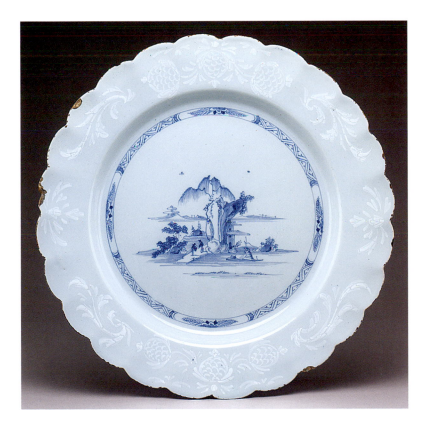

121 **Plate**, about 1770

Probably made in Liverpool
Inscribed: 'E/WQ', painted on the back of the plate
Length: 21.7 cm; width (max.): 23 cm
Reg. no. 1887,0210.144; purchased from the collection of Henry Willett, 1887
Hodgkin and Hodgkin 1891, no. 502; Hobson 1903, E 137

As this plate has a foot, it is likely to have been thrown and then cut into an octagonal shape with the aid of a form. There are three stilt marks on the reverse left by the kiln supports, preventing the glazed back from adhering to another plate during firing when the powdered glaze on the 'raw' pot melted. The glaze is bluish in tone. On the reverse are three stylized grasses or bamboo stems painted in blue.

The decoration is unusually complex, especially on the border and around the central scene. This represents a

well-to-do couple in fashionable clothes, seated on a bench behind a three-legged circular tea table, drinking tea in a garden. The fence and trees behind are in the Chinese style, a theme which is continued in the schematic branches painted on the back of the plate. The tea drinkers are reminiscent of scenes on contemporary English porcelain decoration. The Worcester porcelain factory decorated a large number of tea wares with a similar scene designed by Robert Hancock and printed in many different variations.[1] These porcelains, unlike tin-glazed earthenwares, could withstand boiling water and so were eminently suitable for serving tea.

The initials on the reverse are likely to be those of the married couple for whom the piece was made, rather than of the painter of the plate. Another example with the same initials was with Garry Atkins in March 2002, suggesting that a series of matching plates was made.[2]

The plate is attributed to Liverpool, although a very similar border pattern with butterflies was used at the World's End pottery, Dublin.[3] However, this scene, which exists in a number of variations, might have been familiar to Liverpool potters since it was the subject of tiles and plates printed in Liverpool.[4]

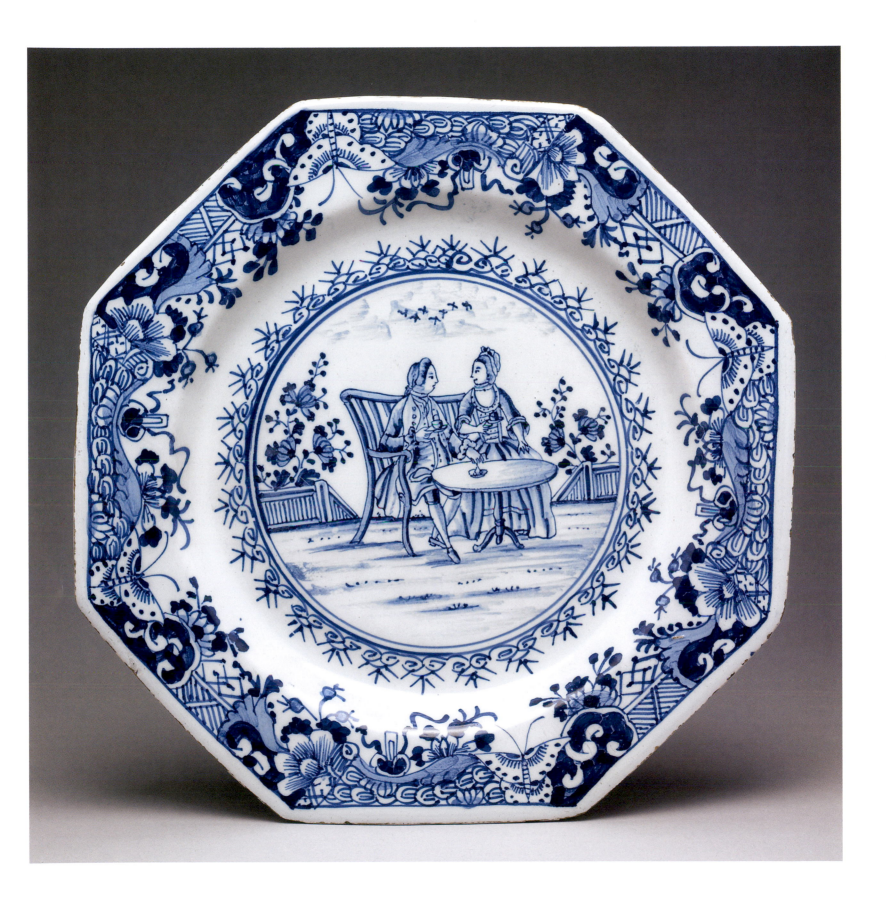

122 **Plate**, about 1770

Made in Liverpool, printed by John Sadler
Diameter: 22.2 cm
Reg. no. 1887,0616.6; presented by William Edkins Snr, 1887
Hobson 1903, E 138

The scene printed on this plate is known as 'The Sailor's Farewell'. This and a different version of the print both appear on delftware tiles.[1] The source of the print on the plate has not been identified, although Drakard signals the print for 'The Sailor's Return', which is closely related, as drawn by Boitard and engraved by T. Booth. This print commemorates the safe return of some of the surviving crew of the George Anson's *Centurion* in 1744.[2] Another delftware plate printed with 'The Sailor's Farewell' was in the Van Oss collection;[3] a third is in Brighton Museum and Art Gallery,[4] where it is displayed next to a creamware plate printed with the same scene;[5] a fourth one has been noted in a private collection.

Printed delftware plates are rare,[6] this being probably the commonest design. Apart from 'The Sailor's Farewell' only a few other subjects are known including the 'Tithe Pig',[7] the 'Sportsman's Arms',[8] and Admiral Boscawen.[9] Printing on delftware tiles was perfected by John Sadler of Liverpool in 1756, after many years of trials.[10] Initially wood blocks were used (see no. 143 for a tile in this technique), but within a year copper plates were substituted. It is not known who engraved the copper plates for the printers. Sadler prints can be found on delftware tiles as well as on creamwares, principally those manufactured by Josiah Wedgwood I. It seems likely that all the prints found on English delftware were done by him.

A different version of the *The Sailor's Return* printed from a woodblock by Sadler in 1756–7 is known.[11]

A printed coat-of-arms, which has been coloured in by hand, is found on a plate made in Limerick, Ireland (see no. 57).

123 **Dish**, 1736

Made in Wapping, London, at the Hermitage pottery
Inscribed: 'James Tidmarsh/1736'
Diameter: 33.7 cm
Reg. no. 1942,1208.3; purchased through the National Art-Collections Fund (The Art Fund), 1942; from the collection of T.G. Cannon
Lipski and Archer 1984, p. 95, fig. 406; Britton 1997, p. 141, figs 2, 3

Whimsical scenes of Chinese figures in the countryside in two large panels alternating with European figures in two small panels, enclosed by scrolling lines, decorate the rim and part of the well of this singular plate, which has a bluish glaze. On the reverse the glaze has 'crawled' in many areas, suggesting unusual difficulties in production, as most dishes are evenly glazed. In the centre at the right is painted an extended arm in a shirt and jacket with the hand holding a tankard. Two phoenixes are painted on the reverse close to the signature of James Tidmarsh and the date 1736. Although it might seem unlikely that Tidmarsh, a pewterer (hence the mug on the front), should sign a delftware dish, Britton has established by comparison with a document that this is indeed how Tidmarsh signed his name. He lived (see no. 124) near the pottery at Wapping, which took on many apprentices who were pewterers, so there was no doubt close contact within the local community. The significance of the date and the painted scenes has not yet been discovered, and indeed there may have been no special meaning attached to either.

Most delftware plates or dishes which can be connected with

individuals are made in series and have relatively conventional decoration. The two pieces connected with James Tidmarsh are a striking exception. Britton suggested in a draft letter preserved in the Department of Prehistory and Europe, British Museum, that Tidmarsh himself might have painted this dish, a suggestion that seems to have some merit, as the decorative scheme is otherwise quite unknown.

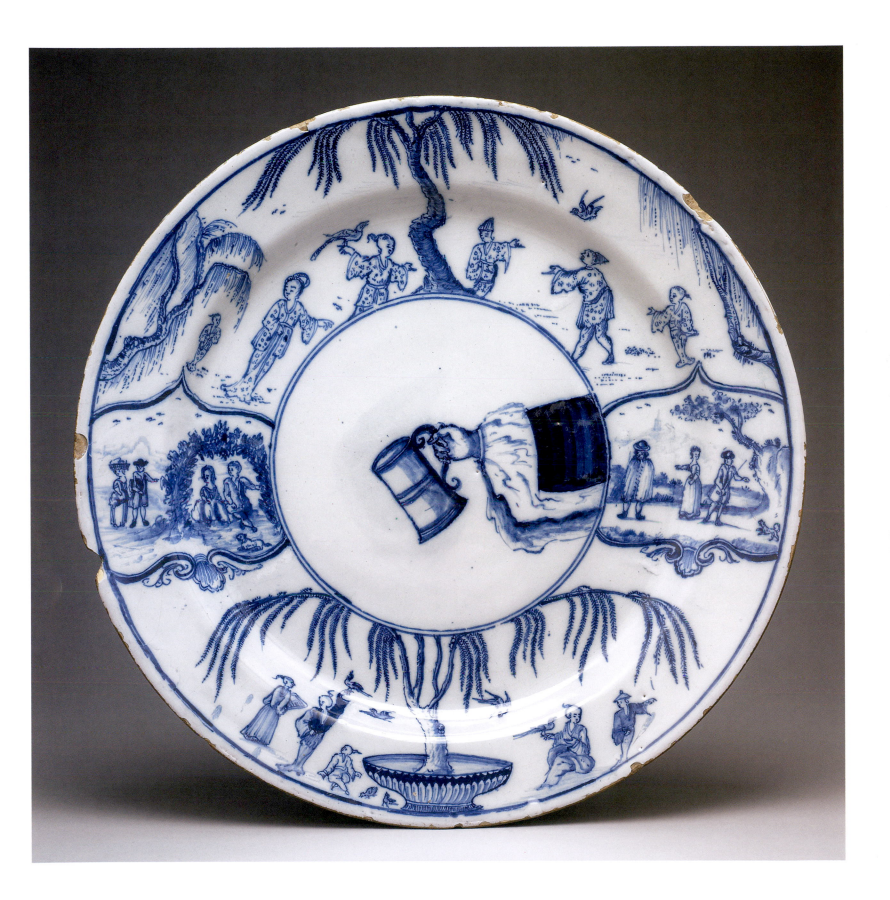

124 **Dish**, 1739

Made in Wapping, London, at the Hermitage pottery
Inscribed: 'THE CHARMER TO A CELEBRATED AIR IN DEMETRIUS' and 'JAMES TIDMARSH, 1739'
Diameter: 29.7 cm
Reg. no. 1943,071.1; purchased through the National Art-Collections Fund (The Art Fund), 1943; from the collections of T.G. Cannon and
A.S. Marsden-Smedley
Ray 1968, fig. 14 and p. 62; Lipski and Archer 1984, p. 104, fig. 452; Britton 1997, pp. 141–3, fig. 1

This unusual, large dish is carefully painted near the rim with musical notes, which is something of a triumph of skill although musical notation with words below it is painted on the 'Flower Bowl' in the Robert Warren Collection at the Ashmolean Museum, Oxford. A plaque decorated with 'Topeing Jack' has also been recorded.[1] James Tidmarsh (d. 1740) was an amateur singer, who may have performed at the Spring Gardens, one of several Pleasure Gardens in eighteenth-century London, which is adjacent to St Dunstans, in the east of the City of London, halfway between London Bridge and the Tower of London, and close to Whitechapel where Tidmarsh is known to have lived and worked as a pewterer. The Tidmarsh family was extensive and had many connections later in the eighteenth century with the ceramic trade, including links with Staffordshire.[2]

The music is from an English song, 'The Charmer', which was set to music from the opera *Demetrius* composed by Giovanni Battista Pescetti (1704–1766) in Venice. The opera was first performed in London on 12 February 1737 at the King's Theatre, Haymarket, at a time when Pescetti was probably in London having arrived there in 1736. The title of the song sheet is identical to the inscription on the dish.

Tidmarsh spent much of his life within a mile of the pottery at Hermitage Dock, which had been established in 1650 by a pewterer named John Campion. The concern took on a number of apprentices who were pewterers like him, and people with whom he no doubt had relations.

The dish, which is unique, was probably painted as a gift for Tidmarsh. For another dated 1736 and signed by Tidmarsh, see no. 123.

Chinese influence can be seen in the chrysanthemums in a basket, painted in the centre of the dish.

Chip and loss of glaze to rim.

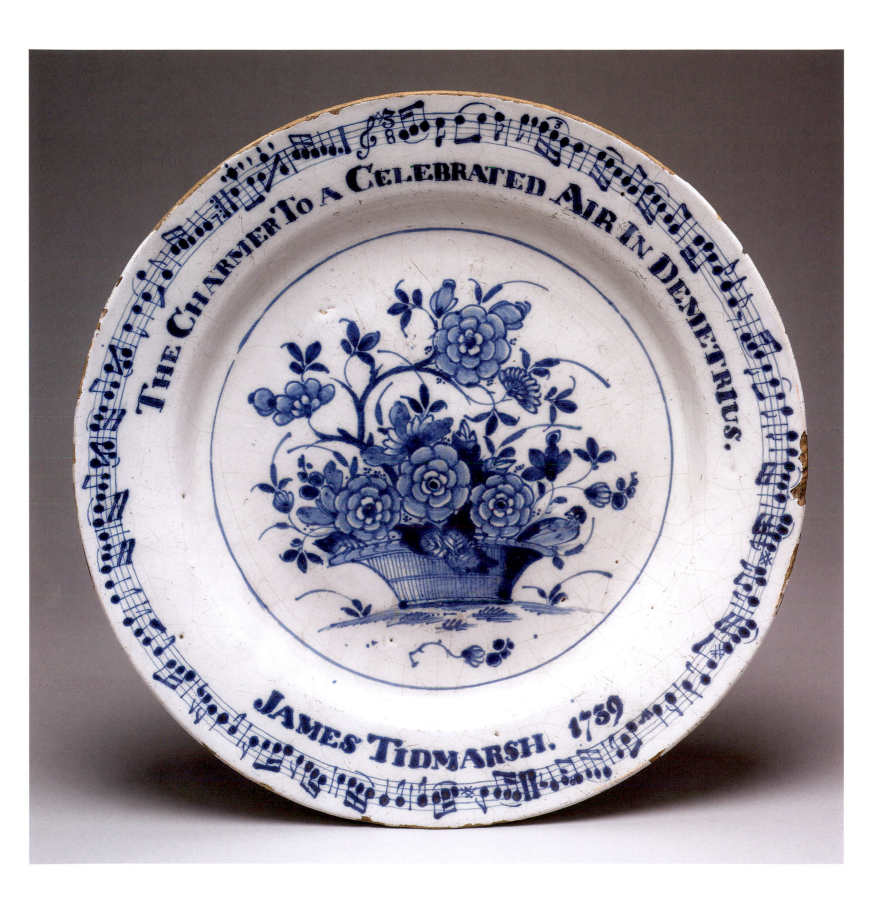

125 Pope Joan gaming dish, about 1750–70

Made in London, Liverpool or Bristol
Height: 3.8 cm; diameter (max.): 26.9 cm
Reg. no. 1887,0310.132; purchased from the collection of Henry Willett, 1887
Hobson 1903, E 145; Grigsby 2000, D386

Few ceramic gaming dishes survive. This is one of two in the British Museum Collection.[1] The other is made of pearlware, that is, lead-glazed earthenware with a bluish glaze, which was manufactured at potteries all over the country from the last third of the eighteenth century. There is another delftware example in the Longridge Collection, USA, which is decorated in blue with the same cards slightly differently arranged and with different lettering in the centre.[2]

A delftware chessboard painted in blue and inscribed 'T.S./1723' is in the Fitzwilliam Museum, Cambridge.[4] A tin-glazed earthenware board for a game called 'Poch', attributed to Künersberg, Germany, is in the Rothschild Collection at Waddesdon Manor, Buckinghamshire.[5]

A rare brown stoneware cribbage board, dated 1780 and inscribed 'Betsey Cuppells', was on the London market in 2003.[6] Incised on the reverse is 'Jas Alsop December ye 7/1780', showing that it was made in Bristol at the Temple Street pottery of James Alsop, who was then in partnership with Thomas Patience.

Pope Joan, a card game, is first recorded in Britain in 1732, although it had Continental forebears. It became particularly popular in the early nineteenth century and is mentioned in Charles Dickens's *The Pickwick Papers*, published in 1836–7, having been first described in the reference work *Hoyle's Games* in 1826. It is named after a legendary ninth-century female Pope. The nine of diamonds, which is painted in one of the compartments, is referred to as the 'Pope'. The Knave, or Jack, of Hearts

represents intrigue; the Queen of Hearts, matrimony. The central compartment held the chips (or 'fish' as they were often known). A clear explanation of the game, which is played with a deck of fifty-one cards from which the eight of diamonds has been removed, is given in the 11th edition of *Encyclopaedia Britannica*, indicating that the game was still being played at that time. The object of the game was to win the most counters or chips.

Delftware plates painted with playing cards, attributed to the factory at Lambeth, are in the Longridge Collection.[3]

The rim is restored.

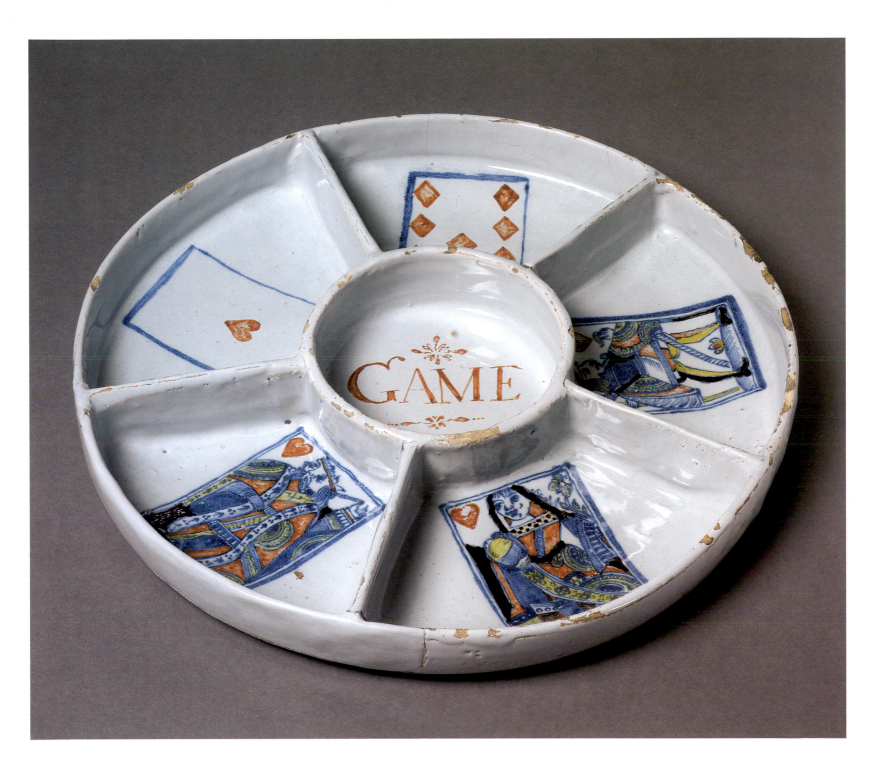

126 **Money box**, about 1760

Made in Bristol
Inscribed: 'MARY PIERCE', painted in blue
Height: 15.3 cm; width (max.): 8.9 cm
Reg. no. 1935,0715.1; presented by Wallace Elliot, 1935, through the English Ceramic Circle

The money box is thrown, has three applied scrolls at the top and a slot pierced on the diagonal for money. Coins would have been extracted with a knife, or otherwise the box would have been broken to obtain the savings inside. Money boxes were made in delftware from at least as early as 1692, as an elaborate example with an upper globe surmounted by a crown finial attests.[1] Lead-glazed pottery money boxes made in England survive from the thirteenth century and were still being made in West Yorkshire and East Lancashire from the mid-eighteenth century.[2] Even in the early years of the twentieth century some potteries, such as Donyatt, Devon, were making money boxes.[3]

The flowers painted over the bluish glaze in bright colours are known as 'Fazackerly-type' flowers and are typical of both Bristol and Liverpool delftware decoration in the second half of the eighteenth century. The name originates with a mug painted in similar colours and inscribed 'T.F. 1757', which was said to have been made at Shaw's Brow, Liverpool, and was presented to a Thomas Fazackerly by a Liverpool potter.[4] Pieces with this kind of painting have been discovered on the site of the Josiah Poole's Lord Street pothouse and Alderman Thomas Shaw's Truman Street pottery, Liverpool.[5] The white scrolls painted around the foot are in a technique known as 'bianco-sopra-bianco', practised at both Bristol and Liverpool (see nos 93, 117 and 120).

Foot repaired, upper part of finial missing, one scroll missing and two others damaged at the lower end.

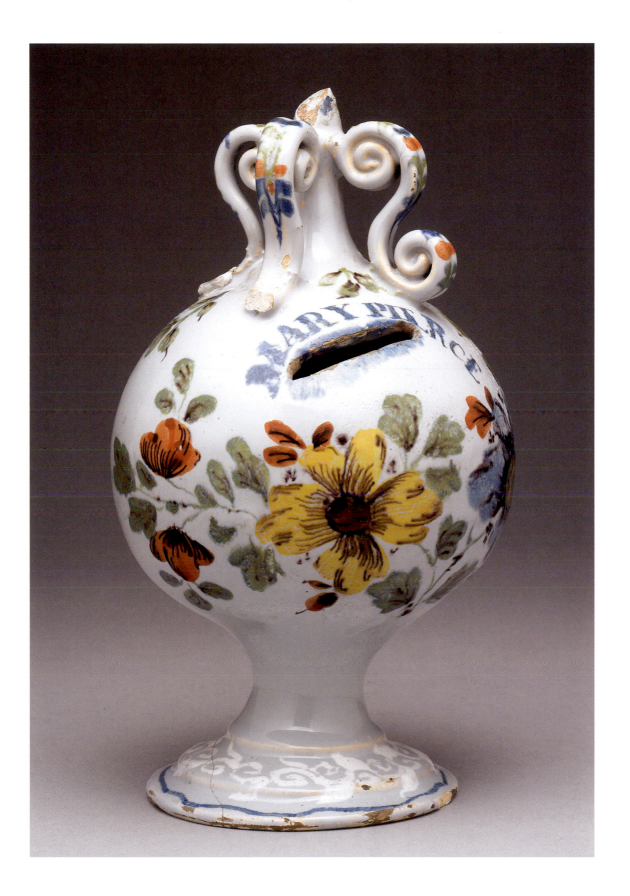

127 Flower vase, about 1650–90

Made in Southwark, London
Height: 13.8 cm
Reg. no. 1856,0701.1587; purchased from the collection of Charles Roach Smith, 1856

It has been suggested that vessels like this with nozzles and handles (broken on this example) may have been intended for wine,[1] but the traditional view that they held flowers seems more likely. This example has two nozzles and handles; other vases are known with three nozzles and three handles. Painted pieces date to the last decades of the seventeenth century. Without doubt, many undated undecorated pieces were made earlier, but these appealed less to the collector and are generally found in archaeological assemblages. Although found in the nineteenth century, rather than excavated (see below), this piece belongs in that category. Examples decorated only with initials and a date painted in blue are known from 1650 and 1661; these have a different neck to the Museum example.[2] Wavy necks are found on most of the examples traced, whereas the Museum vase has a turned neck, as well as a flared rather than globular body.[3] This shape appears to be unrecorded, although the general vase form is not uncommon. A fragmentary biscuit example of similar shape but with three spouts and a wavy rim was acquired from the Roach Smith Collection at the same time as the tin-glazed vase.[4]

The vase was found on a London site, but the location of that site is not known. Its date of acquisition suggests that it may have come from the City of London, like other pieces in the collection, as this is where the collector Charles Roach Smith (1807–1890) worked from about 1828 until he retired in 1855.[5] It was during this period that railways were being built and docks extended. Finds of fragmentary vases of this form from sites in St Olave's parish, Bermondsey, London, recovered between 1954 and 1961 as a result of building operations without proper archaeological control, were recorded by Noël Hume in 1977 and these included parts of two vases of this general type.[6] Further examples with contexts have been excavated at the Pickleherring factory site, dated to 1680–90 and at a site at 129 Lambeth Road in a context dated to 1670–1700.[7]

128 **Flower brick**, about 1750–60

Made in Bristol
Length: 14.8 cm; height: 9 cm
Reg. no. 1887,0616.1; presented by William Edkins Snr, 1887
Hobson 1903, E 131

Flower bricks were one of many types of flower holder with pierced holes made in England in the mid-eighteenth century in various types of pottery and porcelain for the display of cut flowers. This is the simplest shape and there are numerous surviving examples, although the decoration on this piece is highly unusual. Several other more unusual forms are represented in the collection (see nos 130–2).

There is a similar flower brick with a powdered manganese ground, flowers in the Chinese style and a flying bird at either end in the Bristol City Museum and Art Gallery.[1] On the British Museum example there are two birds, both in oriental style, which have been incised into the leather-hard clay and then painted in brown.

129 **Flower brick**, about 1760

Made in Bristol, probably at Richard Frank's Redcliff Back factory
Length: 15 cm
Reg. no. 1887,0307.E130; presented by A.W. Franks, 1887
Hobson 1903, E 130

Most of the surviving flower bricks of this form with related decoration have a series of small perforated holes in the top, which are thought to have held flowers, while others have larger square holes together with small circular ones. There are two examples in the Bristol City Museum and Art Gallery, both painted with a scene similar to the one shown on this brick,[1] as well as another with a sailing ship.[2]

The decoration is typical of painting long attributed to John Bowen, working either at the Redcliff Back or at the Temple Back pottery, Bristol. The attribution is based on an illustration of a large dish inscribed on the back, 'ye Ist: Sept. 1761. Bowen. fecit', which was unfortunately lost in the fire at the Alexandra Palace, London, where it was exhibited in 1873. Only an engraving survives, and the painting on this piece does not compare closely with the lost plate, which once belonged to Henry Willett. As Michael Archer remarks, a number of painters worked in the 'Bowen' style, but none can be securely associated with the inscribed dish except in a most general way.[3] The scene of two ladies walking towards a house in the country is a common one on plates painted in this style (see no. 120).

130 Flower brick or inkwell, about 1760

Probably made in Bristol
Length: 18 cm
Reg. no. 1931,1014.3; purchased, 1931, formerly in the collection of R.G. Mundy
Mundy 1928, pl. LI

This type of flower brick, with three circular holes and four smaller circular holes in the top, a distinctive foot and canted corners, is the rarest of all the many types made in the mid-eighteenth century. No other example is apparently recorded. It is possible that the piece was intended as an inkwell and once had containers for ink and sand for blotting. The bluish glaze suggests that it was made in one of the Bristol delftware factories.

The delicately painted scene of two figures meeting on a bridge, which is loosely based on motifs found on seventeenth-century Chinese porcelain of the late Ming dynasty (1368–1644), is a favourite motif on English eighteenth-century porcelains, such as those pieces made at the Worcester factory.

131 Flower brick, about 1760

Made in London or Bristol
Height: 19.6 cm
Reg. no. 1957,1201.16; presented by A.D. Passmore, 1957
Tait 1958, p.49, fig. I; Tait 1958b, p. 82

When this flower brick was acquired its shape had not been recorded, and no other example like it has since come to light. The holes either side at the upper end are an unusual feature; if the brick was intended for the display of cut flowers, these might have been difficult to insert.

Like the bottle (no. 138) and many other examples of English delftware, the painting combines European landscapes and figures with landscapes and flowers in the Chinese style.

132 **Two pairs of bulb pots**, about 1760

Made in England
Height: 10.3 cm
Reg. no. 1957,1201.19 and 20; presented by A.D. Passmore, 1957
Tait 1958, p 50, fig. II; Tait 1958b, p. 83, fig. 21

The shape of these pots and the large circular holes
surrounded by smaller holes is unusual, although there
are two similar pots in the Glaisher Collection at the
Fitzwilliam Museum, Cambridge and two with five large
and sixteen and twelve small holes respectively in the
Bristol City Museum and Art Gallery.[1] The style of
painting is somewhat heavy and leaves little of the surface
of the pot uncovered.

Bulb pots were produced in cream-coloured
earthenware and porcelain in many different forms during
the second half of the eighteenth century in England and
were equally popular on the Continent, where they were
made at porcelain factories all over Europe.

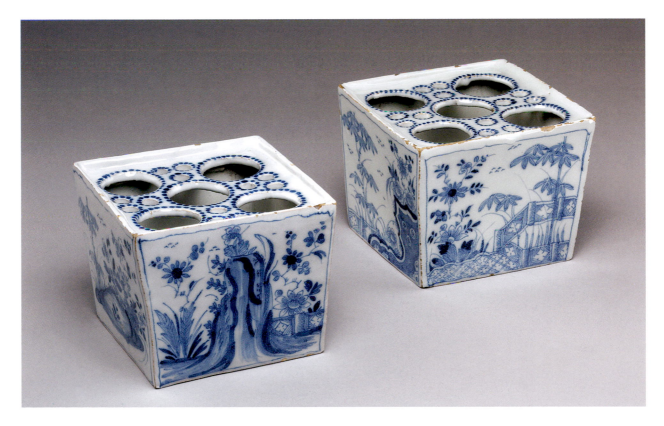

133 **Wall vase**, about 1760

Made in Liverpool
Height (max.): 19.8 cm; width (max.) at top edge: 14.1 cm
Reg. no. 1923,0611.8; purchased, 1923; from the collections of Max Rosenheim and Sir Maurice Rosenheim

From around 1750 a vast number of new vase shapes were made all over Europe in both pottery and porcelain. Vases in the form of cornucopiae, or horns of plenty, were most commonly made in salt-glazed stoneware, creamware and delftware and were moulded with a variety of motifs. Worcester porcelain examples are recorded, although porcelain cornucopiae are much rarer. The decoration on this example follows a moulding that is also known on white salt-glazed stoneware wall vases. Crisply moulded houses, landscapes and other designs are known on contemporary salt-glazed stoneware and creamware examples.

These vases were made in balanced pairs and were designed to be hung on a wall. The back of this example is flat and has been left unpainted although it has a tin glaze, which is slightly bluish in tone. There are two circular holes for suspension at the top. Stains inside the vase could indicate that it held water.

Only one dated example of a delftware cornucopia wall vase has been traced. Painted with flowers in blue, it has a fluted moulding and is dated 1748. It was once in the Louis Lipski Collection[1] and is now in the Longridge Collection, USA.[2] Other examples similar to the British Museum vase are in the National Museums Liverpool,[3] and the Allen Gallery, Alton, Hampshire.[4] The Victoria and Albert Museum Collection includes two wall vases of similar form with the birds looking different ways; the one with the bird facing to the left has been attributed to London, while the other is similar to the British Museum

example but faces the other way.[5] A further related wall vase is in the Fitzwilliam Museum, Cambridge.[6] A pair painted with yellow birds was on the London market in April 2008.[7]

Cornucopia wall vases made in salt-glazed stoneware and cream-coloured earthenware with coloured glazes using a variety of moulds, some with decoration in relief, must have been popular to judge from the number of surviving examples. A green- and yellow-glazed wall vase moulded with a head of Flora together with flowers and a fruiting vine, attributed to Josiah Wedgwood I about 1754–9, is in the Museum collection;[8] a salt-glazed version moulded with a shepherd and buildings was made around the same time in an unknown Staffordshire factory.[9]

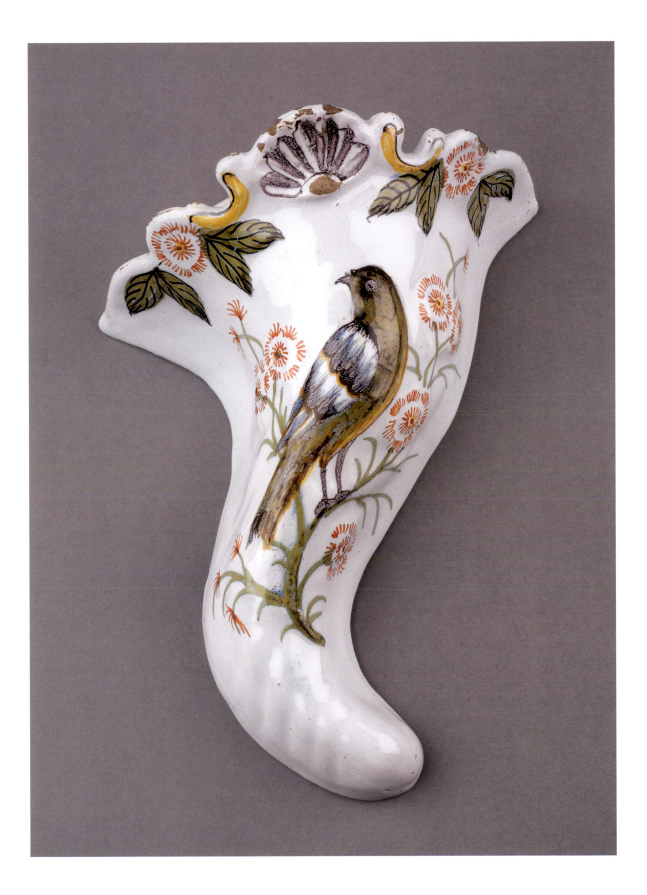

134 **Ornament**, 1658

Made in London
Inscribed: ' DP/1658' within a heart on both sides
Height: 10.8 cm; width (max.) 7.6 cm; depth: 4.7 cm
Reg. no. 1887,0210,130; purchased from the collection of Henry Willett, 1887
Church 1884, p. 38; Hodgkin and Hodgkin 1891, no. 298; Hobson 1903, E 1; Lipski and Archer 1984, no. 1762; Grigsby 2000, p. 390

Book-shaped vessels like these were once thought to be flower-holders, but from 1935 have been identified as hand-warmers, which are thought to have been filled with hot water to warm the hands like muffs. This example has a small circular hole at the top left on the back and another inside the 'book' at the base. However, as they are hardly practical, these so-called hand-warmers are perhaps more likely to have been intended as pieces for presentation, which were ornaments rather than utilitarian items. The heart on this example tends to confirm this, indicating that it was a present for a beloved.

Unlike other known examples, the British Museum book does not have two imitation clasps across the pages, although it has five moulded raised bands on the spine. The edges of the pages are painted yellow (to simulate gold) and manganese-brown, and there are blue dashes all around the edges of the boards. The painted motifs probably replicate bookbinders' tooling on leather bindings.

There are twelve known dated pieces like this, of which the British Museum example is the earliest.[1] The form was probably copied from earlier Continental warmers made in Holland or Italy and enjoyed popularity for several decades, as a book hand-warmer is known with the date 1693. An undated double book with an inscription is in the Fitzwilliam Museum, Cambridge, where there is also a German stoneware book 'hand warmer'.[2]

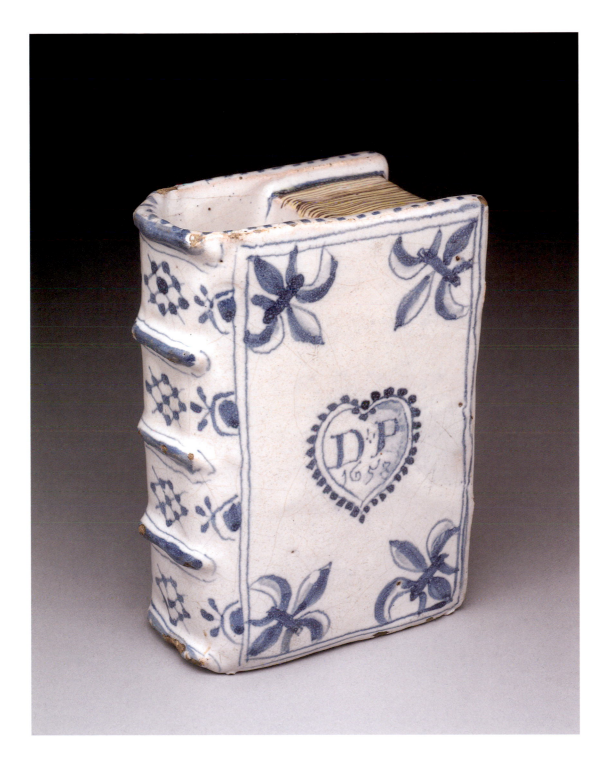

135 Cat jug, 1674

Made in Southwark, London
Inscribed: 'B/R.E/1674' on the front and 'B/RE', painted in blue, on the base
Height: 16.4 cm; width: 7.5 cm
Reg. no. 1887,0210.127; purchased from the collection of Henry Willett, 1887
Church 1884, p. 40; Hodgkin and Hodgkin 1891, no. 337; Hobson 1903, E 11; Lipski and Archer 1984, p. 228, fig. 1007; Archer 1997, p. 255

This is one of the more colourful and inventively decorated of the dozen or so delftware moulded cat jugs made around the middle of the seventeenth century which have survived. Many of the jugs are dated, ranging from 1657 to 1676. The carefully depicted green eyes, the precisely positioned and painted inscription, and the sponged and dotted fur on the British Museum jug are in contrast to some much plainer examples.

These charming jugs, like delftware shoes, were evidently ornaments.

The inscription may commemorate a marriage in 1674, possibly that of Richard Bazer (or Beazer) of St Giles Cripplegate, a brewer, who married Elizabeth Hancock of St Botolph's Aldgate, at Whitechapel on 8 December 1674.[1]

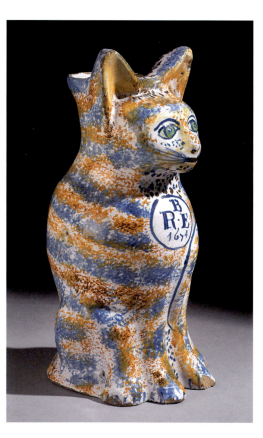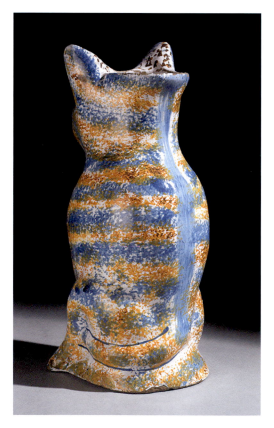

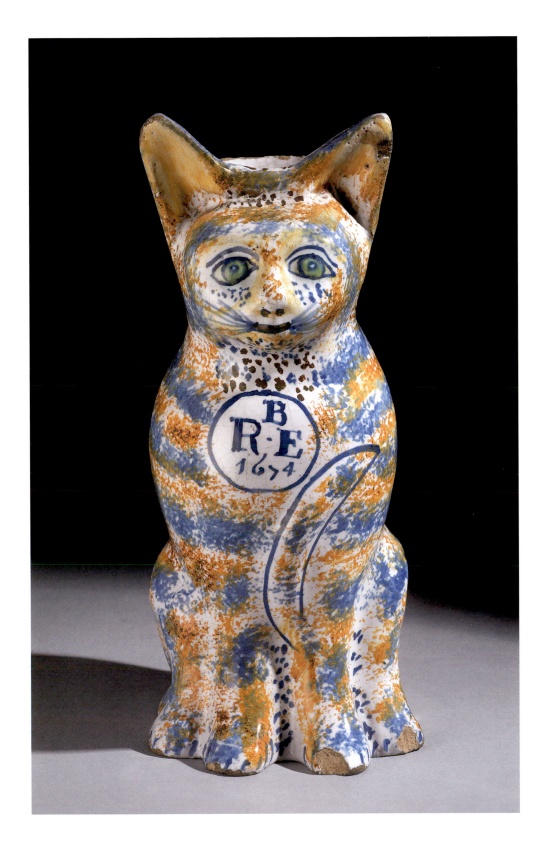

136 **Plaque**, about 1750

Made in Bristol, painting attributed to Joseph Flower
Diameter: 16 cm
Reg. no. 1938,1005.1; presented by Wilfrid Fry, 1938; formerly in the collection of William Edkins Snr, sold Sotheby, Wilkinson & Hodge, 21–3 April 1874, second day's sale, lot 163 (then in a metal frame)
Thomas and Wilson 1979, p. 4, G33; Dolan 1996, p. 32 and fig. 4

This unusual plaque, which was possibly part of a larger dish as the edge is damaged and it has apparently been cut down near the top at the right, is painted with a view of the Cathedral Church of the Holy Trinity at Bristol. The source for the decoration is an engraving by John Harris entitled *The North Prospect of the Cathedral Church of the Holy Trinity at Bristoll*. This includes the arms of William Bradshaw, Bishop of Bristol, 1724–32.

When this plaque was exhibited in Bristol in 1979,[1] it was shown alongside several other finely painted pieces, including the 'Flower' bowl that is inscribed 'Joseph Flower sculp. 1743' and painted with scenes based on engravings in George Bickham's *Musical Entertainer*, published about 1739 and again in 1740.[2] The plaque and the only other view of a church known in delftware, which appears on a tile panel painted in blue with a view of St Mary Redcliffe,[3] were both attributed to Flower, together with another bowl, unsigned but very similar to the 'Flower' bowl.[4] The attribution was on the basis of the quality of the painting, in each case based on an engraved source. However, when the tile panel was catalogued by Michael Archer, there was no mention of Flower; the panel was thought to have been made probably at the pottery of Richard Frank (1711–1785) at Redcliff Back, Bristol.

Decorative plaques, unlike tiles, are extremely rare. There is a rectangular example, pierced with two holes for suspension and painted in blue and green with a landscape, in the Ashmolean Museum, Oxford, which was made in Liverpool around 1750–60.[5] As Anthony Ray points out, there are several plaques, some painted with portraits, which date from the first decades of the eighteenth century, but few from the second half of the century.

The plaque has been restored.

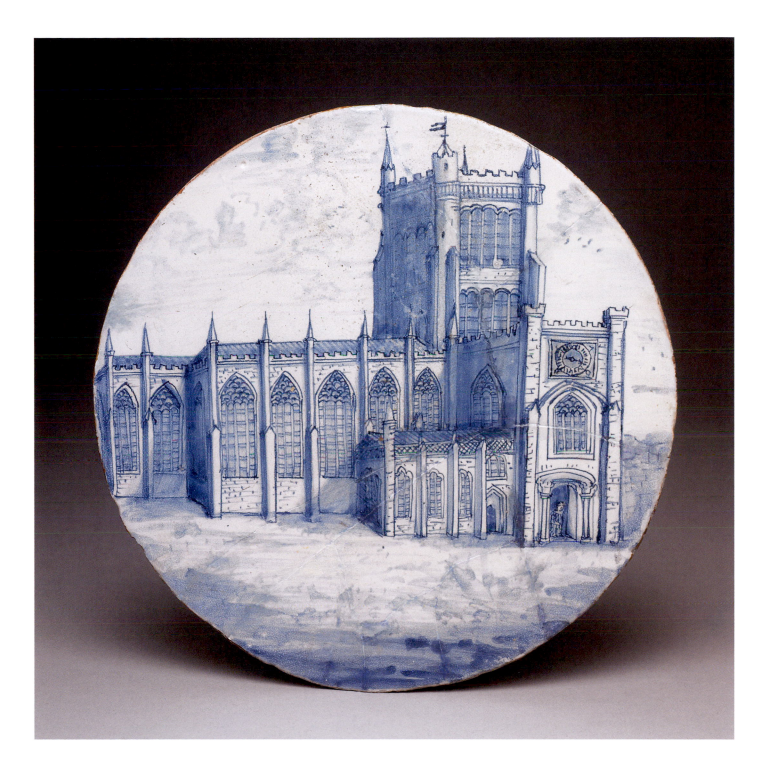

137 **Water bottle**, about 1760–70

Made in England, attributed to Vauxhall, London, Mary or
Jonathan Chilwell V's pottery
Height: 24.5 cm
Reg. no. 1942,1208.2; presented by the National Art-Collections
Fund (The Art Fund), 1942

Bottles like these often had a matching basin and were
intended for washing. An octagonal basin with an everted
rim, which is similarly decorated to this bottle, may
perhaps have once belonged with it, or with a similar
example.[1] The two quatrefoil or lotus-pattern reserves at
the shoulder, and two on the body accompanying two
irregularly-shaped reserves painted with flowers and
leaves, are all based on Chinese porcelain. The attribution
of this bottle follows that made by Michael Archer in his
discussion of a related bottle in the Victoria and Albert
Museum, which is based on the slightly concave underside
without a distinct footrim, said to be a London
characteristic.[2] There is at present no archaeological
evidence for the place of manufacture.

The V&A bottle (see above) has a matching basin and
fits in a mahogany washstand.

'Delph ... Bottles & Basons' were advertised in the
Boston News-Letter of 4 April 1771, indicating that sets were
in use in North America as well as in Britain.

The foot is damaged and the rim has been ground off.
The bottle is likely to have once had a flared or cup-shaped
lip, as on other surviving examples.

138 **Water bottle**, about 1770

Made in Bristol
Height: 24.2 cm
Reg. no. 1931,1014.2; from the collection of R.G. Mundy;
formerly in the Sheldon Collection;[1] collectors' labels printed in
black 'S Col.', numbered in ink '1233' and 'M' in ink
Mundy 1928, pl. 1 (frontis.)

The bottle is painted with a more-or-less recognizable
scene of Bristol Observatory with a windmill, a kiln and a
townscape, as well as with a clump of bamboo and two
buildings in Chinese style (not illustrated). The building
now known as the Observatory, located close to the Clifton
Suspension Bridge above the gorge, was put up in 1766 as
a windmill for grinding corn and subsequently converted
to a snuff mill. It was damaged by fire in 1777 and left
derelict until 1828. It has a single round tower, whereas
there are two towers on the building depicted on the bottle,
so that the delftware painter may perhaps have been
inspired by the observatory, rather than copying it
accurately. Landscape or outdoor scenes depicting actual
places are rare on delftwares, though there are some
exceptions, such as the plaque (no. 136) and dishes painted
with the Battle of Portobello,
attributed to Richard Frank's
pottery at Redcliff Back,
Bristol.[2]

Bottles like these often
had matching bowls when
they were used for washing.
Otherwise they were
intended for water at table,
although this example is
perhaps more likely to have
been for display rather than
use.

Rim chipped.

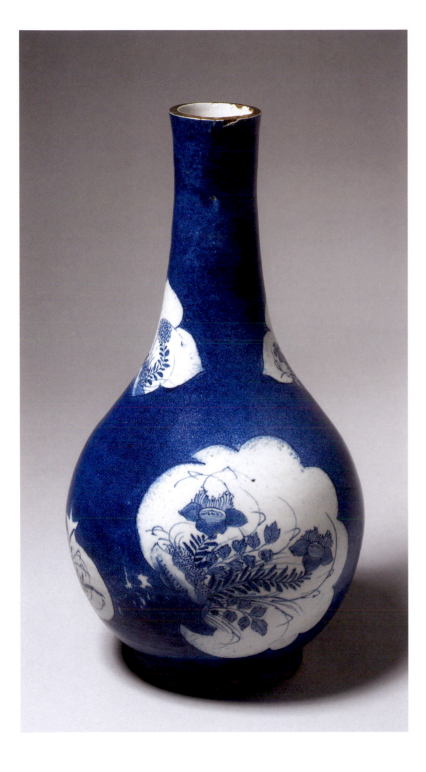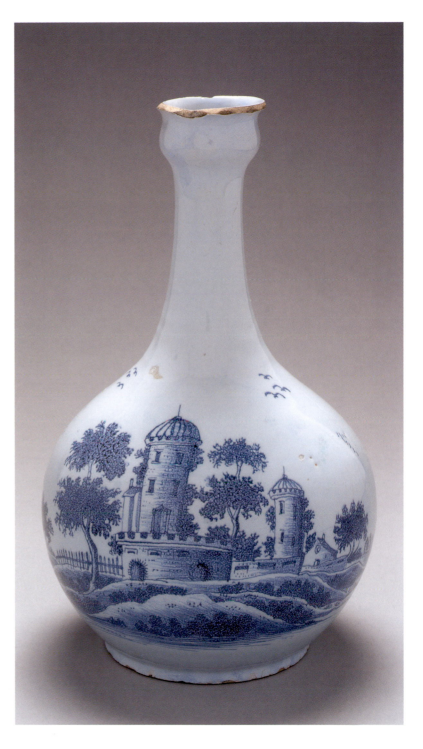

139 Three jugs, probably 1800–30

Made in England, Vauxhall pottery, London, or Mortlake, Middlesex
Height: 13.5 cm (left); 18 cm (centre); 17 cm (right)
Left: reg. no. 1926,1119.2, purchased 1926; centre: reg. no. 1926,1119.1, purchased 1926; right: reg. no. 1961,1102.160, bequeathed by
W.P.D. Stebbing, 1961

These handled jugs are reminiscent in both shape and decoration of stoneware jugs made in the Westerwald, Germany, although they are made of a different kind of pottery. Related fragments excavated on the site of the Vauxhall pottery suggest that an English manufacture is more than probable.[1] Such jugs could have been made at the Mortlake pottery, which was acquired by William Wagstaff in 1804 when delftware production moved to Vauxhall. A plain example inscribed with the name of Joseph Fawsit, a grocer, oilman and tea dealer, with his address, 57 Paddington Street, Mary-le-bone, listed in London directories between 1805 and 1823, is in the Museum of London,[2] while an example with similar painted decoration of a stylized flower spray surrounded by leaves and foliage is in the Victoria and Albert Museum.[3] Another similarly decorated jug with a handle is in the Bristol City Museum and Art Gallery.[4]

The function of these pots is not entirely clear. They may have been used to contain goods purchased from a grocer. Michael Archer[5] believed that they were used for the sale of the condiment soy.

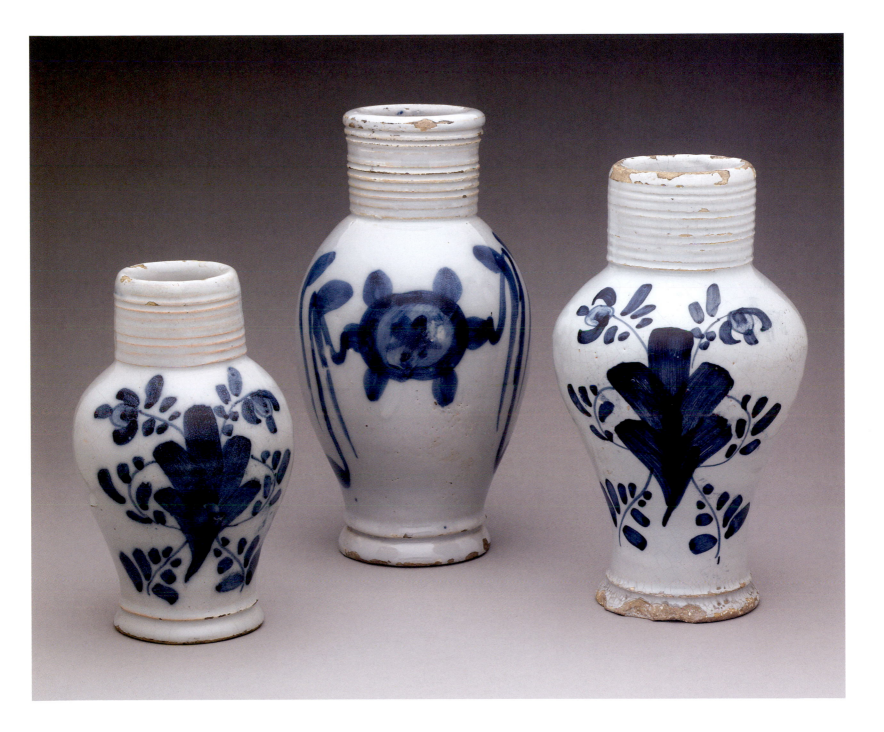

140 Two fragments, 1647 and 1653

Made in London, Southwark
Inscribed: 'N/IE/1647' and '[]A/[]653', enclosed by paraphs
Length (max.): 18 cm (1647); length (max.): 6.5 cm (1653)
Reg. no. 1926,0428.1 (top); excavated at the Pithay, Bristol in 1900, presented by J.E. Pritchard, 1926; reg. no. OA 7951 (date and source of acquisition unknown); excavated in Brislington, near Bristol by J.E. Pountney, February–June 1914
Pritchard 1926, p. 262; Lipski and Archer 1984, no. 17
The fragment dated 1653 is unpublished.

Although these fragments were found in Bristol and Brislington respectively, their dates strongly suggest a London origin. The fragment dated 1647 is in two pieces and has a circular hole in the footrim. It was found in 1901 at the factories in Bristol of J.S. Fry and Sons, in part of the town known as the Pithay.[1] It was given to the Museum in 1926, when it was believed to be the earliest example of Brislington delftware.[2] Frank Britton noted that although the decoration is typical in style of Southwark delftware at this date, the factory at Brislington was founded by a Southwark potter.[3] But recent research has established that a deed transferring the site of the Brislington pottery to a Southwark potter is dated 1651.[4] For this reason the fragment is likely to have been made in London, if indeed it is English.[5]

It was suggested by Britton (see note 3) that the initials 'N/IE' commemorated the marriage on 29 May 1647 of John Norden, a barrister at the Middle Temple, London, to Elizabeth Skinner. Norden later became Member of Parliament for Wiltshire in 1654, for Old Sarum in 1660 and Devizes from 1666 to 1669. He died in 1670. Up to the time of his marriage he lived in Middle Temple, one of the four Inns of Court to which all barristers must belong, on the present-day Victoria Embankment. Looking down the River Thames he might have been able to see the kilns of the Montague Close pottery in Southwark.

The pomegranate motif probably originates in Italy, where it is known on maiolica. English delftware dishes painted with similar fruit are known. A large dish or charger painted with four oranges or pomegranates and a border of blue dashes, which is attributed to Southwark, is in the Potteries Museum and Art Gallery, Hanley, Stoke-on-Trent.[6]

The fragment dated 1653 is also in two pieces. Its date of acquisition by the Museum is unknown but a record of its provenance has survived (see above). The letter and part of a date are enclosed by paraphs in a style typical of decoration on English delftwares made in the mid-seventeenth century.

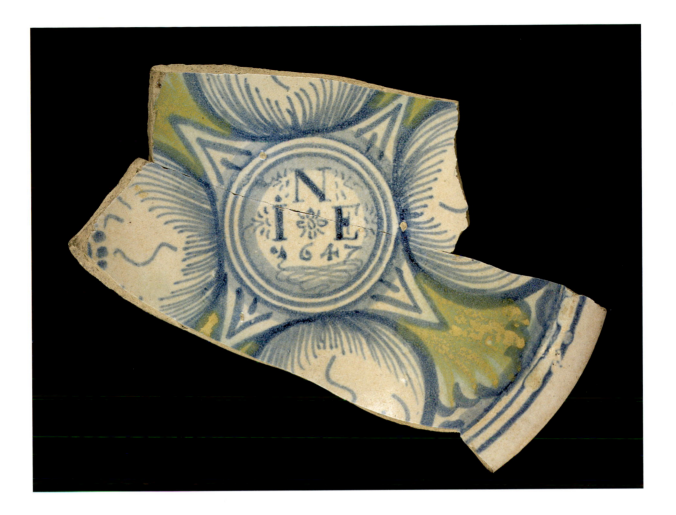

141 Floor tile, about 1580–1620

Probably London, possibly Aldgate, factory of Jacob Jansen and
Jasper Andries or Southwark, factory of Christian Wilhelm, or
perhaps Low Countries
Length: 13 cm
Reg. no. OA 4404 (date and source of acquisition unknown)
Archer 1997, N.9

In the present state of knowledge, despite the discovery of
fragments of 'medallion' tiles at several sites in Aldgate
and Southwark, it is impossible to distinguish English
products (see nos 59, 85, 99) from those made in Holland
in the early years of the seventeenth century and in the
following decades. Further scientific work is needed to
establish the constituents of Dutch and English tiles.

Two 'medallion' tiles, resembling the Museum
example and painted with a camel and bear-baiting within
a medallion 'frame', were found very close to the site of the
pottery at Aldgate, which was in operation from 1570 when
Jansen and Andries petitioned Queen Elizabeth I for the
right to make 'Galley pavinge tyles'.[1] It is therefore
possible that the Museum tile was made at the Aldgate
concern, since the manganese-purple line does not appear
on tiles found on the Pickleherring and Rotherhithe sites.[2]

Christian Wilhelm (died 1630), who is known to have
made 'pavinge tyles' at Pickleherring Quay, Southwark,
from their mention in a warrant for a patent of 1728, in
fact employed two Dutch potters named Christian Rowest
and John Rokenson. Tiles were also made at other
factories in the early part of the century, as a patent was
granted to the potter Hugh Cressey of Montague Close in
1613.

142 Three floor tiles, early seventeenth century

Probably made in Southwark, London, at the Pickleherring pottery
Length: 14 cm
Reg. no. 1839,1029.84 (lion), 1839,1029.106 (ram), 1839,1029.83
(chequer design), purchased from Dr Gideon Algernon Mantell, 1839

The tiles are thick and were therefore made to be used on a
floor. The earliest of all delftware acquisitions made by the
Museum, these tiles are recorded as having been found at
Lewes Priory, together with another painted with a dog.[1]
The previous owner, Dr Gideon Algernon Mantell
(1790–1852), a surgeon and geologist known for his early
work on geology and paleontology, was born in Lewes. He
sold a quantity of objects to the Museum, including a
number of medieval tiles from Lewes Priory.[2] The Priory,
the ruins of which still stand, was founded between 1078
and 1082; it was the first such foundation to belong to the
reformed Benedictine Order of Cluny, but was dissolved in
1537. Following this, Thomas Cromwell built a house,
Lords Place, on the site of the prior's lodgings; it was
gradually demolished after 1668. The huge church
dominated the site.

Tiles like these are close in style to those made in the
Low Countries, but recent opinion favours a London origin
since several medallion tiles have been found at various
sites in Southwark.[3] A tile with a similar chequer pattern
and others with various animals within a medallion
'frame' were found on the site of the Pickleherring pottery,
Southwark.[4] Such tiles were probably made by immigrant
potters who came to London from the Netherlands.

Tin-glazed floor tiles went out of fashion between
1650–80, when thinner tiles began to be used to decorate
walls.

The tile decorated with a ram is damaged.

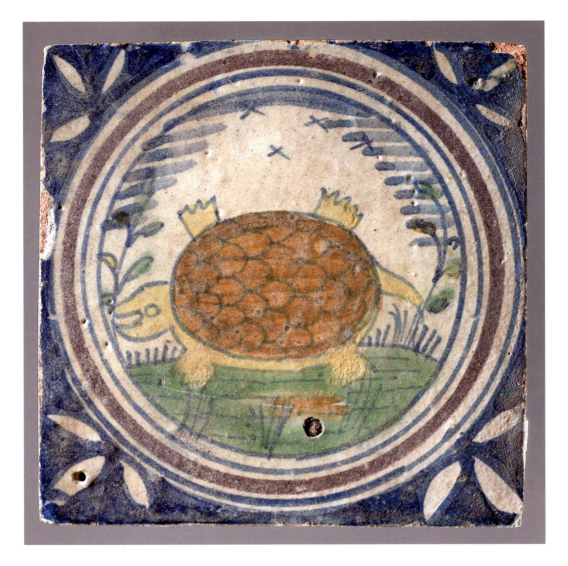

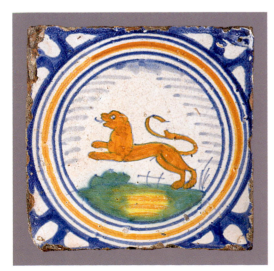

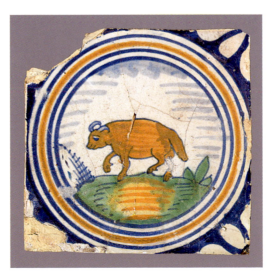

143 **Wall tile**, about 1756–7

Made in Liverpool, printed by John Sadler and Guy Green
Height: 12.8 cm
Reg. no. 1905,1018.6; presented by Thomas Boynton, 1905

The tile is printed in the woodblock technique with a scene from Molière's *Le Dépit amoureux* after François Boucher, engraved by Laurent Cars (1699–1771).[1] There is an example of this print in the Museum collection.[2] The print, in which the scene takes place in an interior with classical pillars rather than in a domestic interior as here, was published in an edition of Molière's plays issued in 1734. This quarto edition was one of the most famous French books of the eighteenth century. Prints by Cars were frequently used to decorate English ceramics.

John Sadler is thought to have used a woodblock process for printing on tiles in 1756, probably not for more than a few months before he perfected the process of copper-plate printing, which gave a sharper image (see no. 122 for a printed plate). It is not known who carved the blocks. Around fifteen different scenes, many in Chinese style, have been identified, several without borders, including this one.[3] The designs were generally printed in blue, but two manganese examples corresponding to this scene are known. One is in the Allen Gallery, Alton, Hampshire;[4] another was exhibited by Jonathan Horne in 1989.[5]

There are around 130 printed wall tiles with fable, theatrical and other subjects in the Museum collection.

Profiles of chargers and dishes

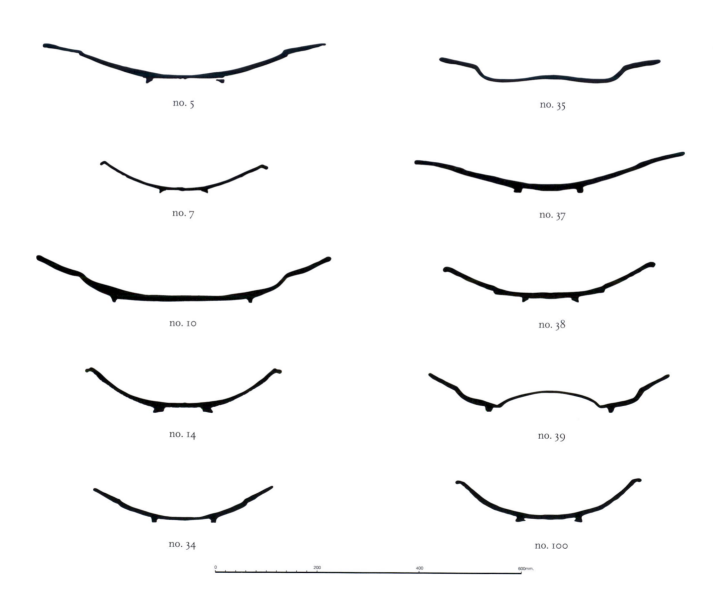

no. 5

no. 35

no. 7

no. 37

no. 10

no. 38

no. 14

no. 39

no. 34

no. 100

0 200 400 600mm.

English delftware destroyed in the Second World War

The Museum collection of English delftware suffered grievously in the Second World War. Many interesting pieces were displayed in an exhibition in the Museum, which was hit by incendiary bombs on the night of 10 May 1941. Twenty-eight items were destroyed. No catalogue of this exhibition was ever made and the full extent of the losses will perhaps never be known. The list below has been compiled on the basis of the War Exhibits Register and Notes and photographs.

The pieces are listed in the order in which they appear in R.L. Hobson, *Catalogue of English Pottery in the British Museum*, London, 1903, with their catalogue and registration numbers. There are three items acquired after 1903. Many objects were described in Hodgkin 1891 and the dated pieces were published by Lipski and Archer 1984.

The measurements are inches, as they appear in Hobson 1903.

1 Wine bottle, white tin-glazed earthenware, inscribed in blue 'SACK 1656'; height 5³/₅ in; made in Southwark, London; purchased from Henry Willett, 1887
Pottery Catalogue E 26 (reg. no. 1887,0210.112)

2 Wine bottle, white tin-glazed earthenware, inscribed in blue 'MARY BISH'; height 7¹/₂ in; made in Southwark, London, mid-seventeenth century; purchased from Henry Willett, 1887
Pottery Catalogue E 30 (reg. no. 1887,0210.116)

3 Wine bottle, tin-glazed earthenware, sprinkled with purplish-black manganese glaze; height 6 in; made in Southwark, London, mid-seventeenth century; gift of A.W. Franks, 1887
Pottery Catalogue E 31 (reg. no. 1887,0307.E31)

4 Plate, tin-glazed earthenware, painted in blue with a wreath and inscribed 'Duke William For Ever'; diameter 7⁹/₁₀ in; about 1746–50; presented by A.W. Franks, 1887; Hodgkin 1891, no. 422, attributed to Lambeth
Pottery Catalogue E 61 (reg. no. 1887,0307. E61)

The inscription refers to William, Duke of Cumberland (1721–1765), third son of King George II, who commanded the Hanoverian armies against Prince Charles Edward Stuart, the Young Pretender, at the Battle of Culloden on 16 April 1746. A plate dated 1746 above the inscription 'Duke William for Ever', with a border of four panels containing scrolls and a diaper design, is in Somerset County Museum, Taunton (Lipski and Archer 1984, no. 498) and another was recorded in the trade (ibid., no. 498A).

A plate attributed to Liverpool in the Longridge Collection, USA, bears a similar inscription in manganese-brown below the date 1746 and is painted with the Duke on a prancing horse in the centre.

5 Plate, tin-glazed earthenware painted in blue with a cartouche, a coronet and arabesques, inscribed 'SR 1691', diameter 10¹/₅ in; presented by A.W. Franks, 1887
Church 1884, p. 38
Pottery Catalogue E 63 (reg. no. 1887,0307.E63)

This plate is probably Dutch.

6 Plate, tin-glazed earthenware painted in blue with a bust of King George I and the initials 'GR' within a border of concentric bands; diameter 7¹/₅ in; presented by A.W. Franks, 1887
Pottery Catalogue E 65 (reg. no. 1887,0307.E65)

7 Plate, tin-glazed earthenware, painted in blue with a crown on a cushion and the initials 'GR' with an orb, cross and crossed sceptres; diameter 8³/₅ in; presented by A.W. Franks, 1887
Pottery Catalogue E 66 (reg. no. 1887,0307.E66)

8 Plate, tin-glazed earthenware painted in blue with a wreath enclosing three fleurs-de-lis, inscribed 'EM 1724'; diameter 8⁴/₅ in; presented by A.W. Franks, 1887
Church 1884, p. 38; Lipski and Archer 1984, no. 332
Pottery Catalogue E 67 (reg. no. 1887,0307.E67)

9 Plate, tin-glazed earthenware, painted in blue with a shield of arms, *a chevron between three cocks passant*, and mantling, inscribed on the back 'TM 1753'; diameter 9⁹/₁₀ in; presented by A.W. Franks, 1887
Lipski and Archer 1984, no. 566

Fig. 16 Pottery displayed in the exhibition held in the British Museum during the Second World War.

Pottery Catalogue E 68 (reg. no. 1887,0307.E68)

There is a plate painted with the same arms and with the same inscription on the reverse in the Ashmolean Museum, Oxford (Ray 1968, no. 40, pl. 13). It may have been the intention to decorate the plate with the arms of the Poulterers' Company but if so, the birds should have been cranes. A mug with similar decoration and inscription has been recorded in a private collection (Lipski and Archer 1984, no. 836).

10 **Plate**, tin-glazed earthenware painted in blue with a shield of arms as above, inscribed on the back 'I/TM/1753'; diameter 8⁹/10 in; presented by A.W. Franks, 1887
Church 1884, p. 71; Lipski and Archer 1984, no. 865A
Pottery Catalogue E 69 (reg. no. 1887,0307.E69)

11 **Plate**, tin-glazed earthenware, painted in blue with the initials 'AF' above '1728' in the centre

and geometric and Chinese-style ornament on the rim; diameter 7⁹/10 in; presented by A.W. Franks, 1887
Lipski and Archer 1984, no. 354A

There is a similar dish inscribed 'HF' above '1728', which is evidently a related piece, probably made from a set for members of the same family, see Lipski and Archer 1984, no. 354.
Pottery Catalogue E 83 (reg. no.1887,0307.E83)

12 **Drug pot**, tin-glazed earthenware painted with blue bands and yellow zig-zag motifs; height 2²/5 in, seventeenth century, made in Lambeth, London; purchased from Charles Roach Smith, 1856
Pottery Catalogue E 93 (reg. no. 1856,0701.1648)

13 **Drug pot**, tin-glazed earthenware painted with blue bands and rough hatching in manganese-purple; height 2¹/2 in, seventeenth

century, made in Lambeth, London; purchased from Charles Roach Smith, 1856
Pottery Catalogue E 94 (reg. no. 1856,0701.1647)

14 **Drug pot** of *albarello* form, tin-glazed earthenware, painted with blue bands and a chevron pattern in manganese-purple and yellow; height 3¹/10 in; purchased from Henry J. Ingall, 1854
Pottery Catalogue E 105 (reg. no. 1854,1130.93)

15 **Jug**, bag-shaped, tin-glazed earthenware, painted in blue in the Chinese style with flowers and a bird on a rock and inscribed 'Margret Latham 1744'; height 6¹/5 in; purchased from Henry Willett, 1887
Lipski and Archer 1984, no. 987
Pottery Catalogue E 111 (reg. no. 1887,0210.122)

16 **Dish**, tin-glazed earthenware, painted in blue in the Chinese style with a girl pointing to a vase of flowers within a panel, the rim decorated with a scale and diaper design, inscribed 'Benj. And Deborah Nunes'; the reverse of the plate is painted with pairs of lines; diameter 11²/5 in; purchased from Henry Willett, 1887
Pottery Catalogue E 121 (reg. no. 1887,0210.142)

The burial of Benjamin Nunes in 1678 is recorded in the *Jewish Historical Society of England*, Miscellanies, Part VI, London, 1962, p.176, where Deborah Nunes is also recorded as a servant in 1659. The dish may not have belonged to these individuals, but was certainly made for a Sephardi Jewish customer. I am grateful to Beverley Nenk for indentifying the names on this piece and on no. 17.

17 **Plate**, similarly decorated, inscribed 'Abraham & Sarah Brandon'; diameter 13¹/5 in; purchased from Henry Willett, 1887
Pottery Catalogue E 122, pl. XIII (reg. no. 1887,0210.141)

The burial of Abraham Brandon of Barbados is recorded in 1720 (see no. 16). For other plates inscribed with the names of Jewish owners see no. 118.

18 **Plate**, tin-glazed earthenware, painted in greyish-blue in Chinese style with a girl sitting

under a tree, and three scroll-edged panels with blue sprigs, the spaces between which are filled with cross-hatching; orange rim; diameter 7¹/₂ in; given by William Edkins, 1887
Pottery Catalogue E 124 (reg. no. 1887,0616.5)

19 **Plate**, tin-glazed earthenware, sprinkled blue ground, painted in blue in the centre with a panel with wavy edges and palmettes at the corners, inscribed 'SIR INo POLE FOR EVER 1754' below hearts and scrolls; on the border four flower-shaped panels containing rose sprays, diameter 8⁴/₅; purchased from G.R. Harding, 1891, formerly in the collection of William Edkins
Freeth 1910, p. 101; Lipski and Archer 1984, no. 577D
Pottery Catalogue E 126 (reg. no. 1891,0524.7)

'Ino' stands for John. Sir John Pole, Bt, of Shute, Devon, who was the Court party's Parliamentary candidate for Taunton in the election of 1754. For an account of this bitterly contested election, see Freeth. Eight plates with this inscription and similar decoration have been recorded. A drinking glass inscribed around the rim 'Sir I Pole for ever 1754' was presented to the Museum in 1891 (reg. no. 1891,0619.1).

20 **Plate**, with design similar to the above on a sprinkled manganese-purple ground and panels on the border, painted in the Chinese style with fishermen; the reverse is painted with alternating crosses and strokes; inscribed in blue 'Calvert & Martin/For Ever/1754/sold by Webb'; diameter 13²/₅ in, presented by A.W. Franks, 1887
Freeth 1910, p. 101; Lipski and Archer 1984, no. 579A
Pottery Catalogue E 128, pl. 13 (reg. no. 1887,0307.E128)

There is a similar plate in the Warren Collection at the Ashmolean Museum, Oxford (Ray 1968, no. 30, pl. 110); seven plates with this inscription were known to Frank Freeth, although he believed there might be more.
 Calvert and Martin were elected in April 1754. They were petitioned against in November and these plates were probably then made to the

order of a local dealer named Webb.

21 **Plate**, tin-glazed earthenware painted in blue with a landscape and tree and inscribed 'IE 1721'; diameter 8⁹/₁₀ in; presented by A.W. Franks, 1887
Church 1884, p. 71; Lipski and Archer no. 316
Pottery Catalogue E 133 (reg. no. 1887,0307.E133)

22 **Puzzle jug**, tin-glazed earthenware, globular body, pierced neck, hollow rim and three spouts, tubular handle, painted on the reverse with a house in a landscape, inscribed in greyish-blue 'Here Gentlemen Come try your skill/I'll hold a wager if you will/That you don't drink this Liquor all/Without you spill or let some fall'; height 7 in; presented by A.W. Franks, 1889
Pottery Catalogue E 144

The inscription is commonly found on puzzle jugs which were designed to fool the drinker.

23 **Plate**, tin-glazed earthenware, painted in dark blue with a bird on a rock, inscribed 'W/IS 1718', 13³/₅ in; purchased from Henry Willett, 1887
Lipski and Archer 1984, no. 298
Pottery Catalogue E 147 (reg. no. 1887,0210,139)

24 **Plate**, tin-glazed earthenware, painted in blue with a Chinese design of an eightfoil containing a scale pattern and a central rosette inscribed 'SS 1735', the border painted with a design of scrolls; inscribed on the reverse 'R.S. October ye 27th 1735'; 8⁹/₁₀ in; presented by A.W. Franks, 1887
Church 1884, p. 71; Lipski and Archer 1984, no. 398B
Pottery Catalogue E 148 (reg. no. 1887,0307.E148)

Another similar plate was in the collection of the late Louis Lipski (Lipski and Archer, no. 398).

25 **Punch bowl**, tin-glazed earthenware, painted on the outer surface in yellow, green, blue, manganese-purple and red with flowers in quatrefoil panels, the spaces painted with a diaper design in black on coloured grounds, the inside of the bowl decorated with a border design

in Chinese style, inscribed in a cartouche in the bowl 'James Wilson 1762'; diameter 10³/₁₀ in; presented by A.W. Franks, 1896
Lipski and Archer 1984, no. 1187
Pottery Catalogue E 160

Possibly made in Liverpool.

26 **Dish**, tin-glazed earthenware, manganese ground, reserve painted in blue, diameter 13 in; presented by Alfred Aaron de Pass, 1904
Reg. no. 1904,0611.2

27 **Plate**, tin-glazed earthenware, inscribed in blue 'Rolle for Ever'; diameter 8 in; presented by Rennie Manderson, 1908
Reg. no. 1908,1112.1

The plate was made for a Parliamentary election. Given the dates of other election plates, it is likely to date from March 1761, when Denys Rolle (1725–1797) was elected MP for Barnstaple, Devon. He sat until 1774. The Rolle family, present in Britain since the Norman Conquest, were one of the three most powerful families in Devon during the eighteenth century. Rolle attempted to establish a colony in Florida in the 1760s. This plate was probably made in Bristol, at the factory of Richard Frank. Ray 1968, p. 128, lists two further plates for this election: (i) inscribed 'Rolle for Ever', formerly in the Warren Collection, and (ii) inscribed 'Roles For Ever', whereabouts unknown. There is a portrait of Denys Rolle by Thomas Hudson in Great Torrington Town Hall, Devon.

28 **Plate**, tin-glazed earthenware painted in mauve, green, blue and yellow with a floral design, mark 'y' painted in mauve on the reverse; diameter 6⁹/₁₀ in; presented by Miss Elizabeth Penelope Bird, 1912
Reg. no. 1912,1004.2

Probably made in Liverpool.

Notes

Introduction

1 Archer 1997, pp. 3, 4.
2 For maiolica in the British Museum, see D. Thornton and T. Wilson, *Italian Renaissance Ceramics, A Catalogue of the British Museum Collection*, 2 vols, London, 2009.
3 Published in facsimile with transl. by R. Lightbown and A. Caiger-Smith, Ilkley, 1980.
4 A rich source of information about the spread of tin-glazed earthenware northwards is D. Gaimster (ed.), *Maiolica in the North, the archaeology of tin-glazed earthenware in north-west Europe, c.1500–1600*, proceedings of a colloquium hosted by the Department of Medieval and Later Antiquities on 6–7 March 1997, British Museum Occasional Paper, no. 122, London, 1999 and in particular T. Wilson, 'Italian maiolica around 1500: some considerations on the background to Antwerp maiolica', pp. 5–21.
5 Archer 1997, p. 428, no. N.8.
6 See M. Hughes and D. Gaimster, 'Neutron activation analyses of maiolica from London, Norwich, the Low Countries and Italy', in Gaimster (ed.) 1999, pp. 65–6.
7 Tyler, Betts and Stephenson 2008, p. 16.
8 For an account of this pottery see I. Davies, 'Seventeenth-century delftware potters in St Olave's parish, Southwark', *Surrey Archaeological Collections*, vol. LXVI, 1969, pp. 11–31.
9 For an exhaustive chronology of delftware manufacture, see Archer 1997, pp. 560–9.
10 Tyler, Betts and Stephenson 2008, p. xiv.
11 See Austin 1994, introduction, pp. 15–23 and Lange 2001, pp. 17–28.
12 B. Blenkinship, 'Lancaster Delftware Pottery', *Northern Ceramic Society Journal*, vol. 28, 2008–9, pp. 40–70.
13 See L.L. Lipski, *Teaware in English Delft 1700–1800*, exh. cat., The Tea Centre, Regent Street, London, Nov. 1954–Jan. 1955. I am grateful to Margaret Macfarlane for bringing this catalogue to my attention, and for allowing me to consult her M. Phil thesis, 'English tin-glazed teaware: its origins and development 1650–1800', University of Southampton, 1991.
14 I owe this suggestion to Jonathan Horne, pers. comm., January 2009.
15 Archer 1997, p. 13.
16 Ibid., pp. 14 and 9.
17 Tyler, Betts and Stephenson 2008, p. 17.
18 See Archer 1997, cat. F.21, for a delftware bowl dated 1731, inscribed 'John Udy of Luxillion/his tin was so fine/it glidered this punch bowl/and made it to shine/pray fill it with punch/lett the tinners sitt round/they never will budge/till the bottom they sound./1731'. John Udy was one of several men with this name who were part of the tin-mining industry in the Luxulyan area of Cornwall. 'Glider'

is an old word meaning to 'glaze over'.
19 Ray 1968, p. 86.
20 See Edwards 1974, pp. 19–20.
21 Noël Hume 1977, pp. 38, fig. 30 shows a stack of plates fused in firing, including a side view with trivets in situ; and Archer 1997, pp. 21–2.
22 See Bloice 1971 and Dawson 1971.
23 Tyler, Betts and Stephenson 2008, p. 17.
24 Archer 1997, p. 22.
25 F. Britton, 'The Pickleherring Potteries: an inventory', *Post-Medieval Archaeology*, vol. 24, 1990, pp. 61–92.
26 I am grateful to Hazel Forsyth for drawing my attention to the various documents that provide information on delftware factories, and to several publications of this material. Much further work remains to be done on many types of surviving inventories.
27 Dawson and Edwards 1974, p. 60; note 74 signals L. Weatherill and R. Edwards, 'Pottery making in London and Whitehaven in the late-seventeenth century', *Post-Medieval Archaeology*, vol. V, 1971, pp. 160–81, which gives further information on the numbers of potters in Lambeth and Southwark during the seventeenth century.
28 Archer 1997, p. 23.
29 Ibid.
30 I am grateful to Margaret Macfarlane for reminding me of the practicalities of running a pottery. The information comes from the inventory of the Pickeleherring pottery, Britton 1990, p. 80.
31 Tyler, Betts and Stephenson 2008, pp. 117–19.
32 For delftware chamber pots and ceramic chamber pots in general, see I. Nöel Hume, 'Through the looking glasse: or, the chamber pot as a mirror of time', in R. Hunter (ed.), *Ceramics in America*, Hanover and London, 2003, pp. 139–71.
33 Tyler, Betts and Stephenson 2008, p. 112.
34 S. Smith, 'Norwich China Dealers of the mid-eighteenth century', *ECC Trans.*, vol. 9, part 2, 1974, p. 195.
35 Quoted ibid., p. 199.
36 'Severall Baskit Women' are listed as owing a total of £21 13s 3d to the Pickleherring pottery, Southwark, when the manager John Robins died in 1699, see Britton 1990, p. 82, and the pottery owned baskets to the value of fifteen shillings, see p. 80.
37 Archer 1997, p. 27.
38 See A. Lange, *Delftware at Historic Deerfield, 1600–1800*, Deerfield, Mass., 2001, pp. 21–7.
39 Ibid., p. 25.
40 Wills 1967, p. 443.
41 I am grateful to Margaret Macfarlane for her comments on this aspect of the history of delftware.
42 Quoted Francis 2000, p. 41.

43 Quoted ibid., p. 55.
44 Ibid.
45 Ray 1968, p. 24.
46 Quoted Francis 2000, p. 64.
47 Britton 1990, pp. 61–92 and Britton 1993, pp. 59–64.
48 Corporation of London Record Office, Orphans inventories no. 2037, 27 October 1683 and probate inventory, exhibited 9 March 1685 in the Court of Orphans, CLRO, Common Sergeants Book, vol. 4, p. 243. I am most grateful to Margaret Macfarlane for this reference and for a photocopy of the list of debtors, which is on file in the Department of Prehistory and Europe, British Museum.
49 Lange 2001, pp. 19–21.

Collecting Delftware

1 See *Horace Walpole and Strawberry Hill*, exh. cat., Orleans House Gallery, Twickenham, September–December 1980, compiled by S. Calloway, M. Snodin and C. Wainwright.
2 *A Description of the Villa of Horace Walpole, Youngest Son of Sir Robert Walpole Earl of Orford, at Strawberry Hill, near Twickenham. With an inventory of the Furniture, Pictures, Curiosities, &c.*, Strawberry Hill, 1774, p. 10. I am grateful to Stephen McManus for drawing this item to my attention. The dish is now in the V&A, London, see Archer 1997, B.1. I am grateful to Michael Archer for bringing this reference to my attention.
3 Ibid., p. 13.
4 I am grateful to Stephen McManus for help in finding a marked-up catalogue of the Strawberry Hill sale, NAL pressmark 23.5(c).
5 Church 1884, p. 37.
6 Their father Joseph Marryat (1757–1824) was a landholder in the West Indies, Member of Parliament for Sandwich and Chairman of the committee at Lloyds.
7 The catalogue issued by Christie, Manson & Woods is dated Saturday, 9 February 1866 but the British Museum example has a pencil annotation altering the year to 1867. The delftware vase was lot 1001.
8 J. Marryat, *A History of Pottery and Porcelain, Medieval and Modern*, London, 1857, p. 143.
9 Donated to the Museum in 1887.
10 He owned a mug with the arms of the Leathersellers' Company and the inscription 'Bee Merry & Wise 1660', (no. 47).
11 The first, along with a 'Fecundity' dish (see no. 44) was purchased at the sale of Ralph Bernal, M.P., in 1855.
12 For his life and collecting activities see M. Gibson and S.M. Wright (eds), *Joseph Mayer of Liverpool, 1803–1886*, London, 1988.
13 National Museums Liverpool, Inv. M 1069.

14 National Museums Liverpool, Inv. M 1070.

15 National Museums Liverpool, Inv. M 1082; see p. 76 for a discussion of these election plates.

16 National Museums Liverpool, Inv. M 2465.

17 Jewitt was not only a Fellow of the Society of Antiquaries but also belonged to the British Archaeological Association and so was part of the antiquarian and archaeological fraternity.

18 L. Jewitt, *The Ceramic Art of Great Britain from Pre-historic times down to the present day, being a history of the ancient and modern pottery and porcelain works of the kingdom and of their productions of every class*, 2 vols, London, 1878.

19 Ibid., p. 160.

20 Ibid., figs 735–40.

21 Author of *Two Centuries of Ceramic Art in Bristol*, London, 1873.

22 Willett was born Henry Catt, the son of a farmer and miller, who took his mother's name and made a fortune in brewing, as well as from investments in railway, tramway, electricity and water companies. He knew John Ruskin, the art critic, A.W. Franks of the British Museum, the Liberal politician Richard Cobden and the American writer Oliver Wendell Holmes, and was a collector of fossils, publishing his *Catalogue of Cretaceous Fossils* in 1871. He also assembled an important collection of old master paintings, many now in leading collections abroad. I am grateful to Stella Beddoe for allowing me to see her unpublished introduction to the Willett Collection of ceramics at Brighton Museum. See also J. Rutherford, 'Henry Willett as a Collector', *Apollo*, vol. CXV, no. 241, February 1982, pp. 176–81.

23 For a brief biography of Lady Charlotte Schreiber, see Archer 1997, p. 586; also R. Guest and A.V. John, *Lady Charlotte, a biography of the nineteenth century*, London, 1989 and A. Eatwell, 'Private pleasure, public beneficence', in C. Campbell Orr, *Women in the Victorian Art World*, Manchester, 1995, pp. 125–45.

24 M.J. Guest (ed.), *Lady Charlotte Schreiber's Journals, Confidences of a collector of ceramics & antiques throughout Britain, France* [etc] ... *1869 to 1885*, 2 vols, London and New York, 1901.

25 Information on prices paid by Lady Charlotte comes from her own interleaved annotated copy of her catalogue *Schreiber Collection. Catalogue of English porcelain, earthenware, enamels, &c., collected by Charles Schreiber, Esq., M.P. and the Lady Charlotte Elizabeth Schreiber and presented to the South Kensington Museum in 1884*, London, 1885, kept in the library of the Department of Prehistory and Europe, British Museum.

26 See *Archaeological Journal*, vol. XXXV, 1878, p. 304 where the bottle dated 1641 is mentioned by Soden Smith. R.H. Soden Smith, FSA, was a ceramic collector and librarian at the South Kensington Museum (now the V&A), London.

27 Now in the V&A, inv. 414-1885, see Archer 1997, cat. D.1.

28 The Interesting Collection of Lambeth Pottery, Rhodian, Hispano-Mauro and other Faience, Silver Plate and Objects of Art formed by Sir John Evans, KCB, FRS, Christie, Manson & Woods, London, 14 February 1911.

29 Lot 40, the dish was painted with the arms of the City of London and of the Embroiderers' Company.

30 Lot 76, formerly the property of Sir Nicholas Miller of Oxenheath, Kent.

31 Hodgkin and Hodgkin 1891.

32 The sections on English delft run from no. 229 to no. 554. The collection passed to Hodgkin's son, Stanley Howard Hodgkin (1860–1944), then to his wife Florence (1869–1950). After Florence Hodgkin's death delftware was

sold from her estate at Sotheby's, 28 March 1950, 18 July 1950 and 11 December 1951.

33 Burlington Fine Arts Club 1913; a bound version of the catalogue was published the following year.

34 See M.R. Parkinson, 'The Incomparable Art – English Pottery from the collection of Mr Thomas Tylston Greg I', *Burlington Magazine*, vol. 112, no. 805, April 1970, pp. 236–9 and the exhibition catalogue *The Incomparable Art, English Pottery from the Thomas Greg collection*, City Art Gallery, Manchester, 1969.

35 Downman 1919.

36 Mundy 1928.

37 Hobson 1903, E.98, for example.

38 A few are illustrated in W.J. Pountney, *Old Bristol Potteries*, Bristol, 1920.

39 See Rackham 1935. This catalogue includes the entire Glaisher Collection, which comprises lead-glazed wares, both Continental and English, as well as delft. The delft collection is currently being re-catalogued. Much of it is visible on the Fitzwilliam Museum website. For Glaisher, see J. Poole, 'James Whitbread Lee Glaisher, ScD, FRS (1848–1928): a Cambridge mathematician and collector', *Transactions of the English Ceramic Circle*, vol. 15, part 2, 1994, pp. 160–83.

40 For an obituary, see *Transactions of the English Ceramic Circle*, vol. 6, part 1, 1965, pp. 52–4. The collection was sold at Sotheby's on 6 October 1964 and on 2 March and 1 June 1965.

41 Ray 1968; Ray 2000.

42 Archer 1997.

43 There are 727 items in Austin 1994.

44 See Taggart 1967.

45 His collection was sold at Sotheby's, London, 1 October 1991 and 7 October 1992.

Collecting Delftware at the British Museum

1 For Franks see M. Caygill and J. Cherry (eds), *A.W. Franks: Nineteenth-Century Collecting and the British Museum*, London, 1997.

2 Reg. no. 1854,1130.93, Register of War Exhibits, Department of Prehistory and Europe, British Museum.

3 Reg. no. 1854,1130.73, found in Bishopsgate, London.

4 Reg. nos 1856,0701.1592, 1593 and 1594.

5 Catalogue kept in the Department of Prehistory and Europe, British Museum.

6 For Willett, see p. 305, note 22. An early catalogue was issued, *Introductory Catalogue of the Collection of Pottery and Porcelain in the Brighton Museum lent by Henry Willett*, Brighton, 1879, followed by *Catalogue of a Collection of Pottery and Porcelain illustrating popular British history ...*, London, 1899.

7 Alexander Christy also presented a marble bust of his brother by Thomas Woolner, RA, see A. Dawson, *Portrait Sculpture, A Catalogue of the British Museum collection c. 1675–1975*, London, 1999, no. 19.

8 See H. Davies, 'John Charles Robinson's Work at the South Kensington Museum Part I', *Journal of the History of Collections*, vol. 10, no. 2, 1998, pp. 169–188.

9 Reg. no. 1903,0214.28.

10 For their sales of medals, plaquettes and coins see Sotheby, Wilkinson and Hodge, 30 April 1923 and four following days; Old Master Drawings and Oil Paintings, 2 May 1923; Pottery and Porcelain, 3 May 1923 and following day; Engraved Ornament, 7 May 1923 and following day; The Library, 9 May and following day; Works of Art, 9 May 1923 and two following days.

11 Mundy 1928.

Notes to entries

2

1 Quoted by J. Horne in Grigsby 2000, preface p. 10; see R.C. Latham and W. Matthew (eds), *The Diary of Samuel Pepys*, vol. 1, 1660, London, 1970, repr. 1971, p. 79.

3

1 For King Charles II see R. Hutton, *Charles the Second, King of England, Scotland, and Ireland*, Oxford, 1989.

2 Sotheby's New York, Important English Pottery, The Harriet Carlton Goldweitz Collection, 20 January 2006, lot 13.

3 Sold from the collection of the late Charles J. Lomax, Sotheby's London, 7 April 1937, lot 16. It was previously in the F. Bennett-Goldney Collection, sold Puttick & Simpson, London, 3 April 1920, lot 100.

4 See Horne 2002, p. 38, illus.

4

1 See D. Thompson, 'Octavius Morgan, horological collector', *Antiquarian Horology*, vol. XXVII, March, June, December 2003, pp. 302–14, 406–22, 618–42, vol. XXVIII, September 2004, pp. 337–47, March 2005, pp. 602–18, vol. XXIX, December 2005, pp. 189–216, vol. XXX, September 2006, pp. 629–44.

2 One in the Glaisher Collection at the Fitzwilliam Museum, Cambridge, inv. C.1305-1928, is dated 1648, illus. Lipski and Archer 1984, no. 1351; another dated 1649 was in the Marsden–Smedley Collection, illus. Lipski and Archer 1984, no. 1368.

3 Illus. Lipski and Archer 1984, no. 1501, formerly in the Louis Gautier Collection, then with Manheim, London.

4 Inv. 1963.26, discussed in Grigsby 2004, in the Chipstone Foundation, Digital Library for the Decorative Arts and Material Culture.

5

1 According to notes made by the late Group Captain Frank Britton, kept in the Department of Prehistory and Europe.

2 I am grateful to John Graves of the National Maritime Museum for this identification.

3 Lipski and Archer 1984, no. 30.

4 Grigsby 2000, D63.

5 Lipski and Archer, 1984, no. 54.

6 Hobson 1903, E 154.

7

1 Austin 1994, p. 134, cat. 171.

2 Image held in the Heinz Archive, National Portrait Gallery, London.

8

1 W. King, 'Lambeth Bust of Charles I', *British Museum Quarterly*, vol. X, no. 3, 1936, p. 131.

2 Otto von Falcke, 'Aus den Museen', *Pantheon*, vol. XVII, April 1936, pp. 138–40, illus. p. 138.

3 C. Louise Avery, 'English Pottery: recent acquisitions', *Bulletin of the Metropolitan Museum of Art*, vol. XXXII, no. 3, March 1937, pp. 64–5.

4 Grigsby 2000, nos D345, two male busts; D346, 347, two figures of couples; D348 two flower-holders in the form of heads of boys.

5 Published by Avery, op. cit., note 3, illus. The head of this example has been broken and re-stuck, and the base has been restored. I am grateful to Jessie McNab for her assistance when I examined this bust in November 2007. The bust was purchased from Guitel Montague who apparently had some connection with Manheim in London (information from notes kept in the Department of European Sculpture and Decorative Art at the Metropolitan Museum). In view of the proximate dates of acquisition of the two busts, it is possible that they were both once in the same collection in England.

6 The British Museum bust has been X-rayed and the results suggest it was not made in multiple moulds, although the base may be separately constructed, see British Museum CRS report AR2008/27. I am grateful to Janet Ambers for taking on this project. The Metropolitan Museum bust has also been x-rayed.

7 For the story of the transportation of the bust to England, see R. Lightbown, 'The journey of the Bernini bust of Charles I to England', *Connoisseur*, vol. CLXIX, no. 682, 1968, pp. 217–20. Images of Charles I are discussed by M. Vickers in 'Rupert of the Rhine, a new portrait by Dieussart and Bernini's Charles I', *Apollo*, vol. CVII, no. 193, March 1978, pp. 161–9, see especially fig. 14, a self-portrait drawing by G. Vertue in the British Museum, which depicts the bust as copied by the artist, who claimed it was a modified cast of the lost Bernini.

8 I am grateful to Dora Thornton for this suggestion. The medal is discussed by Philip Attwood in *Treasure Annual Report 2003*, Department of Culture, Media and Sport, Cultural Property Unit, p. 132, and figs 274.1, 274.2.

9 Lipski and Archer 1984, no. 1744.

10 Macfarlane 1998, p. 262.

11 I owe this observation to Sheila O'Connell of the Department of Prints and Drawings, British Museum.

12 See R.A. Beddard, 'Wren's Mausoleum for Charles I and the cult of the Royal Martyr', *Architectural History*, vol. 27, 1984, p. 37. I am most grateful to Margaret Macfarlane for bringing this article to my attention and for discussing this piece with me.

13 According to L. Potter in 'The Royal Martyr in the Restoration: national grief and national sin', in T.N. Corns (ed.), *The Royal Image: representations of Charles I*, Cambridge 1999, p. 247.

14 Beddard, op.cit., pp. 37–40.

15 Macfarlane 1998.

16 See A. Dawson, *Portrait Sculpture, a catalogue of the British Museum collection c. 1675–1975*, London, 1999, no. 16, col. pl. 4.

17 J. and G. Lewis, 'Pratt Ware': *English and Scottish relief decorated underglaze coloured earthenware, 1780–1840*, Woodbridge, 1984, p. 122, pl. 27.

18 Ibid., p. 123.

9

1 Another Popish Plot tile with a different subject was lot 505 in this sale.

2 Sold by Mrs Florence Hodgkin, widow of Stanley Howard Hodgkin who was the son of John Eliot Hodgkin, at Sotheby's, 18 July 1950, lot 46.

3 A pack of these cards is in the Department of Prints and Drawings, British Museum, reg.no.1896,0501.915.1–52. There is another pack in the Guildhall Library, London, and further cards in the Pepys Library, Magdalene College, Cambridge. I am grateful to Julia Poole for drawing my attention to all these cards.

4 This set was sold by Anthony W. Pullen at Sotheby's, 15 March 1971, lot 21, bought by Wake for £500. I owe this reference to the kindness of Jonathan Horne. Eleven tiles from this set were bequeathed to the Museum in 2009 by Dr William Lindsay Gordon (reg. no. 2009,8014. 1– 11) and another six tiles from the same owner which were nearly all in poor condition were purchased on the market (reg. no. 2009,8015. 1– 6). For a discussion of Popish Plot tiles see Horne 1989, p. 17 and Ray 1973, pp. 61, 114 and pl. 2.

5 Archer 1997, cat. no. N.10-18.

6 Three tiles purchased at Sotheby's, London, 2 February 1982, lots 107–9: 'The Club at ye plow Ale house for the murther of S.E.B.G.', Sir. E.B. Godfree is persuaded to goe down Somerset house yard' and 'Capt. Bledlow examined by ye Secret Comitee of the house of Commons'; information kindly supplied by Meredith Chilton in corresp. of 17 February 1988.

7 Grigsby 2000, D16, D417, 418.

8 Inv. HMCMS DA 1991.231, see *National Art Collections Fund Review of the Year ended 31st December 1992*, p. 99. I owe this reference to the kindness of Neil Hyman, Keeper of Decorative Art, Hampshire County Council Museums and Archive Service.

9 Quoted by Archer 1997, p. 430.

10 Archer 1997, ibid.

10

1 See Anon, 'Fulham Pottery', *Art Journal*, 1 October 1862, p. 204. The article is apparently by 'Mr Baylis'.

2 'A LARGE DISH, with the cipher and arms of Charles II; scrolls, flowers and birds on white and deep-blue ground', under the heading 'Fulham Ware'.

3 See note 1.

4 As often found, these holes would not enable the dish to be hung with the decoration in quite the correct alignment.

5 I am grateful to Jonathan Horne, who identified the dish as French in January 2008; to Madame Antoinette Hallé, personal correspondence, January 2008; and to M. Camille Leprince, who examined it in June 2008. When he examined it in September 2009, M. Jean Rosen expressed the opinion that the body was unlike seventeenth-century Nevers faïence, with which he is very familiar; the painted decoration also seemed to him to be atypical of Nevers productions. Scientific analysis may enable comparisons to be made with fragments found in an archaeological context.

6 M. Taburet, *La faïence de Nevers et le miracle lyonnais au XVIe siècle*, Paris, 1981, pp. 81, 83, dimensions not given.

11

1 The dish is also inscribed below the horse's belly 'T/16BA/80' and has elaborate decoration on the wide flat border, see M. Archer, 'An English delftware charger of General Monck', *Victoria and Albert Museum Bulletin*, vol. IV, no. 1, 1968, pp. 1–8, and Archer 1997, cat. A.59.

2 Archer 1968, p. 6 and Archer 1997, cat. A.59.

3 Ray 1968, p. 110, no. 10 and pl. 3.

4 Inv. C.10-1934, formerly in the Revelstoke Collection, sold Puttick & Simpson, 20 November 1934, lot 655.

5 Grigsby 2000, D17.

12

1 Sold Sotheby's, 10 March 1981, lot 43.

2 Illustrated by John Sandon, 'The King's Head', *Antique Dealer and Collectors' Guide*, January/February 2000, p. 31, fig. 7.

3 Simon Sainsbury, 'The creation of an English Arcadia',

vol. I, Christie's, 18 June 2008, lot 79, sold for £55,000 (hammer price).

4 Michael Archer, 'Delftware from Brislington', *Connoisseur*, vol. 171, no. 689, July 1969, p. 159, fig. 16.

5 Ibid., p. 158.

6 Inv. 1923.235, bequeathed by Thomas Tylston Greg. I am grateful to Alison Copeland for helping me to examine this dish.

7 Horne 2000, no. 585, diameter 23.5 cm.

13

1 Sotheby's, 7 October 1992, lot 9.

2 Inv. no. 1923.270. I am grateful to Alison Copeland for assistance in examining this plate.

14

1 Inv. C.1447-1928.

15

1 Grigsby 2000, D22.

2 Lange 2001, no. 58.

3 Garner and Archer 1972, pl. 22.

4 Ray 1968, pl. 1 (3).

5 Austin 1994, no. 173.

16

1 Archer 1997, p. 80, cat. A.12.

2 Ibid, A.12.

3 Austin 1994, no. 181.

17

1 Archer and Morgan 1977, no. 46.

2 E.J. Sidebotham, *Catalogue of the Greg collection of English pottery*, n.p. [Manchester], n.d. [1924], inv. 1923.236. I am grateful to Alison Copeland for assisting me when I examined this dish.

3 Ray 1968, no. 22.

4 Inv. C.1457-1928; another, inv. C.1458-1928, is a variation with a highly stylized rose.

5 Inv. 83.1.0482; an image of this dish is on the Gardiner Museum website.

6 Noted by Lange 2001, no. 62, entry on an 'AR' plate at Historic Deerfield, referring to R. Edwards, 'An early waste deposit from the Vauxhall Pottery', *ECC Trans.*, vol. 12, part 1, 1984, pl. 55 a–c.

7 Grigsby 2000, D256, mug painted with a geometric design of asterisks in a trellis with crosses at each edge.

18

1 Reg. no. 2002,0401.1.

2 Diameter 28 cm; see Jonathan Horne, *English pottery and related works of art*, 2006 (dealer's catalogue, p. 38).

3 Inv. Willett Collection 6; I am grateful to Stella Beddoe for her assistance in examining this plate.

4 Austin 1994, cat. 196.

5 Taggart 1967, no. 87.

6 Grigsby 2000, D43.

7 With Jonathan Horne.

19

1 Ray 2000, p.42.

2 Ibid., no. 26.

3 Britton 1982, 15.18.

4 Ray 2000, no. 25.

5 Grigsby 2000, D59.

6 Inv. C.1716 & A-C-1928, see J. McKeown, *English ceramics*,

two hundred years of collecting at Rode_, London, 2006,
pp. 36–9, pl. 26.
7 Jackson, Jackson and Price 1982, pp. 162–3. Pottery was
apprenticed to a potter in 1707, became free in 1715 and
remained active as a potter until around 1739.

20
1 Grigsby 2000, D313.
2 Austin 1994, p. 83, no. 46.

21
1 See Prints and Drawings reg. no. 1902,1011.1332.
2 Prints and Drawings reg. no. 1870,1008.2574. I am grateful
to Sheila O'Connell for these suggestions.
3 Freeth 1910, p. 101.
4 Ray 2000, no. 28.

22
1 Mezzotint, National Portrait Gallery, Archive engravings
collection D7943.
2 Plate III, inscribed 'P. Jeffrys sculp.' Another similar
portrait issued by R. Forrest at 'ye Plume of Feathers in
Windmill Street, St,. James's' for a watch case is
surrounded by various emblems and figures and bears the
date 'September 29th 1746', NPG Archive, neg. ref. no.
16503.
3 Reg. no. Heal 5.3.
4 Lipski and Archer 1984, no. 828.

23
1 See F.P. Lole, 'A Digest of the Jacobite Clubs', _The Royal
Stuart Society_, Paper 5, 1999, pp. 9–10.
2 See L.M. Bickerton, _Eighteenth-Century English drinking glass,
an illustrated guide_, Woodbridge, 1986, pp. 277, 282.
3 F.J. Lelievre, 'Jacobite glasses and their inscriptions: some
interpretations', _The Glass Circle_, 5, 1986, pp. 71–2.
4 I am grateful to Julia Poole for bringing to my attention
Lelievre's study.

24
1 Many of these plates are noted in Freeth 1910.
2 Inv. Willett 478; I am grateful to Stella Beddoe for
assistance in examining this plate.
3 Inv. M 1082 (collection of Joseph Mayer), diameter 34.3 cm.
There is a smaller example in the Lady Lever Gallery, Port
Sunlight, inv. X2764, diameter 22.5 cm, purchased by W.H.
Lever in 1918 from Frederick Rathbone. I am grateful to
Robin Emmerson for assistance in examining the large dish
and giving me details of the second.

25
1 Inv. 1923.335. I am grateful to Alison Copeland for her
assistance in examining this bowl. The word 'Arms' is in
capital letters on this example and the interior of the bowl is
elaborately decorated in the _bianco-sopra-bianco_ technique.
2 Austin 1994, no. 52.
3 Lange 2001, no. 19.
4 Austin 1994, no. 52.
5 Lange 2001, no. 19.

26
1 Britton 1986, p. 154 and col. pl. K.
2 Austin 1994, p. 140.
3 An example of this engraving is in the Department of Prints
and Drawings, British Museum, reg. no. 1845,0724.118.

27
1 Illustrated by Lange 2001, p. 93, in connection with a bowl
in Historic Deerfield, Massachusetts, inscribed 'WILKES:
AND: LIBERTY./No: 45:' and a portrait without curtain.
2 Rackham 1935, vol. 2, no. 1597, pl. 115C.
3 Illus. A. Dawson, _The Art of Worcester Porcelain 1751–1788_,
London, 2007, no. 35.
4 Reg. no. 1887,0307.II.46.
5 Reg. nos 1988,0421.1, Franks 625 and 1963,0422.15, see
R. Krahl and J. Harrison-Hall, _Ancient Chinese Trade
Ceramics from the British Museum_, Taipei, 1994, nos 38–40.

28
1 Archer 1997, cat. C.23, inv. 3845&a-1901, acquired by the
Museum of Practical Geology before 1871.
2 Ibid.
3 Reg. no. 2002,0401.1.

29
1 Rockingham also repealed the unpopular excise tax on
cider, see no. 97.
2 In the Smithsonian Museum, Washington, DC; The DeWitt
Wallace Decorative Arts Museum, Colonial Williamsburg,
Virginia, inv. 1953-417, a
& b; the Peabody Essex Museum, Salem, Massachusetts;
another was sold at Pook & Pook Inc., Downingtown,
Pennsylvania, 20–21 April 2007, lot 50, from the Edna
Netter collection.
3 Illustrated in the _Antiques Trade Gazette_, 25 April 2009,
front cover, sold by Hansons at the Mackworth Hotel,
Derbyshire on 15 April 2009, inscribed 'Success to Trade in
America' on one side and 'No Stamp Act.' on the other.

31
1 For a similar bowl, see Archer 1997, F.50.
2 See Austin 1994, p. 93. One of the Virginia fragments is
illustrated here.
3 Britton 1982, no. 8.31.

33
1 Archer 1997, C.1, purchased in 1974.
2 I am grateful to Sheila Vainker for her help in describing
these emblems.
3 Or possibly 'Hercules and the Nemean Lion'. I am grateful
to Stephen McManus for bringing to my attention an
Urbino (Italy) maiolica _albarello_ (drug jar) painted with a
scene identified as Hercules and the Nemean Lion
illustrated by M.C. Villa Alberti, 'Sic et ... similiter, images
sacrées et images profanes sur les pots d'apothicaire de la
Sainte Maison de Lorette', in _Sèvres, Revue de la Société des
Amis du Musée National de la Céramique_, no. 17, 2008, p. 17,
fig. 12; see also Thorton and Wilson 2009, cat. 160, for
which reference I am grateful to my colleague Dora
Thornton.
4 An example of this print is in the Department of Prints and
Drawings, British Museum, reg. no. 1949,0709.59.
5 Described and illustrated in _The Ashmolean, highlights of the
Annual Report, August 2007–July 2008_, p. 24, inv.
WA2008.65; sold Simon Sainsbury, The Creation of an
English Arcadia, volume I, Christie's, 18 June 2008, lot 162.
6 For this factory see Dawson and Edwards 1972 and Britton
1986, pp. 43–5.
7 Wilson 1987, no. 261.
8 In a note kept on file in the Department of Prehistory and
Europe, British Museum.

34
1 Archer 1973, no. 25.
2 In The DeWitt Wallace Decorative Arts Museum, Colonial
Williamsburg, see Austin 1994, no. 153. This dish has a
wide flat border painted with cherubs, four in oval panels.
3 Taggart 1967, p. 86, no. 79, col. ill opp. p. 34. The narrow
border of this dish is painted with blue dashes.

35
1 I am grateful to Stephen McManus for bringing this
engraving to my attention.

36
1 See Britton 1986, nos 112, 113; Archer 1997, nos L.1-5 and
Grigsby 2000, nos D345-352. Margaret Macfarlane has
informed me that she has traced a total of forty-one pieces,
pers. comm. Feb. 2008.
2 Height 4in. Illustrated in Jonathan Horne, _A Collection of
Early English Pottery_, London, part X, no. 260 (dealer's
catalogue). I am grateful to Leslie Grigsby for generously
sharing information on this piece with me.
3 Jonathan Horne, _A Collection of Early English Pottery_, part
XVIII, no. 515 (dealer's catalogue).
4 By Margaret Macfarlane, to whom the writer is most
grateful for sharing her views on this unusual piece.
5 Some parts of England, such as Lancashire, were still
dominated by Catholic families, and private chapels
continued in use in a number of country houses in other
areas.
6 In the caption to the illustrations in _The Connoisseur_ (see
above), presumably written by Hugh Tait. I am grateful to
Stephen McManus for this reference.

37
1 For Morgan see no.4, note 1.
2 British Library, shelfmark c.7.d.18. I am grateful to Stephen
McManus for examining this volume.
3 According to notes made by the late Group Captain Frank
Britton, kept in the Department of Prehistory and Europe,
British Museum.
4 Ibid.
5 Edwards 1974, p. 65.

38
1 British Library, shelf mark c.7.d.15, four large folio volumes,
first volume. I am grateful to Stephen McManus for
examining these volumes.
2 Grigsby 2000, D64.

39
1 Michael Archer, pers. comm., August 2009, expressed the
opinion that this dish is Dutch.
2 British Library, shelf mark c.7.d.18, four large folio volumes.
I am grateful to Stephen McManus for examining this
Bible.
3 R.D. Aronson, _Dutch delftware including selections from the
collection of Dr F.H. Fentener van Vlissingen and a rare group
of I.W. Hoppesteyn marked objects_, Aronson Antiquairs,
Amsterdam, 2008, no. 6. I am grateful to Suzanne
Lambooy for drawing this piece to my attention. Two
variants of this Dutch dish are recorded.
4 Pers.comm. January 2009.

40
1 In the William Rockhill Nelson Gallery, Kansas City,
Missouri, USA, illus. Lipski and Archer 1984, no. 1329A.

This example was in the Harland and Howard collections and was exhibited at the Burlington Fine Arts Club, see Burlington Fine Arts Club 1913, Case D, no. 54.

2 According to notes made by the late Group Captain Frank Britton kept on file in the Department of Prehistory and Europe, British Museum.

41

1 Lipski and Archer 1984, no. 101.

2 I am most grateful to Dr Clive Cheesman, Rouge Dragon Pursuivant, for information about the coat-of-arms. He states that the shield, being red, should be dark, the lozenges and roses, being gold and silver respectively, should be light; the pelican's head in the crest should issue from a basket-like vessel, probably intended to be a nest.

3 Note from the late Group Captain Frank Britton, kept on file in the Department of Prehistory and Europe, British Museum.

42

1 According to a note by the late Frank Britton, kept in the Department of Prehistory and Europe, British Museum. Penry Fussell of the Drapers' Company has confirmed in correspondence of November 2009 that Alder was made free in 1652, but details of his marriage(s) have not been substantiated.

2 Lipski and Archer 1984, no. 724.

3 Ibid., no. 730.

4 Ibid., no. 731.

5 Last recorded in a New Jersey, USA, collection by Lipski and Archer 1984, no. 737.

6 Ibid., no. 742.

43

1 For Morgan see no. 4, note 1.

2 Information from notes made by the late Group Captain Frank Britton, kept on file in the Department of Prehistory and Europe, British Museum.

3 Inv. G83.1.0462; an image of this dish is on the Gardiner Museum website. Garner and Archer 1972, p. 29B; Lipski and Archer 1984, no. 100; diameter 16 1/4in, sold from the collection of Professor F.H. Garner OBE, part II, Sotheby's, 2 March 1965, lot 184 to 'Lipsky' for £460.

4 See Lipski and Archer 1984, no. 107. I am grateful to Anthony du Boulay, who has made a study of ceramics in National Trust properties, for discussing this example with me.

44

1 See Lipski and Archer 1984, nos 90-4, 99, 104-6, 110-11, 113, 118, 119-21, 125-6.

2 For a lead-glazed 'Fecundity' dish now attributed to the school of Palissy, see Britton 1991, p. 173, fig. 13.

3 Rackham 1959, p. 63.

4 Ibid.

5 See Slater 1999, p. 63 for a list.

6 D. Sutton, 'Fontainebleau, a sophisticated school', *Apollo*, vol. XCVII, no. 131, January 1973, pp. 116–18.

7 This information was kindly supplied by the late Group Captain Frank Britton, kept in the Department of Prehistory and Europe, British Museum.

45

1 Burlington Fine Arts Club 1913, Case D, no. 57, and see Burlington Fine Arts Club 1914, Case D, no. 57, illus. pl. XXVIII.

46

1 Inv. C. 419-1928. There is a second one in the Fitzwilliam Museum, inv. C. 1418-1928, which also has brown and green painted decoration in addition to the blue and yellow used. Julia Poole has told me that there is another in the National Trust, Wallington, Cambo, Northumberland.

2 Grigsby 2000, D207.

3 Ibid.

47

1 Bonhams, 10 December 2008, lot 14, now in the Milwaukee Art Museum, Wisconsin, USA.

2 Lipski and Archer 1984, no. 742.

3 Ibid., no. 748. It was on the market in 1975.

50

1 Archer 1997, p. 378.

2 Grigsby 2000, D394.

3 Lipski and Archer 1984, no. 1592, height 18.1 cm and see Hudson 2006, p. 82.

4 Hudson 2006, p. 85.

51

1 Information kindly communicated by Jonathan Horne who has examined many of these slabs.

2 Lipski and Archer 1984, no. 1678.

3 Ibid., no. 1675.

4 Ibid., no. 1676.

5 See Lothian 1960, p. 2 and pl. 2b and Hudson 2006, p. 254.

6 Archer 1997, p. 397, has discussed the dating of these pill slabs. Jonathan Horne expressed the opinion in January 2009 that this example dates from as late as 1770 because of the swags to either side of the badge, but in 2001 dated a slab similar to the Museum example to 1700–30, see Horne 2001, pp. 14–15.

7 Inv. C. 1316-1928, illus. Lothian 1951, p. 23, no. VIII.

8 Horne 2001, p. 14.

52

1 I am grateful to Dr Clive Cheesman, Rouge Dragon Pursuivant, for his kindness in identifying and describing the arms.

53

1 According to the late Group Captain Frank Britton, whose manuscript notes on the Billings are kept in the Department of Prehistory and Europe, British Museum.

55

1 For a study of this subject see Maisie Brown, 'Market Gardening in Barnes and Mortlake: the rise and fall of a local industry', Barnes and Mortlake History Society, 1985; this is a shortened version of a dissertation for the Diploma in Local History, Department of Extra-Mural Studies, University of London, 1982. Mrs Brown has also kindly brought to my attention an invaluable source of reference, C.W. Shaw, *The London Market Gardens – or Flowers, Fruit and Vegetables Grown for Market*, London, 1879.

2 I am most grateful to V. Jane Baxter, Local Studies Librarian, London Borough of Richmond Upon Thames, for information taken from the parish records and from the Borough of Barnes History Society, Newsletter, no. 8, Autumn 1962, Secretarial Notes, held at the Local Studies Library.

3 Information kindly provided by Maisie Brown.

4 Sarah Goodenough appeared in the 1841 census and was described at the widow of William, but she is not recorded in that of 1851. I am grateful to Maisie Brown for this information.

5 Inv. HMCMS DA 1985.95, illus. Lipski and Archer 1984, no. 1159.

6 Austin 1994, no. 96; Lipski and Archer 1984, no. 818.

7 Lipski and Archer 1984, nos 511, 511A, in the Ashmolean Museum, Oxford and the Manchester Art Gallery (inv. 1964.254, dated 1747 and inscribed 'E/TW') respectively.

56

1 I am grateful to Caroline Cartwright of the Department of Conservation and Scientific Research for her assistance in examining the plate under high magnification and for isolating with me areas of the decoration which could have been printed on account of their extreme complexity.

2 The plate has also been examined by Antony Griffiths of the Department of Prints and Drawings who did not consider the decoration typical of etching or engraving, but believed that the design could have been executed in penwork, as was often the case for armorials in the eighteenth century.

3 Information kindly supplied by Mark Dennis of the Museum of Freemasonry, London .

4 There is a Wedgwood creamware teapot and cover in Norwich Castle Museum which can be seen on the Museum's website, and in R. Emmerson, *British Teapots and Tea Drinking 1700–1850*, London, 1992, cat. 111, pl. 40.

5 Mundy 1928, pl. XXXII; the plate may have belonged to Mundy.

6 Sotheby's, 24 March 1959, lot 83.

7 Archer 1997, p. 307. It is not known whether he ever examined the plate.

8 In her entry for a Liverpool punch bowl painted with the Masons' arms belonging to the Chipstone Foundation, Milwaukee, USA, inv. 1993.14, see *Digital Library for the Decorative Arts and Material Culture Record Display*.

9 Lipski and Archer 1984, no. 418.

57

1 The other four are in the National Museum of Ireland, see Francis 2000, p. 160.

2 For a history of the factory see Francis 2000, pp. 158–62.

3 W.B. Honey, 'Limerick Delftware', *ECC Trans.*, vol. 2, no. 8, 1942, pp.155–7.

4 Archer and Hickey 1971, cat. nos 9, 10, illustrated.

5 See Archer 1997, F40.

6 Francis 2000, pp. 161–2.

7 Brooks was probably in London.

58

1 Britton 1987, p. 163; see p. 75 for the history of the pottery.

59

1 For storage jars and apothecaries' wares, see Archer 1997, pp. 377–80.

2 For some excavated in 2001–2, see J. Pearce, 'An assemblage of 17th-century pottery from Bombay Wharf, Rotherhithe, London SE16', *Post-Medieval Archaeology*, vol. 41, part 1, 2007, pp. 83–4.

60

1 See no. 59, note 1.

61

1 For information on drugs and their uses, see Douglas C.

Harrod, 'Inscriptions and Recipes', in Lipski and Archer 1984, pp. 393–402.

2 Tait 1962, p. 42.

3 Tait 1962, pp. 41–2, quotes the formula and the use of the drug as given in N. Culpeper, *Pharmacopoeia Londinensis: or the London Dispensary*, London, 1661, p. 158.

4 Sotheby's, 24 July 1956, lot 56, sold to Tilley for £95.

5 I am grateful to Jonathan Horne for this information, see Horne 2005, p. 10.

6 See Archer 1997, p. 391; illustrated in Tyler, Betts and Stephenson 2008, p. 79, fig. 119.

7 Hudson 2006, cat. 2.

62

1 Archer 1997, no. F.53.

2 Horne 2005, no. 360.

63

1 I am grateful to Stephen McManus for this reference, which antedates that given for 1825 by Houghton and Priestley 2005, p. 26. According to *Kent's Original London Directory* for 1825, the firm had become Hastings & Bryant by this date. Directories not infrequently printed information that was out of date by the time of printing.

2 Houghton and Priestley 2005, p. 26.

3 Ibid., p. 23.

4 See Houghton and Priestley 2005, p. 42.

5 Ibid., pp. 34–5.

6 Ibid., p. 33.

64

1 For Morgan, see no. 4, note 1.

2 For information on all these phases see Tyler, Betts and Stephenson 2008, pp. 105–10.

3 See note 1.

4 Information from J. Lawrence, *A Practical Treatise on Breeding, Rearing, and Fattening, All Kinds of Domestic Poultry, Pheasants, Pigeons, and Rabbits: Also the Management of Swine, Milch Cows, and Bees, and Instructions for the Private Brewery*, London 1830, p. 265. I am grateful to Jonathan Williams for this reference.

5 Matthews 1971, pl. 17; the artefacts from this collection are now part of the Wellcome Museum of the History of Medicine at the Science Museum, London.

65

1 See E. Wenham, 'Silver-mounted porcelain', *Connoisseur*, vol. 97, no. 416, April 1936, pp. 189–94 and E. Wenham, 'Silver-mounted pottery', *Connoisseur*, vol. 97, no. 417, May 1936, pp. 251–56.

2 Garner 1948, the first comprehensive book on English delft, judges this class of pottery to have been the earliest English delftware. In 1992 H. Tait, in 'The earliest dated English delftware', *Everyday and exotic pottery from Europe, studies in honour of John G. Hurst*, eds D. Gaimster and M. Redknap, Oxford, 1992, p. 368, refers to 'Malling' jugs, but states that the question of their origin remains unresolved; Archer 1997 no longer believes that the Museum jug was made in England.

3 Hughes and Gaimster 1999, pp. 61–2.

4 From left to right: Reg. no. AF 3136, mount unmarked; 1887,0307.E36, mount undated; AF 3135, mount undated; AF 3137, mount dated 1549–50, A.W. Franks 1897. All these jugs were presented by Sir Augustus Wollaston Franks in 1887 and have been much referred to in ceramic literature.

66

1 Inv. C.55-1931, Poole 1995, p. 18.

2 Sold Sotheby's, 20 January 2006, lot 5.

3 Britton 1987, no. 30.

4 Grigsby 2000, D218.

5 Sold Christie's, 29 May 1990, lot 13.

6 Grigsby 2000, D219.

7 See Britton 1987, p. 35.

8 Old attribution in manuscript Slip Catalogue, kept in the Department of Prehistory and Europe, British Museum, scored out by Hugh Tait and altered to 'Southwark'.

67

1 I am grateful to Jonathan Horne for bringing to my attention the slipware fuddling cups, see Grigsby 2000, S77 and S78 and D. Barker and S. Crompton, *Slipware in the collection of the Potteries Museum & Art Gallery*, London, 2007, pp. 57–9.

2 M. White, 'A Bovey Tracey fuddling cup', *ECC Trans.*, vol. 19, part 3, 2007, pp. 501–07.

68

1 Archer 1997, p. 261 discusses the posset pot, posset and syllabub.

2 Fitzwilliam Museum, Inv. C.-1294 & A-1928; Archer 1973, no. 11; Grigsby 2000, D218.

3 See D. Carritt, *Some Masterpieces from Manchester City Art Gallery*, 1983. Inv. 1977.60.

69

1 Archer 1997, nos C.2, 3, 4.

2 Notes kept in the Department of Prehistory and Europe, British Museum.

70

1 Lipski and Archer 1984, no. 1249; in Birmingham Museum and Art Gallery, inv. 58'41.

2 Lipski and Archer 1984, p. 308.

3 Reg. no.1887,0210.115, height 12.7 cm, purchased from Henry Willett, 1887.

4 Grigsby 2000, D221. This bottle measures 18.4 cm in height.

5 Ibid.

6 D. Gaimster, *German Stoneware 1200–1900, archaeology and cultural history*, London, 1997, p. 79.

7 Ibid., pp. 92–4 and p. 212, no. 49.

71

1 For a wine bottle with later mount, see no. 4.

72

1 Austin 1994, p. 284, no. 715.

2 Lipski and Archer 1984, no. 1509.

3 *Frankfurter Fayencen aus der Zeit des Barock* at the Museum für Kunsthandwerk, Frankfurt-am-Main, December 1988–February 1989.

4 According to Dr Jan Daniël van Dam of the Rijksmuseum, Amsterdam.

73

1 Note in the manuscript Slip Catalogue, kept in the Department of Prehistory and Europe, British Museum. Mr Porter's letter to this effect does not survive on file.

74

1 The flask was either unsold and went to the vendor's daughters or was purchased by them. The first twenty-one lots of this sale were delft wine bottles.

2 In the manuscript Slip Catalogue, kept in the Department of Prehistory and Europe, British Museum.

75

1 For five dated examples (including the British Museum goblet), two decorated with arms of City Livery Companies and one fragmentary, see Lipski and Archer 1984, nos 869–74.

2 Austin 1994, no. 82.

3 For a discussion of these excavations carried out between 1987 and 1992, see Tyler, Betts and Stephenson 2008, pp. 26–59.

4 I am grateful to Jonathan Horne for this information.

76

1 Grigsby 2007, D87.

2 Burman 1992, p. 104.

3 It measures 11.3 cm, illus. Burman, p. 107, fig. 7.

4 Inv. C. 1308-1928. I am grateful to Julia Poole for bringing this plate to my attention.

5 In Manchester Art Gallery, inv. 1975.28, illus. Lipski and Archer 1984, no. 891, credited as in private possession (possibly another posset pot).

6 Bonhams, 10 December 2008, lot 14, now in the Milwaukee Art Gallery, Wisconsin, USA. 'The Clarkes' dish is illustrated in this catalogue, where the Museum caudle cup inscribed 'Bee Merry and Wise 1660' (see no. 47) is also referred to.

7 DA328591, Willett cat. 557. I am grateful to Stella Beddoe for assistance in examining this piece.

8 Pers. comm. 1994, kept on file in the Department of Prehistory and Europe, British Museum.

77

1 This aspect of inscriptions on delftware is briefly discussed by S. Richards, *Eighteenth-century ceramics, products for a civilised society*, Manchester, 1999, pp. 107–8.

2 Austin 1994, p. 104, no. 88.

3 Ibid., and see Noël Hume 1977, p. 31, pl. 18.

4 Britton 1987, p. 121, no. 67; reg. no. A26223, height 6.7 cm.

5 Reg. no. 1907,1014.1.

78

1 Dated 1631, see Lipski and Archer 1984, no. 886 in the Fitzwilliam Museum, Cambridge, inv. C. 1294&A-1928.

79

1 Lipski and Archer 1984, no. 899.

2 It fits rather loosely and the painted decoration is somewhat different to that around the rim of the pot. However, Michael Archer stated in November 2007 that it might well be contemporary with the pot.

80

1 In the old manuscript Slip Catalogue, kept in the Department of Prehistory and Europe, British Museum, it is described as 'Probably ? Rouen'; a more recent hand has annotated this in pencil 'English, Lambeth', probably in the 1980s when checks were being carried out on the collection.

2 Lipski and Archer 1984, no. 906.

81

1 Grigsby 2000, D275.

82

1 I am grateful to Jessica Harrison-Hall for her observations on the form and decoration of this piece.

84

1 But see examples of 1687 and 1697, illustrated in Lipski and Archer 1984, nos 917, 918.
2 Grigsby 2000, no. D289.

85

1 Grigsby 2000, p. 332 cites a letter of 1632 in the *Oxford English Dictionary*, which refers to punch.
2 Grigsby 2000, D306.
3 I owe this suggestion to Dr Jan Daniël van Dam, who examined the bowl in June 2008, and viewed the dish (no. 39) in the Museum gallery.
4 Lipski and Archer 1984, no. 214: 'The English origin of this dish is not absolutely certain', and ibid., p. 8. Archer states that he does not believe this punch bowl to be English. In the old manuscript Slip Catalogue, kept in the Department of Prehistory and Europe, British Museum, the dish is described as Dutch.
5 Grigsby 2000, D90.

86

1 R.L. Hobson (1872–1941), an acknowledged authority on English pottery and porcelain, as well as on Chinese ceramics, was in charge of the Department of Ceramics and Ethnography at the British Museum from 1921 to 1938.
2 Margaret Macfarlane has kindly referred the writer to J. Hayward, *Huguenot Silver in England 1688–1727*, London, 1959, pl. 16B, a slightly taller silver example, which is dated 1693, and to an example with flared sides dating from 1701 in R. Wark, *British Silver in the Huntington Collection*, San Marino, 1978, p. 25, fig. 56.
3 Archer 1997, H.2 and pl. 216.
4 Ibid., H.4 and pl. 217.
5 G. Elliott, *John and David Elers and their contemporaries*, London, 1998, p. 35, fig. 11C.
6 Grigsby 2000, vol. 1, S60, inscribed RC 1711; an earlier example dated 1704 in the DeWitt Wallace Decorative Arts Museum, Colonial Williamsburg is rather more full-bellied than the usual capuchine shape, see Grigsby 1993, p. 57, fig. 71.
7 A slipcast red stoneware example decorated with sprigs dating from the end of the seventeenth century and probably made by the Elers brothers in Staffordshire, is illustrated in Elliott 1998, op. cit., p. 34, fig. 10; two brown stoneware examples attributed to Staffordshire around 1700 are illustrated in Elliott 1998, p. 35, fig. 11B. Capucine wasters found on the site of John Dwight's stoneware pottery at Fulham, London, are shown in fig. 11A. A brown stoneware example belonging to the Potteries Museum and found locally is shown in J. Horne, *A Catalogue of English Brown Stoneware from the 17th and 18th Centuries*, London, 1995, p. 33, no. 69; an example in the V&A, which was dug up in 1912 in London Wall, is illustrated in R. Hildyard, *Browne Mugs, English Brown Stoneware*, exhibition at the V&A, Sept.–Nov. 1985, no. 346.
8 Hildyard 1985, no. 348, given to the Museum of Practical Geology by Sir A.W. Franks.
9 A. Oswald, R.J.C. Hildyard and R.G. Hughes, *English Brown Stoneware 1670–1900*, London, 1982, fig. 57, kept at the Bodleian Library, Oxford.
10 Oswald, Hildyard and Hughes 1982, fig. 66.

11 Lipski and Archer 1984, nos 505, 505A. I am grateful to Margaret Macfarlane for suggesting the date of this cup.
12 With Venners, London; information kindly supplied by Margaret Macfarlane.
13 I am grateful to Margaret Macfarlane, who has seen this fragment, for bringing it and these references to my attention.
14 F.H. Garner, 'Liverpool Delftware', *ECC Trans.*, vol. 5, part 2, 1961, p. 72 and pl. 71.
15 Published by Nancy Valpy, 'Extracts from 18th Century London Newspapers', *ECC Trans.*, vol. 12, part 2, 1985, pp. 161–2.

88

1 Lipski and Archer 1984, no. 1069, from the Louis Gautier Collection.
2 Ibid., no. 1082, Lord Revelstoke Collection. This bowl was on the London market in 2003, see Gary Atkins, 'An Exhibition of English Pottery, March 11th to 22nd 2003', no. 16.
3 Lipski and Archer 1984, no. 1085.
4 Ibid., pp. 243–53.
5 For a brief discussion of the social dimension of delftwares, see S. Richards, *Eighteenth-century ceramics, products for a civilised society*, Manchester and New York, 1999, pp. 107–8.
6 Inv. V&A C.309-1923, see Archer 1997, F 10.

89

1 I am grateful to Margaret Macfarlane for this suggestion and for the reference to the exhibition catalogue compiled by J. Starobinski, *Largesse*, Paris, Musée du Louvre, 20 January–18 April 1994, illus. p. 32.
2 Horne X, no. 254, length 40.6 cm.
3 Lipski and Archer 1984, no. 1556, sold at Christie's, 2 June 1975, lot 282.

90

1 Another example is in the Manchester Art Gallery, see Parkinson 1969, no. 84, inv. 1923.318.

91

1 For the most recent study of Delamain's factory see Francis 2000, pp. 46–56.
2 Letter on file in the Department of Prehistory and Europe, British Museum.
3 He presumably learned about delftware on the Continent.
4 The pottery was established around 1735 by John Chambers and continued under Crisp & Co from *c.* 1746–8 before being taken over by David Davis.
5 *Irish House of Commons Journals, App.*, p. LIII, reference given by Longfield 1971, p. 41, fn 6.
6 Published in full in Francis 2000, p. 174.
7 Longfield 1971, p. 43.
8 Britton 1987, p. 61. For a plate inscribed on the back 'Iohn Saunders 1754', see no. 113.
9 By Kieron Tyler in Tyler, Betts and Stephenson 2008, pp.106–7.
10 Francis 2000, p. 52.

92

1 Lipski and Archer 1984, no. 1142.
2 Ibid., no. 1143.
3 Ibid., no. 1144.
4 Christie's, 9 April 1984, lot 88. I am grateful to Gary Atkins for this information.

5 Illustrated Gloria Seaman Allen, 'Living with antiques, The Dolz collection of tin-glazed earthenware', *Antiques*, April 1986, pp. 854–63, figs 3, 3a.
6 Pers. comm. November 2007, letter kept on file in the Department of Prehistory and Europe, British Museum.
7 See D. Vaisey (ed.), *The Diary of Thomas Turner 1754–1765*, Oxford, 1984, see in particular Appendix C, a list of Turner's suppliers. I am grateful to Margaret Macfarlane for this reference.

93

1 I am grateful to John Graves of the National Maritime Museum for his comments on the ship.
2 Archer 1997, F.27.
3 Britton 1982, pp. 255–6.

94

1 I am grateful to John Graves of the National Maritime Museum for this information.
2 Inv. 50.60.22, inscribed 'Success to the John & Mary/John Spencer'. I owe this information to the kindness of Robin Emmerson.
3 There is a good collection in the Merseyside Maritime Museum as many were made in Liverpool.
4 I am grateful to Jill Cook for this information.
5 There is an example dated 1762 and inscribed 'Success to Trade and Navigation' in the Museum collection, reg. no. 1996,0105.1. An enamelled ship bowl, made in Liverpool around 1778–90, was acquired in 1986 by the Curtis Museum and Allen Gallery, Hampshire through the Art Fund.
6 Inv. C.1723-1928. I am grateful to Julia Poole for bringing this piece to my attention.

95

1 For a discussion of the process of discovery of the nature of this ceramic body, see Archer 2000, p. 251. As Archer points out, two dated pieces are known: a teapot inscribed 'Mary Acton 1756', illus. in the catalogue of the dealer J. Horne, *A Collection of English Pottery*, part VII, 1987, no. 171, and a mug inscribed 'I.A 1764' in the City of Bristol Art Gallery, illus. Britton 1982, 6.11.
2 By Jonathan Horne in conversation with the writer, December 2008.
3 A suggestion put forward by Jonathan Horne in his discussion of a tin-glazed stoneware coffee-pot, shown in J. Horne, *A Collection of Early English Pottery*, part IV, 1984, no. 85.
4 A. Smith, 'An enamelled tin-glazed mug at Temple Newsam House', *Leeds Arts Calendar*, no. 82, 1978, pp. 14–19.
5 Ray 2000, p. 66, Garner 1961, p. 72 and Knowles Boney 1957, pl. 24.
6 Illustrated R. Hildyard, *English Pottery 1620–1840*, London, 2005, p. 119, fig. 59 and Archer 1997, H 19.
7 See *Made in Liverpool, Liverpool Pottery and Porcelain 1700–1850*, exhibition of the Northern Ceramic Society, Walker Art Gallery, Liverpool, June–September 1993, cat. 44.
8 Inv. 1965.22.2a&b.
9 Inv. 1965.23.2.
10 Inv. 1965.22.1, cover lacking.
11 Inv. 421.47.
12 Op. cit. in note 7, cat. 45–8.
13 Inv. C.110&A-1951.
14 R.E.Taggart, *The Frank P. and Harriet C. Burnap Collection of English Pottery in the William Rockhill Nelson Gallery*, Kansas

City, 1967, cat. 135.

15 Sotheby's, 21 July 1981, lot 14, from the Frank Arnold collection. I owe this and the preceding reference to the kindness of Margaret Macfarlane.

16 Ray 2000, p. 66.

17 Smith, op. cit., p. 15.

96

1 See G. Elliot, *John and David Elders and their Contemporaries*, London, 1998, fig. 3B.

2 Sotheby's, London, European Ceramics, Glass, Silver and Vertu, 6 July 2005, lot 121.

3 See, for instance, two canisters in the Warren Collection at the Ashmolean Museum, Oxford, illustrated in Ray 2000, no. 42, painted on one side with a lady gathering her skirts as on the British Museum canister. An example similar to the Oxford canister, with a gentleman holding his hat on one side and on the other a lady holding up her skirt, is in the Fitzwilliam Museum, Cambridge, inv. C.21-1996.

97

1 See Church 1884, p. 37, where 'a curious perforated bin label of delft ware much like that of Lambeth' is mentioned; it was inscribed 'SACK' in blue and was said to come from the collection of Horace Walpole, 'with his [i.e. Diamond's] SACK jug of 1647'.

2 Quoted Archer 1997, p. 405.

3 An extensive bibliography of cider and cider production compiled by Michael B. Quinion for the Hereford Cider Museum Trust, 1984, can be found on the website of the Cider Museum, Hereford.

4 See Austin 1994, nos 112–16.

5 Bonham's, 2 October 2003, *The Contents of Harveys Wine Museum, The Art, Craft and Science of Wine*, part 2, lot 597 etc.

6 Garry Atkins, 'An Exhibition of English Pottery', 1–12 March 2005, exh. cat., no. 31.

7 Inv. HMCMS DA 1992.105 and HMCMS ACM 1948.155. I am grateful to Neil Hyman for allowing me to examine these wine labels.

8 Inv. M 2458 (Joseph Mayer Collection).

9 Archer 1997, pp. 570–1, Appendix D.

98

1 Quoted Lipski and Archer 1984, p. 434.

2 Compare with a plate dated 1734 and another dated 1736, illustrated in Garner and Archer 1972, pls 56B and 57A.

99

1 See, for example, 1852,1129.7, Thornton and Wilson, 2009, cat. 100. I am grateful to Dr Dora Thornton for her comments on the delftware dish.

2 In the manuscript Slip Catalogue kept in the Department of Prehistory and Europe, British Museum, where it is described as 'maiolica'. The mark is compared with one in C.D.E. Fortnum, *Maiolica, a historical treatise on the glazed enamelled earthenwares of Italy, with marks and monograms, also some notice of the Persian, Damascus, Rhodian and Hispano-Moresque Wares*, Oxford, 1896, p. 138, no. 469, said to be the mark of Rossetti's factory in Turin, active a century later. The delft dish was not published in Hobson's 1903 *Catalogue of English Pottery in the British Museum*.

3 Dr Jan Daniël van Dam of the Rijksmuseum, Amsterdam, examined the dish in June 2008.

4 By Dr Jan Daniël van Dam, and Mme Antoinette Hallé of the Musée National de Céramique, Sèvres, the latter on the basis of images only. Jonathan Horne, who examined the dish in May 2008, was also inclined to believe that it was made to deceive. Michael Archer in Lipski and Archer 1984, p. 9 stated that he did not believe that the dish was English.

100

1 Dr Jan Daniël van Dam of the Rijksmuseum in response to an e-mail in 2006 did not believe the dish could be Dutch. He subsequently examined the dish in June 2008 to confirm this opinion.

2 Grigsby 2000, D87.

3 Archer 1997, A.56 and pl. 35.

4 Grigsby 2000, D7 and Grigsby 2000, D65.

5 Neither object examined by the writer; illus. Caiger-Smith 1973, col. pl. T and pl. 141

6 Grigsby 2000, D87.

101

1 Sir John Charles Robinson (1824–1913) was employed at the South Kensington Museum (now the V&A) from 1857 until 1863 in one of its most dynamic periods. See H. Davies, 'John Charles Robinson's work done at the South Kensington Museum, Part I', *Journal of the History of Collections*, vol. 10, no. 2, 1998, pp. 169–88 and Part II, vol. 11, no. 1, 1999, pp. 95–115.

2 *Catalogue of the Special Exhibition of Works of Art of the Medieval, Renaissance, and more recent periods, on loan at the South Kensington Museum, June 1862*, London, 1863, Section 8, Bernard Palissy Ware, by J.C. Robinson, nos 1,231 and 1,232. 'A pair of quandrangular pedestal or altar-shaped salt-cellars, enamelled with varied colours. Each of their sides is ornamented with an architectural panel or framework, crowned by a triangular moulded pediment; within it, a figure of Neptune, &c. In the interior of these pieces are seen the initials B.C. This pair of salt-cellars is probably unique, *i.e.* none others of the same pattern are known. Height, 6in.'

3 Gardiner Museum, Toronto, inv. G83.1.0535, sold Sotheby's, 13 February 1979, lot 14. An image of this salt can be found on the Gardiner Museum website.

4 I owe this suggestion that the prototype for this salt was a bronze salt to Jonathan Horne.

102

1 There is a damaged example in the collection, reg. no. 1887,0307.E 6.

2 See Garner and Archer, 1972, pl. 29b. This example was then in the Mrs Coleman Curtis Collection, Virginia, and is now in the Longridge Collection, USA, illus. Grigsby 2000, D209; Grigsby also refers to another in the Winterthur Museum, illus. L.C. Belden, *The Festive Tradition, table decoration and desserts in America, 1650–1900*, New York and London, 1983, p. 45, fig. 2:4.

3 Inv. C.1377-1928.

4 Grigsby 2000, D209.

5 According to Austin 1994, p. 189, no reference supplied.

103

1 For Morgan see no. 4, note 1.

2 This type of pottery is known in Persia from as early as the fourteenth century, see Archer and Morgan 1977, p. 41.

3 Archer and Morgan 1997, cat. 19, pl. II.

4 City of Bristol Art Gallery, N.3061, see Britton 1982, 8.51.

5 Victoria and Albert Museum, see Archer 1997, p. 247, C.11.

6 Victoria and Albert Museum, inv. C. 253-1991, see Archer 1997, p. 281, no. F.1.

7 For an example see Archer and Morgan 1977, p. 41, no. 20.

8 Height 21 cm, inv. MoL 23079, excavated in the City of London, see Britton 1986, p. 136, no. 100. This collection also includes a vase measuring 16 cm, inv. MoL 22315, found in Sumner Street, Blackfriars, see Britton 1986, p. 135, no. 99.

9 Diameter 22.2 cm, Grigsby 2000, p. 2000, D177.

10 Inv. C.135, illustrated in Archer 1973, no. 54 and Glaisher Collection, Fitzwilliam Museum, Cambridge, inv. C.1388-1928, acquired at Christie's, 9 January 1903.

11 According to Archer and Morgan 1977, p. 41, there seems some uncertainty as to whether shards of blue-ground delft have been found at Brislington or Bristol.

104

1 Archer 1997, F.2.

106

1 Archer and Morgan 1977, no. 21, mentions an example with a different design in the Glaisher Collection at the Fitzwilliam Museum, Cambridge, which is dated 1676.

2 See Austin 1994, nos 165–8.

3 Tulip dishes are discussed in Ray 2000, no. 6. For a study of tulipomania, see A. Pavord, *The tulip: the story of the flower that has made men mad*, London, 1999.

107

1 Inv. C.1509-1928; the cover is probably a replacement.

2 I owe this observation to Stephen McManus.

3 See Lipski and Archer 1984, nos 939 (inv. C.1652-1928), 942. I owe this observation to Julia Poole.

4 Horne XIII, no. 358, described as having 'a series of small circles and dots' on the reverse. Horne signals another from the same set as Lipski and Archer 1984, no. 252. The plate is now in the Longridge Collection, see Grigsby 2000, D70.

108

1 This suggestion was made by the late Group Captain Frank Britton in 1994, note kept on file in the Department of Prehistory and Europe, British Museum.

2 Lipski and Archer 1984, no. 261.

3 See note 1.

109

1 For Morgan see no. 4, note 1.

2 For another plate in the collection numbered '2' and inscribed 'Let him Doo what he Cann / 1734', see 1887,0307.E54; repaired.

3 Grigsby 2000, D79; these plates bear the initials 'I/IK' on the border above the rhyme.

4 For four Dutch plates dated 1683, painted with rhymes, perhaps made for a country or village inn, and possibly specially ordered, see J.D. van Dam, *Dated Dutch Delftware*, Amsterdam, 1991, no. 17.

5 Reg. nos 1887,0307.E52 and E53. These were catalogued as English by R.L. Hobson in 1903.

6 For a brief discussion of the social dimension of delftware, see S. Richards, *Eighteenth-century ceramics, products for a civilised society*, Manchester, 1999, pp. 107–8.

110

1 Francis 2000, p. 42.

2 Archer 1997, B.128.

3 Ibid.

4 Lipski and Archer 1984, no. 521A-E.

III

1 Lipski and Archer 1984, no. 524, formerly in the Louis Gautier and F.H. Garner collections.
2 Austin 1994, no. 267.
3 Ibid., no. 268. There are several other variations on this theme in the collection, which have scratched border motifs and central scenes of oriental trees and flowers etc, see nos 272–4.
4 Ibid., p. 163, ref. 2HA.0364.

112

1 See Britton 1982, nos 12.42–12.44 and Austin 1994, nos 308–9.
2 A sale of the property of William Edkins of Queen Square, Bristol, was held by Sotheby, Wilkinson & Hodge on 21 April 1874 and two following days, in which no. 112 (1) was lot 163.
3 For a biography of Michael Edkins, who died in 1811, see Jackson, Jackson and Price, 1982, pp. 102–3.
4 For Thomas Greg, FSA, see M. Parkinson, 'The Thomas Greg Collection of English Pottery', *ECC Trans.*, vol. 8, part 1,1971, pp. 42–56. His collection of pottery is found in the Manchester Art Gallery.
5 Archer 1997, B.67, inv. C.817.1935.
6 Britton 1982, p. 249, no. 15.46.
7 Various coloured grounds were introduced at this pottery, see Jonathan Horne, *English Pottery and related works of art*, exh. cat., London, 2002, pp. 10–11.
8 See note 4.
9 I am grateful to the owner for kindly providing this information.
10 For a dish and a bottle see Austin 1994, nos 282, 598.
11 Archer 1997, B.61, inv. C.77-1965.
12 Ibid., B.60, inv. C.3-1960.
13 Austin 1994, pl. 21, no. 276.
14 Ibid., no. 271.
15 Archer 1997, B.69, inv. Circ.1245-1926.
16 Austin 1994, no. 272.

113

1 I am grateful to Jessica Harrison-Hall of the Department of Asia, British Museum, for her comments on the decoration.
2 Britton 1987, pp. 61–2.
3 Lipski and Archer 1984, no. 581.

114

1 For Morgan see no. 4, note 1.
2 Westropp, 1913, pl. I. This may be the one shown by Francis 2000, pl. 18.
3 Inv. 1976.115, diameter 16.2 cm. I am grateful to Alison Copeland for her help when I examined this bowl.
4 See Francis 2000, figs 128, 129, for example.

115

1 Francis 2000, pl. 24.

116

1 I am grateful to Jessica Harrison-Hall for her assistance.
2 Archer 1997, B.253.
3 Owen 1873, p. 329.

117

1 Archer 1997, no. B.86.
2 Biographical information taken from notes made by the late Group Captain Frank Britton, kept on file in the Department of Prehistory and Europe, British Museum.

3 Lipski and Archer 1984, nos 600, 609.
4 Britton 1982, p. 263, no. 16.25.
5 Lipski and Archer 1984, p.135.
6 For this technique, see no. 93.

118

1 See H.J. Cadbury, 'An account of Barbados 200 years ago', in *Journal of the Barbados Museum and Historical Society*, vol. 9, 1941–2, p. 82 and American Jewish Archives, Cincinnati, USA, Caribbean Jewry Commercial Documents, 1708–90.
2 Ibid.
3 In private possession, unpublished. This plate was discovered recently on the market in a Bristol saleroom.
4 Information kindly communicated by Jennifer Marin of the Jewish Museum, London.
5 E. Faber, *Jews, slaves and the slave trade: setting the record straight*, New York and London, 1998, p. 92.
6 Margaret McGregor, archivist, Bristol Record Office, traced an Anke Jacobs who was christened in Holland in 1760, who may have been Jewish.
7 Lipski and Archer 1984, no. 607, whereabouts unknown.
8 I am grateful to my colleague Beverley Nenk for bringing to my attention the significance of the inscriptions on these plates.
9 See J. Pearce, 'A rare delftware Hebrew plate and associated assemblage from an excavation in Mitre Street, City of London', *Post-Medieval Archaeology*, vol. 32, 1998, pp. 95–112.
10 Information taken from J. Samuel, *Jews in Bristol, the history of the Jewish community from the Middle Ages to the present day*, Bristol, 1997. I am grateful to Stephen McManus for his work on this group of plates and their possible Jewish connection.
11 Archer 1997, pp. 231–2.
12 Archer 1997, nos B 206–8.
13 Britton 1982, p. 206, no. 12.85, inv. G.1991, diameter 25.6 cm, purchased in 1923 from T. Charbonnier.

119

1 See Britton 1982, p. 279, nos 18.3, 18.4.
2 Archer 1997, B232.

120

1 For a discussion of this transmission of techniques, see R.J. Charleston, 'Bristol and Sweden, some delftware connexions', *ECC Trans.*, vol. 5, part 4, 1963, pp. 222–34.
2 Ibid., p. 232.
3 Britton 1982, p. 263, no. 16.23, inv. G. 756.

121

1 For a saucer in the British Museum Collection, printed in red with a similar pattern and the addition of a black servant, see A. Dawson, *The Art of Worcester Porcelain*, London, 2007, no. 63.
2 Garry Atkins, 'An Exhibition of English Pottery', 12–23 March 2002, no. 21, now in a private collection.
3 Francis 2000, p. 127, fig. 157.
4 See for instance Ray 1994, p. 26, nos B4-14, 15, p. 33, no. C2-6.

122

1 Horne, 1989, p, 128, fig. 698; Ray 1994, p. 29, fig. B6-22.
2 Drakard 1992, p. 128, fig. 351.
3 Illustrated Garner and Archer 1972, pl. 115B.
4 Inv. Willett 286. I am grateful to Stella Beddoe for assistance in examining this plate.

5 Inv. Willett 287.
6 For a list of the six printed subjects known on delftware see Archer 1997, p. 307.
7 There was a mug printed with this subject in the collection of Norman Stretton, sold Phillips, 21 February 2001, lot 161. The print is signed 'Sadler Liverpool', and see C. Williams-Wood, *English Transfer-Printed Pottery and Porcelain, a history of over-glaze printing*, London, 1981, pl. 148. An example signed 'Sadler' and 'Liverp' is in the National Museums Liverpool, inv. 12.3.26.2.
8 Plate sold from the Lipski Collection, Sotheby's, 1 March 1983, lot 571.
9 Plate in the National Museums Liverpool, inv. 12.3.26.3, see Williams-Wood, op.cit., pl. 149.
10 See Archer 1997, p. 307.
11 Ray 1994, p. 18, A2-2.

124

1 Ray 1968, p. 162, citing W.J. Pountney, *Old Bristol Potteries*, Bristol and London, 1920, pl. XLIV.
2 This has been explored by E. Adams, 'James Tidmarsh of Cobridge: discovering the history of an unknown potter', *Northern Ceramic Society Journal*, vol. 2, 1975–6, pp. 31–7.

125

1 The other is reg. no. 1970,10-3,1.
2 Grigsby 2000, D386.
3 Ibid., D179, inscribed 'Bowcock' on manganese on the reverse.
4 Inv. C.1359-1928. I am grateful to Julia Poole for drawing this piece to my attention.
5 I am grateful to Michael Archer for bringing this piece to my attention, to Colette Warbrick, registrar, Waddesdon Manor, for images of the board, and to John Mallet for comments on its origin and for the reference to G. Himmelheber, *Spiele, Gesellschaftsspiele aus einem Jahrtausend*, Munich, 1972, pp.137–8, cat. 336, which describes another similar board in the Bayerisches Nationalmuseum, Munich.
6 Gary Atkins, *An Exhibition of English Pottery*, March 11th to 22nd, 2003, no. 8.

126

1 G. Wills, 'English Pottery in 1696: an unpublished document', *Apollo*, June 1967, vol. LXXXV, no. 64, p. 436, fig. 1, in Colonial Williamsburg, Virginia, height 19.7 cm and illus. Austin 1994, no. 719.
2 P.C.D. Brears, *The English Country Pottery, its history and techniques*, Newton Abbot, 1971, pp. 67–8.
3 I owe this information to Julia Poole, who informed me that Glaisher put his own name and the date 'September 27 1910' on two Donyatt examples. She also reminded me of nineteenth-century lead-glazed earthenware money boxes from Lancashire and Sussex in the Glaisher Collection, Fitzwilliam Museum, Cambridge.
4 Illustrated Garner 1961, pl. 64 and see p. 71. The mug was destroyed in the Second World War.
5 Garner 1961, p. 70.

127

1 Austin 1994, no. 599.
2 Lipski and Archer 1984, nos 1564 and 1565.
3 For an undecorated vase with three nozzles and spouts and a straight neck and flared rim, see Archer and Morgan 1977, no. 12 and for a painted example of similar form see Austin 1994, no. 599.

4 Reg. no. 1856,0701.1586, probably the one mentioned by Noël Hume 1977, p. 70, fn 17.
5 For Roach Smith see D. Kidd, 'CRS and his Museum of London antiquities' in *Collectors and Collections, British Museum Yearbook 2*, London, 1977, pp. 105–35. There are over 4,000 items in the collection, around half of which are recorded as coming from London.
6 Noël Hume 1977, p. 67, figs, 17, 18, and p. 70.
7 Grigsby 2000, p. 410.

128
1 Britton 1982, no. 15.59.

129
1 Britton 1982, p. 280, nos 18.6, 18.7.
2 Ibid., p. 283, no. 18.18.
3 Archer 1997, p. 222.

132
1 Rackham 1935, nos. 1578, 1579; Britton 1982, p. 283, no. 18. 19 and p. 285, no. 18.26.

133
1 Lipski and Archer 1984, no. 1568.
2 Grigsby 2000, D377.
3 E.M. Brown and T.A. Lockett, *Made in Liverpool, Liverpool Pottery and Porcelain 1700–1850*, exh. cat. Walker Art Gallery, National Museums and Galleries on Merseyside and the Northern Ceramic Society, 1993, no. 8.
4 Inv. HMCMS DA 1979 75/53. I am grateful to Neil Hyman for allowing me to examine this piece.
5 Archer 1997, I.24 and I.25.
6 Inv. C.1726-1928.
7 Bonhams, Fine British Pottery, Porcelain and Enamels, 23 April 2008, lot 1.
8 Reg. no. 1923.0122.44, illus. A. Dawson, *Masterpieces of Wedgwood in the British Museum*, London, 1984, pl.1.
9 Reg. no. 1923.0122.95.

134
1 Grigsby 2000, p. 390 and see nos D353-6.
2 Inv. C.1326-1928; Inv. C.2041-1928, made in the Westerwald, Rhineland.

135
1 Notes dated 1994 made by the late Group Captain Frank Britton, kept in the Department of Prehistory and Europe, British Museum.

136
1 Thomas and Wilson 1980, p.4.
2 Lent by the Visitors of the Ashmolean Museum, Oxford, illus. Ray 2000, no. 29.
3 Inv. 3144-1901, illus. Dolan 1996, fig. 1 and discussed by Archer 1997, N 7.
4 City of Bristol Museum and Art Gallery, G 1690; cat. no. G36.
5 Ray 2000, no. 39.

137
1 Britton 1982, 15.2.
2 Archer 1997, B 71.

138
1 Note in the manuscript Slip Catalogue kept in the Department of Prehistory and Europe, British Museum.

2 For an example see Archer 1997, B.11.

139
1 See D. Gaimster, *German Stoneware 1200–1900, archaeology and cultural history*, London, 1997, p. 324, fig. 180, inv. Circ.951-1924.
2 Britton 1987, no. 175.
3 Archer 1997, p. 390.
4 Britton 1982, p. 92, no. 6.22.
5 See note 3.

140
1 See J.E. Pritchard, 'The Pithay, Bristol', *Transactions of the Bristol and Gloucestershire Archaeological Society*, vol. XLVIII, 1926, p. 262, p. VI.
2 Op. cit., vol. XXIII, p. 267 and vol. XXVII, p. 333.
3 Note kept on file in the Department of Prehistory and Europe, British Museum.
4 Jackson and Jackson 1982, p. 45.
5 Michael Archer, when examining the fragment in 2007, commented on its light weight and believed that might be an indication that it was Dutch rather than English.
6 Illus. Garner and Archer 1972, pl. 13B.

141
1 Ian M. Betts, 'Early tin-glazed floor tile production in London', in David Gaimster (ed.), *Maiolica in the North, the archaeology of tin-glazed earthenware in north-west Europe c. 1500–1600*, British Museum Occasional Paper, no. 122, 1999, pp. 173–4, col. pls 8, 9.
2 Tyler, Betts and Stephenson 2008, p. 114.

142
1 Reg. no.1839,1029.107.
2 See E. Eames, *Catalogue of Medieval Lead-Glazed Tiles in the Department of Medieval and Later Antiquities in the British Museum*, London, 1980, 2 vols.
3 Archer 1997, no. N.9.
4 Illustrated Tyler, Betts and Stephenson 2008, p. 56, fig. 76, D14/1; see 14/2 for an animal subject.

143
1 Guy Jones 2004, p. 525, fig. 1.
2 Department of Prints and Drawings, British Museum, reg. no. 1914-2-28-2965 (PD 161.615). I am grateful to Antony Griffiths for his assistance in supplying information about the print.
3 See J. Horne, *English Tin-Glazed Tiles*, London, 1989, p. 126 and A. Ray, *Liverpool Printed Tiles*, London 1994, pp. 17–18.
4 Inv. HMCMS 1980.75/9.
5 See Horne 1989, p. 126, no. 682.

Bibliography

ECC Trans.:
Transactions of the English Ceramic Circle

G.S. Allen, 'Living with antiques, the Dolz collection of tin-glazed earthenwares', *Antiques*, April 1986, pp. 854–65

Anon 1961 [probably Hugh Tait], 'Documentary pottery: a post-medieval acquisition at the British Museum of a dated Dublin punch bowl', *Apollo*, vol. LXXIII, no. 431, January 1961, p. 12

M. Archer and P. Hickey, *Irish delftware*, an exhibition of eighteenth-century Irish delftware at Castletown House, Celbridge, Co. Kildare, 1971

M. Archer, *English Delftware*, exh. cat. Rijksmuseum, Amsterdam, March–July 1973

M. Archer and B. Morgan, *'Fair As China Dishes', English Delftware*, exh. cat. Washington, International Exhibitions Foundation, 1977

M. Archer, 'A Group of Liverpool delftwares', *ECC Trans.*, vol. 16, part 1, 1996, pp. 109–24

M. Archer, *Delftware, the tin-glazed earthenware of the British Isles, a catalogue of the Collection in the Victoria and Albert Museum*, London, 1997

J.C. Austin, *British delft at Williamsburg*, Williamsburg, Virginia, 1994

B. Bloice, 'Norfolk House, Lambeth, excavations at a delftware kiln site, 1968', *Post-Medieval Archaeology*, vol. V, 1971, pp. 99–159

F. Britton, *English Delftware in the Bristol Collection*, London 1982

F. Britton, *London Delftware*, London, 1987

F. Britton, 'The Pickleherring potteries: an inventory', *Post-Medieval Archaeology*, vol. 24, 1990, pp. 61–92

F. Britton, 'Bernard Palissy and London delftware', *ECC Trans.*, vol. 14, part 2, 1991, pp. 169–76

F. Britton, 'Delftware inventories', *ECC Trans.*, vol. 15, part 1, 1993, pp. 59–64

F. Britton, 'Musical Delftware', *ECC Trans.*, vol. 16, part 2, 1997, pp. 141–3

Burlington Fine Arts Club, Illustrated Catalogue of Early English Earthenware, London 1914

L. Burman, 'Motifs and Motivations: the decoration of some 17th century delftwares: Part 2: Images & Emblems', *ECC Trans.*, vol. 15, part 1, 1993, pp. 99–107

W. Burton, *A History and Description of English Earthenware and Stoneware*, London, 1904

W. Chaffers, 'The earliest porcelain manufacture in England and imitation of the Cologne Ware in the seventeenth century', *Art Journal*, June 1865, pp. 179–81

A.H. Church, *English Earthenware, a handbook to the wares made in England during the seventeenth and eighteenth centuries as illustrated by specimens in the national collections*, London, 1884

I. Davies, 'Seventeenth-century delftware potters in St Olave's parish, Southwark', *Surrey Archaeological Collections*, vol. LXVI, 1969, pp. 11–31

G.J. Dawson and B.J. Bloice, 'The origins of London delft: Christian Wilhelm the potter in Tooley Street, Southwark', *Southwark and Lambeth Archaeological Society Research Paper no. 1*, n.d.

[G.J. Dawson], 'Two delftware kilns at Montague Close, Southwark', *The London Archaeologist*, vol. 1, no. 10, 1971, pp. 228–31

G.J. Dawson and R. Edwards, 'The Montague Close delftware factory prior to 1969', *Research volume of the Surrey Archaeological Society*, no. 1, [1974], pp. 47–63

S.H. Dolan, 'Bristol on display: Bristol delftware with locally inspired designs', *Ars Ceramica*, no. 13, 1996, pp. 30–38

E.A. Downman, *Blue dash chargers and other early English tin enamel circular dishes*, London, 1919

E.A. Downman, 'Blue dash chargers and the origin of their designs', *Connoisseur*, vol. LXXXII, December 1928, pp. 220–5

R. Drey, *Apothecary Jars*, London, 1978

R. Edwards, 'London Potters circa 1570–1710', *Journal of Ceramic History*, no. 6, 1974

P. Francis, *Irish delftware, an illustrated history*, London, 2000

F. Freeth, 'Old English Election Pottery', *Connoisseur*, vol. XXVIII, no. CX, October 1910, pp. 100–5

F.H. Garner, 'Liverpool delftware', *ECC Trans.*, vol. 5, part 2, 1961, pp. 67–73

F.H. Garner and M. Archer, *English Delftware*, London, 1972 (2nd rev. ed.)

L.B. Grigsby, *The Longridge Collection of English slipware and delftware, volume 2, Delftware*, London, 2000

S. and G. Guy-Jones, 'Further sources of designs on 18th century on-glaze transfer-printed tiles, *ECC Trans.*, vol.18, part 3, 2004, pp. 525–35

E. Hannover, *Pottery and Porcelain, a handbook for collectors, I: Europe and the Near East, earthenware and stoneware*, London, 1925

D. Haselgrove and J. Murray (eds), 'John Dwight's Fulham Pottery 1672–1978, a collection of documentary sources', *Journal of Ceramic History*, no. 11, 1979

R.L. Hobson, *Catalogue of English Pottery in the British Museum*, London, 1903

J.E. and E. Hodgkin, *Examples of early English pottery, named, dated and inscribed*, London, 1891

W.B. Honey, *English Pottery and Porcelain*, London, 1933

J. Horne, *A collection of early English pottery*, parts I–XX, 1981–2000 (annual catalogues of exhibitions at Kensington Church Street, Kensington, London)

J. Horne, *English Tin-Glazed Tiles*, London, 1989

R.J. Houghton and M.R. Priestley, *Delftware and Victorian Ointment Pots*, privately published, 2005

B. Hudson (ed.), *English delftware drug jars, the collection of the Museum of the Royal Pharmaceutical Society of Great Britain*, London and Chicago, 2006

D. Imber, *Collecting European delft and faience*, New York and Washington, 1968

R. and P. Jackson and R. Price, 'Bristol Potters and Potteries 1600–1800', *Journal of Ceramic History*, vol. 12, 1982

A.E. Lange, *Delftware at Historic Deerfield, 1600–1800*, Deerfield, Mass., 2001

L. Lipski and M. Archer, *Dated English delftware*, London, 1984

A.K. Longfield, 'Irish delft', *Quarterly Bulletin of the Irish Georgian Society*, vol. XIV, no. 3, 1971, pp. 36–55

A. Lothian, '"Observables" at the Royal College of Surgeons, 31. English delft drug jars bequeathed to the College by Sir St. Clair Thomson in 1943', *Annals of the Royal College of Surgeons of England*, vol.7, December 1950, pp. 3–8

A. Lothian, 'The armorial London delft of the Worshipful Society of Apothecaries', *Connoisseur*, vol. CXXVIII, no. 524, March 1951, pp. 21–6

A. Lothian, 'Vessels for Apothecaries', reprinted from *Connoisseur Year Book*, 1953, pp. 1–9A

A. Lothian, 'Bird designs on English drug jars', *The Chemist and Druggist*, 26 June 1954, pp. 672–7

A. Lothian, 'The Pipe-Smoking Man on seventeenth century English drug jars', *The Chemist and Druggist*, 21 May 1955, pp. 566–8

A. Lothian, 'Angels in the design of seventeenth century English drug jars', *The Chemist and Druggist*, 25 June 25, pp. 732–6

A. Lothian, 'English delftware in the Pharmaceutical Society's collection', *ECC Trans.*, vol. 5, part 1, 1960, pp. 1–4

A. Lothian Short, 'Apothecaries in the Haymarket and their unguent pots', *ECC Trans.*, vol. 10, part 1, 1976, pp. 69–71

M. Macfarlane, 'Apollo Reconsidered', *ECC Trans.*, vol. 16, part 3, 1998, pp. 257–68

M. Mactaggart, 'English delft Adam and Eve chargers, their earliest dating and derivation', *Connoisseur Year Book*, 1959, pp. 58–63

J. Marryat, *Collections towards a history of Pottery and Porcelain*, London, 2nd ed. 1857, 3rd ed. 1868

L.G. Matthews, *Antiques of the Pharmacy*, London, 1971

Major R.G. Mundy, *English Delft Pottery*, London, 1928

I. Noël Hume, *Early English Delftware from London and Virginia*, Williamsburg, 1977

H. Owen, *Two centuries of ceramic art in Bristol*, London, 1873

M. R. Parkinson, *The Incomparable Art, English pottery from the Thomas Greg Collection*, Manchester 1969

J. E. Poole, *English Pottery*, Cambridge, 1995

J.E. Pritchard, 'The Pithay, Bristol', *Transactions of the Bristol & Gloucestershire Archaeological Society*, 1926, vol. XLVIII, p. 262 and pl. VI

B. Rackham, 'English earthenware and stoneware at the Burlington Fine Arts Club, *Burlington Magazine*, vol. XXIV, 1913–1914, pp. 265–78

B. Rackham, 'Early Dutch maiolica and its English kindred', *Burlington Magazine*, vol. XXXIII, October 1918, pp. 116–21

B. Rackham, *Catalogue of the Glaisher Collection of Pottery and Porcelain in the Fitzwilliam Museum, Cambridge*, Cambridge, 1935

B. Rackham, 'Bernard Palissy and Lambeth delft', *ECC Trans.*, vol. 4, part 5, 1959, pp. 61–4

R.L. Raley, 'Eighteenth-century Irish delftware', *Antiques*, January 1963, pp. 106–9

A. Ray, *English delftware pottery in the Robert Hall Warren Collection, Ashmolean Museum, Oxford*, London, 1968

A. Ray, *English delftware tiles*, London 1973

A. Ray, *Liverpool printed tiles*, London, 1994

A. Ray, *English delftware in the Ashmolean Museum*, Oxford, 2000

G. Slater, 'English delftware copies of La Fécondité pattern dishes attributed to Palissy', *ECC Trans.*, vol.17, part 1, 1999, pp. 47–63

R. E. Taggart, *The Frank P. and Harriet Burnap collection of English pottery in the William Rockhill Nelson Gallery*, Kansas City, Missouri, 1967

H. Tait, 'Outstanding pieces in the English ceramic collection of the British Museum', *ECC Trans.*, vol. 4, part 3, 1957, pp. 45–54

H. Tait, 'The Passmore Gift: some outstanding pieces of English ceramics', *Apollo*, vol. LXVIII, no. 402, August 1958, pp. 49–51

H. Tait, 'The Passmore Gift', *Museums Journal*, 1958, vol. 58, issue 4, pp. 81–4

H. Tait, 'Southwark (alias Lambeth) delftware and the potter Christian Wilhelm: I', *Connoisseur*, vol. CXLVI, no. 587, August 1960, pp. 36–42; part 2, ibid., vol. cxlvii, no. 591, February 1961, pp. 22–9

H. Tait, 'The Passmore Gift', *British Museum Quarterly*, 1962, vol. XXV, nos 1–2, pp. 41–4

H. Tait, 'A Dwight family heirloom (pre-1685) and a fake (pre-1887)', *Ars Ceramica*, 1997/1998, no. 14, pp. 8–15

N. Thomas and A. Wilson, *Bristol Fine Wares 1670–1970, Ceramics in Bristol*, City of Bristol Museum and Art Gallery, September 1979–January 1980

F. Tilley, 'London City Company Arms on English delftware', *The Antique Collector*, June 1967, pp. 124–9

F. Tilley, 'London City Company Arms on English delftware, Part II', *The Antique Collector*, December 1967, pp. 265–71

F. Tilley, 'London City Company Arms on English delftware Part III', *The Antique Collector*, June 1968, pp. 125–30

K. Tyler, I. Betts and R. Stephenson, *London's delftware industry, the tin-glazed pottery industries of Southwark and Lambeth*, Museum of London Archaeology Service monograph 40, 2008

P. Warren, 'The English posset pot', *Antiques*, April 1983, pp. 835–41

R.H. Warren, 'Blue dash chargers', *ECC Trans.*, no. 4, 1937, pp. 12–22

M.S. Dudley Westrop, 'Notes on the Pottery Manufacture in Ireland', *Proceedings of the Royal Irish Academy*, vol. XXXII, series C, no. 1, 1913, pp. 1–27

G. Wills, 'English Pottery in 1696: an unpublished document', *Apollo*, vol. LXXXV, no. 64, June 1967, pp. 436–43

Index